SILVER HORN

The Civilization of the American Indian Series

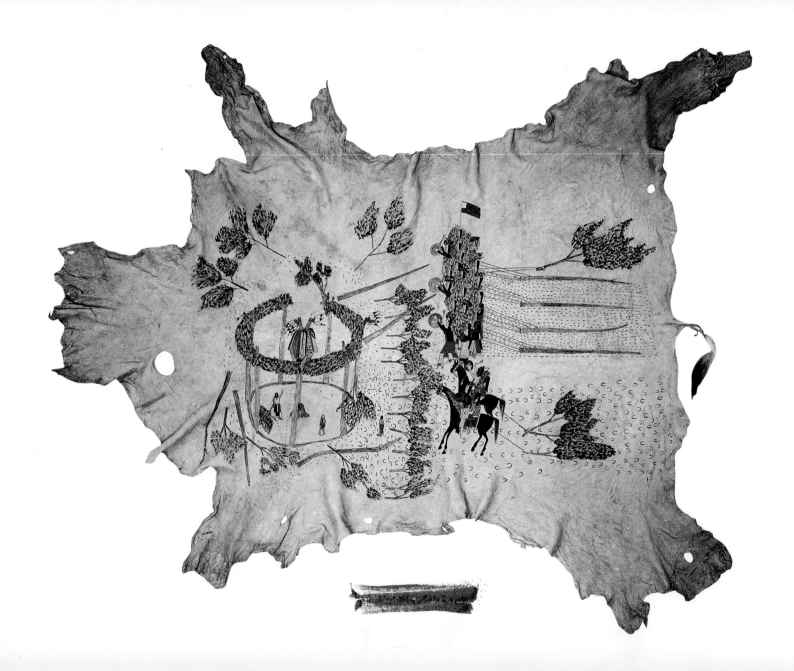

SILVER HORN

Master Illustrator of the Kiowas

Candace S. Greene

Foreword by Donald Tofpi

University of Oklahoma Press : Norman

Publication of this book is made possible through the generosity of Edith Gaylord Harper.

Library of Congress Cataloging-in-Publication Data

Greene, Candace S.
 Silver Horn : master illustrator of the Kiowas / by Candace S. Greene ; foreword by Donald Tofpi.
 p. cm.— (The civilization of the American Indian series ; 238)
 Includes bibliographical references and index.
 ISBN 0–8061–3307–4 (hc : alk. paper)
 1. Kiowa Indians—Social life and customs—Pictorial works. 2. Silver Horn, 1860–1940 3. Kiowa art. I. Title. II. Series.
E99.K5 G74 2001
978.114'9749'00222—dc21

00–061594

Silver Horn: Master Illustrator of the Kiowas is volume 238 in The Civilization of the American Indian Series.

To Max Silverhorn, Sr.

Contents

Foreword

Donald Tofpi, on behalf of the Silverhorn Family

The Haun-gooah (Silverhorn) family would like to thank all contributors to this book, especially Candace Greene, who took the time not only to come to Oklahoma and meet the family but also to become our friend. We hope that all who gain access to this book will learn that Haun-gooah was a man with vast knowledge of the tribe's customs, ceremonies, religion, and everyday life. He was not only an artist but also a religious man who was keeper of one of the Tsaidetalyi medicine bundles. Haun-gooah's bundle is still maintained by family members.

Haun-gooah lived from the times when he roamed the Plains as a Kiowa warrior to being forced onto a reservation and finally living with his family near Stecker, Oklahoma. This is the time when we talked, laughed, and cried with him. This is the time when he shared his life and stories with us.

We hope that all who have an opportunity to view Haun-gooah's art will have a better understanding of the ways of the old Kiowas and how they lived and dealt with everyday life. These are the ways that have been passed down to the generation of today, the Kiowa way.

Acknowledgments

One day in 1991, when I was already well launched on the research for this book, my friend John C. Ewers came into the office that we then shared and plopped down on my desk a thick notebook of photos and a fat box of file cards, the fruits of his own years of intermittent research on Silver Horn. "Here. It's all yours now," he said. What a gift! I was thrilled . . . at least at first. On second thought, I was a bit dismayed. Jack was the dean of Plains Indian art studies. His work was so impressive, his knowledge so vast— what would I ever be able to add? In time I came to realize that what he had given me was a solid foundation on which to build and a heap of tumbled facts with which to start construction. It was up to me to find some sort of plan to fit them together. That plan emerged through a series of research trips to Kiowa country.

My greatest support in this project has come from members of the Silverhorn family, who welcomed my interest and shared their knowledge. They helped me to recognize Silver Horn as a complex person as well as a gifted artist and guided me to a richer understanding of the world in which he lived. It was my great privilege to work with the artist's son Max Silverhorn, Sr., who, sadly, passed away just as this book was going into production. The volume is dedicated to him. Special thanks are due to Donald Tofpi, Silver Horn's great-grandson, who was always ready to make arrangements to get me in touch with family members. Other members of the family who graciously shared their knowledge with me are Ruth Silverhorn Tofpi; Velma Silverhorn; Bessie Silverhorn Ahhaitty and her husband, Reuben; Phyllis Silverhorn Calcaterra and her husband, Paul; Alice Konad Littleman; David Paddlety; Vanessa Jennings; Richard Aitsan; and Barney and Frances Oheltoint.

Many other Kiowa people helped me to understand Kiowa ways and the cultural framework within which Silver Horn produced his art. I would particularly like to acknowledge the assistance of Florene Whitehorse-Taylor; Roland Whitehorse; Jacob Ahtone; Parker McKenzie; Gus Palmer, Sr.; and Dixon Palmer.

Following up the leads in Jack's notes took me to collections in museums and archives around the

country. I received gracious help from many people, but I would especially like to acknowledge the following colleagues who went out of their way to find resources and make them available to me: David Binkley at the Nelson-Atkins Museum of Art, Kansas City; Jeff Briley at the Oklahoma Historical Society, Oklahoma City; Rosemary Ellison at the Southern Plains Indian Museum, Anadarko; Linda Foss-Nichols at the Museum of Fine Arts, Boston; Janice Klein at the Field Museum of Natural History, Chicago; Mike Leslie at the National Cowboy and Western Heritage Museum, Oklahoma City; Drew McDaniels at the Museum of the Great Plains, Lawton; Roberta McGregor at the Witte Museum, San Antonio; John Powell at the Newberry Library, Chicago; Sonja Schierle at the Linden Museum, Stuttgart; Towana Spivey at the Fort Sill Museum, Fort Sill; and John (Doc) Walker at the Panhandle Plains Museum, Canyon. Thanks are also due to Charles and Valerie Diker, who shared with me their Silver Horn drawings, since donated to the Museum of Indian Arts and Culture in Santa Fe. And at the National Museum of Natural History, where so much of Silver Horn's work is preserved, I am much indebted to Jake Homiak and Felicia Pickering for their ongoing support and cooperation.

Funding for research travel was made possible through grants from the Smithsonian's Research Opportunities Fund over many years. I am grateful to recent chairs of the Department of Anthropology, National Museum of Natural History, for allowing me to commit time to this project. I would especially like to thank William L. Merrill, curator of ethnology, for his continuing encouragement and Ross Simons, associate director, for underwriting the substantial cost of acquiring illustration materials for this book.

I have benefited from discussions with many friends who have helped me to think ideas through, look at things in new ways, and generally figure out how to get it all down on paper, particularly Dan Swan, Fr. Peter Powell, Janet Berlo, Bob Donnelley, Barbara Hail, and Bill Meadows. An enormous thank you is due to Julie and Farrell Droke, who gave me a home away from home whenever I was in their part of Oklahoma and who helped me crack that fascinating pictorial diary.

For some reason, acknowledgment of one's family always comes last in the Western literary tradition, although Kiowa folks know that it really counts for more than anything else. Will and Emily, what can I say except thanks? Long ago I sought career advice from my father and got the recommendation to "do something interesting." Thank you for that good advice.

SILVER HORN

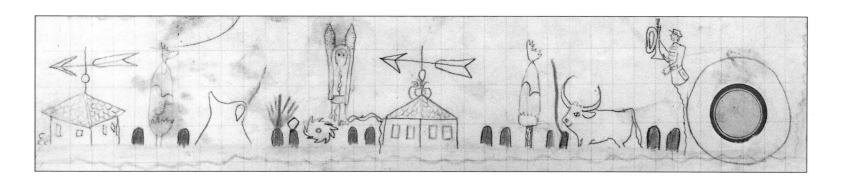

Abbreviations

BAE	Bureau of American Ethnology
BAE LR	Bureau of American Ethnology, Letters Received
FMNH	Field Museum of Natural History
FMNH D-M	Field Museum of Natural History, Dorsey-Mooney Correspondence
LOC	Library of Congress
MIAC	Museum of Indian Art and Culture, Museum of New Mexico
NA	National Archives
NAA	National Anthropological Archives, Smithsonian Institution
NA RG	National Archives Record Group
NA SRC	National Archives, Southwest Regional Center
NMNH	National Museum of Natural History, Smithsonian Institution
SPIM	Southern Plains Indian Museum

Chapter 1

From the Plains Pictorial Tradition

The buffalo days of the Plains are gone—a time when feather-bedecked warriors dashed across the prairies on painted ponies, boldly striking down enemies with their deadly lances. Stories of those days still live on, told and retold, tumbled and worn smooth and at times reshaped into fantastic forms by the many voices that have claimed them as their own. Pictures of that time also survive, for Plains men were artists as well as fighters and made many drawings of themselves and their deeds. These small, brilliant illustrations told stories too, but in a form that white people on the Plains could begin to grasp. Many travelers acquired books of drawings as well as painted hides and took them home as a record of their encounter with another people and another way of life.

As interest in Indian history and culture has grown in recent years, so has interest in Plains Indian drawings. The stories they carry seem so palpably near and fresh; the artists speak to us so directly, proudly proclaiming the glories of war or poignantly recounting efforts to maintain dignity amid the many indignities of reservation life. These drawings are surely one of the best sources of material for gaining insight into Plains Indian cultures of the nineteenth century and hearing direct native testimony about a time now gone and the way of life of a people who have moved on to face new challenges and adventures. No artist offers a greater wealth of drawings or finer opportunities to learn the stories they tell than Silver Horn, master illustrator of the Kiowas.

Silver Horn, called Haungooah in Kiowa, was perhaps the most productive Plains Indian artist of all time. More than one thousand of his drawings survive, all produced between the late 1870s and the early 1910s and depicting a remarkable range of subjects. His repertoire includes topics long established in Kiowa art—scenes of warfare and of the Sun Dance (fig. 1.1), visionary images represented in abstract form on the covers of shields, and events of years past as recorded in the pictorial calendar. He went far beyond the artistic range established by other Plains artists, however, to create an unparalleled visual record of Kiowa culture. His drawings of warfare depicted events of the distant past as well as more recent conflicts, while his images of ceremonies included rituals just emerging at that time. He created unprecedented illustrations of myths and other oral traditions, giving visual form to monstrous and magical figures previously

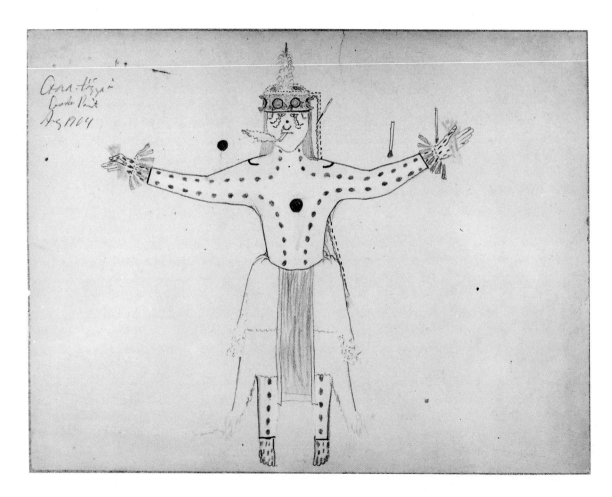

1.1. Medicine Lodge priest in ritual dress, including sacred body paint, downy head feather, and deerskin kilt. MS 2538. Courtesy of the National Anthropological Archives, Smithsonian Institution. (All illustrations are by Silver Horn unless otherwise noted.)

known through words alone. He conceived and produced a unique pictorial diary, leaving a fine-grained chronicle of events as well as a graphic record of how he conceptualized time. Continuing the calendar-keeping tradition of his family, he transformed the Kiowa annual calendar from a bare mnemonic device to a complex form of picture writing that can almost be read by reference to the images alone. While he was employed as part of a Smithsonian research and exhibition project, Silver Horn translated nearly the entire corpus of Kiowa shield designs into miniaturized form on a series of brilliantly painted and adorned buckskin models. Like artists before him, he illustrated scenes that were once part of everyday life—hunting, courting, and the camp dandy parading in all his finery.

Silver Horn's remarkable productivity was supported by a brilliant talent. His sure hand was ideally suited to Plains graphic art of the time, which was built upon carefully delineated forms filled in with blocks of color. His fine draftsmanship was complemented by a gift for capturing and conveying the essence of a scene through the arrangement of line and mass, and he displayed great confidence in tackling new topics, media, and even styles. His talent assured a ready market for his drawings, which in turn gave him the freedom to indulge his passion for drawing as well as the means to obtain quality materials. For a few years he even held regular paid employment as an artist, and some of his finest works resulted from that opportunity to focus on his art. Whether made for sale or for himself, Silver Horn's drawings convey the sense that he derived great pleasure from producing art and that the translation of mental images into graphic form was an integral and essential part of his life. Delicate human forms grace the page in fulfillment of an idealized vision, and decorative detail is applied with a loving hand.

Silver Horn illustrated many aspects of Kiowa culture, and his drawings offer visual representation of an amazingly broad array of topics. In addition to providing rich detail on many cultural practices, they also offer the personal perspective of a member of that culture to whom such activities were intensely meaningful (plate 1). He carefully recorded aspects of prereservation life that he had known as a boy, which were threatened or already gone forever by the time he came of age as an artist—coup counting, war medicine, and the communal Sun Dance ritual. He provided eyewitness documentation of changing cultural practices during the reservation years, especially in religious rituals such as the Ghost Dance and the Peyote religion. His own changing conceptualizations of time are graphically mapped in the pictorial diary that he maintained over many years. But amid such highly charged public events, he also found room to record the small events through which people crafted their daily lives: play and storytelling, amorous adventures, and the lovely details of personal dress and ornament.

These pictures represent Kiowa culture, but they are also a re-presentation of it. Works of art are always embedded in the context of the artist's social position and personal history as well as within the more generalized history and culture of the community. No recorder is a passive mirror reflecting everything that passes before it, and Silver Horn would undoubtedly have regarded any attempt to create an impartial record as a strange objective. Plains art had always served active purposes in social and spiritual life. Silver Horn's work was guided by the underlying assumptions of this tradition of what art was supposed to do and be. He was a part of Kiowa society, not a detached observer of it, but he was also an active participant in shaping that society, applying a unique personal perspective to an old and established art.

We seldom have enough information about Plains artists of the nineteenth century to consider their personal perspective. The authorship of much Plains art from that time and even from the early twentieth century remains anonymous. Unsigned and undocumented drawings are often assumed to represent tribal or perhaps more broadly regional perspectives. Even when the name of the artist is recorded, we rarely know much about his personal history or the circumstances under which the particular images were created. Perhaps the bare outline of his life can be traced in the bureaucratic Indian agency records, censuses, ration lists, allotment records, and so on, but these tell us little of his place within his family and wider community. Equally seldom do we have a wide range of works by the same artist, spanning a range of time and circumstance.[1]

Silver Horn presents a unique opportunity for the study of a Plains artist. He created a phenomenal number of drawings on a wide range of subjects that have survived with a clear record of authorship. His documented work covers a broad time range and provides a firm foundation for tracing the development of his distinctive style, allowing other, undocumented works to be attributed to him with certainty. This rich body of images is complemented by equally rich information about the artist and his life. Silver Horn himself worked with anthropologists in the first decade of the twentieth century and again in the 1930s, helping them record information about the Kiowas. Their notes include his comments on tribal history and culture as well as details of his own life and family history. This commitment to the recording of traditional knowledge has continued in his family. In the 1960s, his oldest son, James Silverhorn, participated in an oral history project directed by the University of Oklahoma. In many interviews, he offered a very personal view of his father and his times as well as keen observations on Kiowa culture and the changes it has incorporated over time. When I began my research on Silver Horn in the 1990s, I was privileged to work with the artist's youngest son, Max Silverhorn, Sr., and to talk with many other family members who

knew him well. They generously shared their knowledge and their memories to sketch a fuller picture of Silver Horn, to help me see him not only as an artist but also as a man, a quiet but esteemed cultural leader within his community during an era of great change.

The visual record of Kiowa culture that is Silver Horn's legacy would be a phenomenal source of information even if the identity of the artist remained obscure. Its value is enormously enhanced by all that is known about Silver Horn. Rarely are we so well informed about the personal as well as tribal background that shaped the vision of a native artist in the nineteenth century. Building upon long-established pictorial conventions, his drawings provide a uniquely detailed and rich illustration of many aspects of Kiowa culture. This is ethnographic information recorded directly by a member of the culture. It comes to us fresh, without mediation by the selective filter of an outside recorder. All sets of data are of course shaped by their producer's concepts of what it is appropriate to record or in this instance to draw. Silver Horn's work is not a complete picture of Kiowa life. Rather than marring the record, however, such choices and omissions can offer insight into the underlying principles that guided his system of visual representation. We can observe, for example, that women's activities were not a topic to which he devoted much attention, and we can begin to trace the general principles that he followed in representing his culture. To what extent were his pictures shaped by the tradition of Plains graphic art to which he was heir? Was he bound by established Kiowa precepts regarding issues of representation, or did he pursue an independent course of personal creative freedom? Did the content and nature of his work change in response to the audience he expected to view his drawings, and did his own views change over time? These are the sorts of questions that I will be considering as I explore Silver Horn's work, seeking to elucidate the concepts that guided its production as well as to discover what insights it offers in helping to understand the stories told in the many other drawings left to us by less well known Plains artists.

The Plains Pictorial Tradition

Silver Horn was both a traditionalist and an innovator, following old canons of Plains graphic art as well as exploring new topics and techniques. His artistic vision reflects both the established tradition of Plains pictorial art, particularly as produced by the Kiowas, and new concepts of representation.

Pictorial art was more fully developed on the Plains than in any other part of North America. Incised and painted figures still survive on rocky outcrops throughout the Great Plains region. Such sites are often

difficult to date precisely, but extend back at least a thousand years. The arrival of European goods such as the horse, firearms, and other trade items is well documented in rock art throughout the Plains (fig. 1.2). Two different basic styles have been identified in the rock art of the region. The earlier images consist primarily of single, static human, or at least anthropomorphic, figures. Many exhibit attributes that are known from more recent Plains art to indicate spirit beings, such as horns rising from their heads or wavy lines extending from their bodies. While many figures may appear upon the same rock panel, at times even overlapping, they are not in interaction with each other, and the connections between the figures are not apparent. This style of art, which was produced on the Northern Plains ca. 1000–1600, is believed to be ceremonial in nature and to have been created in an effort to invoke supernatural forces or to memorialize contact with the spirit world.

A more secular form of rock art emerged just prior to the period of extended contact with Euro-American immigrants and soon replaced ceremonial art. Best known from protohistoric sites (1625–1775) on the Northern Plains, it provides a visual record of the emergence of the Plains war complex and of the

1.2. Compilation of rock art scenes of war from the Writing-on-Stone site in the Milk River valley of southern Alberta. Courtesy of James D. Keyser, based on originals obtained from the Glenbow Museum, Calgary, Alberta, and Stuart Conner.

integration of horses and firearms into patterns of warfare. Individual shield designs and other personal markers are carefully delineated and often incised with a remarkable level of detail, making it clear that these are accounts of specific men engaged in specific events. Some rock art panels show battles between large groups of figures, but more often scenes show individual combat encounters. The production of rock art declined during the historic period as artists turned to other media, although some panels on the Southern Plains have been dated as late as the 1870s (Turpin 1989).

Hide painting may be as old as rock art, but the record of this more perishable medium is much less complete. Members of Francisco Vásquez de Coronado's expedition of 1540 recorded that the people they encountered on the Southern Plains wore painted buffalo hides, but they did not describe the nature of the decoration; comments by other travelers on the Plains over the next two and a half centuries were equally vague. By the beginning of the nineteenth century, however, when our record of hide painting becomes more extensive, there were two distinct types of designs, and this distinction continued throughout the century. Geometric designs were the province of women artists, while pictorial images were produced by men (fig. 1.3). The pictorial images on hides are closely related in form and content to those found at historic rock art sites, and the two may well have developed simultaneously, rather than one emerging from the other.

While hide painting became increasingly detailed and finely executed over the course of the nineteenth century, many of the basic elements of style and convention are evident in the earliest recorded hides, such as those in the collection of the Musée de l'Homme (pictured in Horse Capture et al. 1993). Figures were drawn in outline, sometimes filled in with solid blocks of color, creating flat images without shading or modeling. The outline forms are simplified, and the aspect chosen is that most readily recognizable in silhouette. Human forms are usually drawn in frontal view, with only the feet turned to one side, while horses are presented in profile. Although almost all drawings are of people (primarily men), little attention is given to proportions or details of the human form. Various items of weaponry and personal paraphernalia, however, are represented in some detail. Figures appear against the blank surface of the hide without indication of setting or background, focusing attention on the action. They are always shown in close combat, without concern for realistic representation of spatial relations. A number of discrete scenes may be scattered over the surface of the hide, much as they were over a rock surface. These scenes represent a series of individual events rather than a connected narrative, although several may represent various deeds of the same protagonist.

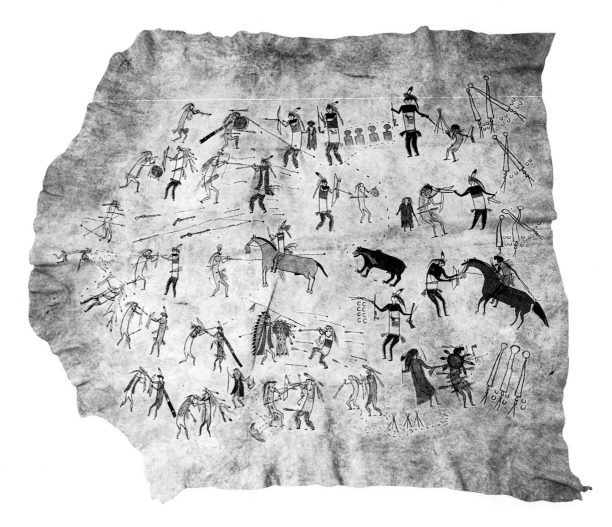

1.3. Painted buffalo hide showing the exploits of several warriors.
The man in the upper right corner (wearing a two-tone shirt, roach headdress, and fringed leggings) appears a number of times, often carrying a pipe to signify that he was the leader of a war party.
Unknown artist. #2130. Courtesy of the Department of Anthropology, National Museum of Natural History, Smithsonian Institution.

This same basic style of drawing was widely used in Plains pictorial art, appearing on items that were often quite different in nature. They served different social purposes, and their content and form were shaped by their place in society. Three basic genres of Plains pictorial art can be recognized—narrative art, visionary art, and pictorial record keeping.[2]

Narrative art is deeply rooted in the depiction of warfare, as seen in both early contact rock art sites and the earliest surviving hide paintings. This art is concerned with representing individual warriors and their deeds. The recitation of deeds of glory known as coups, formally honored deeds of war, was an important form of oral performance in Plains society, necessary for a man to validate his war record. These pictures, whether on rock or on hide, constituted the visual parallel of that verbal record. A series of widespread conventions developed in narrative drawings to assist in efficiently telling their tales of war. Footprints of men and horses delineated the course of action, while gunfire was shown by lines radiating from the muzzle of a weapon, and the flight of bullets was indicated with a squiggly tail trailing the ball. A weapon floating free over a man's head indicated that a coup had been struck upon him with that weapon, and an array of weapons might indicate items captured. Spatial relations between figures were compressed so that opponents appeared close together, regardless of whether they used short- or long-range weapons. Protagonists were identified by distinguishing features such as shield designs or distinctive items of dress. Name glyphs, small pictorial representations of a person's name, might also be placed above a figure.

Narrative art served men's need to advertise their accomplishments publicly in order to gain social recognition, and its form and content were open to constant view and public critique. Buffalo robes, tipi liners, and the occasional pictorial tipi were all intended for public display. Even their production was often public, with multiple artists working together while others looked on (fig. 1.4). A man with artistic ability might paint his own deeds, while other warriors of less skill dictated their accomplishments for depiction by others. Paintings on hides were virtual billboards, constantly proclaiming the deeds of those portrayed upon their surfaces.

During the last half of the nineteenth century, paper and pencils became increasingly accessible to Plains people through trade networks. Much of the paper was in the form of ledger books, bound volumes of blank ruled paper intended for the entry of financial accounts. Plains artists readily perceived their potential for the recording of much more interesting pictorial accounts (plate 2). In recognition of this early medium, Plains drawings on many types of paper are now commonly called "ledger art." Artists found that the individual episodes depicted on hides could be transferred to the individual leaves of paper

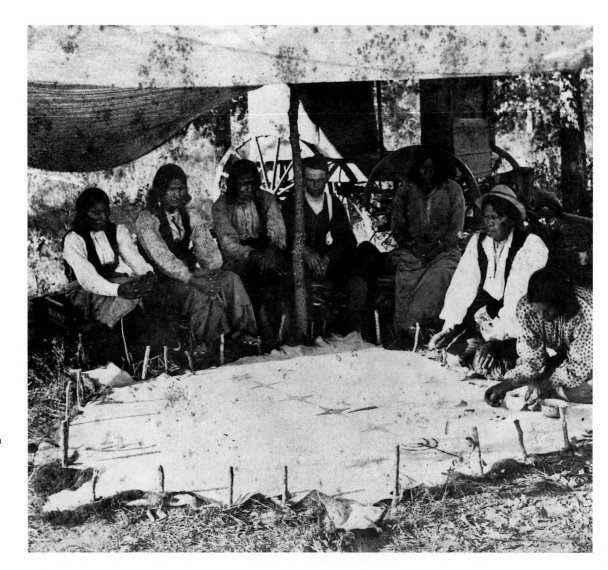

1.4. Kiowa and Comanche men painting a buffalo hide.
This photograph was taken during a treaty gathering at Okmulgee, Indian Territory, in 1875.
Photograph by Jack Hiller, 1875. #8820. C. W. Kirk Collection. Courtesy of the Indian Archives, Oklahoma Historical Society.

without a radical change in scale or form, and they readily mastered the use of colored or graphite pencils in place of the sharpened wood or bone stylus dipped in pigment. With these new materials, it was possible to produce very finely detailed images upon the smooth surface of the paper in a brilliant range of colors. These features plus the ease of pulling out a small volume and a handful of pencils made ledger art a desirable alternative medium even when hides were abundant upon the Plains. Once the bison were exterminated, it was almost the only medium available.

Over time, ledger artists expanded the subjects they chose to depict beyond the relatively limited repertoire of previous hide painting. The potential for more informal production as well as a different context of display encouraged the exploration of new subject matter. Much ledger art continued to be produced communally, as evidenced by the work of multiple artists within many books, but the audience that viewed it might now be limited to a group of friends who passed the book around among themselves rather than the camp as a whole. Scenes of warfare continued to dominate the art, but they were joined by many other topics (fig. 1.5). Narrative art appearing in ledgers was still concerned with men's interests and activities, but scenes of hunting, ceremonies, and parading dandies displaying their finest apparel entered the repertoire, and images of courting became quite popular. Much surviving ledger art was produced after Plains people were confined to reservations. In this new situation, paper was readily available, but opportunities to achieve war honors worthy of depiction were severely restricted. Artists continued to commemorate past deeds, although they also looked to current life for topics of manly interest.

There are few surviving examples of prereservation Kiowa pictorial art (fig. 1.6), although verbal accounts as early as the 1830s make it clear that this is an accident of preservation rather than the result of an impoverished art tradition (Greene 1997). The Southern Plains where the Kiowas lived were not frequently visited by collectors of Indian art, and we do not have many examples of Kiowa pictorial art produced before they were confined to a reservation in 1875. Examples of Kiowa work dating to the last quarter of the nineteenth century demonstrate that a number of artists were active, although few are known by name. Works by Silver Horn, however, dominate collections of Kiowa art. His drawings on paper alone account for well over half of known Kiowa reservation art.

Kiowa drawings by other artists follow the general themes of Plains reservation art—warfare, hunting, courting, and major tribal ceremonies, the most important of which for the Kiowas was the Sun Dance. Frequent contact with other tribal communities administered by the same agency is reflected in engaging representations of the dress and dances of Wichita and Apache neighbors. The mix of work by

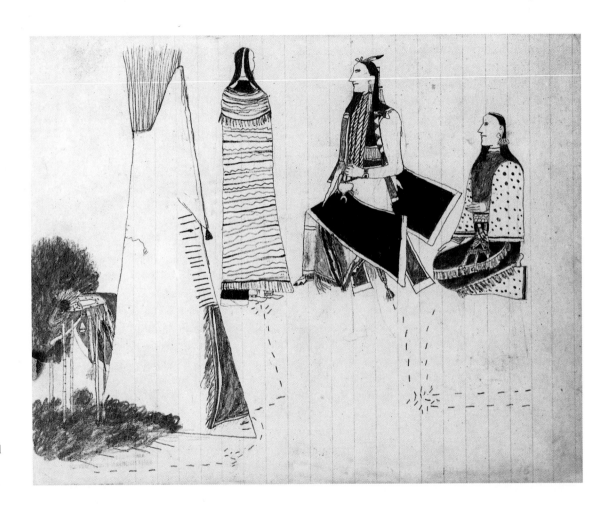

1.5. A young woman being courted outside her father's tipi by a suitor who has just parted with another woman. Koba, 1875. MS 39C. Courtesy of the National Anthropological Archives, Smithsonian Institution.

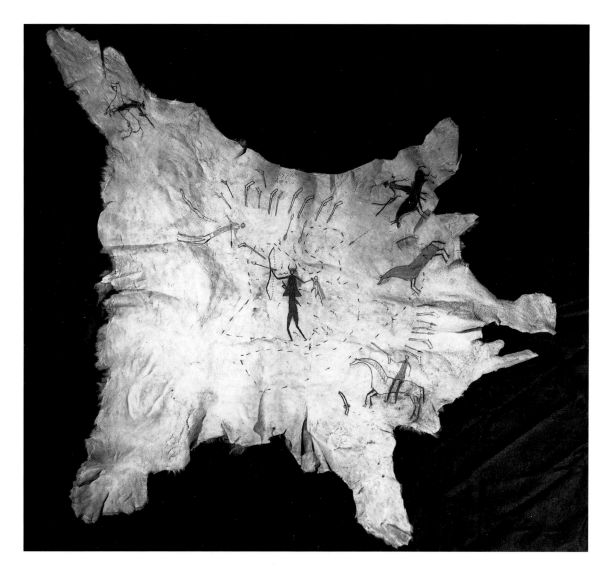

1.6. Painted buffalo calf skin.
Footprints tell the story of the central warrior, whose horse has been shot. Armed only with a bow and arrows but protected by a horned headdress, he is surrounded by enemies with firearms, only a few of whom are fully depicted.
Artist unknown, ca. 1868. #6974.
Courtesy of the Department of Anthropology, National Museum of Natural History, Smithsonian Institution.

several artists in some ledgers indicates that communal art production continued, while other books by a single hand demonstrate that individual work was also acceptable within the community. In style, Kiowa drawings are similar to those of other Plains artists. Figures are defined by solid outlines filled in with unshaded blocks of color, although great attention was often devoted to careful presentation of details of dress and equipment. Pictures were visual representations of stories of action; there is little concern with naturalism, realistic perspective, or indication of setting because such elements were not an essential part of storytelling.

Working in close association, Kiowa artists developed some subtle shared characteristics in the way they represented figures, but these were not sufficiently distinctive to allow drawings that have survived without documentation to be assigned an obvious tribal designation in the absence of other clues to their origin.[3] The clearest identifiers of Kiowa drawings are distinctive elements of material culture and ceremonial practice. Their shield designs, which are well recorded, are clearly depicted in many scenes of warfare (McCoy 1996; Merrill et al. 1997). Painted tipi designs, rare in the art of other tribes, also often appear in Kiowa ledger books (fig. 1.7). Another distinguishing feature of Kiowa drawings is the frequent representation of a lance or other medicine object displayed upon a tall pole outside a tipi or next to a warrior figure. While many features of dress and domestic furnishing were shared throughout the Southern Plains, occasionally a distinctive geometric painted robe or cradleboard pattern identifies a scene as Kiowa.

Curiously, the best-known and best-preserved Kiowa art of this era was not produced on the reservation but by a group of men held prisoner in Florida. At the conclusion of the Southern Plains Indian wars in 1875, the U.S. government took seventy-two men, including twenty-six Kiowas, into custody as prisoners of war and transported them to Fort Marion in Saint Augustine, Florida, where they were held until 1878. Originally kept in chains, they were soon given a measure of freedom by the officer in charge, Capt. Richard Pratt, and encouraged to pursue a variety of activities, including the production of craftwork for sale to the many tourists who visited the historic old fort to meet these exotic Indians from the West. Several of the men relied upon their knowledge of narrative art and made drawings for sale, usually upon the leaves of small drawing books purchased for that purpose (fig. 1.8). Many of these books are inscribed with the name of the artist, and the work of ten Kiowa artists has been identified (Petersen 1971).[4]

The Fort Marion work contains comparatively few scenes of warfare or of courting, the staples of reservation production. Instead, these artists turned their attention to scenes involving hunting, the activities of camp life at home, and their new experiences in exile. There are many pictures of the trip to Florida by train and boat, of life at Fort Marion, and of activities in and around Saint Augustine. These men were

constantly exposed to Western concepts of illustration, and their drawings became more naturalistic in the depiction of figures and much more concerned with including representations of setting, even well-developed landscape, very different from the work of their counterparts who had remained on the reservation (plate 3). Although their compositions became increasingly complex, these artists remained committed to the concept of art as narrative, and their drawings retain a focus on stories of people and their

1.7. Two warrior societies meeting in painted tipis.
On the left, the Mountain Sheep Society (Adltoyui), identified by a name glyph above the lodge, meets in the Tail Picture Tipi of its leader Big Bow. On the right, another society meets in the Buffalo Picture Tipi, identified by the picture of an elk on the back.
Unknown artist, ca. 1875. MS 392,725. Courtesy of the National Anthropological Archives, Smithsonian Institution.

activities. In contrast to this outpouring of artistic energy while at Fort Marion, these men's interest in drawing seems to have ended with their return to the reservation (some after additional schooling or employment in the East). They turned their energies to other endeavors. No work by the returned Kiowa prisoners is known until twenty years later, when a few of them produced some illustrations under commission for the Smithsonian anthropologist James Mooney.[5] Because they were so active, successful, and innovative as artists while in Florida, it has been assumed that the return of these men to the reservation must have influ-

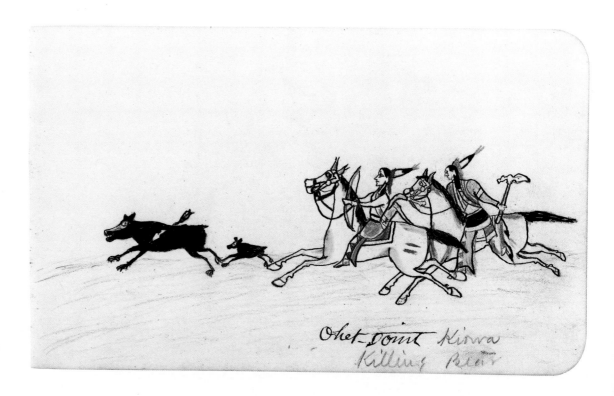

1.8. "Ohet-toint, Kiowa, Killing Bear," from a small book of drawings by several Fort Marion prisoners.
Oheltoint was one of Silver Horn's brothers.
Oheltoint, ca. 1875–78. MS S-1174. Courtesy of the Yale Collection of Western Americana, Beinecke Rare Book and Manuscript Library.

enced artists working there. Convincing evidence for this, however, remains to be presented, as I have discussed elsewhere (Greene 1992a). As we shall see in the following chapters, Silver Horn drew his inspiration instead from artists, including family members, who had remained on the reservation.

Silver Horn worked extensively within the narrative tradition of Plains pictorial art, and his work contains a strong storytelling component throughout his career. During his youth, he must have seen men working together to paint their exploits upon buffalo hides. That art form was obsolete by the time he became an artist, but he worked with other men on the large muslin paintings covered with battle scenes that came to replace them. In all but one of his books of drawings, however, he worked alone, both developing his own distinctive style of representation and recording his own vision of Kiowa life. He pursued a wide range of subjects and styles, but his narrative images remained deeply rooted in oral tradition, as were the coup pictures on which Plains art was built. The range of stories that he chose to illustrate grew, however. The link to storytelling remained strong, but cannibal ogres and adulterous wives joined the cast of more traditional characters.

Visionary art was another major art form with links to the pictorial tradition. It was based on the reproduction of images that had been revealed to humans through supernatural encounters. The historic roots of visionary art are deep and not fully known, but there are undoubted connections to early rock art.

During the historic period, such images were often received during a vision quest in which a man withdrew to a remote location and sought contact with the spiritual world in the hopes of gaining spiritual power, termed *dwdw* or medicine by the Kiowas. Other visions came unsought during sleep or at times of isolation or suffering. The person who experienced the vision was often instructed to create a physical representation of this spiritual encounter, sometimes in the form of a medicine object, sometimes in the form of a design to be painted upon a shield or tipi cover (fig. 1.9). He might produce the image himself or employ a specialized artist to do so under his direction. Not all men were successful in establishing direct contact with the supernatural; but those who were had the right to share their power with others through a formal process of transfer, and these recipients could in turn transfer it to yet other individuals. Many visions also gave the recipient the right to divide the power a specified number of times without reducing its efficacy. Thus a series of identical shields might be produced, based on a single powerful vision. Visionary designs might endure long beyond the life of the original recipient and be reproduced many times by many artists. Each design, like the spiritual power that it represented, was enduring and was conceptualized as separable from the object on which it was placed. Visionary drawings included both

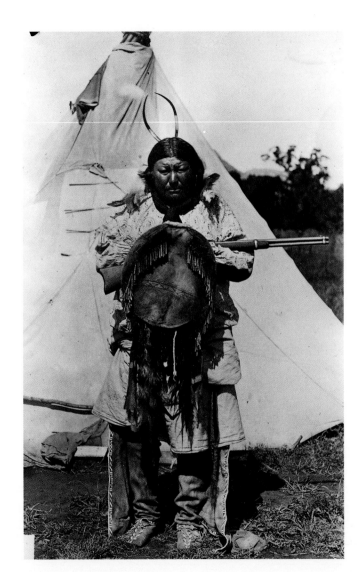

1.9. White Horse, one of the most noted warriors of the Kiowas, displaying his war shield, known as the Cow Shield.
The shield's protective powers were associated with the domestic bull, the rainbow, and the Morning Star, which were painted on its cover. On his head is the split horn headdress that was a part of his war medicine.
Photograph by Hutchins and Lanney, 1892. BAE Glass negative 1379a.
Courtesy of the National Anthropological Archives, Smithsonian Institution.

recognizable figures, most often animals, drawn in the outlined style of Plains pictorial art and more abstract elements representing supernatural forces in symbolic form. Some designs were kept private, but many visionary designs were open to public view, whether on a tipi or on the outer covering of a shield. While knowledge of their appearance was thus widespread, the ownership of such designs was carefully guarded. These images could not be reproduced without the owner's permission.

Kiowa visionary art is among the best recorded pictorial art traditions of the Plains. While few Kiowa shields and no painted tipis have survived from the nineteenth century, the designs of both were intensively studied and recorded at the turn of the century by the Smithsonian anthropologist James Mooney (fig. 1.10). Shields were painted with a variety of circles, crosses, crescents, and other abstract forms symbolic of spiritual forces. Many shields also bore pictorial representations of spirit encounters in the form of animals, such as a bear, mountain lion, or dragonfly, or anthropomorphic beings with spiritual attributes. Tipi designs likewise included both colorful abstract designs and recognizable images, including birds, horses, buffalo, and bears (Mooney MS 2531, MS 2538).

Silver Horn never owned a visionary shield or tipi, but a shield design as well as two painted tipi designs were passed down to other members of his family. One tipi design was visionary in origin, while the other came as a gift from a Cheyenne ally. Silver Horn represented both the shield and the two tipi designs in a number of drawings. With the end of warfare, Kiowa warriors put away their shields; during the reservation years, painted tipis fell into disuse, replaced with coverings of plain canvas. Silver Horn was born too late to participate in the great era of visionary art. Nevertheless, he was not too late to participate in its recording. He worked with Mooney as he interviewed old warriors and their families about their tipis and shields, Mooney recording their information in words while Silver Horn recorded it in pictures. Throughout this project, the old process of visionary art production was followed, with the owner of a visionary design instructing an artist in its representation.

During the reservation period (and afterward), Kiowa people continued to seek contact with the supernatural in various ways and were at times blessed with visions that could be represented in physical form. Visions were sometimes received during the Ghost Dance ceremony (fig. 1.11), and Silver Horn painted stylized representations of such images upon the garments worn by dancers. The Peyote religion was another source of visionary experience (fig. 1.12), and it became a major source of inspiration for artists in the twentieth century. Long before that, however, Silver Horn had produced representations of his own Peyote visions, committing to paper a unique form of visionary art.

The third genre of Plains pictorial art, record keeping, was more prosaic in nature. The people of the Plains did not develop a written language or a system of symbolic numeric notation. At times, they needed tangible records for reference purposes, however, and pictorial art was called into service. Some records served short-term needs and were subsequently discarded. When a camp was relocated, a pictorial

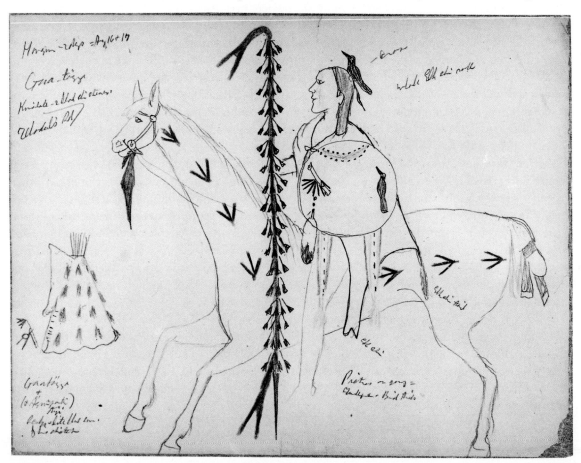

1.10. Tebodal with his war medicine: a shield, a stuffed crow tied to his hair, a feathered lance, and protective bird tracks painted on his pony. MS 2538. Courtesy of the National Anthropological Archives, Smithsonian Institution.

1.11. Ghost Dance dress painted with symbols of the moon and stars as an invocation of spiritual protection. Paint on buckskin. Artist unknown, Kiowa. 8427/1810. Courtesy of the Collection of the Gilcrease Museum, Tulsa.

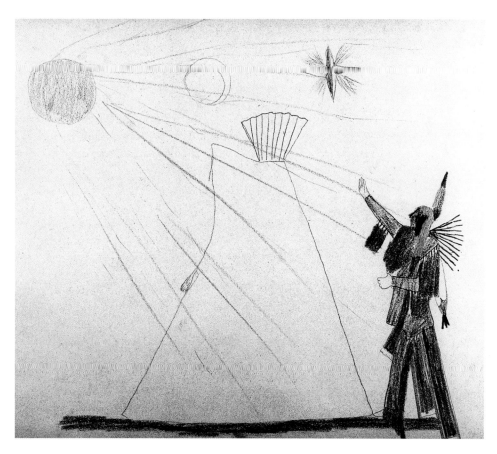

1.12. A man outside the Peyote tipi, raising a hand to the blessing rays of the Sun, the Moon, and the Morning Star. #67,719 (neg. A113214). Courtesy of the Department of Anthropology, Field Museum of Natural History.

message might be left, often painted on a bison scapula, to tell absent members where the new camp could be found (fig. 1.13). For longer travel beyond familiar territory, maps were drawn with place names indicated by name glyphs similar to those used in narrative art to identify individuals (Ewers 1977; Fredlund et al. 1996). Garrick Mallery (1893:336, 359, 363) documented a remarkable array of other examples of nineteenth-century pictorial record keeping, ranging from trail markers to lengthy letters sent through the United States postal system.

The best-known examples of Plains record keeping are the pictorial calendars (fig. 1.14). Produced by the Sioux, the Kiowas, the Blackfeet, and probably other tribes as well, these calendars consisted of a series of ordered pictures representing names assigned to specific years. Rather than referring to years by number as in the modern Western calendar, each year was named for a notable event, such as When the Stars Fell or When They Ate Their Horses, and the picture calendar helped to keep the names in proper sequence.

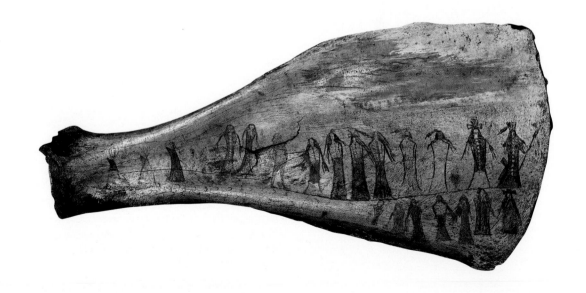

1.13. Bison scapula signboard showing painted tipis and rows of human figures, one evidently a white man, found on the prairie near Austin, Texas, in 1874. Artist unknown. #15,253. Courtesy of the Department of Anthropology, National Museum of Natural History, Smithsonian Institution.

The Kiowa calendar system was the most elaborate on the Plains, with two names and associated pictures for each year, one for summer and one for winter, as described in Mooney's study *Calendar History of the Kiowa Indians* (1898). Summers were often named for some event in association with the Sun Dance, such as the place where it was held. While the numerous Sioux people maintained a number of calendars, throughout much of the nineteenth century there was only one calendar keeper among the Kiowas, the great tribal chief Tohausen. By the beginning of the twentieth century, a number of calendars were kept by Kiowa people as well.

Silver Horn was one of the late calendar keepers within the tribe. He was following his father, who had become a calendar keeper at the death of the original Tohausen. As in so many forms of art, however, Silver Horn exceeded his predecessors. His picture calendar is vastly richer in both the number of pictures and the details of the imagery (plate 4). He also recognized the potential of the calendar as a medium for making a finer-grained record of the passage of time. For a number of years, he kept a personal record in the form of a pictorial diary, and he later used pictures to maintain his employment records.

While these three genres of Plains art had distinct functions that influenced their form, they overlapped at various points. Narrative art often included representations of objects of visionary origin, as did pictorial records. Items such as shields and painted tipis were important identification markers associated with particular individuals and functioned much like the name glyphs in providing identifications. And these visionary markers as well as abbreviated narrative scenes appeared in calendars when needed to designate a year. Much as writing is used for a variety of purposes in literate societies, Plains people used pictorial art in many ways.

The past of many nonliterate cultures is accessible only through present day oral tradition or through observations and narratives recorded by literate outsiders. While such sources contain a great amount of information, both are inherently at a remove from the lives that they record. Stories are filtered through the passage of time, while outside observations are clouded by cultural distance. For the native people of the historic North American Plains, pictorial art offers a third source of information. The production of narrative images was an indigenous tradition, allowing people to record their view of the world and its events in their own terms. These images constitute a series of direct, unmediated statements, inscribed in characters that communicate across boundaries of time and culture. They offer great potential for deepening our knowledge of the historic Plains people who created this enduring record. The basic story that the pictures tell can be fairly

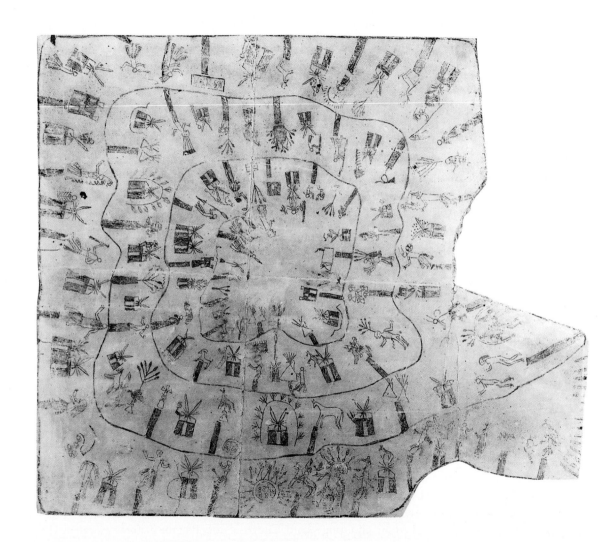

1.14. Kiowa calendar drawn on brown paper by Agiati, Silver Horn's father. *Pictures representing summer and winter events from 1832 to 1892 appear along a line that spirals toward the center.* Agiati, 1892. Colored pencil on paper. #2-4933. Courtesy of the Phoebe Apperson Hearst Museum of Anthropology and The Regents of the University of California.

easily recognized, but many layers of meaning lie beneath the surface content. These more subtle messages that make the drawings valuable as cultural documents are more difficult to decipher.

Silver Horn's drawings illustrate many aspects of Kiowa life, providing valuable information about many cultural practices. They also reveal much about the cultural concepts and personal views of the artist. Placed within a cultural and historical framework, the work of this one artist can also contribute to a richer understanding of Plains art as a whole. To use drawings as a source of knowledge, we must understand the role and function of art in Kiowa society and learn to recognize how art is revealing of broad concepts underlying much of Plains culture.

Chapter 2

It Comes from Family

Family is a major factor in determining position in Kiowa society. In the past as well as the present, it has shaped people's view of the world and what the Kiowa world expected of them. Silver Horn was born into a distinguished family that positioned him well to become an artist. It included prominent warriors and artists as well as religious leaders, calendar keepers, and owners of painted tipis and shields. Members of his family owned many things considered worthy of representation in art and had a tradition of exercising these rights.

An amazingly rich amount of information is available about Silver Horn (fig. 2.1) and his family. Much of it comes directly from him, recorded in interviews with James Mooney and later by members of the Santa Fe Laboratory of Anthropology 1935 field school among the Kiowas. In these sources, he appears as a man of few words, providing factual information without digression. Other members of his family were active in contributing to the written record of Kiowa culture as well. Two of his brothers also worked with Mooney, and both his sister and his sister-in-law contributed many pages of notes to the field school project. To the great good fortune of everyone interested in Silver Horn, the students seem to have encouraged (or at least tolerated) an open, often rambling discourse in the interviews with these elderly women. The memories they shared are warm and personal ones, focused on family and camp life.

Silver Horn's descendants have also collaborated with anthropologists over the years, helping them to record information about Kiowa culture. His oldest son, James Silverhorn, worked extensively with anthropologists from the University of Oklahoma on the Doris Duke Oral History Project in the 1960s. Julia Jordan worked most closely with him, and I first heard of Silver Horn from her long before I had seen any of his drawings. When I began research on Silver Horn's art in the 1990s, I sought out his family and found that many members were still living around Anadarko, Oklahoma. James had passed on, as had most of Silver Horn's other children, but I had the opportunity to spend time with his youngest son, Max Silverhorn, Sr., and to talk with several of James's daughters who had lived with their grandfather when they were young. Don Tofpi, a great-grandson of Silver Horn, was particularly helpful in arranging get-togethers. Through meetings in homes, family reunions in the park (no house is big enough to hold that

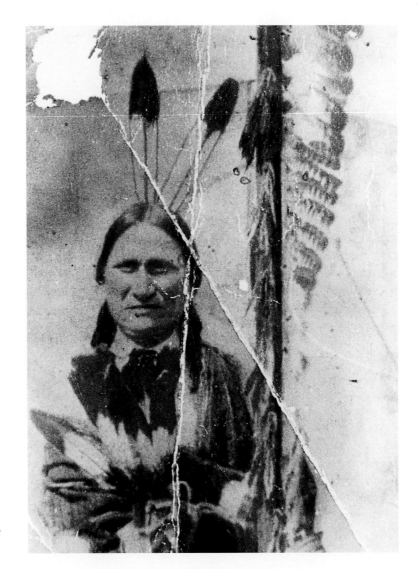

2.1. One of the few photographs of Silver Horn prior to his old age. *The feathers above his head are not original to the photograph, but were drawn on the print, possibly by Silver Horn himself.* Photographer unknown, n.d. Courtesy of Donald Tofpi and the Silver Horn family.

whole family), and more informal visits, we shared our knowledge. I brought out pictures and they brought out memories.

I once read an article about the conservation of some of Silver Horn's paintings in which the author stated, "Little is known about the artist." He just hadn't asked the right people.

Silver Horn was descended from Tohausen ("Little Bluff") (fig. 2.2), the principal chief of the Kiowas from 1833 until his death in 1866. He was a man of enormous diplomatic skills, a leader of the elite Koitsenko warrior society, and was credited with having the best war record in the tribe. Like many warriors, Tohausen was also an artist. No doubt he made pictures of his war exploits, but he also introduced innovations in Kiowa graphic art. One art form new to the Kiowas was the calendar system that recorded a sequence of summer and winter events pictorially. The other was the use of a tipi design with pictures of coup counting, a topic never before represented by the Kiowas on a lodge cover.

Silver Horn's father, Agiati ("Gathering Feathers"), was the son of Tohausen's sister, a relationship nearly as close as one's own son in Kiowa kinship reckoning. Agiati was also a prominent warrior with many coups who was one of the leaders of the Tsentanma ("Horse Headdresses") warrior society.[1] Tohausen had marked his nephew in many ways to follow him in tribal leadership and had conferred his own name on him in 1864. Agiati was also recognized as an artist, and Tohausen transferred the rights to both the calendar and the Tipi with Battle Pictures to him. In later years, Silver Horn worked on producing versions of both of these pictorial family heirlooms.

Agiati married three sisters, who were half Kiowa and half Apache, and had many children. The middle sister, Seipote ("Traveling in Rain," also spelled Sephote), was Silver Horn's mother. She was a woman of distinction who later was a leader of the prestigious and somewhat secret Old Women's Society (Mooney MS 2531, 6;165; LaBarre et al. 1935:573). She and Agiati had five children. Keintadle ("Moth Woman"), the firstborn, was the only daughter. In her old age, Keintadle was a principal informant for the Laboratory of Anthropology field school, and she provided many details of family history that appear in the notes of that project (LaBarre et al. 1935). Next after Keintadle came twin boys, White Buffalo and Oheltoint ("High Forehead"). Oheltoint, also known as Charley Buffalo, was one of the warriors who was active as an artist while imprisoned at Fort Marion. After he returned home, he was employed on the Indian police force, working to protect the reservation from horse thieves and illegal cattle operations. His widow, Mary Buffalo, was another major source of information for the field school project. Silver Horn was the next-born child. He was followed seven years later by the youngest son, Kogaitadal ("Lean Elk"), who took the

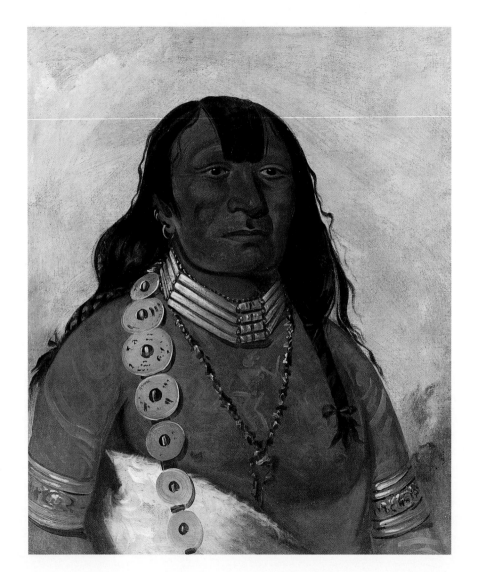

2.2. Portrait of Tohausen ("Little Bluff"), Silver Horn's great-uncle, who was principal chief of the Kiowas for over thirty years. "Teh-toot-sah," George Catlin, 1834. Oil on canvas. 1985.66.62. Courtesy of the National Museum of American Art, Smithsonian Institution. Gift of Mrs. Joseph Harrison, Jr.

name James Waldo while at school at the Carlisle Institute in Pennsylvania (Mooney MS 2531, 6:189; LaBarre et al. 1935:343). The children of Agiati's other wives were also part of a tightly knit extended family. Silver Horn was particularly close to his older half-brother Haba ("Hill Slope").

Many Kiowa men had a number of names throughout their lives, but Silver Horn retained the one he had received in early childhood, Haungooah as it is rendered in Kiowa.[2] It has appeared under a variety of spellings, such as Hangun and Hawgone, but the form used here is the one accepted by his family and formalized in agency records. "Haun" refers to metal, especially white metal, and his name has also been translated as Iron Horn (Mooney 1898:406; J. Harrington 1936). Many years ago, James Auchiah told the anthropologist John Ewers that the name refers to the way sunlight reflecting from a buffalo's horns makes them look like polished metal. Alice Littleman explained to me that the name alludes to a figure in Kiowa mythology. Usually called Metal Horn in English, he was a huge, dangerous buffalo bull with horns of metal with which he would tear apart anyone who approached. He appears in the story of the culture heroes the Split Boys as one of the perils they must overcome.

Silver Horn told Mooney that he was a sickly baby and his parents hoped that a medicine name would strengthen him. They took him to the elderly religious leader Tontanti ("Tail Headdress"), who gave him the name Haungooah in a sweat-lodge ceremony. It was a new name, never used before (Mooney MS 2531, 6:165). His parents' efforts were well rewarded. Silver Horn lived for eighty years, a long life for a man of his generation. When Silver Horn was in his forties, Mooney described him as a wonderful physical type who would make an ideal model for a cast or statue (Mooney 1904d). Photographs show him still slender and erect in old age.

According to Silver Horn, he was born in the "Summer That Tenebadai Was Killed," as recorded by the Kiowa calendar system, or 1860 by the Western calendar (Mooney MS 2531, 6:165). The broad outline of his early life can be reconstructed from knowledge of Kiowa history and his family's place in it. At that time, the Kiowas were a nomadic buffalo-hunting people, who were also deeply involved in long-distance horse raiding and trading. Silver Horn must have grown up with the expectation of becoming a warrior in a society that placed war honors above all other achievements. The many successful warriors in his family could help him greatly, for teenaged boys could gain valuable experience if a relative who was leading a war expedition would take them along as camp helpers. Silver Horn's older brother Haba liked to tell of the first war expedition he went on when he was fourteen, a story he later depicted in a hide painting. He became separated from the war party and had a harrowing experience, but he also achieved fame

and fortune at that early age (Mooney MS 2531, 1:53a). Silver Horn must often have heard of his brother's war exploits, as well as many other stories told by warriors when they gathered to recount their deeds. In addition to absorbing such tales of glory, he would have been trained in the more mundane tasks of all boys, herding and caring for horses as well as hunting small game. Like other members of the community, he would have participated in buffalo hunts and in the religious life of the tribe. Many evenings were no doubt filled with listening to the oral traditions of the tribe, involving events of both recent and mythic history.

Agiati's family was a prestigious one, and Silver Horn grew up surrounded by material objects that were visual symbols of his family's position, continuity, and prominence in the system of war honors. First among these was a painted tipi cover known as the Tipi with Battle Pictures. This tipi design had origi- nated among the Cheyennes and was presented by a chief of that tribe to the Kiowa chief Tohausen in 1845. One side was painted with yellow and black horizontal stripes, representing war expeditions. A row of tomahawks appeared on the back, and a row of feathered lances on the front, each denoting a coup with that weapon. The other half was devoted to scenes of warfare, a novelty for the Kiowas, who painted bat- tle scenes on hide robes and in ledger books, but not on tipis. As a result, the Kiowas named it Do-giagya- guat, Tipi with Battle Pictures. Tipi covers wore out and had to be replaced frequently, at which time the design would be painted on a new cover. While the black and yellow stripes and the rows of tomahawks and lances were permanent features, other scenes might change. At the time of renewal, Tohausen would gather about him a number of prominent men, who would discuss what events were worthy of depiction and agree on two or three dozen. A man's deeds were not included without his permission, since he owned the story of his accomplishments and their representation. But few would decline such an honor.

In 1864, Tohausen transferred the rights to the tipi to Agiati, Silver Horn's father. Agiati lived in the tipi for the remainder of his life. Prior to confinement to the reservation, he renewed the cover regularly, calling together warriors and artists to participate in the process. His sons must eagerly have anticipated this event. In the stark conditions of reservation life, renewals were less and less frequent. When James Mooney observed the tipi in the winter of 1891–92, it was the last painted tipi still in use among the Kiowas. It had not been renewed for a number of years and was in poor condition, with the images on its surface barely discernible (Greene 1993; Greene and Drescher 1994).

The Padogai shield was another significant family heirloom. It originated with Padogai ("White-Faced Bull"), a prominent warrior of the early nineteenth century, who was Tohausen's father. He received the shield design in a vision, which he represented on the shield's outer cover. It was yellow with a blue spot

and a circle of blue dots inside an unpainted disk in the center. On one side hung the complete tail feathers of a crow together with a single eagle feather; on the other, a bunch of antelope hoofs and a single down feather. A horse tail partially wrapped in red stroud cloth was attached in a line down the center of the shield. Two curling yellow cow tails were suspended from the bottom with a large cow bell between them. The inner cover of the shield was unpainted (Mooney MS 2531, 6:79).

Padogai gave this shield design to his son with instructions on how to maintain its power and the authority to make up to four copies of it. Tohausen gave one of these to his nephew Agiati, on whom he had also bestowed the tipi design. In the summer of 1869, Agiati transferred his shield rights to his oldest son, Haba. Haba still had the shield at the time of the surrender in 1875 and concealed it to prevent its confiscation. He disposed of it about 1880, burying it with his father's brother when he died. Some years later, he provided James Mooney with a full history of the shield design and its various owners (Mooney MS 2531, 6:78–81). Silver Horn depicted this shield in many drawings.[3]

Associated with the shield in Haba's time were additional items of war medicine: a headdress, a red cape, and a feathered lance. Haba suggested that the headdress, consisting of a bunch of crow feathers and beaded strands, originated with Tohausen, but he did not provide information on the origin of the other items (Mooney MS 2531, 6:81). The cape may have been a symbolic representation of the Mexican soldier's red coat mentioned in Abert's 1845 report (Galvin 1970:47), which Tohausen had captured and presented to his father.[4] The shaft of the lance was ornamented with large, black clipped feathers, as shown in plate 5 (Mooney MS 1874) and drawings at the School of American Research (illustrated in Greene 1993:73).[5] They appear to be crow feathers, linking the lance ideologically to the shield and headdress, which also drew power from that bird.[6]

The years following Silver Horn's birth in 1860 were a time of deep and inexorable change for the Kiowas. White settlement was expanding westward, and the U.S. government was determined to exert control over the Southern Plains (fig. 2.3). Kiowa raiding was a direct threat to this process. The first open hostilities between the Kiowas and government troops were in 1864 (Mooney 1898:314; Nye 1968:8). A series of unequal engagements followed. In 1867, the Kiowas reluctantly agreed to the Medicine Lodge Treaty, which ceded to the government all their land except a specified reservation in the Indian Territory, although with off-reservation hunting rights. Throughout the decade, the Kiowa band structure was changing as families began to utilize different territories based on their choices on a number of fronts, including war or peace, an economic focus on hunting or raiding, and orientation toward commerce with Anglo or Hispanic traders.

By this time, Silver Horn's father, Agiati, was the leader of a *topotoga* or residential band, which included some of his brothers as well as his brother-in-law Patadal ("Poor Buffalo"), his wives' brother. This group of kin became the nucleus of a new regional band known as Guhale. Guhale is the Kiowa word for antelope, also referring to the Staked Plains region where antelope abounded and to the Comanche band that frequented the area, who called themselves Kohadi or Quohada, from which the Kiowa term is derived. The Guhale band, which formed during the 1860s, was made up of families that had withdrawn to the Staked Plains, seeking to avoid white encroachment and to continue their hunting and raiding way of life (LaBarre et al. 1935:6–15, 41). After the Medicine Lodge Treaty, the Staked Plains—once a hunting area

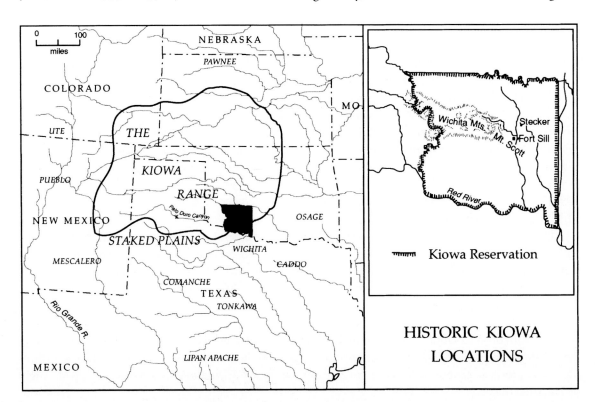

2.3. Nineteenth-century Kiowa territory and subsequent reservation boundaries. Map created by Marcia Bakry, Smithsonian Institution, based on information provided by the author.

but not an area of regular Kiowa residence—increasingly became a refuge for conservative Kiowas who resisted government efforts to regulate their lives. Agiati allied himself closely with the Quohada Comanches, who called him Pakonkya ("Black Buffalo"), often raiding and camping with them (Greene 1996a). But even in this remote area, clashes with government troops could not always be avoided. Stories of these times still circulate. Alice Littleman, the granddaughter of Silver Horn's brother White Buffalo, remembers a story that he told of those days. Their family was overtaken at one time by army troops, and there was no way to get away. Their mother took all the children into a streambed to hide, ducking down under the water and holding their breath until the soldiers had passed by.

By 1870, Kiowa people had been forced to define themselves as either "hostiles" or "friendlies," depending on the strategies they adopted for coping with the reservation system. The Guhale were among the hostiles and had attracted such notorious raiders as Big Bow, White Horse, and Mamante ("Screaming Above") (LaBarre et al. 1935:6–15). Many members of Silver Horn's family were involved in the Southern Plains uprising of 1871–74. While warriors raided on the reservation, attacking surveyors, even driving off a herd of horses from Fort Sill, the family camps were constantly on the move seeking safety for the women, children, and old people. Palo Duro Canyon in the Texas Panhandle was a favored place of refuge. It was there that the last of the Kiowa war factions were ultimately pursued and defeated by Col. Ranald Mackenzie in the early winter of 1874. Silver Horn was only fourteen years old, but a reference to him appears in one story of that desperate encounter (Nye 1938:243, 1962:197). Botalye later recounted to Hugh Scott how his horse went down under him, but "a little fellow" named Silver Horn helped him get it back on its feet. Agiati and his brother-in-law Poor Buffalo were among the last of the Kiowa leaders to surrender to the army in February 1875 and submit to reservation existence (Mooney 1898:211; LaBarre et al. 1935:7).

On the reservation, Agiati established the camp for his extended family near Mount Scott in the Wichita Mountains, far from the agency at Anadarko but fairly near Fort Sill (Scott MS 2932, 2). There Silver Horn grew up within the limited scope that reservation life offered a young man. Warfare and the chance to achieve military honors had ended before he grew to manhood, and the extermination of the bison followed soon after. With all opportunity to achieve war honors curtailed, the system of social position became frozen, and younger men's status came to be based on the war records of their fathers (Mishkin 1992). Silver Horn's father was a man of great prestige, which placed his son high in social rank. As a child, he had belonged to the Polanyi ("Rabbits"), as did all boys. When he was fifteen, he was sought out for

membership in a warrior society and joined the Adltoyui or Mountain Sheep Society (Mooney MS 2531, 6:165; LaBarre et al. 1935:526). Big Bow (Zepkoeete or Zebaedal), whom Silver Horn represented in many pictures, was the leader of this society, which was usually the first of the adult societies that men joined (LaBarre et al. 1935:190, 559). Later Silver Horn was invited to join the Tsentanma or Horse Headdresses, the society of which his father was once chief (Mooney MS 2531).[7] Silver Horn had little to say about the function of the warrior societies during reservation times, but he did tell Mooney that members of the Adltoyui were very popular with the women due to their handsome looks.

In 1891, Silver Horn made a dramatic break from the dreary order of reservation life by joining the army. The U.S. Army had decided to experiment with the enlistment of all-Indian troops, following lines of racial segregation already established with all-black troops. Indians had long been employed by the military as scouts, but this new service was to consist of regular enlistment for five years. Such troops were recruited from reservation populations and were intended to serve primarily in their home territories (Price 1977). Lt. Hugh Scott, a young officer at Fort Sill who had previous experience with Indian scouts on the Northern Plains, was assigned the duty of recruiting and commanding the new Indian Troop L of the Seventh Cavalry. As might be expected, he encountered initial resistance from tribal leaders. He was soon able to win the approval of the Kiowa leader Poor Buffalo (Silver Horn's uncle), however, and was successful in recruiting many Kiowa men. Few Comanches joined the troop because Quanah Parker, one of the principal chiefs, continued to oppose Indian enlistment (Scott 1928:169).

Silver Horn was in the first group of nine recruits to enlist in the troop, which eventually included over fifty men. In some ways, army service was a radical departure from traditional Kiowa life. Soldiers were required to cut their hair and wear uniforms; days were spent in ordered drilling and marksmanship practice; discipline was strict and many duties menial. Yet, within the reservation context, military service offered unique responsibilities akin to the traditional roles of the warrior societies. Their duties included maintaining order at tribal gatherings, as had the old societies, although now the tribe gathered for ration issues rather than for the Sun Dance. They patrolled the reservation, expelling white intruders and chasing horse thieves as they once had pursued marauding Pawnees, Osages, and other enemies. Service in Troop L was prestigious. Many of the men who joined were the sons of prominent war leaders, and today membership in the troop remains a point of pride for descendants. Under Scott's command, Troop L was highly successful, but Indian troops at other posts did less well. The army decided to abandon the experiment, and troops were mustered out short of their original term of enlistment. Silver Horn was discharged from

the army on November 23, 1894, "character excellent," at the end of three years of service (NA RG 94). His commander, Scott, described him as "a faithful, upright, and serious man . . . an excellent horseman as well as a fine shot with rifle and revolver" (Scott ca. 1920a:39).

After leaving the army, Silver Horn returned to his father's camp and to the life he had left behind. His years in the army did not produce any radical change. He had learned to sign his name, but still knew no English beyond the commands of the parade ground (Scott, LOC, Box 76). His association with Fort Sill and its personnel remained a cordial one. His pictorial diary (see chapter 7) indicates that he visited the post often, sometimes hauling freight on contract, and Scott also visited him in his camp on occasion (NAA 4252; Scott MS 2932). Silver Horn's father had died while he was in the service, and his older half-brother Haba had become the head of the family camp. Silver Horn was very close to this brother, who was nine years his senior, and his descendants often referred to Haba as the source of Silver Horn's knowledge on many topics (Mooney MS 2531, 6:88; J. Silverhorn 1967a:15; SPIM n.d.).

In the summer of 1901, Silver Horn married at the age of forty-one. His wife, only thirteen years old, was Tanguma ("Bending Knee Woman"; i.e., "Catholic Woman"). Prior to their marriage, she lived at the Catholic mission school, and her name referred to the ritual gesture of genuflection. She was the orphaned daughter of the Comanche man Naboni ("Looking Glass"), with whom Silver Horn shared many associations. They both had served in Troop L, and both were Peyote men (NA RG 94, Muster Rolls; Merrill et al. 1997:317). Tanguma's Kiowa mother, Zonih or Zonety, was also deceased (Mooney MS 2531, 6:165; Barbara Hail, personal communication, 1995). With other relatives unable to take her in, she found a new home and family with the old bachelor Silver Horn. Tanguma, who became a noted craftworker, is now referred to by family members by her English name of Hattie Silverhorn.

It was shortly after their marriage that Silver Horn again found regular employment, a rarity on the reservation, this time with the Smithsonian Institution. James Mooney, an anthropologist with the Smithsonian's Bureau of American Ethnology (BAE), had for some years been carrying out fieldwork among the Kiowas. Initially he had stayed in the camp of Gaapiatan ("Feathered Lance") in the Mount Scott area, but later he established his own camp around a government house that he was able to secure nearby. In late 1901, he initiated an ambitious project to produce models of Kiowa shields (see chapter 8), and he engaged an Indian work force that came and camped at his headquarters (Colby 1977:341; Moses 1984:131). He employed Silver Horn as an artist to draw the designs of shields and related accouterments of warfare as described by old warriors. Silver Horn's brother Haba was also a part of Mooney's

work force, as was his younger brother, James Waldo (Mooney MS 2531, 6:78–81; Mooney 1911). Mooney was accompanied by his own young wife, Ione, who was kept busy cooking meals for all of the resident Indian workers and consultants. Silver Horn and Hattie were an integral part of the small community that the Mooneys assembled about them, and perhaps Hattie assisted Ione in maintaining the camp. Hattie's first child, James, was born at the Mount Scott camp in 1902, as was the Mooneys' first child.[8] These two women must have formed a strong bond—one so young for motherhood, the other so far from home and family. Max Silverhorn remembers his mother reminiscing about their time with "Mr. Mooney" and wondering whatever became of that little boy. Silver Horn worked for Mooney fairly steadily from early 1902 through 1904 and irregularly as late as 1906.

While Mooney had always been successful in finding Kiowa people who were willing to work for him, he found them particularly eager for employment when he resumed his heraldry studies in 1902. His project coincided with the opening of the reservation to general settlement and the end of the reservation era. Indian people had been required to select an allotment of 160 acres of land per person, and the remainder of the reservation except for some shared pasturage was opened for claim by non-Indians. White settlers poured in by the thousands, and Indians suddenly found themselves a minority population on lands they had once called their own. This radical shift in the cultural landscape is represented on Silver Horn's calendar by a neat gridwork of squares containing identical images of tiny cabins, each topped with identical smoking chimneys (fig. 2.4). In the postreservation economy, the issuing of rations ceased; the Indians were expected to earn a living by farming their allotments.[9]

In government records of this era, Silver Horn, like other Kiowa people, became a statistic on charts of progress toward "civilization" as defined by white missionaries and agents. He was registered as #94 on the allotment list, and his allotment location was recorded as SW ¼, 23-7N-8W (NA SRC, RG 75, Schedule). Such bald numbers mask the social processes of Kiowa life that continued beneath the hard veneer of government management. A careful reading of the allotment records reveals that many family camps remained largely intact, registering for allotment together. Silver Horn and other members of his family chose adjacent plots of land north of Mount Scott where they had long resided. In the years after his work with Mooney ended, he and Hattie moved to live on her allotment near the community of Stecker, closer to Anadarko. Their young son James continued to live at Mount Scott with Haba, who was a second father to him in the way that links Kiowa extended families so closely (J. Silverhorn 1967a:2). In 1910, Silver Horn received permission to sell half of his original Mount Scott allotment to raise money

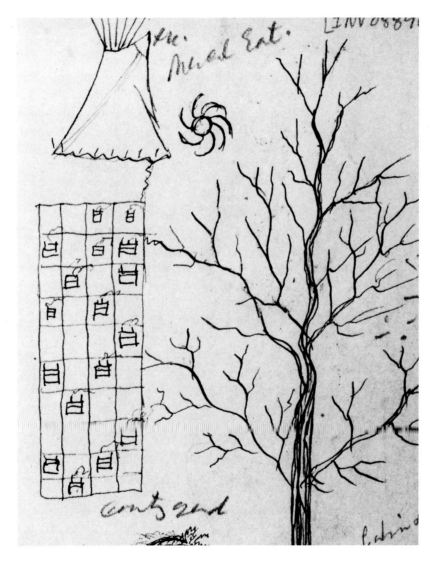

2.4. Detail from Silver Horn's calendar for winter 1901–2, showing the country divided into a grid for the allotment of land. MS 2531. Courtesy of the National Anthropological Archives, Smithsonian Institution.

to build a house on the Stecker land. In 1916, he was reported to have ten acres of land in corn and to own two mules, three ponies, one hog, three dozen chickens, a wagon, a hack, a harness, two walking plows, a cultivator, a go-devil, a stalk cutter, and a mowing machine. Like many Indian people, he and his family left the isolation of their farm each winter to join a communal camp at nearby Hog Creek. In spite of this perceived lapse from progress, the Indian agent still officially deemed him to be "of good moral character." In 1918, however, his moral habits were reported as only "fair" (NA SRC, RG 75, Allottee File). He had by this time come to the attention of the agent as a stubborn source of resistance to the forces of civilization. In fact, he had a long history of such resistance.

During the 1890s, Silver Horn was involved in protest against the notorious Jerome Agreement, which claimed that a majority of the Kiowas had agreed to the allotment and sale of their land. A great many Kiowas asserted that their consent to the agreement had been obtained fraudulently, through trickery and faulty translation, and sought to prevent its ratification by Congress. Silver Horn was among those who signed a formal petition of protest in 1898 (Scott MS 2932, 2).[10] Such complaints slowed but could not ultimately prevent the opening of the reservation.

A major goal of the Bureau of Indian Affairs was conversion of the Indian population to Christianity. While actual proselytization was left to missionaries of various denominations, agents were expected actively to assist the process through suppression of native religious practices. The Kiowa Sun Dance, or Medicine Lodge ceremony, had been effectively stopped by 1891. During the early reservation years, however, other religious movements developed among the Kiowas. One was the Peyote religion, eventually incorporated as the Native American Church. Consisting of small, private meetings held in often remote camps scattered throughout the reservation, Peyotism proved to be a difficult religious ceremony to control and disrupt. Ghost Dance gatherings were another source of concern to agency officials. Although the guidance of Lt. Hugh Scott and his Kiowa scout Iseeo prevented the sort of military intervention in the religion that led to the Wounded Knee tragedy on the Northern Plains, agents spent years pressuring the Kiowas to give up such expressions of belief (Mooney 1896:900; Scott 1928:154).

Silver Horn was deeply involved in these new movements as well as in older aspects of the complex religious life of the reservation community. His detailed representations of the Medicine Lodge demonstrate his intimate familiarity with that traditional ceremony in the years when it was still held. As early as 1883, he had become involved with Peyotism and was producing drawings of the growing new ritual. According to his son James, he served as a Peyote Drum Man during the years when he lived at Mount

Scott (J. Silverhorn 1967a:27, 1967b). His great-grandson Don Tofpi still preserves the Chief Peyote that Silver Horn used when he eventually become a Road Man or leader of the ceremony (fig. 2.5). Silver Horn was also active in the Ghost Dance, which came to the Kiowas in 1890, was briefly discontinued, but was subsequently revived in a new form known as the Feather Dance and practiced until 1916. One of the leaders of the Ghost Dance in both its early and later forms was Poor Buffalo, Silver Horn's mother's brother (Kracht 1989:794, 803). In later life, Silver Horn took on one of the oldest religious offices among

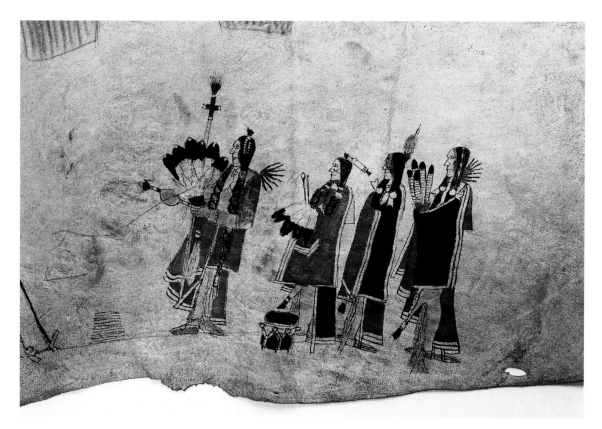

2.5. Detail of a hide painting (shown in full in plate 22), showing the ritual leaders of a Peyote ceremony.
The penciled word "By," with its tail connected to the first man, suggests that this is a self-portrait.
#229,897. Courtesy of the Department of Anthropology, National Museum of Natural History, Smithsonian Institution.

the Kiowas, serving as a keeper of one of the sacred bundles known as the Tsaidetalyi or Ten Medicines (LaBarre et al. 1935:777–88).

It was Silver Horn's participation in the "dance crowd," however, that brought him directly into agency disfavor. He not only participated in the Feather Dance but was a leader of the Ohomah, a secular dance often performed at the same gatherings (Kracht 1992). He was one of the original Kiowas who had received the Ohomah Dance as a gift from the Sioux in the 1880s (Mooney MS 2531, 6:185). During the 1910s, agents on the Kiowa reservation sought to suppress all dance gatherings, claiming that they promoted idleness and prevented participants from attending to their farms and stock. Lists of prominent leaders in the "dance crowd," as they termed it, included Silver Horn as well as his brothers White Buffalo, Oheltoint, and James Waldo. In 1917, the agent finally resolved to withhold annuities from known troublemakers until they would sign a pledge to renounce dancing. Silver Horn was among the few who were able to withstand such economic pressure and was never made to sign (Kracht 1989:834–46, 1992:466–69). The Ohomah continues to this day.[11]

In addition to his participation in the Peyote religion and the Ghost Dance, Silver Horn became a keeper of one of the Tsaidetalyi bundles. These ten bundles, known variously as the Ten Medicines, Boy Medicines, or Ten Grandmothers, are among the most sacred items of Kiowa belief. In earlier times, they played an important part in maintaining peace within the community, and the role of bundle keeper has always been one of great prestige and respect, carefully and thoughtfully conferred (Richardson 1940:10–12). The bundle that Silver Horn kept came to him upon the death of its keeper, his uncle Poor Buffalo, the former Ghost Dance leader (LaBarre et al. 1935:777–88). As there were no public ceremonies associated with the Ten Medicines, this aspect of Kiowa religion escaped the persecution of missionaries and agents and has quietly continued to the present. Silver Horn's bundle is still maintained by a member of his family.

In his old age, when Kiowa people were firmly incorporated into at least a marginal position in the dominant economic and religious systems of American society, white people in the area no longer viewed Silver Horn as a troublemaker. Changing circumstances transformed him into a romantic figure of "the real old-time Indian" (fig. 2.6). Recognized by his community as a respected religious leader, he was untroubled by occasionally participating in shows for an outside audience curious about Indians. Photographs taken at events such as the Craterville Fair show him wrapped in an old, worn buffalo robe (which his grandchildren say he always slept with) and various other bits of traditional Indian clothing assembled for the

occasion (fig. 2.7). While the photographs reveal the artificial nature of the assembled costume, a painting made from one of them by Silver Horn's grandnephew Stephen Mopope resolves the dissonance of the image (fig. 2.8). It offers a sensitive portrait of the man that he knew, linked to Kiowa tradition by belief rather than by costume.

2.6. Silver Horn standing outside the Red Store, a mercantile establishment at Fort Sill that catered to the Indian trade. Photographer unknown, 1926. Lawrence Collection, #3. Courtesy of the Museum of the Great Plains, Lawton, Oklahoma.

2.7. Silver Horn costumed for his appearance at an Indian fair.
This photograph is identified by the Poolaw family as having been taken by the Kiowa photographer Horace Poolaw. Photograph by Horace Poolaw (?), n.d. Lawrence Collection, #9. Courtesy of the Museum of the Great Plains, Lawton, Oklahoma.

2.8. "Silverhorn—Haungah," painted by Silver Horn's grandnephew Stephen Mopope from the photograph in figure 2.7. Stephen Mopope, 1933. Acee Blue Eagle Collection. Courtesy of the National Anthropological Archives, Smithsonian Institution.

Silver Horn died at his home on December 14, 1940, leaving six grown children. He and Hattie had divorced in 1929. He was buried at Red Stone Mission Cemetery with services officiated by the Reverend Ted Ware, a Kiowa Methodist minister (Anadarko Indian Agency n.d.; *Anadarko Daily News* 1940a, 1940b).

For many years before his death, Silver Horn was plagued with eye problems that eventually led to complete blindness. The last entry in the pictorial calendar that he prepared for Mooney in 1904 shows a picture of himself with pen in hand and a patch over one eye (fig. 2.9). The notation is "Eye sore" (Mooney MS 2531, 7). The problem was trachoma, a painful infection of the surface of the eye, now easily treated with antibiotics. When his old Seventh Cavalry commander Hugh Scott visited Silver Horn in 1920, he found him nearly blind in spite of having spent over $600 on medicine. Scott arranged for him to receive treatment at the Indian hospital in Lawton, but it was without success (Scott MS 2932, 2). His sight continued to fail, although his family remember that he maintained partial vision for several more years. It is likely that he produced no artwork in the last twenty years of his life.

Throughout most of his life, Silver Horn worked as an artist in addition to being a hunter, a soldier, and a farmer. The history of his artistic career is taken up in detail in the next chapter, but the economic aspects of his work deserve some attention here. The earliest specific information regarding payment for his work is from his employment for James Mooney. He received $30 a month for his services, compared to the $35–$40 that Mooney paid to his interpreters (BAE 1902; Mooney 1904a). In 1909, a collector working for the Museum of the American Indian purchased two Silver Horn hide paintings, paying $7.50 for one and $14 for the other (M. Harrington 1909). The more expensive one was bought at a trading store in Anadarko, probably accounting for the markup in price. Around the same time, Silver Horn sold another hide painting of a Ghost Dance for $20 to a white collector, who was related to him by marriage. While these pieces vary in their quality and investment of effort, the prices paid by the professional collector are probably more reflective of what Silver Horn usually received for his paintings, most of which were sold outside the Kiowa community. The collector who paid more, Everett Rowell, was his classificatory brother-in-law, brother to the man married to Hattie's half-sister Maude (Hail personal communication, 1995). Generosity among relatives was obligatory, and Rowell would have been expected to give as much as he could rather than to have sought a bargain. The Kiowa system of payment for craftwork was well described by Silver Horn's son James: "Just give whatever they wanted to. That's Indian way. You make something for somebody, then give it to him, then he'll pay you something" (J. Silverhorn 1967a:16).

2.9. Detail from Silver Horn's calendar for winter 1904, with a self-portrait of himself with pen in hand, perhaps at work on this calendar.
He wears a patch over one eye, and the picture is captioned "Eye sore."
MS 2531. Courtesy of the National Anthropological Archives, Smithsonian Institution.

Silver Horn is widely recognized by students of Native American art as a premier graphic artist of the Plains region. Within the Kiowa community, however, few people outside of his family know of his drawings. Nearly all of Silver Horn's pictures for which clear provenance is available were produced for sale to a white market rather than for a Kiowa audience. With the end of warfare, pictorial representations had become peripheral to Kiowa life. Yet Silver Horn is well remembered by older Kiowa people as an artist in other media who produced things for use within his own community. He is best known as a silversmith, and his son James believed that he learned the craft from his brother Haba (J. Silverhorn 1967a:14–15). While German silver had become the primary medium of Southern Plains metalwork by reservation times,

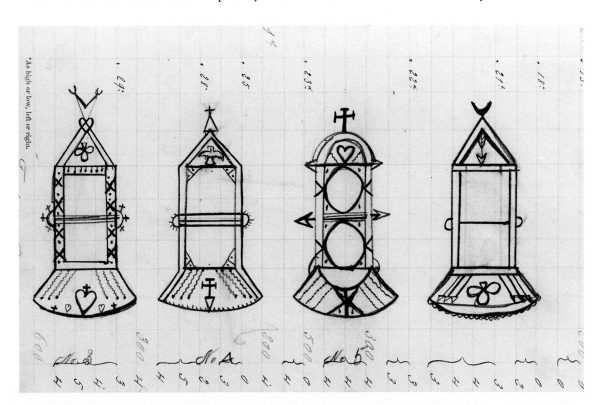

2.10. Designs for silver neckerchief slides on a page of a book previously used to record the results of army target practice. *These designs may have been drawn by Silver Horn, who was a silversmith, but other artists worked in the book as well.* MS 4252. Courtesy of the National Anthropological Archives, Smithsonian Institution.

Silver Horn worked in coin silver, hammering pesos or quarters into items of jewelry for use in the Peyote church. He did not sign his pieces, but Richard Aitsan, himself a fine craftsman, showed me a heavy silver Peyote pin that belonged to Silver Horn's brother James Waldo, which he believes to be a sample of Silver Horn's work. Some designs for silver tie slides are sketched in one of Silver Horn's books of drawings and may be plans for future work (fig. 2.10).

Much of Silver Horn's craft production was devoted to ritual objects for use in the Peyote religion. He crafted feathers into Peyote fans; the handles were covered with beadwork, as were other objects used in Peyote worship such as the staff, rattle, and gourd. Beading had always been a woman's art among the Kiowas, but many worshipers felt it was not appropriate for women to work on these ritual objects (J. Silverhorn 1967a:17, 27; Max Silverhorn, personal communication, 1991). Many Peyote rattles of the 1890s are further adorned with designs incised on the surface of the gourd. Most have small figures relating to the iconography of the religion, but one rattle stands out as stylistically unique (fig. 2.11). It is dominated by the large figure of a man in Peyote costume holding a rattle and fan before the crescent altar. An image of the water drum appears on the reverse. The maker of the gourd is not recorded, but the figure so closely resembles Silver Horn's distinctive drawings of Peyote ritual that it must surely have been produced by him.[12]

Max Silverhorn told me that his father also prepared the ornamented feathers worn by dancers in the Ghost Dance. Ella Brace, a Kiowa woman interviewed in the 1960s, remembered him as a man who painted the women's buckskin dresses worn for that ceremony with their array of symbolic elements (Brace 1967:2). Perhaps the hide painting of the Ghost Dance that he sold to Everett Rowell includes pictures of ritual costumes that he had made himself.

Silver Horn was a man of many talents. He came from a family in which artistic creativity was well established and passed that love of creativity to his own descendants. His six children all participated in art production of various types, although only one took up painting. James did featherwork and beadwork; George (more often called Dutch) was a painter and woodcarver as well as a noted silversmith; Arthur and Chester also worked in silver; Louise was a beadworker and hide tanner. Max was active in beadwork and

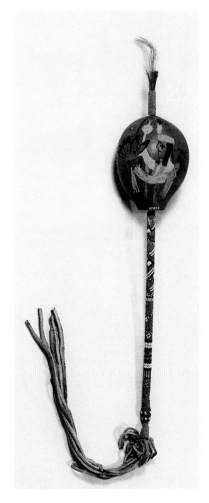

2.11. Gourd rattle with beaded handle and incised and painted scene on the head.
A Peyote man is shown in a posture often represented by Silver Horn in drawings, holding up a fan and rattle.
#67,839. Courtesy of the Department of Anthropology, Field Museum of Natural History.

featherwork up to the time of his death (Ellison 1972:12, 1976:73; J. Silverhorn 1967a, 1967b; Silverhorn family, personal communication). Many other members of the extended family have also received significant recognition for their skill in various media (Schneider 1982). Perhaps the best known is his grand-nephew, the painter Stephen Mopope, who acknowledged Silver Horn as his first teacher (Jacobson ca. 1954; Ellison 1972).

Silver Horn was a traditional man raised within a traditional family. He lived at a time of enormous change. Born when huge bison herds roamed the Plains, he lived to see the land crisscrossed by highways and speeding automobiles. In his own life, he embraced a number of cultural innovations. He adopted new religious beliefs, participating in the Ghost Dance and the Peyote ritual. He accepted the Ohomah Dance, which came to take the place of the older men's societies. He worked for wages and accepted the structured life of the army. Throughout these changes, however, we can see a firmly fixed set of internal principles that guided his life. He was never an iconoclast, but one who found new ways to express traditional values in his life and in his art.

Chapter 3

Paper to Buckskin: Illustrating Kiowa Culture

"He is in love with his work, and is always at it," E. A. Burbank (1900:90) wrote of Silver Horn. Silver Horn was indeed the most prolific and innovative Plains artist of the nineteenth century. Beginning his career when warrior art was still an active tradition among the Kiowas, he seized upon new opportunities that the reservation years offered in the form of new materials, markets, and exposure to alternate styles of representation. His broad range of work offers a rare chance to trace an artist's development over a long period, to observe changes, and to examine the personal and cultural contexts within which works were produced.

A born artist with an innate drive for visual expression, Silver Horn left a rich legacy of artwork in an amazing variety of materials and techniques. He was not content to work within the framework established by other artists of the time, but was ready to experiment and explore new options within the Plains pictorial tradition. His talent was recognized by several visitors to the reservation, and their interest and patronage were critical to the volume of material that he produced as well as to its continued preservation.

While his work as a whole was embedded in an overarching historical and personal setting, each set of drawings was also influenced by more immediate circumstances surrounding its production. The specific documentation for each group of works is given in the appendix, together with my comments. A chronological look at his career, however, helps to relate the works to major influences and opportunities that arose during his life.

The earliest beginnings of Silver Horn's career as an artist are unknown. He pursued art production with such intensity throughout his adult life, until limited by failing eyesight, that his interest in drawing was probably evident when he was a small boy. His father was an artist, as was his brother Haba, with whom Silver Horn lived in close daily association for the first three decades of his life. They undoubtedly influenced his art, teaching him what it was right to draw if not necessarily how to draw it (J. Silverhorn 1967a:29; SPIM n.d.; Domjanovich 1982). He would have learned in the Kiowa way, through observation rather than by direct instruction. As his son James explained it, someone who has ability at something just "picks it up." White people call it talent, but for Indians "it's just in the nature of families, you know"

(J. Silverhorn 1967a:19, 27). A look at Agiati's pictorial calendar (fig. 1.14) shows that Silver Horn was certainly more gifted than his father. Mooney also considered Haba a much less talented artist than his brother (Mooney 1911). One unsigned illustration among the papers of James Mooney (plate 5) captioned "Haba's War Gear" may be by Haba. Regrettably, the only documented example of Haba's work, a pictorial calendar formerly in the collection of the National Museum of the American Indian (2/2601), cannot now be located to allow comparison of their styles.

Another of Silver Horn's brothers, Oheltoint, was also an artist. His name is well known because he was one of the Fort Marion prisoners who produced many signed works for sale.[1] Family reports that Silver Horn learned from an older brother have led to the mistaken assumption that he was taught by Oheltoint, whose name is better known than that of Haba. In fact, Silver Horn had little opportunity to associate with this brother after his childhood. Oheltoint was arrested and sent to Fort Marion in 1875. After his release, he stayed in the East for further education, first at Hampton Institute and then at Carlisle Indian School, where he was enrolled as student #1 in 1879. He did not return to the reservation until 1880, after which time he worked for the agency office at Anadarko, some miles from the family camp at Mount Scott, eventually taking an allotment in that area (Petersen 1971:166–68). Oheltoint is not known to have produced any drawings after his return to Indian Territory, except for the single tipi model that he painted for James Mooney in the 1890s (fig. 3.1).

The 1870s Muslin

The earliest known work by Silver Horn is a painting on muslin in the collection of the Oklahoma Historical Society Museum (plate 6). A large and ambitious work nearly eight feet long, it is covered with an intricate array of figures. Men, horses, tipis, trees, and even a meandering stream are part of a complex scene of combat in which a camp is under attack, its defenders kneeling before their painted lodges.

The muslin came to the museum without documentation as a part of the Neal W. Evans collection. Evans was a licensed Indian trader and came to Fort Sill in 1868, to help manage his brother's trading establishment (Evans n.d.). In 1880, he opened his own business at Fort Reno, adjacent to the Cheyenne and Arapaho Agency. Over the years, Evans assembled a small collection of artifacts, and James Mooney visited him at his home in El Reno in 1905 to view his collection. Mooney was primarily interested in a ledger book of Cheyenne and Arapaho drawings (now in the Gilcrease Museum collection), but Evans also

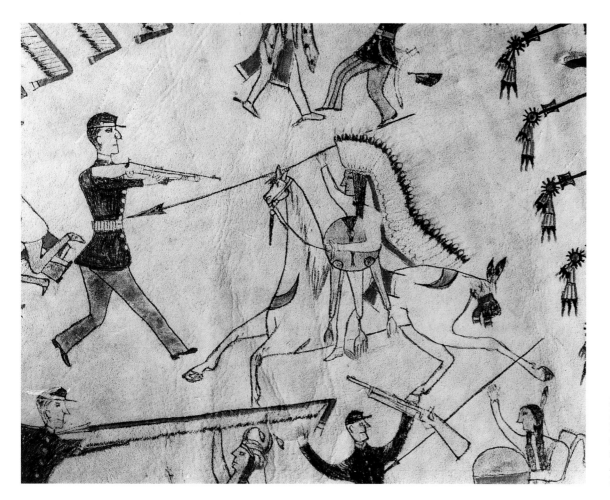

3.1. Detail from a model of the Tipi with Battle Pictures painted by Silver Horn's brother Oheltoint for the Smithsonian anthropologist James Mooney, ca. 1892. #245,001. Courtesy of the Department of Anthropology, National Museum of Natural History, Smithsonian Institution.

showed him a muslin that he said he had bought from the Kiowas in the 1870s while he was at Fort Sill trading for buffalo robes. Mooney made rough notes about the painting, including a count of the number of painted tipis and men on horses shown—an exact match to the Evans muslin now at the Historical Society (Mooney MS 2497). Mooney's notes provide a tribal origin and date, but Evans did not know the name of the maker, and Mooney did not recognize the work as that of his current employee, Silver Horn. It is not surprising that he failed to note the connection, as Silver Horn had experienced enormous stylistic growth in the intervening three decades. Sometime after the museum received the muslin, a note attributing the piece to Silver Horn was added to the museum's records based on comments by an unrecorded member of the Silverhorn family.

Even in this earliest known work, many of the distinctive features of Silver Horn's later style are already evident (figs. 3.2, 3.3). The human figures have long, well-muscled legs and slightly pointed toes, giving them an appearance of almost prancing across the surface of the muslin. Facial profiles are carefully shaped, with the eyes shown in true profile rather than the lozenge shape employed by most Plains artists. Silver Horn's later concern with the delineation of hands is already evident in this work, although he had not yet developed a satisfactory technique for their representation. On a few figures he attempted to draw individual fingers wrapped around weapons, but in most instances he avoided the issue by concealing the hands. The horses are large and boldly proportioned, with long necks and jutting rumps. Their heads are quite small, and the eyes, like those of human figures, are drawn in profile. Unique items of horse decoration known from later drawings make their first appearance here, such as strips of cloth knotted around the neck and oversized feathers tied to the tail. The artist has carefully planned the juxtaposition of horse and rider, avoiding the "transparent" effect of many Plains drawings, in which the outline of the horse shows through the rider's body. Other features are not unique to Silver Horn, but are characteristic of his work. The cavalry troops are drawn tightly packed together, overlapped in identical postures to create a chorus-line effect, and extensive footprints show the paths of riders and combatants.

The drawing, however, lacks the sureness of hand that Silver Horn later developed. There are stylistic inconsistencies among the many figures in this large piece, as might be expected in a developing young artist. It is even possible that this was a collaborative project, with Silver Horn responsible for only some of the work. The faces do not have the sharp, graceful outline that he soon perfected, and, like many other Plains artists, he often chose to conceal the hands rather than attempt their depiction. Although the scene is eminently one of action, the figures appear stiff and static rather than arrested in motion. Yet one

figure in the bottom center foreshadows his later gift for capturing a critical point in the action. The warrior with roached hair is caught at the moment when he falls from his horse, with his head turned to show the back, a posture repeated in several later works.

Muslins of the 1880s

Silver Horn remained active in muslin painting during the following decade, and three additional muslin paintings are attributed to him. Two of the muslins were acquired between 1885 and 1887 (fig. 3.4; plate

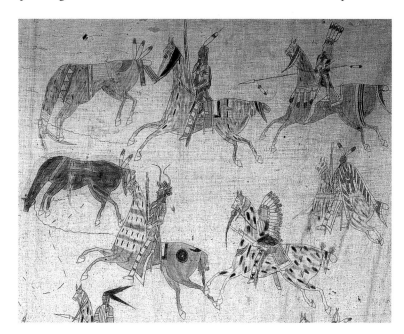

3.2. Detail from Silver Horn's first known muslin (shown in full in plate 6), showing his early style of drawing horses with large bodies and small heads. #4396. Courtesy of the Museum, Oklahoma Historical Society.

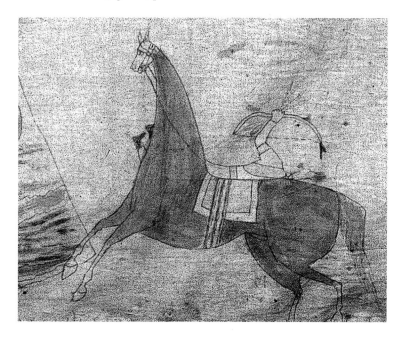

3.3. Detail from muslin painting (shown in full in plate 6).
Even in this early work, Silver Horn was willing to attempt the complex back view of a man falling from his horse.
#4396. Courtesy of the Museum, Oklahoma Historical Society.

7). The third lacks documentation but is probably of similar age (fig. 4.4). All of the muslins, ranging in size from about six feet square to six feet by ten feet in length, contain scenes of warfare scattered across their surfaces. Like old-time tipi liners, they combine the work of several artists, not Silver Horn alone, and depict many different warriors and deeds of war. Like the family's Tipi with Battle Pictures, the muslins were probably produced in a social context in which old warriors dictated their battle exploits for depiction or drew them themselves. This communal method of production in which men worked in close collaboration must have resulted in substantial mutual influence as artists learned from and emulated each other. By the time these muslins were produced, Silver Horn was evidently a leader in this process.

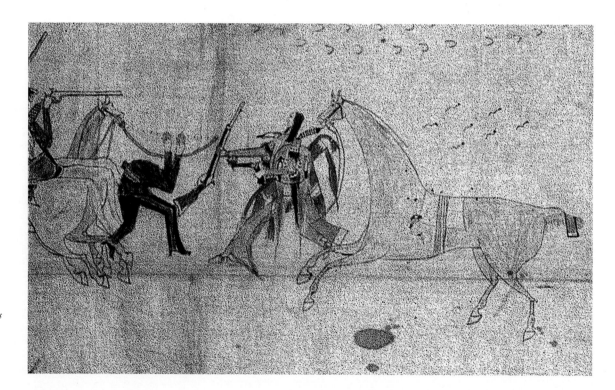

3.4. Detail from muslin painting (shown in full in plate 7).
A warrior carrying the Padogai shield uses his bow to count coup on a soldier who ducks his head between his arms, while his companions flee, firing wildly.
#68.20.1. Courtesy of the Museum, Oklahoma Historical Society.

The collecting history of two of these pieces suggests that all of the muslins were made for sale. The antecedents to reservation muslin paintings were the liners that hung inside tipis as draft screens. These pieces are more varied in size and shape, but like the earlier liners they are composed of scenes of war. Evidently the purchasers of the muslins were pleased to accept traditional subject matter rather than innovations in the art that they acquired as mementos of their years among the Indians and may even have sought out "old style" art.

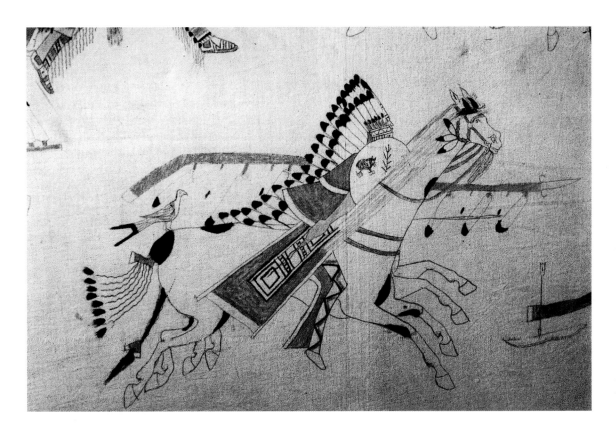

3.5. Detail from muslin painting.
Two warriors race side by side, the second horse and rider a close shadow of the first.
#40-151. Courtesy of the Witte Museum, San Antonio, Texas.

Silver Horn had matured considerably as an artist by the time these works were produced (figs. 3.4, 3.5, and 4.2). The human figures have clear, consistent profiles and carefully shaped hands, with each finger often drawn separately. The figures still have well-muscled bodies, now drawn in a variety of action postures that convey much of the narrative, and Silver Horn has included both frontal and back views. He continued to represent horses with heavy bodies, long necks, and jutting rumps, but their heads are larger in these works. Some scenes on the muslins are of two figures in interaction, but others include a richer suite of characters, often overlapping in complex compositions. Individual landscape elements, such as a single tree or dense brush, are included when important to the narrative, much of which is carried through the traditional pictorial devices of lines of footprints or bullets flying through the air.

Works on Paper of the 1880s

While none of the muslins have documentation of authorship, their identification is firmly grounded by comparison with five books of drawings documented as dating to the 1880s. Produced on the leaves of commercial drawing books, they contain a number of pictures done in pencil, colored pencil, and crayon.

The earliest book, now at the Nelson-Atkins Museum in Kansas City, is accompanied by several pages of captioning written by Dudley P. Brown in 1883 (fig. 3.6). D. P. Brown came to the Kiowa-Comanche Reservation in the 1870s and remained until the early years of the twentieth century. Initially an agency employee, he eventually went into private business, leasing tracts of reservation land for both a cattle operation and a horse ranch, the latter of which was located on Cache Creek only a few miles from Silver Horn's home at Mount Scott. A largely self-educated man, Brown evidently had considerable intellectual curiosity, which extended to his Indian neighbors. He assembled a collection of Indian artifacts, which he sold to the Field Columbian Museum in 1899. He retained this book of drawings, however, which his son donated to the Nelson-Atkins many years later. The book contains seventy-five drawings placed on both sides of the leaves of a blank drawing book. The range of topics is quite broad. Warfare and relations between men and women account for most of the images, but there are also a few scenes of hunting and a remarkable range of depictions of various ceremonial activities. The interest of the book is enhanced by the captions written by Dudley Brown on several separate leaves of paper. Their level of detail indicates that the information must have been received directly from the artist. Almost every individual is

3.6. Detailed handwritten captions provided by Dudley P. Brown to accompany a set of 1883 drawings. #64.9. Courtesy of the Nelson-Atkins Museum of Art, Kansas City, Missouri. Gift of Mr. and Mrs. Dudley C. Brown.

identified by name, most in Kiowa, although a few are given in English translation. Regrettably, Brown's efforts to render unfamiliar Kiowa sounds into the Western alphabet were largely unsuccessful. It is difficult to determine to whom many of the written names might refer, although it is clear that the pictures are of specific people and particular events.

The pictures are drawn in pencil with extreme care as well as great sureness of hand and are colored with colored pencils. These are among the most carefully and delicately rendered of all Silver Horn's works, and they were probably produced for his own enjoyment and only later sold. While most figures are drawn in profile, they are captured in a variety of action postures, ranging from the gentle swaying of a line of dancers to the violent assault of war (plates 8 and 9). A confident artist by this time, Silver Horn laid down the firm, continuous outlines characteristic of Plains drawing with hardly a correction or unplanned overlapping.[2] For the straight lines of tipi covers or lance shafts, he used a straightedge to ensure a hard, sharp line, while he sketched rather than firmly outlined the softer contours of feathers, manes, or buffalo hides. Sensitive to the visual qualities of different surfaces, he even represented the highlighted white sheen on the dark hooves of many horses. The majority of pictures include a minimal groundscape beneath the figures, a band of green suggestive of the ground surface above which the figures float.

The other four books from the 1880s were collected by military officers and had probably been made for sale. Two were acquired by Capt. (later Gen.) John L. Bullis, and both contain inscriptions identifying the artist and dating the works to July 1887. One book is at the McNay Museum in San Antonio, while the other is believed to be in private hands.[3] It is not known how Bullis acquired the books. He was never posted in Indian Territory, although he served in Texas and might at some time have visited fellow officers at Fort Sill. The inscriptions in both books were written by Horace Jones, who was the interpreter at Fort Sill from its founding through the 1890s (Thoburn 1924). The other two books, now at the Museum of Fine Arts in Boston, were collected by Capt. (later Gen.) Alfred C. Markley, who was posted at Fort Sill from 1881 to 1887 (plate 10). They lack specific documentation regarding the date or the artist, but are quite similar to each other as well as having close stylistic connections to the books acquired by Bullis. One of the Markley books also contains captions written by Horace Jones, which are somewhat more extensive than those he provided in the 1887 books. While he does not include specific dating, two historical references place the book in a narrow time frame. A drawing that can be recognized as the Buffalo Calling ceremony (fig. 5.10) is captioned as having occurred "about 4 years ago." The ritual was a short-lived one and was performed only between 1881 and the spring of 1883,[4] dating the inscription to approximately

1885–87. Another image (plate 16) of a disastrous war episode that occurred in 1868 is captioned "about 17 years ago," suggesting that the reference was written around 1885. As these were works made for sale, it is likely that they were disposed of soon after being made and that the inscription dates are close to the time of production.

Silver Horn was living at Mount Scott in the 1880s and must have visited Fort Sill, where the sub-agency was located, fairly often. He seems to have established an arrangement of some sort with Horace Jones, who served as his sales agent, captioning works in English for the benefit of purchasers who had limited knowledge of Indian customs. While some of the information is sufficiently specific that it must have come from the artist, much of it is general enough in nature that Jones could have provided it from his own extensive knowledge of Kiowa art and culture. Such drawings may well be of specific people and events, but in most instances their identity is lost in spite of the captioning. Indeed, in the McNay book (and perhaps the other Bullis book) the events themselves appear to be simplified, with fewer unique features distinguishing events than in the muslins or other books (fig. 3.7). As Jones wrote in the frontispiece, "The battle scenes are intended to represent events that have actually occurred . . . The other pictures merely represent scenes that happened in their ordinary, every day life." A progression can be seen in the simplification of both images and captioning from the Nelson-Atkins book (1883) to the Markley books (1885–87) to the Bullis books (1887). Market influences were at work, as images were increasingly being produced and packaged according to the standards of a largely ignorant and undiscriminating audience, who found the artwork engaging but who did not expect or value the level of specificity that the native audience demanded.

The form of these four books also suggests that they were made for sale. Drawings appear on a single side of each leaf (in some books the recto and in others the verso), thus "filling" the book with the fewest possible images, ranging from thirty to thirty-four. This contrasts with both the Nelson-Atkins book and other later works in which every available surface was used.

Yet Silver Horn's artistic standards remained high, and he continued to explore new forms rather than produce images by rote. His human figures from this period are tall and slender with very long legs; the feet of figures on horseback often reach the ground. He experimented with various ways of representing faces in frontal view, including delineating the nose in profile. He had perfected one of his signature elements, hands with fingers folded around an object, and apparently drew with such rapidity that he sometimes lost count of digits, producing many pictures of people with five fingers in addition to a thumb. His

horses were bold creatures, now with large heads atop soaring necks. Their eyes and nostrils were prominent, outlined with a separate ridge. The figures were becoming more firmly planted upon shaded green groundscapes. While Silver Horn continued to use a strong single line to delineate most figures, he was also experimenting with using a discontinuous, sketched outline for more types of figures and surfaces.

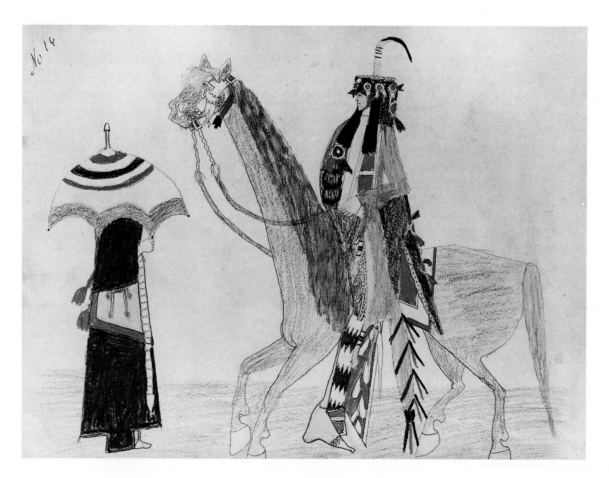

3.7. "Kiowa dude paying his respects to a young Kiowa belle," as captioned by Horace Jones.
An elegantly dressed man on horseback greets a woman shading herself coquettishly beneath a brightly colored parasol. "It may be interesting to the public to know that there are 'Dudes' among the Indians as well as whites," Jones added.
#1962.1. Courtesy of the Collection of the McNay Art Museum. Gift of Mrs. Terrell Bartlett.

Some of the drawing books that he obtained contained paper of different shades, giving him the opportunity to place light images upon a darker surface. The drawings in these books were all done in pencil, but they show a great variety of coloring techniques, obtaining a range of intensity and saturation with colored pencils as well as occasional crayons.

Another undated book recently acquired by the National Cowboy and Western Heritage Museum continues the trends of these works from the 1880s, particularly simplification in works made for sale. An inscription from the frontispiece identifies the pictures merely as by "an Indian Artist," dated 1890–96. Generalized captions on individual pages identify the majority of figures as Comanches but include some references to Kiowas. This casts doubt on the credibility of all the captioning, as the drawings are undoubtedly by Silver Horn. The inclusion of drawings of the Ghost Dance circle in the book indicates that it cannot date before the winter of 1890, when that religious movement first reached the Kiowas (fig. 5.11). While these images are finely executed, as is another of the Peyote ceremony (plate 25), the majority of the works show evidence of hasty execution. The pictures are highly repetitive, with many pages containing a series of nearly identical figures, overlapped so that only a portion of each had to be drawn. There are many mistakes in outline, which are roughly corrected, and color is used sparingly, principally for details that could be filled in quickly rather than for large areas.

Silver Horn's drawing books from the 1880s can be seen as a continuation of the ledger art tradition as it developed during the reservation years from an earlier warrior art. Figures were drawn in hard outline then filled in with solid blocks of color. They were placed against the void of the page without indication of setting. Men and animals were typically drawn in profile, and their actions were revealed through narrative conventions of footprints, lines of hoof marks, and flying bullet trails. Unlike many ledger artists, however, Silver Horn worked alone in these books and expanded upon each of these areas of convention. He developed new drawing techniques to represent different surfaces and angles of view and began regularly adding an indication of the ground space within which his figures moved. Even in his earliest dated book (1883), he had moved beyond the usual subjects of Kiowa drawings. While pictures of courting and of ceremony were produced by many artists, Silver Horn showed aspects of these activities not previously depicted. But his innovations were along more conventional lines than those pursued by the Fort Marion artists of the previous decade. He did not attempt full landscapes or use multiple registers or show scenes of camp life. His early work shows innovation, but within an established framework.

The Field Museum Books

Fully one-quarter of Silver Horn's known works (256 pictures) are contained in a group of four drawing books in the collection of the Field Museum of Natural History (figs. 3.8 and 3.9; plate 11). The Field Museum purchased them in 1899 from Dudley P. Brown, the collector of the Nelson-Atkins book, who provided the information that they were by Silver Horn. He was not able to add captioning information for these works as he had for the earlier set, but he offered to take George Dorsey, the museum's curator,

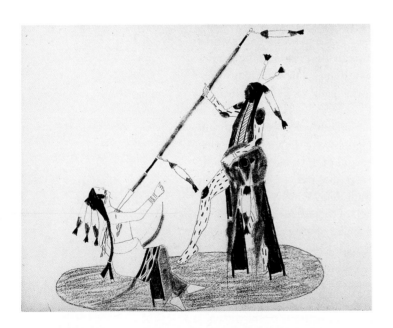

3.8. A tall, slender warrior, his body elaborately painted, lancing an enemy. #67,719 (neg. A113235). Courtesy of the Department of Anthropology, Field Museum of Natural History.

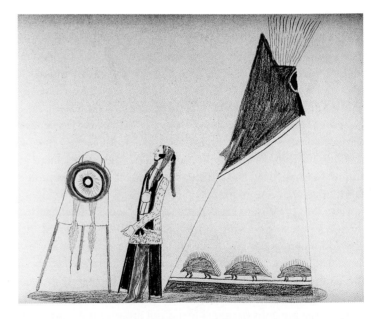

3.9. A man standing outside the Porcupine Tipi, which originated with Tumor and was subsequently owned by Black Cap and Red Otter. #67,719 (neg. A113220). Courtesy of the Department of Anthropology, Field Museum of Natural History.

to visit Silver Horn to obtain explanations of the drawings. Regrettably, that visit never occurred. A card with the books reads: "Painted 1891 by Kiowa artist, Haun-quoh, Silver Horn," the spelling of the artist's name that Brown used in correspondence. One of the volumes is also inscribed "How.e.Gon—Kiowa, Troop L. 7th U.S. Cavalry, Fort Sill Indian Ty. September 20th, 91, Thomas Clancy." Silver Horn had enlisted in Troop L in August 1891, after which time he must have been in frequent contact with Clancy, who served as orderly to Lt. Hugh Scott, the troop commander (Scott 1928:127).

The sheer number of pictures in the volumes suggests that it must have taken some time to produce the whole series. Nevertheless, they appear to be a relatively contemporaneous group, and two of the sets of drawings are placed in identical drawing books. The books are linked by distinctive themes that appear across volumes as well as by the exploration of common narrative modes of illustration that are not seen in previous works. Three of the books are closely related in drawing style while one (now designated vol. 1) differs somewhat. The figures in this volume are more delicate than those in the others, suggesting either a separation in time or, equally possible, a carefully concentrated effort to produce images with a different look. The exact dating of the works may never be known, but it is likely that they were produced over a span of time shortly prior to or immediately following Silver Horn's 1891 enlistment. The inclusion of one drawing of what appears to be the Ghost Dance movement of 1890–91 supports that dating.

The books differ in a number of ways from Silver Horn's earlier works made for sale, which contained easily recognizable images and conventional topics. These volumes look like personal sketchbooks in which the artist explored a number of new themes and modes of representation, sometimes repeating and reworking an image over and over on page after page before moving on to explore another idea. Some topics are readily identifiable, such as warfare pictures and scenes of courting, as well as highly decorative renditions of both male and female figures. These are joined and often overshadowed by new topics, however, many of which are indecipherable to the casual observer. A number of pictures illustrate various myths and historical incidents, presenting images that seem bizarre until illuminated by the associated oral traditions. Other drawings relate to the Peyote religion, depicting aspects of the ceremony as well as a remarkable series of abstract designs representing Peyote-inspired visions. Still other drawings are easily enough identified but are monotonous in their repetition of simple images on page after page, such as a series of pictures of longhorn cattle occupying seven pages or twelve pages of rows of seated, blanket-wrapped figures.

In addition to exploring new topics in these books, Silver Horn explored new modes of narrative presentation. In his previous work, he followed the Plains tradition of illustrating a story in a single image. A

key moment was selected for depiction, and the broader narrative was indicated through various conventions that collapsed a series of events into one visual moment in time. Footprints indicated the course of action, arrows or bullets in midair showed an extended exchange of fire, and participants from a perhaps complex engagement were drawn in close proximity. Occasionally an artist would use two facing pages in a book for a single picture, in which case they were treated as a larger surface on which to place a single composition.[5] There are several instances in these books, however, in which Silver Horn used a number of consecutive pages to produce illustrations of a sequential narrative. Several of these are illustrations of myths, in which the events of the story unfold from page to page. Others follow the ritual sequence of the Peyote ceremony step by step. The coherence of these narratives is slightly obscured by the varying ways in which Silver Horn used the pages of the books. Sometimes he worked from front to back, at other times reversing the direction in which the narrative should be read. He also was concerned with making maximum use of the paper available to him, covering both front and back of all the leaves in the four books. Thus he might have used the verso of a series of leaves for one narrative running from the back of the book toward the front and then come back later to fill in the blank recto surfaces with another narrative that would be read from front to back. The confusing interdigitation of images was irrelevant to the artist, who was concerned with exploring a new mode of visual storytelling rather than with serving a market audience.

In three of these books, Silver Horn continued working in much the same style he had developed by the end of the 1880s. Human figures were tall and slender, with very long legs, and the heads of horses rose high above those of their riders, although he had abandoned the prominent ridge over eye and nostril. While one book contains the sketchy colored groundscape of previous works, in others he represents the ground as a carefully outlined section upon which figures are placed. The ground rather than the figures now seems to float on the surface of the page. One of the books, however, shows marked differences (figs. 6.1 through 6.4). The works in it are particularly carefully drawn, with much more sketching of outlines rather than laying down a bold, solid line. Both human and animal figures are more realistically proportioned: riders are now able to look their mounts in the eye and keep their toes out of the dust. The outlined, floating groundscape is used in many images, while a continuous groundscape reaching from one edge of the paper to another appears in several pictures of myths. Black ink is used to color in some details, adding a strong note to the pencil and colored pencil used in all of the volumes. In all of the books, as in his previous works, Silver Horn continued to rely on the use of footprints and hoof prints to help convey the course of the narrative.

The Field Museum's books are the result of self-directed artistic exploration and refinement as the artist worked with new topics as well as new concepts of narrative illustration. He was the sole artist of the books, and many of the pictures were based upon his personal experiences and knowledge. While throughout his life he was exposed to various forms of visual art, both native and nonnative, in these drawings he worked alone for his own satisfaction, selecting or rejecting such influences without reference to market expectations or the critical commentary of his community. These books were produced for pleasure rather than with commercial intent, although they were ultimately sold once the pages were filled and there was no more room in which to produce drawings. They offer a view of private, contemplative artistic production, perhaps never shared with other Kiowa people. The books contain Silver Horn's personal vision, both literal and figurative.

The Fort Sill Period

During his service with Troop L of the Seventh Cavalry, Silver Horn continued to find time for his art, producing works on muslin, paper, and hide. It was a period of exploration and growth, as he expanded into new media and solidified the drawing techniques with which he had been experimenting.

Many of his works from this era were purchased by his commander, Hugh Scott. Chief among these was a book of drawings placed on the leaves of a discarded army "Target Record" book (fig. 3.10). Scott did not become aware of the book and acquire it until 1897, but the majority of the pictures in it were probably produced during the years 1891 to 1894, when Silver Horn was enlisted in Troop L. In addition to many pictures by Silver Horn, the book contains drawings by at least two additional artists of less skill as well as a number of unrelated inscriptions with the names of various scouts and dates in the summer of 1893. Near one end of the volume is a daily pictorial calendar that Silver Horn maintained from January 1893 until June of 1897 (fig. 3.11). Works by the different artists are interspersed throughout the book, indicating that it was produced in a social context much like the ledgers of earlier warrior artists, where each man's work was open to examination and comment by others. Other artists working in the volume produced scenes of warfare, but Silver Horn did not pursue that topic here. Like them he produced a few courting scenes, but his work was primarily devoted to illustrations of the Medicine Lodge ceremony (plate 24) and of myths about the trickster figure Saynday (figs. 6.7 to 6.10; plate 30). Although both of these topics would have lent themselves to the sequential series of narrative illustrations that he used in the Field

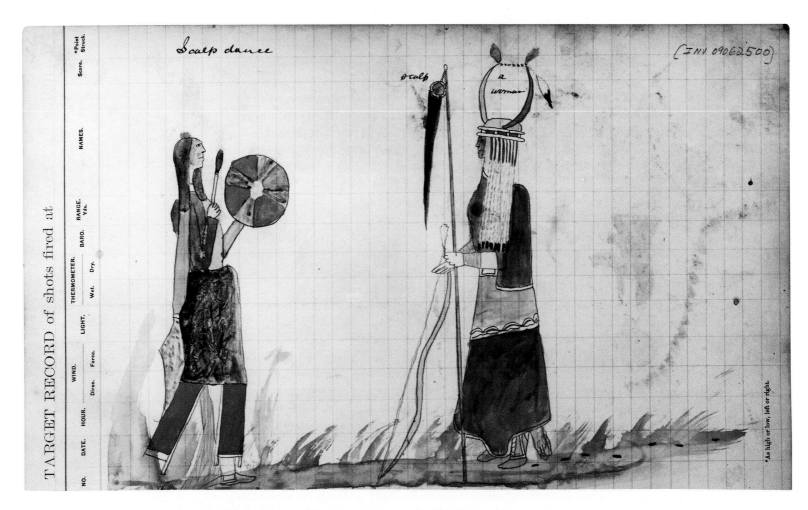

Scalp dance

scalp

a woman

(INV. 09062500)

3.10. Scalp Dance with a woman carrying a trophy scalp that her husband or other close relative has taken in war. *She has donned his headdress and carries his bow to honor him, while a drummer beats the time for the dance.* MS 4252. Courtesy of the National Anthropological Archives, Smithsonian Institution.

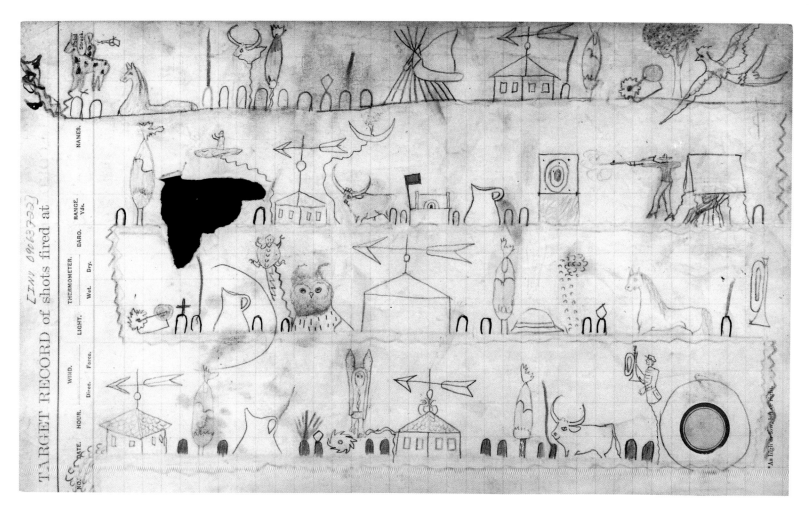

3.11. A page from Silver Horn's pictorial diary showing places and events from his period of enlistment in the army—target practice, the guard house with its weathervane, and the company bugler. MS 4252. Courtesy of the National Anthropological Archives, Smithsonian Institution.

Museum books for the Peyote ceremony and other myths, he did not continue that practice here. The Medicine Lodge pictures appear scattered through the pages of the book and show various aspects of the ritual rather than presenting it systematically. Nor do any of the Saynday pictures form extended series. Each story is illustrated with a single drawing or with pictures placed on two facing pages. These two-page narratives, in which the base of each drawing is placed near the gutter of the book, require that the book be rotated to view each image right side up. This arrangement echoes page usage in traditional ledger art, where single pictures sometimes spread across facing pages, but the book had to be rotated to view each half. In this instance, however, Silver Horn was placing two complete pictures in juxtaposition rather than two halves of one image.

The social context in which Silver Horn produced the drawings in this book must have influenced the choices that he made. Works by other groups of Indian scouts living in similar circumstances suggest that art was often produced in a playful, joking atmosphere (Greene 1998). Saynday, whose very name evokes smiles among Kiowa people today, would be a suitable topic for such a situation, and other images in the book also suggest a distinct vein of pawky humor. Scenes of the Medicine Lodge offer a marked contrast in sentiment and suggest instead an effort to share and record information about a sacred ceremony that was imperiled. Social input to the drawings is most evident in the pictorial diary, where several of the early entries have been forcefully expurgated by erasure or the more effective expedient of snipping out what must have been an objectionable entry.

Silver Horn continued to create graceful figures. People are slender, but with legs in relative proportion to their overall height; while horses have long necks, their heads are no higher than those of their riders. Many figures are built up with delicate sketch strokes rather than with a continuous hard outline. Here for the first time Silver Horn began to use watercolor extensively for his coloring medium, achieving good control in most images. Usually he applied it in solid blocks of color, but occasionally he varied the density and brush technique to suggest the wooly texture of a buffalo hide or other surface. The use of watercolor in the floating groundscape allowed him to add soft upright sprigs of grass around figures or flickering flames above a fire.

Hugh Scott had graduated from West Point in 1876 with an avid desire to serve on the Indian frontier. Initially it looked as though he would be unable to secure a commission for the type of service he wanted, but following the Custer disaster at the Little Big Horn a number of vacancies became open in the Seventh Cavalry for frontier service (Scott 1928:26). Scott secured one and was posted to Dakota

Territory, where he worked closely with Indian scouts from the Sioux, Cheyenne, Arikara, and Crow tribes. Reluctant to rely solely upon interpreters and recognizing the problems of learning a variety of languages, Scott devoted himself to mastering the sign language that was the lingua franca used throughout the Plains to facilitate intertribal communication. This knowledge stood him in good stead when he was transferred to Fort Sill in Indian Territory in 1889 and made him the ideal officer to command the troop of Indian scouts that he recruited in 1891, of which Silver Horn was a member. Aside from his linguistic skills, Scott had a serious scholarly interest in Indian culture and established himself as a competent amateur ethnologist. He sought out the elders of the tribe, as well as gaining information from his own men, and conducted extensive interviews in the sign language on many topics of cultural and practical interest. He published a brief paper on the sign language in 1898 and an extensive report on the Kiowa Sun Dance in 1911, which he had originally drafted in 1897 while detailed briefly to the Smithsonian's Bureau of American Ethnology. It was illustrated with pictures by Silver Horn.

Over his years in the West, Scott assembled a small but fine collection of Indian material, unfortunately keeping only limited records on the origin of many pieces. Much of the collection, which he sold to the museum at the University of California at Berkeley in 1901, was accompanied by scanty notes, and the visit that he promised to provide additional information in person never transpired. Yet several Silver Horn pieces can be identified within the Scott collection.

The most impressive is a painting on muslin containing four vignettes of events from the Medicine Lodge or Sun Dance. Although undocumented, and indeed lacking accession information, it is undoubtedly by Silver Horn and must have come from Scott. It consists of four separate scenes of portions of the Medicine Lodge ceremony, formally arranged in a symmetrical composition. As in Silver Horn's works on paper from this period, the figures are fairly realistically proportioned, and parts were carefully sketched before their final firm outline was laid down. It seems likely that this work was commissioned by Scott, who was much interested in the ceremony but had never had an opportunity to observe it. It is certainly quite different from another Silver Horn muslin painting collected around the same time, although it may have been produced at a slightly earlier period. The other piece, now in the collection of the Southwest Museum, was collected by a relative of Lieutenant Scott's wife who visited them during their tenure at Fort Sill and is inscribed as having been produced by Silver Horn. It shows an attack on a tipi camp by U.S. soldiers and is captioned as representing the Battle of the Washita.[6] While Silver Horn must have drawn many of the figures on this muslin, the work of at least one other hand can be discerned. The proportions

and outlines of the horses Silver Horn drew here are characteristic of his work of the late 1880s through the first three books of the Field Museum set.

Scott also collected a small buckskin model of the Tipi with Battle Pictures, complete with a tiny model of the Padogai shield of Silver Horn's family. The model was received without specific documentation; although the artist had difficulties getting sharp lines on the soft buckskin surface, the basic shapes and postures of the figures are clearly recognizable as Silver Horn's work. During the time when Silver Horn was serving in Troop L, James Mooney was traveling the reservation asking Kiowa people to paint tipi models for him. This model, although somewhat different in size and construction, was no doubt inspired by that project, although whether Silver Horn or Scott was the initiator may never be known. It represents Silver Horn's first work in a medium he was later to take up with enthusiasm, painting on buckskin.

During his period of enlistment, Silver Horn also experimented with painting scenes on rawhide. Two such paintings are in the Scott collection, and James Glennan, another officer serving at Fort Sill, acquired a similar painted rawhide (fig. 3.12), which he recorded in his personal catalog as being by Silver Horn. The rawhide paintings were an unsuccessful experiment with a new medium. Produced on small sheets of thin rawhide, the images were first carefully drawn in pencil then painted in thick, opaque colors with some outlines retraced in black paint. While the initial drawing is very fine, the artist had difficulty controlling the paint on the smooth rawhide surface, and the results are thick, muddy images that largely obscure the delicate original drawings. Silver Horn may have produced a number of works during this period for sale to interested officers. Glennan's catalog also lists a painting on deerskin by Silver Horn, which regrettably was not received when the rest of his collection was donated to the Smithsonian's Department of Anthropology (NMNH acc. 177,672).

While the drawings were produced at a time when Silver Horn and other scouts were in particularly close contact with both military and civilian personnel at Fort Sill, there is little evidence that any of these people directly influenced the drawings. It is possible that Hugh Scott might have asked Silver Horn to add a few more Sun Dance pictures to the book at the time of acquisition, but most of the book was filled long before he became aware of it. Nevertheless, Silver Horn, like other Indian people, was subject to a number of indirect influences that changed the way that they perceived the world. As discussed in more detail in chapter 7, nowhere is this more evident than in the picture diary he placed in this book, which is dominated by Western modes of marking time.

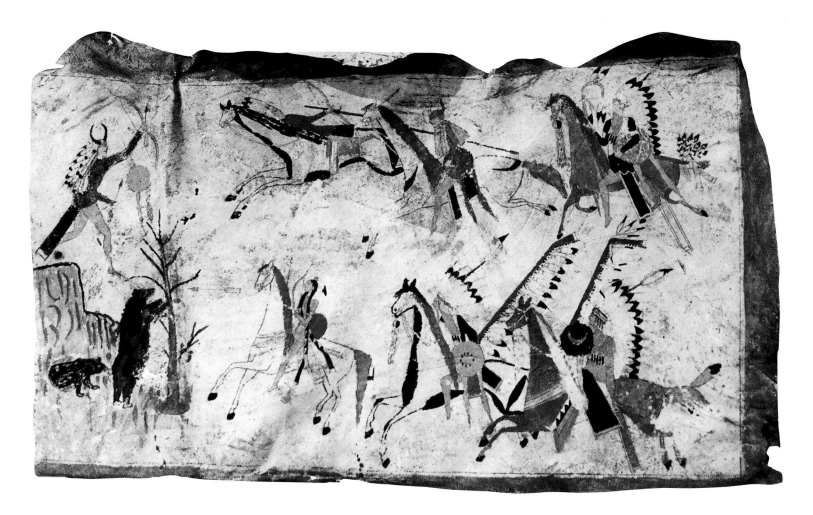

3.12. Painting on rawhide with scenes of war and of an encounter with a bear. Collected by Dr. James D. Glennan at Fort Sill while Silver Horn was enlisted there. #385,902. Courtesy of the Department of Anthropology, National Museum of Natural History, Smithsonian Institution.

The Burbank Influence

The Saynday pictures in the Target Record book intrigued Hugh Scott; soon after he acquired the book in 1897, he commissioned Silver Horn to produce additional images of these and other myths. Scott was planning to publish a series of Indian stories and felt that Silver Horn's pictures would make ideal accompanying illustrations, provided one could remove the distracting ledger lines of the record book and the ribald touches of Saynday's anatomy. Silver Horn accordingly produced two sets of drawings, which remained in Scott's family for nearly a century before entering the market and finally being placed in a public collection.[7]

One set of forty pictures on the pages of a once-bound sketchbook is inscribed by Scott as having been drawn and painted by Hawgone (Iron Horn) near Fort Sill in 1897 (fig. 3.13). They are worked in pencil and watercolor and are similar in style to the original images in the Target Record book, but with several changes in the narrative format. A number of the Saynday stories that are illustrated with two images in the book are here compressed onto a single page. Rather than selecting a single point in the story, however, Silver Horn has produced a more complex illustration by depicting several stages in the story in a single image, often with Saynday shown twice in the same picture (fig. 6.11). Footprints are used extensively to connect various parts of the image in narrative sequence (fig. 6.13). Yet for a few other stories Silver Horn returned to his earlier mode of producing separate sequential images. In one instance, he used a remarkable series of nine images to tell a long and complex story. In this book of drawings, he illustrated a larger and slightly different set of Saynday stories than in the Fort Sill book, including some tales of a more serious nature. He also drew pictures of several other stories of Kiowa origins, as well as one picture of Sun Dance participants and ritual equipment (fig. 5.4). Never before had Silver Horn been so directly influenced by a purchaser of his works. Scott must have defined the content of the pictures to a large extent, indicating to him stories for which he had already collected texts and now needed illustrations. Scott's publishing needs no doubt also influenced the form of the images, as Silver Horn was encouraged to find ways to compress various parts of a narrative into as few images as possible.

Another group of thirteen images produced for Scott on loose sheets of paper at about the same time is remarkably different stylistically. All illustrate mythological stories, three depicting aspects of the origin of the Twin Boys and the remainder being Saynday stories. The style of illustration is, however, highly Westernized (plate 12). Rather than conceiving the base sheet of paper as a void upon which relevant

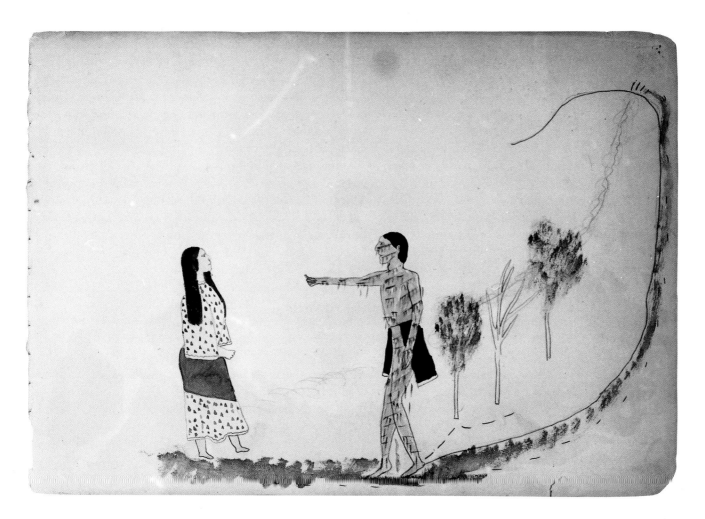

3.13. The trickster Saynday scratched and bleeding—the result of overly aggressive courtship of the Whirlwind Woman. Gift of Mr. and Mrs. Charles Diker. Courtesy of the Museum of Indian Arts and Culture/Laboratory of Anthropology, Museum of New Mexico.

elements are placed, Silver Horn treated the entire surface as a unified landscape field, clearly differentiated into land and sky and containing a variety of features such as hills, trees, and rocky crags that are extraneous to the story being illustrated. The outlines of figures are sketched rather than solidly drawn, and the colored pencil used to fill the outlines is in many places shaded rather than solid. Some figures are given further three-dimensionality by indicating lines of musculature or creases at joints. Glimpses of Silver Horn's more familiar methods of illustration peep out here and there, however. He was not entirely consistent in giving figures well-rounded forms, and some rather flat Sayndays appear within much more three-dimensional landscapes. Throughout the series of drawings, he remained committed to the use of footprints as a narrative device, offering a whimsical touch in these otherwise highly Westernized drawings. Consistent with his efforts at naturalism, the prints in these drawings are at times realistic outlines of the human or animal foot rather than the more conventional dashed lines (fig. 6.12). Although these pictures are drawn on slightly different paper than the drawings inscribed as November 1897, the history provided by Scott suggests that they were produced at essentially the same time. Their unusual character can be directly attributed to Silver Horn's recent contact with the artist E. A. Burbank.

Edward Ayer Burbank was a successful Chicago portrait painter who had a special interest in portraying people of non-European origin. In 1897, with support from his uncle Edward E. Ayer, he traveled through the West preparing an Indian series (Lockwood 1929:179). As part of this project, he spent some weeks at Fort Sill, where he became acquainted with Silver Horn and produced a drawing of him in red chalk now at the Gilcrease Museum, later working up a full portrait in oils (Newberry Library Ayer Collection). Burbank was interested in Indians as artists as well as subjects. He was quite impressed with Silver Horn's ability, remarking that if he "had been able to secure real art training in his youth, I have no doubt he would have become an artist of note" (Burbank and Joyce 1944:186–87). For his own part, Silver Horn seems to have been impressed with Burbank as well and spent days at Fort Sill watching him at work. Burbank offered him specific instruction. "I used to try to explain different things to him, to which he would listen very attentively. After such lessons I invariably noticed improvement in his work" (Burbank 1900:90). As Silver Horn did not understand English, he may have benefited little from the verbal explanations, but the opportunity to observe new methods and concepts in production was enormously stimulating.

Silver Horn and Burbank had totally different ideas of the key elements of portraiture. Silver Horn came from an artistic tradition in which figures were identified by distinctive elements of dress and

accessories. In contrast, Burbank's conception of portraiture was rooted in capturing a facial likeness, and many of his works are of heads only. After he returned to Chicago, Burbank sent Silver Horn a set of water-color paints, and in return Silver Horn sent him a set of pencil drawings with watercolor fill to join the pictures that Burbank had already acquired (figs. 9.9 and 9.10; Burbank and Joyce 1944:223). The Ayer Collection at the Newberry Library now holds 123 works by Silver Horn (plates 13 and 43). Several of these are inscribed as produced by Hawgone, Fort Sill, May 1897. Most of the drawings are portraits, although there are also images of wildlife and of painted tipi covers. The portraits are of single figures, posed for the artist in a variety of postures. In many of them, Silver Horn continued to focus upon details of dress rather than on facial features, and the figures are often drawn in solid lines with faces in simple pro-file. In the few front face views, some shading is introduced around the eyes to suggest their depth. In one group of drawings on slightly different paper, however, Burbank's influence is strongly apparent in the high level of detail devoted to rendering the facial features, many of which are drawn in full face. The pos-tures of the figures are complex, including many seated figures, and the faces are heavily worked. The fig-ures are fully sketched, and line and shading are used in profile, frontal, and three-quarter views to suggest the planes of the face. As in the second set of mythological drawings produced a few months later for Hugh Scott, Silver Horn sought to capture the three-dimensionality of the figures with attention to both facial features and naturalistic draping of clothing elements.

These portrait studies are a remarkable leap from Silver Horn's earlier works, but they are equally dif-ferent from the majority of the Saynday pictures he produced some six months later for Scott. Without the additional thirteen mythological drawings in the Scott collection that also utilize a naturalistic style, the Newberry images would appear anomalous, and an error in the documentation would be suspected. Instead it is evident that Silver Horn was capable of working in two different artistic "languages." These two unusual groups of drawings produced for Scott and Burbank represent a brief experiment in Western modes of illustration rather than an evolutionary stage in his artistic development. After 1897, Silver Horn never produced drawings of this type again, although a few elements of increased naturalism can be dis-cerned in his later works.

Works for Mooney

During the first decade of the twentieth century, Silver Horn was employed as an artist by the Smithsonian

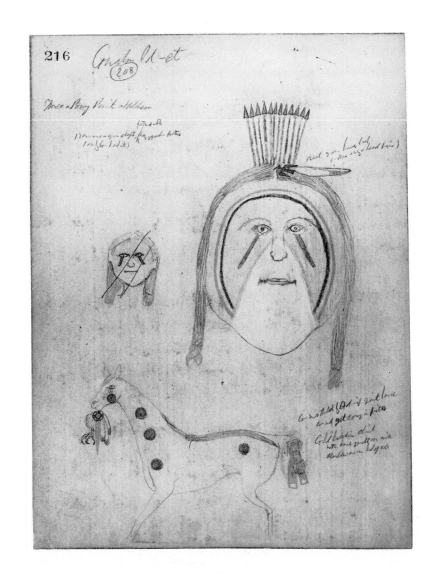

3.14. Illustration showing the face paint, headdress, and pony decorations that accompanied the Bird Shields.
Silver Horn made many such drawings for James Mooney.
MS 2538. Courtesy of the National Anthropological Archives, Smithsonian Institution.

anthropologist James Mooney and produced scores of well-dated works. Mooney was involved in a study of Kiowa shields and associated war medicine, and Silver Horn's work provided visual support for that project. Mooney scribbled Silver Horn's name (Hangun) and the date on many sheets of drawings, while others can be assigned to him on stylistic grounds. Some pictures are of warriors on horseback carrying shields and show their distinctive pony paint as well as personal dress and weaponry. Other images are drawings of men's heads, positioned frontally to show their face paint. Many pictures are of shields alone. All of these are elements that Silver Horn had often depicted in scenes of warfare, but never before in such detail or in isolation from any context or event. The drawings range from quick sketches to carefully compiled redrawings of previous images. A few pictures explore the Medicine Lodge ceremony (fig. 1.1) or other topics. Most of the illustrations produced for Mooney are pencil drawings, with the outlines delicately sketched with colored pencil fill. The full figures that Silver Horn created are small and proportionate, some of the most careful drawings he ever made. A few elements of naturalism carry over from his previous work under Burbank's influence. The full-face images contain some detailing of features, with shaped lips and a suggestion of depth to the eye sockets, and a few drawings of horses include shading to suggest the musculature of the animal (fig. 3.14; plate 1).

Silver Horn's shield drawings were produced under the close scrutiny of both James Mooney and the elderly Kiowa traditionalists who provided information about the designs. These older men no doubt insisted upon accuracy in the drawings, but would have left the mode of representation to the discretion of the artist. Through their participation in Mooney's project, they had already demonstrated their acceptance of the value of recording information about this aspect of their culture. Mooney followed their lead in his concern with content rather than style. Carl Sweezey, another artist who worked for Mooney, later described painting in the traditional Indian manner as "the Mooney way" (Bass 1956:430). Plains art, with its emphasis on clear illustration without extraneous elements but with great detail in the depiction of warrior equipment, suited Mooney's purposes exactly. The only change that he asked was for Silver Horn to isolate the elements in which he was interested and enlarge them so that they could be depicted in greater detail.

Silver Horn's shield drawings on paper were accompanied by a series of miniature shield models that he painted on buckskin (plates 36 and 37). Aspects of shield design and decoration that had first been worked out on paper in consultation with shield owners or their heirs were transferred from paper to this different medium. By the time Silver Horn painted these shield models now in the collection of the

National Museum of Natural History, he had developed a complete mastery of the medium. On shields with pictorial images, finely detailed figures are drawn in pen and ink, using much the same style as in his works on paper. For geometric designs, the paint is applied in lines of various widths as well as in solid blocks of pigment, and the color is smooth and even throughout. The museum has preserved a number of small wooden paint sticks with variously shaped ends that were used to apply color to the models as well as a few samples of the powdered pigments (Merrill et al. 1997:44).

While the recording of shield designs was Silver Horn's primary task with Mooney, he also had the opportunity to apply his artistic ability in other areas. One of the most fascinating is a pictorial calendar (figs. 7.2, 7.3, 7.4; plates 33 and 34). Drawn on the pages of a notebook identical to others that Mooney took to the field with him in 1904, it is a copy of an existing calendar rather than an original maintained over a period of years. Covering many of the same years as the calendar maintained by Silver Horn's father, Agiati, it is much more detailed in the information it records and extraordinarily rich in visual imagery. Silver Horn was continuing a family tradition of calendar work, but his images far surpass those of any other known calendar in delicacy and detail. Finely drawn in pen and ink with watercolor fill, the pictures include minute detail to aid in interpreting the events they reference. He continued to use the old conventions of footprints and flying bullets to convey information, but the calendar is the only work in which he also used name glyphs to identify individuals. Regrettably, as in so many of the beautiful images that Silver Horn produced for Mooney, their original appearance is marred by the extensive notes that Mooney wrote across their surfaces.

The finest artistic achievement of Silver Horn's work with James Mooney, and perhaps of his entire career, was the production of a series of hide paintings of the Medicine Lodge or Sun Dance (plates 18 through 22). These five paintings, first pencil sketched, then drawn over in ink with tempera coloring, are remarkable for the fineness of the drawing as well as their vibrancy of color. Silver Horn had complete mastery of the media. He was able to produce very finely detailed drawings upon the napped surface of the buckskin (fig. 3.15) and to apply paint with a soft edge when desired to capture the sense of the leafy foliage of the Medicine Lodge arbor.[8]

The hides form a narrative series illustrating the ritual preparations for the ceremony. Two of them represent single events, while two others show multiple events on the same hide. The fifth presents a more static display of ritual objects and participants in the Medicine Lodge as well as events from the Peyote religion. Representation of all these aspects of the ceremony was a complex undertaking, and a few

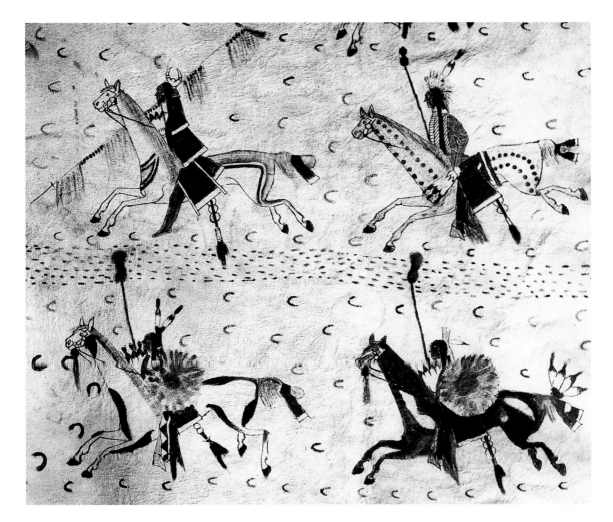

3.15. Detail of hide painting (shown in full in plate 19) showing preparations for the Medicine Lodge ceremony. *The riders are engaged in a mock battle before the center pole is cut.* #229,895. Courtesy of the Department of Anthropology, National Museum of Natural History, Smithsonian Institution.

surviving preliminary drawings on paper demonstrate that Silver Horn invested considerable planning in the project. He was evidently comfortable working in this larger format and produced well-balanced compositions, whether of single or multiple subjects. The old narrative device of footprints is used here extensively. The prints meaningfully support the storyline, but also serve as a compositional device to unify groups of figures. These hides were produced specifically for display and are the culmination of a project that Mooney had conceptualized long before. As in the other work that Silver Horn produced for Mooney, it must be assumed that the basic topic and form were determined by the Smithsonian anthropologist, while the mode of representation and all the details of content were left to the artist's discretion (Greene 1992b:162).

Three additional hide paintings date from the period of Smithsonian employment. In one, titled "The Kiowa Pantheon" by Mooney, Silver Horn presented a series of figures from Kiowa mythology and religion, rather than a connected narrative (plate 32). Of all his later works, this one is the most naturalistic, if that term can appropriately be applied to the fantastic supernatural creatures depicted. Another hide contains a series of war scenes (plate 14), similar in both concept and execution to the early drawings on muslin. As in the Saynday pictures done for Hugh Scott, Silver Horn demonstrated in these two hides the facility with which he could work in various styles. A third hide painting now in the collection of the Linden Museum in Stuttgart suggests that Silver Horn continued to paint privately while working for Mooney, perhaps during his years of less regular employment between 1904 and 1906. This painting (fig. 5.5) purchased in 1906 bears the same basic motives and style as the final composite hide of his Medicine Lodge series.

The Later Hides

Silver Horn perfected the technique of buckskin painting while working for Mooney, and all of his known works from later years are in this medium. These were works made for sale; hide paintings, with their inherent allusion to the vanished days of the hunting culture, probably brought a better return for investment of effort. All of the documented hides were purchased between 1909 and 1911. One is a beautifully integrated composition of a circle of Ghost Dancers, carefully executed with a fine level of detail (plate 29). The others all contain a series of scattered scenes, including illustrations drawn from ceremony, myth, and war, topics the artist had previously explored (fig. 3.16). These are not his finest works. Images are

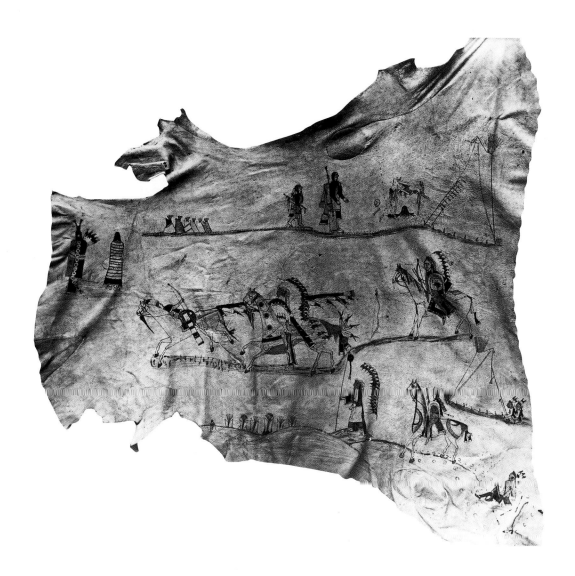

3.16. A late hide painting with scenes of courting, warfare, and oral traditions. #2/8329. Courtesy of the National Museum of the American Indian, Smithsonian Institution.

often crowded together, and the extensive use of groundscape, verging in one instance on full landscape (fig. 6.14), is confusing and detracts from the basic narrative. The drawing is sometimes awkward, and in general the delicacy of figures that characterized his previous works is lacking. Many figures are drawn frontally or in three-quarter view and do not have the elegance that he consistently attained in profile views. Action scenes abound, and the heads of exuberant horses again soar above those of their riders, while tails stream from jutting rumps. These were works produced for commercial sale, which may have influenced the level of effort that Silver Horn invested in them. It is also likely that his diminishing eyesight had begun to affect the quality of his work.

An interesting feature of the hide paintings is the presence of the artist's name on two of them. On one it resembles the signature on a drawing done for Scott. The other appears to have been written by a more practiced hand (fig. 3.17). Whether this is a signature or inscription, placing a name on the work mirrors Silver Horn's commercial drawings of two decades earlier, when inscriptions were added to enhance their value to purchasers.

The last known chapter in Silver Horn's long career as an artist came in the late 1910s, when he helped to paint a new version of the Tipi with Battle Pictures, in which he had lived as a child. That cover has not survived, but over one thousand other works offer testimony to his gift as an illustrator of Kiowa life.

Over the course of time, Silver Horn produced illustrations in many media and techniques. We can trace his career through his contacts with a series of individuals. His brother Haba provided tutelage when he was beginning his career. Dudley Brown and Horace Jones were instrumental in providing a market for his early work. Later, Hugh Scott, E. A. Burbank, and James Mooney were patrons who gave him opportunities to explore and develop subjects, styles, and media. None of these, however, can be credited with exerting a substantial influence upon him, for he was already experimenting with many of the innovations that characterized his work with them. Burbank's influence was certainly more dramatic than that of other patrons, but less lasting. Ultimately, Silver Horn relied upon an inner vision of the possibilities of visual representation, a vision that was shaped by cultural as well as personal factors.

3.17. Various Haungooah signatures: *a,* Target Record book 1891–97 (NAA 4252); *b,* Lawrence collection hide ca. 1910 (Museum of the Great Plains); *c,* Scott drawing, 1897 (MIAC); *d,* Claremont College hide ca. 1910.

Chapter 4

The Art of Coup Counting

Warfare was the driving force behind nineteenth-century Plains graphic art. When that source of energy was abruptly snuffed out, the art faltered, attempted new directions, and ultimately died. Silver Horn came of age as an artist just at that critical moment when the glories of war were cut off and warrior art became a narrative of the past rather than of the present. During his early career, he was one of many artists trying to continue old forms under new circumstances. Over time, fewer and fewer artists found purpose in such production, until he stood alone as almost the only active artist among the Kiowas, producing scenes of war as well as other topics.[1] Spanning several decades, Silver Horn's art illustrates not only many Kiowa battles, but also a changing view of warfare.

The Plains was a dynamic region during the eighteenth and nineteenth centuries. The introduction of the horse, the gun, and European trade outlets created new economic opportunities and triggered more extensive population movements than ever before—and resulting territorial conflicts. Subsistence hunting became more reliable, as hunters were able to travel greater distances and transport larger quantities of stored food. The addition of a vast European market for hides, however, made hunting a source of considerable wealth. Horses also were a major trade item, and Plains people participated in a redistribution system, moving horses among various Euro-American settlements through a process of capture and sale. Within this ever-changing environment of displaced populations and economic opportunities, conflict was constant and violent as each tribe sought to position itself to secure the best access to resources for hunting and trade. Patterns of warfare emerged throughout the Plains that supported the economic welfare of the group as a whole by richly rewarding individual warriors for their personal achievements. A system of formalized honors, known as coup, allowed men to rise in status through demonstrating their bravery in war.

The Kiowas epitomized this history of Plains warfare. War was a major factor of Kiowa life for generations prior to their confinement to a reservation in Indian Territory in the 1870s. The early history of the Kiowas records a series of territorial conflicts as they moved onto the Plains from an earlier home in the Rocky Mountains near the headwaters of the Yellowstone River. Although always a small tribe and often

dispersed over vast distances, the Kiowas were nevertheless able to secure a rich territory for themselves through vigorous attack, selective retreat, and successful alliance.[2] Moving onto the Plains perhaps as early as 1700, they occupied the Black Hills region through the middle of the century, but were eventually displaced around 1770 by the Sioux and the Cheyennes, who were both expanding their territories westward. Movement south brought conflict with the Comanches, but about 1790 the two tribes agreed to peace and formed an enduring alliance as a defense against common enemies to the north and east, among them the Osages. Undoubtedly the most keenly remembered event in Kiowa history is an Osage attack upon a Kiowa camp in the Wichita Mountains, which occurred in 1833 (fig. 4.1). The camp was ineffectually defended and nearly all of the residents were slaughtered by the Osages, who cut off their heads and left them in buckets to be found by the scattered survivors. As devastating as the massive loss of life was the capture of the Taime, a sacred tribal bundle essential for the performance of the Kado or Medicine Lodge ceremony. The return of the Taime was negotiated the following year as part of a peace agreement between the Kiowas and the Osages, ending their longstanding enmity. A few years later, the Kiowas also agreed to peace with the Cheyennes. After this, Kiowa territory was largely secure, with the Pawnees the only tribe likely to press attack upon them on their home ground. Peace with the Pawnees was not secured until 1871. A new source of trouble, however, had entered the scene. White traders had come to the Kiowas early in the century and were welcomed, but white settlers moving onto or across the Plains created a new threat. On their behalf, the U.S. government sought to assert control over Kiowa raiding behavior through a series of treaties and punitive military expeditions. This conflict escalated through time and culminated in the Red River War of 1874–75, in which the Kiowas and other Southern Plains tribes were finally defeated and confined to strict reservation boundaries (Mooney 1898; Mayhall 1962).

Like other tribes, the Kiowas institutionalized military conflict into an organized system known as the Plains warfare complex. In this system the role of warrior was elevated from a fact of life, a basic necessity, to become the preferred occupation of every male and the ultimate source of personal prestige. An elaborate system of recording war honors was formalized. Throughout the Plains region, high honors were given to striking an enemy with an object held in the hand rather than shooting from a distance. Thus the French word for stroke, *coup,* came into English usage to describe formalized deeds of war, while the term "counting coup" referred to each man maintaining a record or count of his recognized war deeds.

The achievement of war honors was the primary means by which rank was established in Kiowa society, and such honors were a prerequisite for any position of authority or prominence. Honors were based

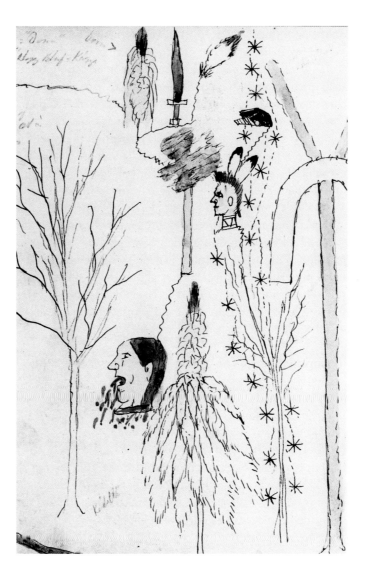

4.1. Detail of Silver Horn's calendar for 1833–34, showing the "Summer That They Cut Off Their Heads," the "Winter That the Stars Fell," and the summer when they made peace with the Osages and the Taime was returned. MS 2531. Courtesy of the National Anthropological Archives, Smithsonian Institution.

on the performance of deeds that were formally recognized as acts of bravery, and deeds were themselves ranked in a general order of prestige. Being the first to strike an enemy, for example, carried higher status than did killing an enemy. Lesser recognition was also given to second, third, and fourth strokes upon the same enemy, however, even if the first stroke had been fatal. Other acts of war, such as scalping, were not considered in ranking. A scalp was valued as a proof of killing, but scalping itself was not a prestigious deed. The emphasis on granting war honors for acts of bravery rather than for efficacy in exterminating the enemy has sometimes led to the false perception that the Plains war system was a glorified albeit dangerous game of tag. This view fails to take into account the often deadly results of honorific acts or their strategic value (Foster 1992:viii–x). The Kiowas, for example, ranked charging the enemy to cover the retreat of one's party or rescuing a comrade nearly as highly as making first strike on an enemy (LaBarre et al. 1935:596). A warrior racing alone close to the lines of the enemy was not only a dramatic demonstration of bravery but also an effective way to empty their guns before his comrades charged.

The achievement of war honors was essential for advancement in Kiowa society, but to achieve full recognition of such accomplishments it was necessary to publicize them widely. Social gatherings offered many opportunities at which men were invited to recount their deeds, and wealthy families might sponsor additional feasts to honor their rising young men (Mishkin 1992:40–41). In addition to such verbal recounting of deeds, graphic art was another major medium of advertisement. Plains pictorial art was the visual equivalent of the oral genre of recounting coup.

Traditional Scenes of War

Warfare was a prominent theme throughout Silver Horn's artistic career. His earliest known muslin painting (plate 6), produced when he was perhaps only seventeen or eighteen years old, is covered with a complex scene of war, and his last works, done when he was in his mid-fifties, continue the celebration of battle. The percentage of works devoted to warfare declined as Silver Horn expanded his repertoire of topics, but it was a subject that he continued to return to over time.

Three works on muslin produced in the 1880s are his most traditional examples of warrior art. Each consists of a series of separate scenes of combat scattered across the surface, illustrating Kiowa warriors counting coup against a variety of enemies. A number of the scenes are by Silver Horn, but other artists contributed to each muslin as well. These muslins with their richly detailed and varied scenes are the visual

equivalent of an evening of coup recounting, in which men gathered in the home of a host to smoke and retell their war deeds. They do not present connected narratives, but rather a compilation of stories contributed by those present; their common theme is the celebration of Kiowa valor. The communal nature of the artistry suggests that these muslins were also produced in a social setting in which a number of men assembled, some to tell of their deeds, others to record them.

A large muslin in the collection of the Oklahoma Historical Society Museum (plate 7) contains twenty-one scenes of warfare, as well as a row of parading warriors. Silver Horn drew six or more of the scenes, while another five may be at least partially his work. The figure in the upper left corner lancing an Indian enemy carries the Padogai shield and wears the red war cape, which were hereditary in Silver Horn's family, passed down through a series of owners to his brother Haba. The same shield appears in two additional pictures, carried by a warrior who combats U.S. Cavalry troops (fig. 3.4). In one (fig. 10.2), he circles alone before a phalanx of firing troops, drawing their fire to cover the escape of his party, which includes two women and a small child. This may be a scene from the Southern Plains war of 1874–75, during which the camps of the Kiowas who refused confinement to the reservation were frequently under attack by massed troops. If so, the brave warrior must be Haba, as the shield had passed to him by this time. Another scene of a similar coup in which a lone warrior circles before the enemy to cover the escape of two women may also represent a member of Silver Horn's family. In this picture (fig. 4.2), the attacking cavalry troops are preceded by Indian allies, whose feather bonnets suggest that they are Utes. In 1864, a troop of soldiers and Ute scouts under the command of Kit Carson attacked a Kiowa village near Adobe Walls. Almost all of the Kiowa fighting men were away from camp, but the aged chiefs Little Bluff and Stumbling Bear coordinated a stout defense while the women and children fled to safety (Nye 1943:36–37). Like the warrior depicted here, neither man carried a shield at the time, having long since passed them on to younger men. While these identifications of people and events are speculative, the detail of the images makes it clear that each represents a specific war deed of a known individual, which would have been recognized by Kiowa people of the time who had heard the coups recited.

A somewhat smaller muslin painting in the collection of the Witte Museum contains eleven scenes of war as well as one of a bison hunt. At least three artists worked on the muslin, with Silver Horn contributing three of the scenes. In one of these, a warrior with a red cape and a variant of the Padogai shield has pursued an enemy wearing a hooded capote and carrying the pipe of a war leader into a thicket. In spite of the furious action indicated by a maze of footprints, two birds remain perched on the limbs of a

dead tree projecting above the surrounding foliage. Another scene shows a Kiowa warrior on foot facing two mounted Pawnees, one of whom is falling from his horse (fig. 4.3). The third scene shows a leader of the Koitsenko warrior society, considered the bravest of the brave. He displays the distinctive headdress and rattle of the society as well as the "no-retreat" sash worn over the shoulder. He has staked himself to the ground by an arrow thrust through the trailing end of the sash and stands ready to meet the charge of two mounted enemies who are bearing down on him. Only the four leaders of the society, once including Silver Horn's great-uncle Tohausen, wore such sashes. They were only employed in desperate circumstances to cover the retreat of other members of a war party.

Silver Horn was the primary artist of a third communal muslin painting of similar style and content in the collection of the Philbrook Museum of Art (fig. 4.4). Of the eighteen scenes of warfare it contains,

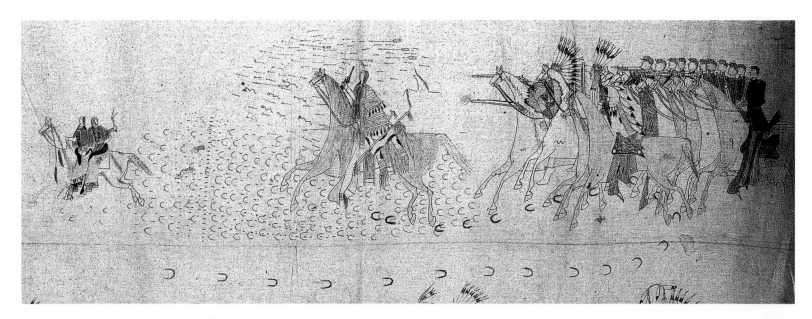

4.2. Detail of muslin painting (shown in full in plate 7).
Massed prints show that many people have fled before an attack by the U.S. Cavalry led by Indian scouts. A single man armed only with a revolver rides back and circles before the enemy to cover the desperate escape of two women riding double.
#68.20.1. Courtesy of the Museum, Oklahoma Historical Society.

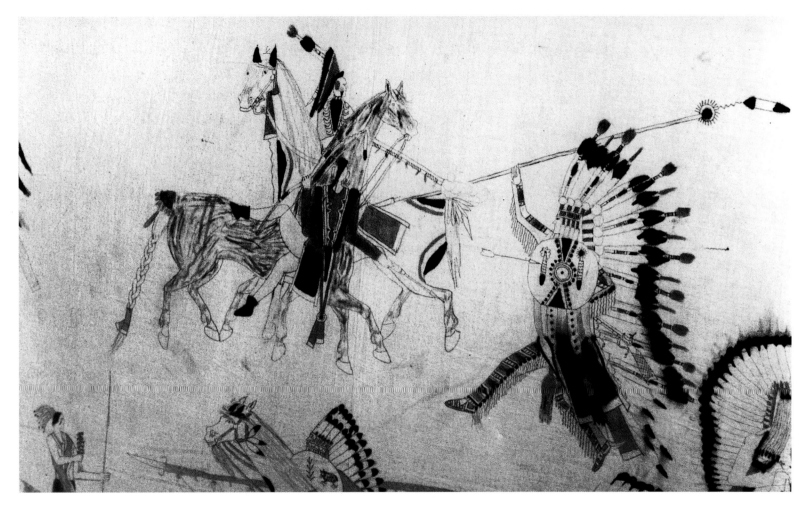

4.3. Detail of muslin painting.
A warrior in fringed shirt and leggings fights on foot against two mounted Pawnee enemies, striking one from his horse while the other fires at him.
#40-151. Courtesy of the Witte Museum, San Antonio, Texas.

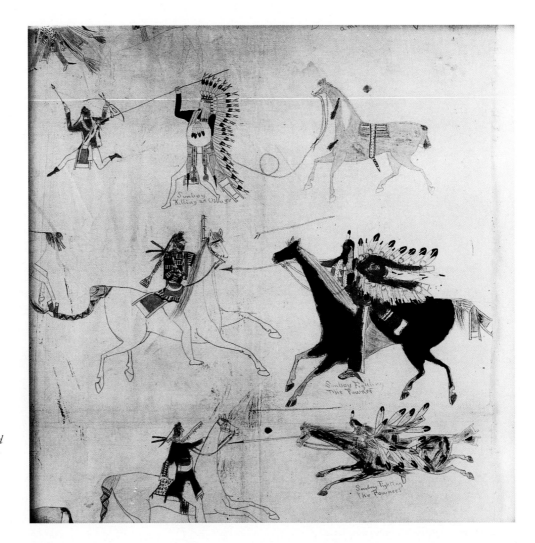

4.4. Detail of muslin painting with three scenes by Silver Horn of Sun Boy's exploits.
In the upper picture, he carries a plain shield and wears a full eagle feather bonnet. In the lower two scenes, he carries a red shield and wears a single feather upright on his forehead.
82.6. Courtesy of the Philbrook Museum of Art, Tulsa, Oklahoma.

ten are by Silver Horn, who also appears to have contributed to parts of two or three others (such collaboration is not unusual in Plains art, with one artist drawing the horses and another the human figures, for example). His artistic leadership is evident in other ways as well. One of the images produced by another artist is a near copy of the scene he placed in the lower left corner of the muslin.

Several of the pictures on the muslin are captioned with inscriptions by an unknown hand that identify the protagonist as Sun Boy, while another is captioned as depicting Tanati.[3] Sun Boy was a prominent warrior, known to the Kiowa as Paitalyi. Warrior art did not attempt to make individuals recognizable through delineation of facial features, but the inclusion of distinctive personal items such as shields and other war accouterments served as a form of portraiture to facilitate identification. In this muslin, the figures labeled as Sun Boy carry two different shields, one red and the other with a plain unpainted cover. Fortunately, detailed information regarding Sun Boy's shield ownership is available to resolve this apparent discrepancy. Sun Boy owned four different shields over the course of his war career. The first was a Buffalo Shield; the second was not well remembered, but was possibly a Bird Shield; the third was a plain, unpainted shield that had no medicine; and the final one was a version of the Akopti Shield, one of the red shields dedicated to the Taime (Mooney MS 2531, 11:56–57). This information suggests that five additional unlabeled figures, each carrying a Buffalo Shield with a central blue "eye" and wearing the same single feather headdress as the warriors with the red shields, are also Sun Boy. Silver Horn and his fellow artists were precisely depicting events from the long history of this famous warrior's life, showing him with three of the four shields he owned over time.

A later painting by Silver Horn that is accompanied by detailed notes demonstrates the accuracy with which war scenes were normally depicted, as well as the difficulty there may be in interpreting them today. In 1904, Silver Horn produced a painting on buckskin for James Mooney (plate 14), which is reminiscent of the muslins of twenty years earlier. It contains three scenes illustrating events dictated by his brother Haba and written down by Mooney (Mooney MS 2531, 2). Warriors carrying identical versions of the Padogai shield are shown in two images. It would be reasonable to assume that the pictures showed two exploits by the same man. One picture is of Silver Horn's father, Agiati, however, and the other is of his brother Haba, to whom Agiati had transferred the shield.

Traditional warrior art was an accurate representation of specific events, but only the aspects of importance to society were presented. Rarely can we now link a picture to a known event with any certainty.[4] Even at the time they were produced, people must have drawn heavily upon the accompanying oral

testimony to recognize the events pictured. While Silver Horn and other artists' careful delineation of detail makes it possible to identify the shields in both the muslin paintings and the hide painting, this may not be sufficient to ensure accurate identification of the men carrying the shields. A verbal narrative formed the essential foundation of each story, while the pictures referenced it in abbreviated form. They were illustrations of an oral tradition and ultimately were dependent upon it.

Impressive as the muslin paintings are, most of Silver Horn's warfare pictures were produced on paper in a series of drawing books dating primarily from the 1880s and early 1890s. Most Kiowa books of drawings, aside from those produced at Fort Marion, combine the work of a number of artists. Silver Horn, however, usually worked alone. Only one volume of his drawings, the one produced while he was a soldier at Fort Sill (NAA MS 4252), includes the work of other hands.

The drawing books, like the muslins, are compilations of a series of discrete events. Only rarely can any connection be recognized between pictures on separate pages, except when a single scene extends across facing leaves. They consist of isolated images showing a number of warriors facing many different enemies, demonstrating the geographical range of Kiowa warfare. Pawnees or Osages are the enemies most frequently represented, distinguished by their shaved heads and roached hair, often wearing moccasins with flared cuffs, front seam leggings, and bear claw necklaces. Silver Horn seems to have made no visual distinction between members of these two tribes and may have used the same distinguishing characteristics for other Prairie tribes as well, such as the Omahas and Sauk and Fox. The Navajos are the next most common enemies shown in Silver Horn's work. They are represented with the men's hair gathered and bound into a thick club at the back of the neck and wearing distinctive leggings, with a wide flap below the knee. Ute enemies are identified in many captions. They commonly wear full-feather Plains-style war bonnets, but are indistinguishable from other bonneted enemies identified in captions as Cheyennes or Sioux. Members of this tribe participated in battles with the Kiowas while they were serving as scouts for the U.S. Army.

Silver Horn's warfare pictures follow the pattern of coup stories and concentrate on individual deeds. The majority of pictures are of two warriors in combat, one counting coup upon the other. Pictures occasionally show other deeds for which coup was awarded, such as rescuing a comrade or protecting a retreat. Warrior art had developed to serve as a form of personal advertisement of coups, with combat depicted as a series of isolated individual triumphs rather than as a group activity. Although most opportunities for coup counting occurred in group actions such as revenge parties, the pictures seldom suggest that context.

Silver Horn had grown up immersed in the warrior art tradition, and he remained faithful to many of its basic representational conventions. Yet he was introducing subtle changes in content within the conventionalized form, as were some other artists of the period.

There are, however, two muslin paintings by Silver Horn that depart from this norm. Evidently working by himself on each, he used the full scope offered by the large format to create complex narratives broader in scope than any of his other works. One of these, the Evans muslin at the Oklahoma Historical Society, represents his earliest known work. The confusion of figures it includes is difficult to sort out and may represent a compilation of occurrences over time, here compressed into a single image, rather than a large-scale encounter, but it clearly consists of groups of figures arrayed against each other rather than scenes of individual encounters. The other large, integrated scene is a muslin at the Southwest Museum, which was probably produced in the 1890s. It is captioned as representing "Custer's Fight on the Washita with Black Kettle & Cheyennes."[5] The picture shows U.S. Army troops attacking a tipi camp, in which a woman has been killed. A group of defenders has taken refuge behind a small breastwork, represented as usual by a heavy encircling line, while five others are on horseback, one carrying the Padogai shield passed down in Silver Horn's family. Hoof prints show that they have ridden close before the line of the attacking enemy to draw their fire, and one has been shot from his horse. The scene is more organized than the Evans muslin, and specific deeds of glory are more easily discerned; but, like it, the picture is an overview of an engagement rather than a collection of individual coups. There is no ready explanation as to why Silver Horn departed in these two works from the norm of viewing warfare in individualized terms, but they demonstrate his willingness to experiment with new forms.

A Changing Picture of War

While many of Silver Horn's pictures are quite detailed, in others the figures are surprisingly vague and cannot be identified even broadly. In these pictures, shields and other medicine items, the basic elements of Kiowa portraiture, are either too nondescript to be useful or do not correspond to any known Kiowa design. Captions accompanying several works offer some insight into the nature of this change in representation. Three different sets of drawings contain pictures of a warrior with a shield captioned as White Horse (Tsentainte). White Horse's original shield has been preserved at the Smithsonian, as have photographs and models of it (Merrill et al. 1997:98–102, 215, 316), allowing a comparison of the drawings

with the original. In two instances, the drawings represent a significantly abbreviated version of the actual shield, reduced to the point that the drawing alludes to the design more than it represents it (plate 15). The connection would probably have been missed without the guidance of the caption. In the third drawing (fig. 4.5), the design bears no resemblance to White Horse's shield, but the man wears a horned headdress, which was another component of the famous warrior's medicine. These subtle allusions suggest that Silver Horn was at times depicting real people and actual coup events, but was intentionally obscuring the

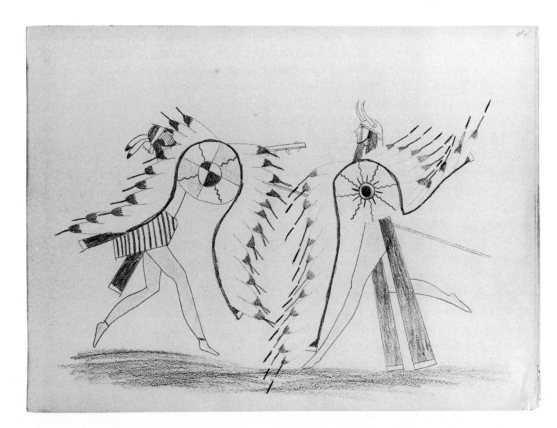

4.5. "White Horse killing Ute," as captioned by D. P. Brown.
White Horse, on the right, carries a shield that bears no resemblance to his famous Cow Shield (see fig. 1.9), but he wears the horned headdress that was also part of his war medicine.
#64.9. Courtesy of the Nelson-Atkins Museum of Art, Kansas City, Missouri. Gift of Mr. and Mrs. Dudley C. Brown.

identity of the figures. Such subtlety would be of no advantage to a warrior employing Silver Horn's skills to advertise his achievements, the classic role of Plains art. It would, however, be entirely appropriate if Silver Horn were working alone without the warrior's participation, using the story of a man's deed as the inspiration for a drawing, but not wishing to depict it in recognizable form without his authorization. In these pictures, Silver Horn had moved one step away from the traditional role of Plains art. He was illustrating real events, but without the involvement of the participants. The connection between the person and the event depicted was weakening.

Other pictures of warfare are even more obscure. Shields are shown as plain disks or are adorned with decorative patterns outside the basic corpus of Kiowa iconography. Clothing and accouterments are undistinguished; warrior and enemy are nearly indistinguishable; weapons and even deeds have a repetitive sameness (fig. 4.6). The scenes are often formulaic, and the image of a Kiowa warrior running an enemy through with a lance is repeated over and over, varying only in details of posture and clothing. Many of these drawings are captioned as pictures of combat with Sioux, Cheyenne, or Osage enemies, tribes with which the Kiowas had been at peace for decades. I believe that the identifications are reliable and that these pictures represent events of some historical depth. The warriors shown were probably long dead when Silver Horn made the pictures, and the stories of their deeds had been transformed over time from detailed accounts of personal achievement to more general tales of tribal history. The actors are truly anonymous rather than obscured. Silver Horn was illustrating events, not people—or perhaps the generalized remembrance of a type of event. While the drawings retain the outward form of coup pictures, their significance is different. In these pictures, Silver Horn has moved from the personal representation, "he did this," to the tribal statement, "we did this."

During the same period when Silver Horn was producing these new, more generalized images of two figures locked in timeless combat, he continued making other quite detailed pictures of complex war stories. Some are illustrations of stories that have survived to the present day. Twice Silver Horn illustrated White Horse's capture of a Navajo boy, which took place in 1867. According to the story as told by Aytah, White Horse swept past the boy on horseback, grabbing him by the hair and swinging him up behind his saddle "like an eagle snatching a rabbit" (Nye 1962:143). One drawing (fig. 4.7) shows the moment of capture, while another (plate 15) shows the boy riding behind White Horse, who lances a Navajo man. An earlier drawing of the same event by another Kiowa artist, Koba (NAA MS 39C), reveals that White Horse had to strike down several enemies to capture the boy, but it was the capture itself, not considered

a coup in the Kiowa system, that Silver Horn chose to illustrate.[6] The capture of a white child is shown in one other Silver Horn drawing, and the same subject appears in the work of other Kiowa artists, including one that collaborated on the muslin painting now at the Witte Museum. During the reservation period, Kiowa art expanded to include a variety of war stories in addition to strict coup counts. Child capture and other events were now considered suitable for illustration.

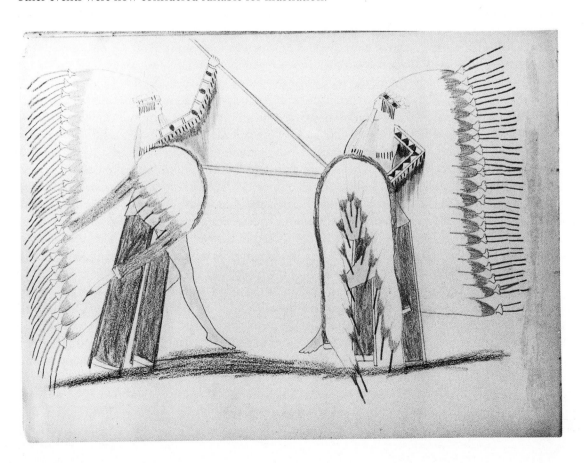

4.6. "Broken Wrist (Kiowa) and Cheyenne fighting—Broken Wrist on the right," as captioned by D. P. Brown. #64.9. Courtesy of the Nelson-Atkins Museum of Art, Kansas City, Missouri. Gift of Mr. and Mrs. Dudley C. Brown.

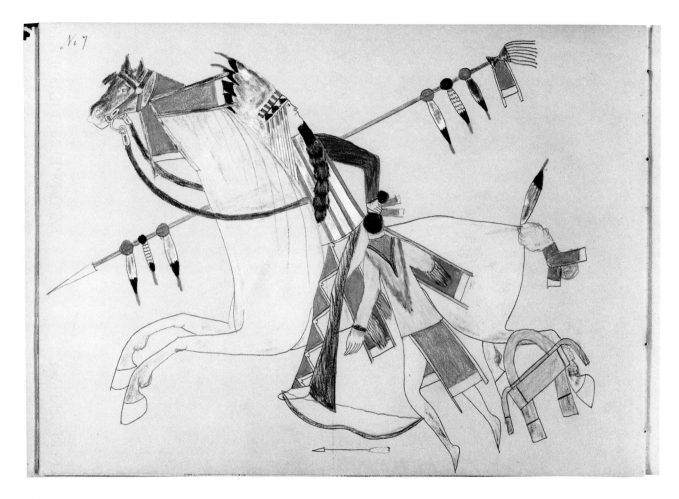

4.7. "White Horse (Kiowa) capturing a Navahoe boy," as captioned by Horace Jones.
The warrior displays none of White Horse's distinctive war medicine, but the scene matches Ay-tah's description of the capture well. See plate 15 for another version of this event.
#1994.429. Courtesy of the Museum of Fine Arts, Boston. Gift of the Grandchildren of Lucretia McIlvain Shoemaker and the M. and M. Karolik Fund.

One of the most tragic events of Kiowa history, the loss of two of the sacred Taime images, is illustrated in another drawing (plate 16). In the summer of 1868, Patadal ("Poor Buffalo"), Silver Horn's mother's brother, organized a revenge raid against the Navajos. He recruited over 200 men, including several Comanche warriors. Among the members of the party were Setdayaite ("Many Bears" or "Heap of Bears"), the son or perhaps nephew of the Taime Keeper, and his adopted son, a Mexican captive. Heap of Bears received permission to bring along two of the Taime images as powerful war medicine, leaving only the largest one at home with the Taime Keeper. Proper care of this medicine entailed a number of prohibitions, and it was discovered that the Comanches of the party had broken some of these taboos. Although many of the Kiowa men foresaw disaster and returned home, it was still a large group that pressed on and encountered a war party of Utes near the present Texas–New Mexico border. The Utes were significantly outnumbered, but they were able to rout the disheartened Kiowas, who knew that their medicine was broken, killing seven. Among those slain were Heap of Bears and his son. The Taime figures were captured, never to be recovered (Mooney 1898:322–24; Nye 1962:116).

Silver Horn's picture of this dramatic moment corresponds in many details to the account obtained by Mooney from Setimkia and Anko, who were present. Heap of Bears fights on foot, armed with bow and arrows. His son, who came to his aid, lies dead at his side. The faces of both men are painted like the Taime itself with a crescent on the brow and wavy lines below each eye. Mooney reported that the Taime was carried in a bag on Heap of Bears' back, but Silver Horn has shown the figure openly displayed upon his chest, with the jackrabbit headband of a Taime priest upon his brow.

Another drawing also shows the Taime carried into battle (fig. 4.8). Here the warrior is naked except for a breechcloth, his whole body painted yellow with the Taime markings upon his chest and face. He wears a scalp hanging upon his back and the exposed Taime figure upon his breast. He, however, successfully defeats an enemy, perhaps a Ute, dressed in an orange capote.

Silver Horn produced a number of illustrations of another aspect of warfare almost unique in Plains art—the torture and mutilation of enemies. Scenes of war almost by definition represent acts of violence, but their depiction is often highly stylized in Plains art. The viewer can recognize splashes of red as indicating wounds or even fatal injuries while still remaining emotionally distanced from the act. Many of Silver Horn's own scenes of warfare maintain this aura of detachment, a cool factual statement of an encounter. Others, however, offer a more involving depiction of the violence of warfare. One image (fig. 4.9) shows two Kiowa warriors lancing a fallen army officer. The subject itself is not an uncommon one, but the

method of portrayal is significantly different. Rather than merely touching the victim, the lance points are clearly shown entering his abdomen. Blood gushes from his wound and from his mouth in standard fashion, but the careful depiction of the facial features contorted in anguish is most unusual. Unlike conventional scenes of coup, attention in this drawing is focused on the violence inflicted on the victim rather than on the achievement of the conquering warrior.

Other drawings represent acts of violence far beyond conventions of striking down and killing enemies. Two show men being tortured, tied to frames and pierced with many arrows. Several others show beheaded and dismembered corpses; in one, the torso has been split open and entrails spill from between exposed ribs. The most gruesome of the images shows a cowboy tied to a stake and being burned alive while

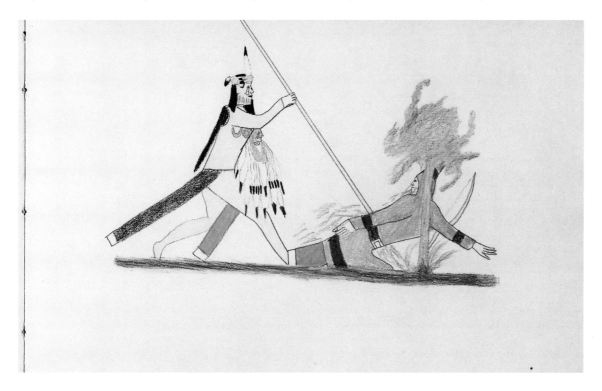

4.8. A warrior who carries the Taime using that powerful medicine to overcome an enemy before he can get to cover behind a tree. #1994.430. Courtesy of the Museum of Fine Arts, Boston. Gift of the Grandchildren of Lucretia McIlvain Shoemaker and the M. and M. Karolik Fund.

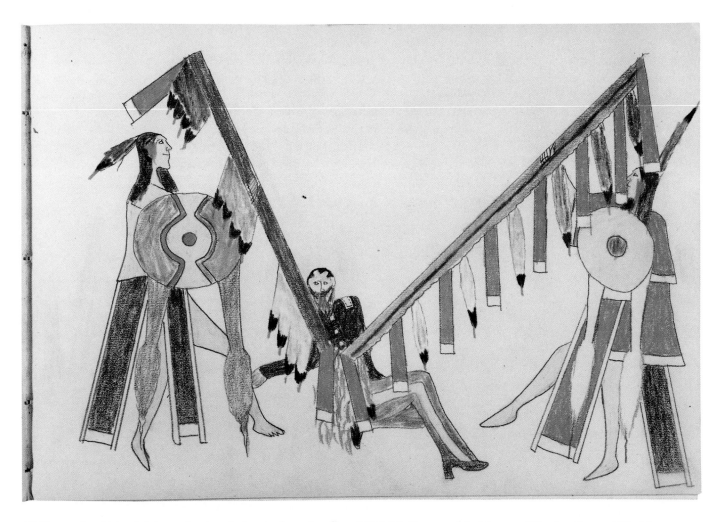

4.9. Two warriors driving their lances deep into the bowels of a cavalry officer. #1994.430. Courtesy of the Museum of Fine Arts, Boston. Gift of the Grandchildren of Lucretia McIlvain Shoemaker and the M. and M. Karolik Fund.

a group of women dances before him, brandishing his scalp on a pole (plate 17). In all of Silver Horn's images of torture and mutilation but one, the victims are white, often identifiable as military men. It would seem that in warfare against U.S. forces the mere killing of an enemy was insufficient revenge for the destruction brought upon the Kiowas.[7]

It has often been said that Southern Plains artists were reluctant after their defeat to depict scenes of warfare against white enemies, at least in images that were made for sale. Such self-censure seems to have been variable, but certainly the graphic depictions of torture and mutilation are not found in the work of other artists. Silver Horn seems to have been unconcerned with the sensitivities of the white audience for whom many of his images were destined. Yet his wide range of images of warfare must have been surprising to a Kiowa audience as well. Images of torture and child capture and defeat were all aspects of warfare that did not appear in the coup-counting system that the art was developed to support. They were new additions to the visual repertoire.

From Personal to Tribal

Pictures of counting coup were the archetype on which Kiowa art was based, and warfare was an important topic for Silver Horn throughout his artistic career. Some of his works carried on the traditional role of art in celebration of the war honors of individual men and were produced as part of a communal activity. The era of active warfare ended before Silver Horn came to adulthood, however, and Kiowa art had already begun to change before he produced his earliest extant drawings. He participated in these changes and, as the most prolific artist of his time, may well have influenced their course.

The prestige and power associated with the coup persisted for many members of Kiowa society long after the end of warfare, but counting coup became something to look back upon rather than an objective that could still be pursued. While individuals treasured their personal achievements, society as a whole esteemed the system of war honors that had been halted so abruptly. During the reservation era, pictures of warfare were transformed from being celebrations of individual deeds to also serving as illustrations of a shared way of life, now ended. While the ownership of particular coups remained vested in the individual who had won them, a sense of ownership of the coup system was widely shared. Silver Horn found ways to serve both of these concepts in his art. He depicted warriors in detail when he felt he had the right to do so, working with the authorization of the warrior or his family (often his own) to celebrate specific

deeds. At other times, he obscured the identity of the participants or reached more deeply into the past for scenes of coups that referenced a time rather than a person to celebrate warfare as a shared endeavor. He and other reservation artists crafted a new mode of representation that took the outward form of traditional coup art, but altered the meaning of the images.

Silver Horn also expanded the illustration of warfare to include a wider range of activities than just the counting of coups, those formally ranked deeds of war. He showed scenes of taking captives, of mutilating hated enemies, and of noble and tragic defeats. All of these were honorable activities, although none were recognized as specific honors. As they were outside the formal system of coup recitation, these war stories circulated more freely than the treasured coup accounts that men held tightly as personal badges

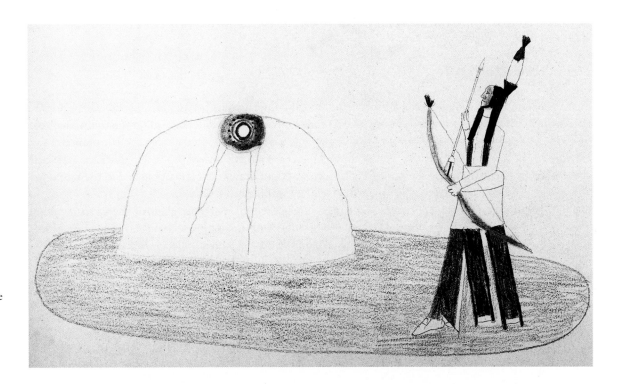

4.10. The Padogai shield of Silver Horn's family placed on top of a sweat lodge to be purified and strengthened for war by the ceremony taking place within. #67,719 (neg. A113240). Courtesy of the Department of Anthropology, Field Museum of Natural History.

of honor. They represented a body of oral tradition from which an artist could draw without seeking permission or giving offense. Together with other artists, Silver Horn also illustrated aspects of war other than combat. He showed meetings of military societies, the Scalp Dance held following a victory, and the purification of the Padogai shield in a sweat lodge ceremony (fig. 4.10). Taken together, his images provide an ethnography of war practices much richer than any series of traditional coup pictures could offer.[8]

The range of ways in which Silver Horn illustrated warfare is indicative of a fundamental shift that was occurring in Kiowa warrior art during the reservation period. The visual tradition had been built upon the system of coup counting and had been concerned with deeds that were personal and biographic. Its purpose was to reflect the glory of the individual. With the end of warfare, art increasingly became oriented toward representation of the tribal and historic. It celebrated the past and was developing ways to treat the past independently of the individuals whose histories constituted it. Warrior art became an illustration of war rather than an integral part of the war system.

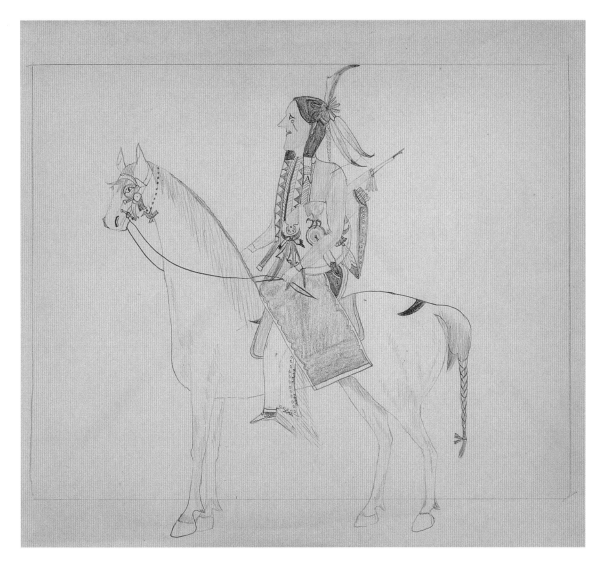

Plate 1. A man carrying the Red Shield, which originated with Akopti ("Timber Mountain"), with his horse painted for war and wearing a small amulet at its neck.
The drawing is in the delicate style of illustration that Silver Horn practiced at the height of his career.
MS 1874. Courtesy of the National Anthropological Archives, Smithsonian Institution.(All illustrations are by Silver Horn unless otherwise noted.)

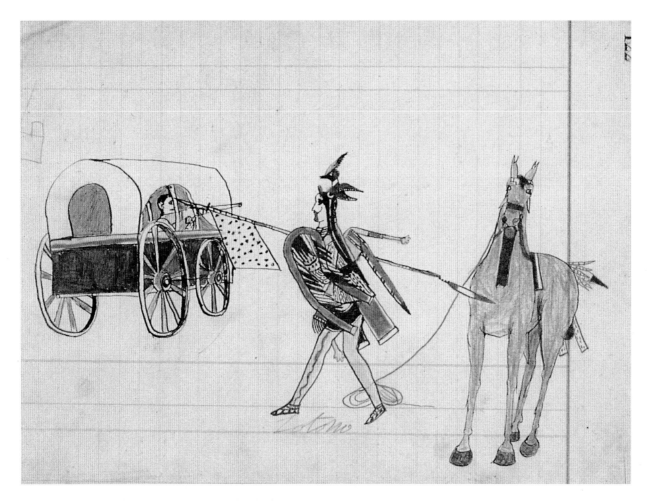

Plate 2. A warrior attacking a white man sheltered in a wagon.
The careful depiction of his war medicine, including his painted shield and the stuffed kingfisher on his head, ensured that Kiowa viewers would recognize him. The scene on ledger paper was drawn by Koba, a Fort Marion prisoner, shortly after he was taken captive in 1875.
MS 39C. Courtesy of the National Anthropological Archives, Smithsonian Institution.

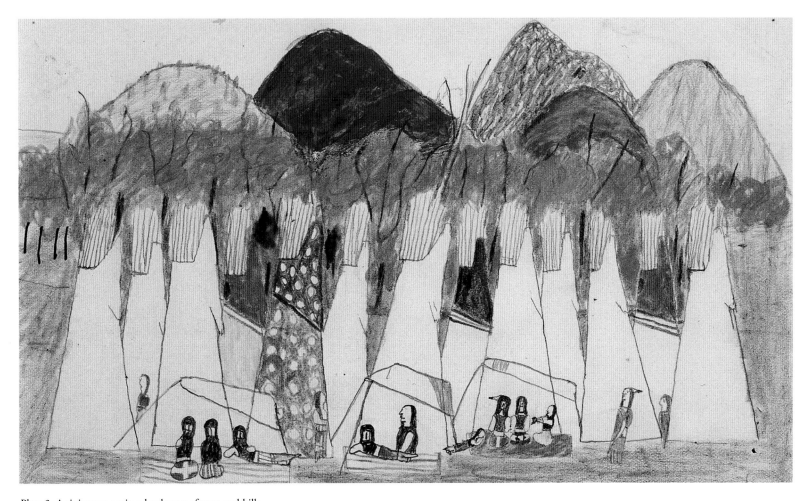

Plate 3. A tipi camp set in a landscape of trees and hills.
Men lounge in the tipis, with their sides rolled up for ventilation on a hot day. Pictures of quiet camp life are unique to the Fort Marion artists and contrast with the scenes of action more typical for Kiowa art.
Drawn by Wohaw, 1875–78. MS 30,747. Courtesy of the National Anthropological Archives, Smithsonian Institution.

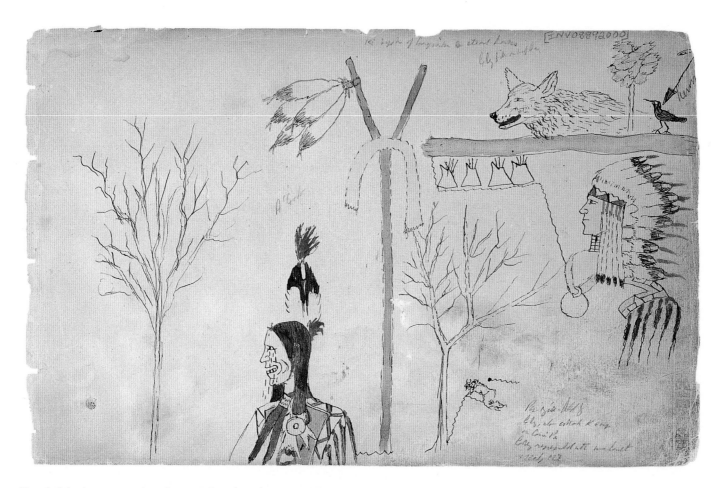

Plate 4. Calendar page covering winter 1836–37 through summer 1838.

No events are shown for the opening winter, marked by a bare tree. The summer of 1837 shows a man weeping, representing the "Wailing Sun Dance." The Kiowas had massacred a Cheyenne war party soon before, but had lost some of their own warriors, whom they mourned. The next winter, Buffalo Calf was killed, as shown by a bullet streaking toward his name glyph. The figure of a leafy tree shows that no Medicine Lodge was held in the summer of 1838. The Cheyennes (shown with feathered bonnet) attacked the Kiowa camp on Wolf Creek. In the same season, Crow Lance went on his first horse-stealing expedition.

MS 2531. Courtesy of the National Anthropological Archives, Smithsonian Institution.

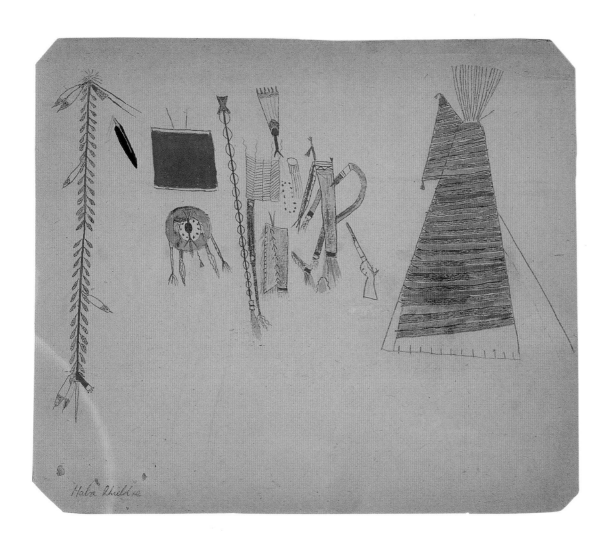

Haba Khebxe

Plate 5. The medicine items hereditary in Silver Horn's family, depicted when they were owned by his brother Haba.
The striped Tipi with Battle Pictures, the Padogai shield, the red war cape, and the feathered lance all appear in various Silver Horn drawings. The artist of this undated work is not recorded, but it may have been made by Haba himself.
MS 1874. Courtesy of the National Anthropological Archives, Smithsonian Institution.

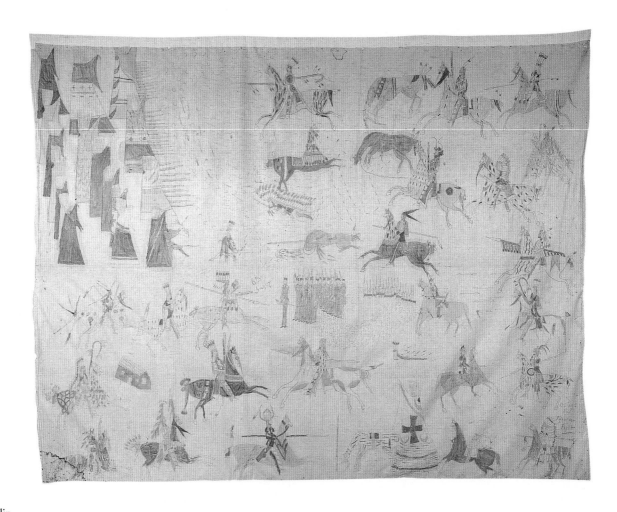

Plate 6. Painting on muslin.

The earliest known work by Silver Horn, this ambitious piece reveals both naive energy and elements of the elegant drawing technique that he would soon master. The events depicted here have not been clearly identified. Cheyenne men who examined the muslin with James Mooney in 1904 suggested that it might represent a battle of 1854 against eastern tribes (perhaps Otoes or Omahas) in which both Cheyennes and Kiowas participated. Details of the muslin are shown in figs. 3.2 and 3.3.

#4396. Courtesy of the Museum, Oklahoma Historical Society.

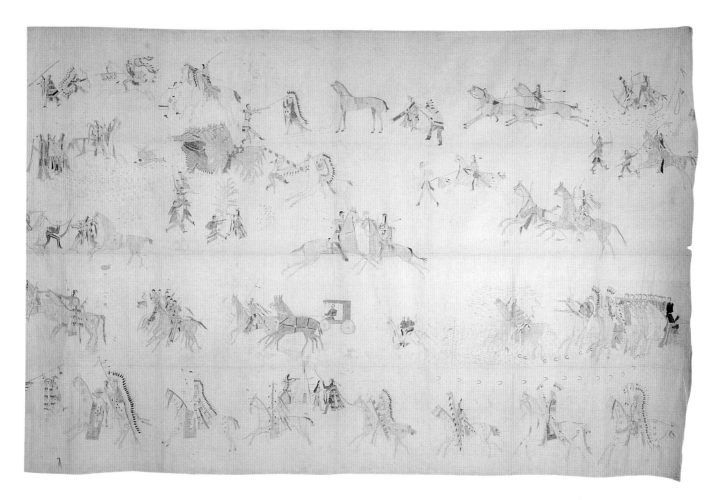

Plate 7. Painting on muslin.
Like many of the earlier hide paintings, this muslin is composed of a series of separate vignettes of war drawn by several artists. In two of the scenes by Silver Horn, warriors carry the Padogai shield, hereditary in the artist's family (see details in figs. 3.4 and 10.2), while another scene may represent the bravery of his great-uncle Tohausen (fig. 4.2).
#68.20.1. Courtesy of the Museum, Oklahoma Historical Society.

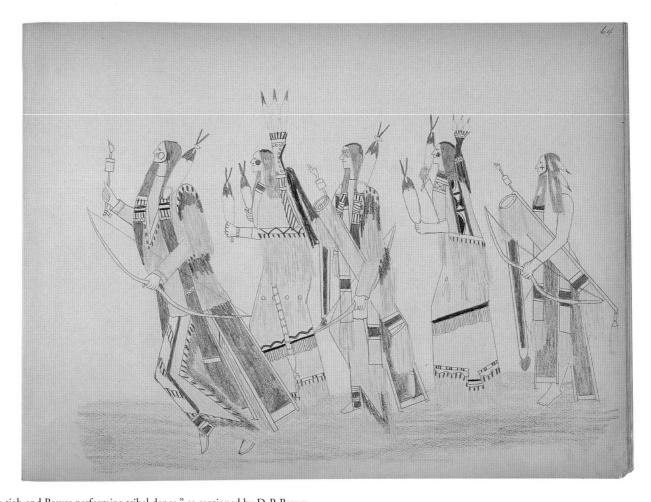

64

Plate 8. "Pau-tigh and Braves performing tribal dance," as captioned by D. P. Brown.
The men carry bows and the women feathers as the dancers move to the rhythm of the rattles that the men hold in their right hands. Silver Horn has depicted the regalia of the dancers precisely, but their identity and its meaning are lost to modern viewers.
#64.9. Courtesy of the Nelson-Atkins Museum of Art, Kansas City, Missouri. Gift of Mr. and Mrs. Dudley C. Brown.

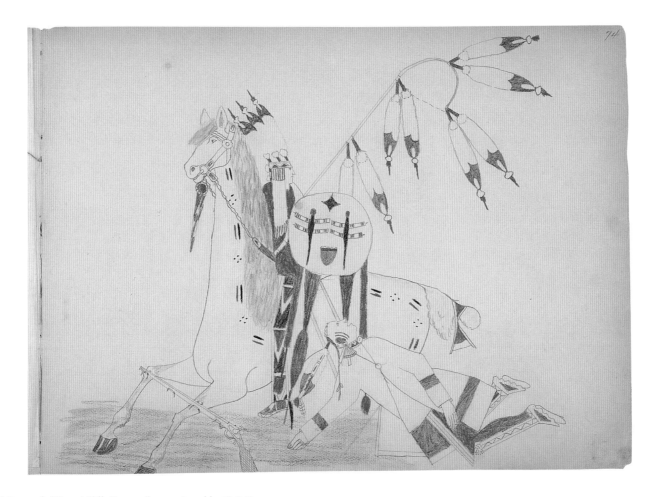

Plate 9. "Mine-yock (Kiowa) Kills Pawnee," as captioned by D. P. Brown.
The warrior riding a painted pony and carrying a crooked lance and a variant of the Dragonfly Shield has ridden down a Pawnee. The long neck of the horse is characteristic of Silver Horn's work from the 1880s.
#64.9. Courtesy of the Nelson-Atkins Museum of Art, Kansas City, Missouri. Gift of Mr. and Mrs. Dudley C. Brown.

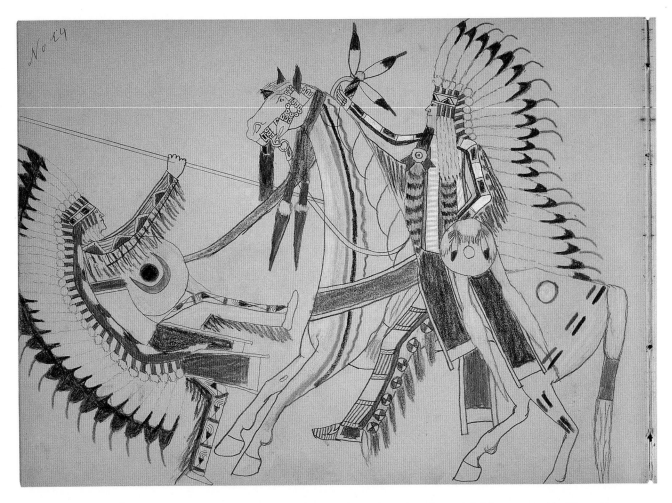

Plate 10. "The once famous Black Eagle (Ko-et-ti-kone-ke) of the Kiowas in deadly conflict with the Ute chief—Ute killed," as captioned by Horace Jones. *Black Eagle strikes his fallen enemy with a saber to count coup. Silver Horn's drawings from the late 1880s are boldly drawn and often intensely colored.* #1994.429. Courtesy of the Museum of Fine Arts, Boston. Gift of the Grandchildren of Lucretia McIlvain Shoemaker and the M. and M. Karolik Fund.

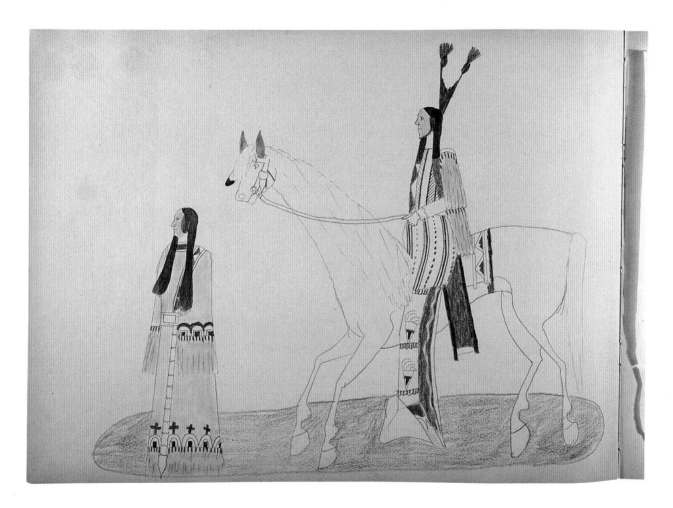

Plate 11. Courting scene with an elegantly clad man on horseback approaching an equally well dressed lady.
Silver Horn lavished great attention in scenes of courting on items of personal adornment, from beaded dresses to appliquéd saddle blankets.
#67,719 (neg. A113238). Courtesy of the Department of Anthropology, Field Museum of Natural History.

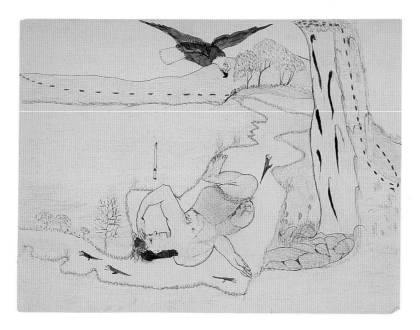

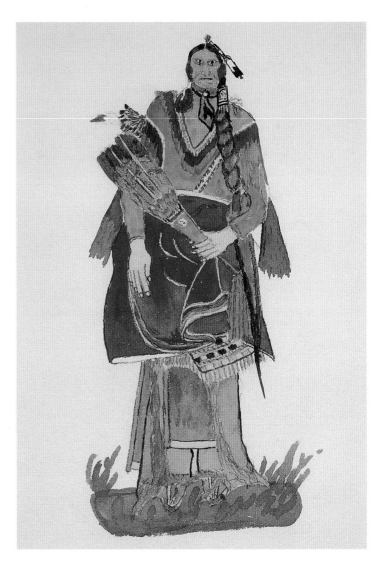

Plate 12. Scene from the story "Saynday and the White Eagle."
Saynday, the Kiowa trickster, abused the eagle's magical gift and lost his power to dive through the ice. Silver Horn has drawn Saynday as a fully three-dimensional figure, the most naturalistic pose and musculature he ever attempted. He has placed the figure within a landscape with a horizon line in the distance, but retained the old narrative convention of a dashed line of footprints to carry elements of the story. This picture contrasts dramatically with another illustration of the same story produced in a traditional style (fig. 6.11).
Gift of Mr. and Mrs. Charles Diker. Courtesy of the Museum of Indian Arts and Culture/Laboratory of Anthropology, Museum of New Mexico.

Plate 13. Full-length frontal portrait of a man, identified by Hugh Scott as a self-portrait of the artist.
Following conventions of Plains portraiture, his clothing is carefully represented, including the fan and bunch of red flicker feathers on one sleeve, which mark him as a Peyote man. Western concepts of portraiture are evident in greater concern with details of facial features.
#101. Courtesy of the Newberry Library, E. E. Ayer Collection.

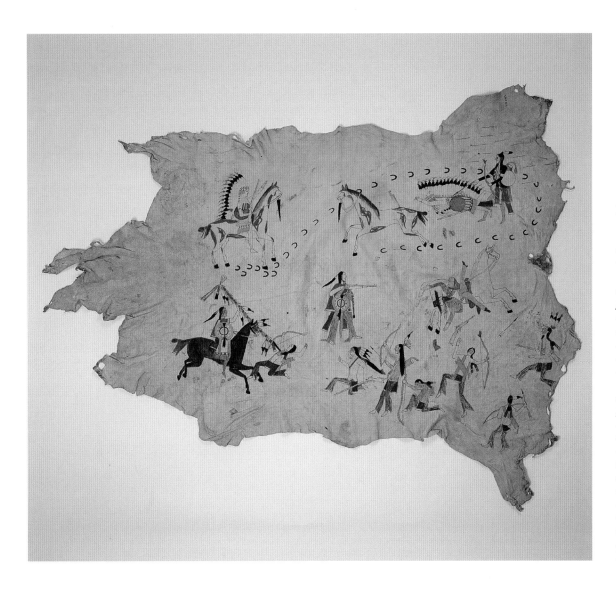

Plate 14. "Haba Buckskin Painting (drawn by Hangun), S[eptember] 28—1904," as captioned by Mooney in his detailed interpretation of the scenes on this hide (Mooney MS 2531, 2:52–53). *The lower row illustrates a fight in 1866 against the Navajos in which Silver Horn's father, Agiati, carrying the Padogai shield, counted coup seven times, killing the first enemy with his feathered lance. In the center, Silver Horn's brother Haba carries the same shield and wears a red war cape during a fight in 1872, in which he shot a Texan from his horse. The upper scene is a story often told by Big Bow, which was also painted on the Tipi with Battle Pictures. An Indian scout, probably a Ute, rode out in advance of a party of soldiers in challenge to the Kiowas. Big Bow went out on foot to meet him. The Ute charged, as shown by the hoof prints, and fired his rifle, but the shot missed. Big Bow brought him down with a single arrow, which he is shown jerking out of the fallen body.* #233,092. Courtesy of the Department of Anthropology, National Museum of Natural History, Smithsonian Institution.

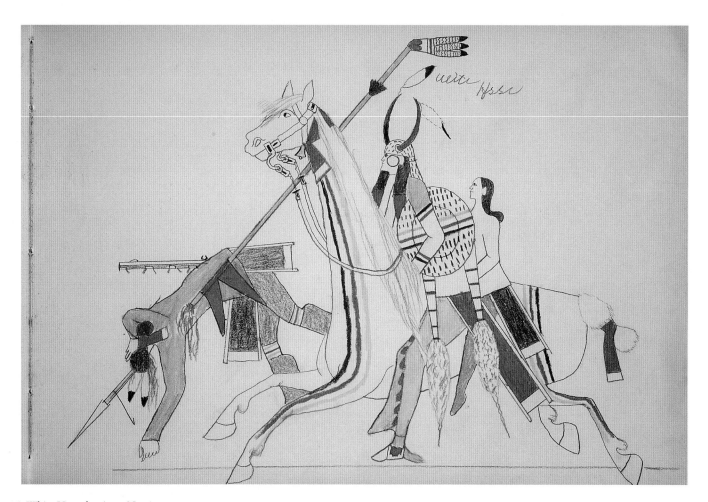

Plate 15. White Horse lancing a Navajo enemy.
The young Navajo boy that he has captured is mounted behind him. (See fig. 4.7 for another version of this episode.) The shield bears little resemblance to his famous Cow Shield, but his split horn headdress is distinctive (see fig. 1.9). White Horse's authorization for Silver Horn to make this drawing is attested by his signature, roughly inscribed above the image. He had learned to write his name while a prisoner at Fort Marion in the 1870s.
#1994.430. Courtesy of the Museum of Fine Arts, Boston. Gift of the Grandchildren of Lucretia McIlvain Shoemaker and the M. and M. Karolik Fund.

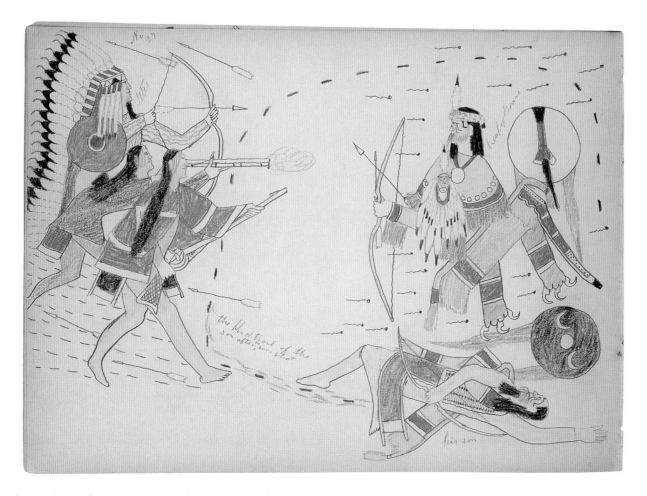

Plate 16. "Saip-kogo or 'Heap of Bears,' a great Kiowa brave in battle with Utes in which he was killed," as captioned by Horace Jones.
"This event occurred about 17 years ago. His son who came to his father's assistance was also killed," according to Jones. The sacred Taime figure that Heap of Bears wears on his chest was captured and never returned. The bravery and fidelity of the son, an adopted captive, are demonstrated by the foot marks showing where he circled back to aid his father, meeting his death in the effort.
#1994.429. Courtesy of the Museum of Fine Arts, Boston. Gift of the Grandchildren of Lucretia McIlvain Shoemaker and the M. and M. Karolik Fund.

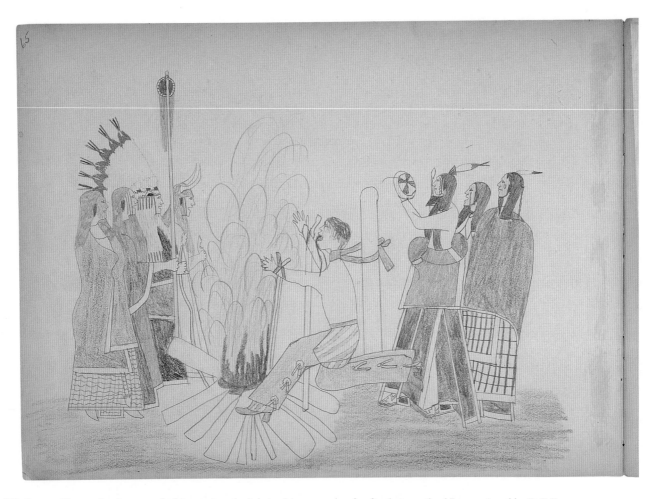

Plate 17. "Big Bow and braves dancing around white captive who is being burnt to stake after first being scalped," as captioned by D. P. Brown.
These dancers are not men but women, some wearing their men's war headdresses, who celebrate a victory to the accompaniment of a single male drummer and the screams of the prisoner.
#64.9. Courtesy of the the Nelson-Atkins Museum of Art, Kansas City, Missouri. Gift of Mr. and Mrs. Dudley C. Brown.

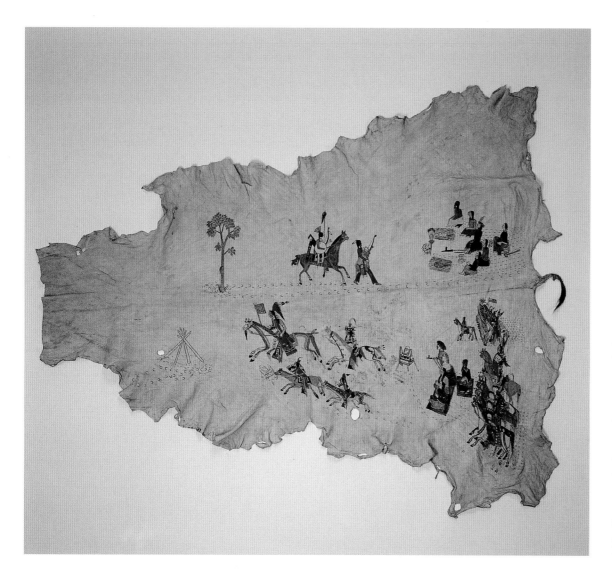

Plate 18. "The Sun Dance—Smoking to the Medicine," as captioned by James Mooney.

This is the first of a series of hide paintings showing preparations for the Sun Dance or Medicine Lodge ceremony. In the lower register, the Taime Keeper smokes his sacred pipe in preparation for removing the Taime from its painted case. To his right is the assistant Mokeen, a Mexican captive who assisted the last four Keepers in their ritual duties. In the upper register, a warrior carrying a scalp on a pole approaches the Taime Keeper to announce that he has counted coup on the cottonwood tree selected to become the center pole of the Medicine Lodge. The Taime stands upright before the Keeper, who has donned a headdress of jackrabbit skin. Behind him is seated the woman, also a captive, who will cut down the tree.

#229,894. Courtesy of the Department of Anthropology, National Museum of Natural History, Smithsonian Institution.

Plate 19. "The Sham Battle," as captioned by James Mooney.

This hide shows the mock battle staged to capture the tree selected for the center pole of the Medicine Lodge. Men join the women who will bring it to camp in constructing a breastwork around the base of the tree. Other warriors armed with shields and coup sticks of leafy willow branches stage a high-spirited attack upon their position. Silver Horn shows women as well as men joining in the playful attack.
#229,895. Courtesy of the Department of Anthropology, National Museum of Natural History, Smithsonian Institution.

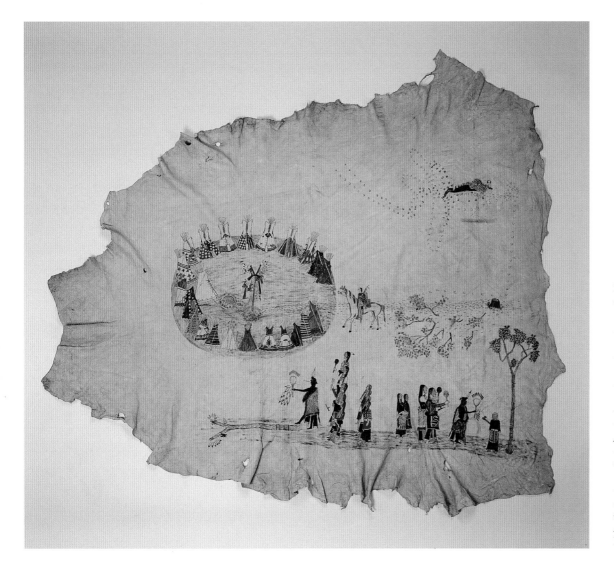

Plate 20. "The Camp Circle—Measuring the Pole," as captioned by James Mooney. *The events shown on this hide begin in the lower right, where the captive woman cuts the tree under the supervision of the Taime Keeper, who holds up a fan. Behind him, two priests hold the Taime rattles. At the left, the Taime Keeper measures the pole. The center of the hide shows the pole already erected in the center of the camp circle amid the painted tipis of prominent people. The unpainted tipi within the circle is the Taime Keeper's lodge. The rider approaching the circle has killed a buffalo (upper right) to procure the sacrificial strip of hide used to make the buffalo effigy for the forks of the center pole.* #229,901. Courtesy of the Department of Anthropology, National Museum of Natural History, Smithsonian Institution.

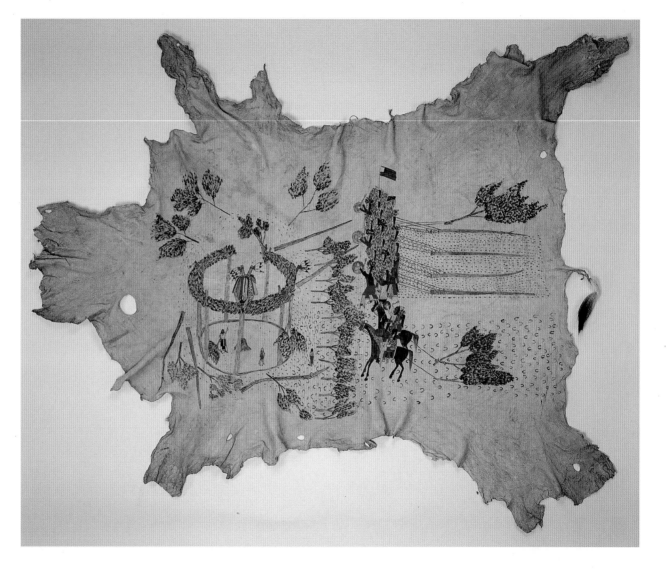

Plate 21. "Building the Medicine Lodge," as captioned by James Mooney. *In this hide, Silver Horn has shifted to a closer view of the Medicine Lodge. With the center pole and four corner posts in place, women bring in additional uprights and branches to construct the circular enclosure. They are escorted by warriors beating drums, and all are singing. Two couples mounted double on horseback in the foreground represent the many warriors who took young women up behind them and rode double around camp.* #229,896. Courtesy of the Department of Anthropology, National Museum of Natural History, Smithsonian Institution.

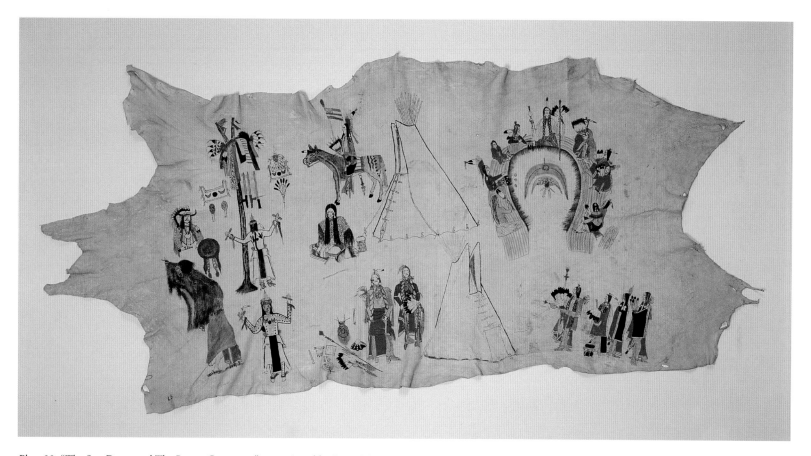

Plate 22. "The Sun Dance and The Peyote Ceremony," as captioned by James Mooney.

The figures on the left represent participants in the Medicine Lodge ceremony—a buffalo impersonator concealed beneath a hide and two Taime priests, one in frontal view and the other standing before the center pole, which is flanked by the ritual equipment of the ceremony, including the Taime itself. An old warrior with horned headdress and shield looks on. The remaining pictures relate to the Peyote ceremony. At the lower right, four Peyote leaders approach the tipi. Behind it, two leaders are shown again, with their ritual equipment displayed beside them. In the upper center, the Water Woman waits to bring water into the tent at dawn. The scene at upper right, one of the most intimate ever produced by Silver Horn, shows the participants seated around the central fire and the crescent-shaped altar upon which rests the sacred peyote.

#229,897. Courtesy of the Department of Anthropology, National Museum of Natural History, Smithsonian Institution.

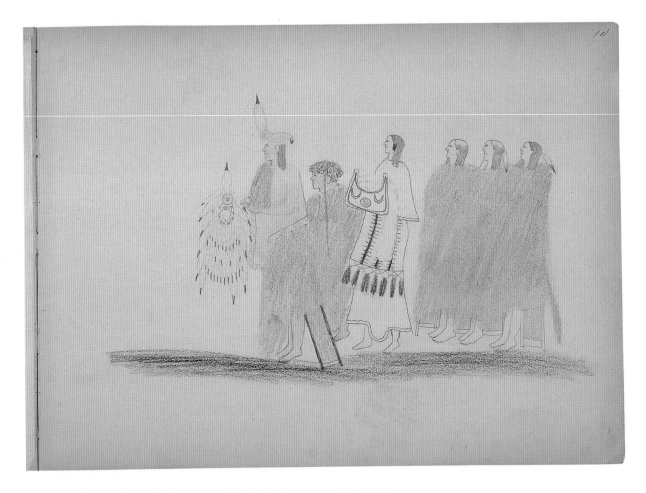

Plate 23. "To-hane-daugh and party carrying 'Medicine' to Medicine Lodge," as captioned by D. P. Brown.
The Taime Keeper, Dohente ("No Moccasins"), carries the sacred image that was exposed to view only during the Medicine Lodge ceremony. His wife carries the rawhide case in which it was always kept. Both Dohente and his assistant Mokeen are painted yellow for the ceremony.
#64.9. Courtesy of the Nelson-Atkins Museum of Art, Kansas City, Missouri. Gift of Mr. and Mrs. Dudley C. Brown.

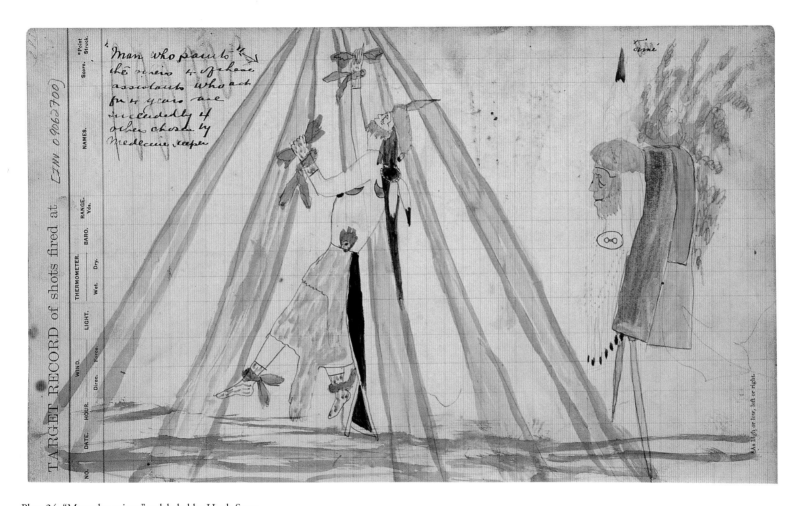

Plate 24. "Man who paints," as labeled by Hugh Scott.
One of the four Taime priests gazes upward, bathed in rays of sunlight filtering through the roof of the Medicine Lodge. His face is painted in likeness of the Taime, which is displayed on a pole behind him, draped with offering cloths. His body is ritually painted, and the scalp of an enemy hangs on his back.
MS 4252. Courtesy of the National Anthropological Archives, Smithsonian Institution.

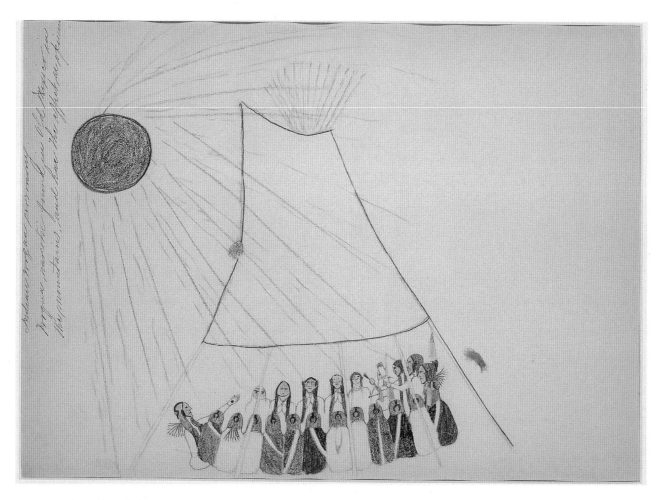

Plate 25. A Peyote tipi, with its sides rolled up to reveal the worshipers inside seated around the crescent altar.
The Road Man sits at the right, holding the rattle and fan.
Silberman Collection, #96.27.831. Courtesy of the National Cowboy and Western Heritage Museum, Oklahoma City.

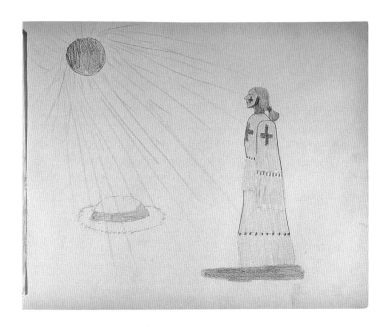

Plate 26. A Peyote woman, her face and dress painted with stars, standing before an oversized peyote button, the vegetal representative of the Sun. *Both she and the peyote are bathed in blessing rays emanating from the green disk of the Sun.*
#67,719 (neg. A113198). Courtesy of the Department of Anthropology, Field Museum of Natural History.

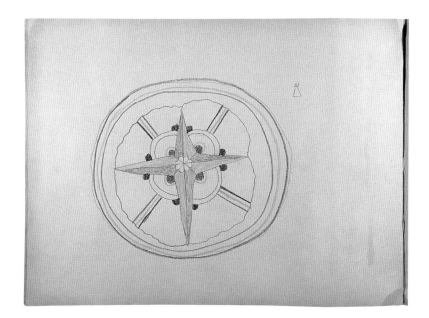

Plate 27. Graphic representation of a Peyote vision experienced by Silver Horn. *The bright colors and flaring patterns are characteristic of Peyote visions. Here they resemble the cross of the Morning Star, which appears in other Peyote scenes, as well as the rainbow that Silver Horn used in scenes of the Medicine Lodge and the Ghost Dance.*
#67,719 (neg. A113207). Courtesy of the Department of Anthropology, Field Museum of Natural History.

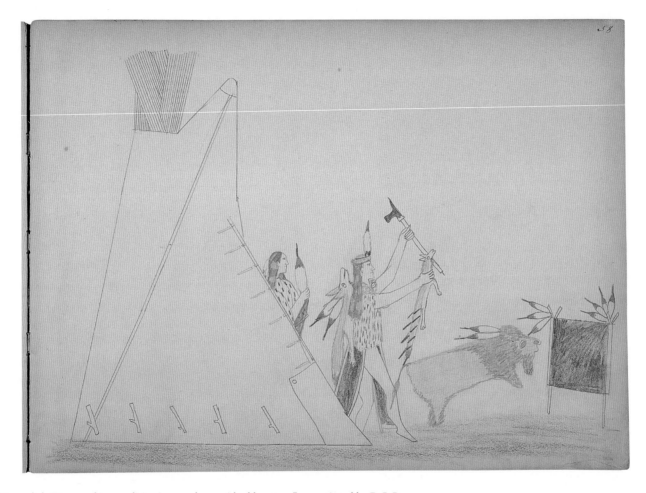

Plate 28. "Tau-ta-kah Kiowa making medicine in accordance with old custom," as captioned by D. P. Brown.
Datekan (later known as Patepte) performs the Buffalo Returning Ceremony, a revitalistic movement he initiated to bring the vanished herds back to earth. He wears a cloak with blue beads and has a wolf skin on his back and a fox skin in his hand. A buffalo hide on a wooden frame is placed before the red blanket stretched on poles, behind which Patepte made medicine.
#64.9. Courtesy of the Nelson-Atkins Museum of Art, Kansas City, Missouri. Gift of Mr. and Mrs. Dudley C. Brown.

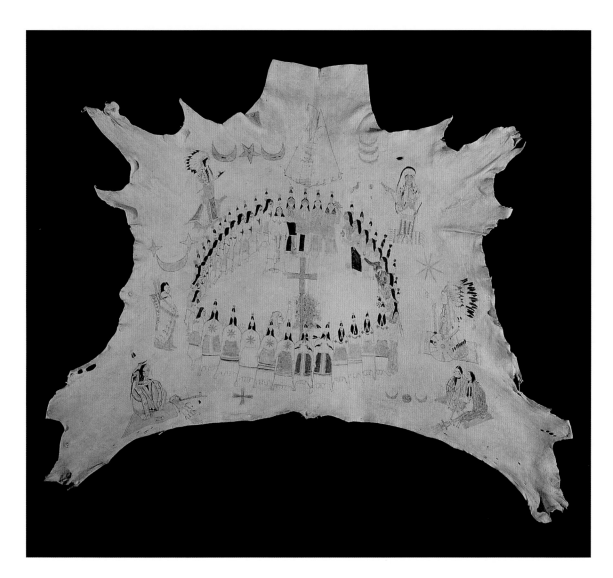

Plate 29. The Ghost Dance, or Feather Dance, as performed in the early years of the twentieth century.
Participants are gathered in a circle around the leader, who stands next to a cross and cedar tree, one hand pointing upward. The men have cloth shirts, but the women wear buckskin dresses painted with celestial motifs that are repeated around the edge of the hide. The dancers wear upright feathers in their hair, a central symbol of the Kiowa version of the intertribal Ghost Dance. #77-188. Courtesy of the Haffenreffer Museum of Anthropology, Brown University.

Plate 30. An illustration from "Saynday and the Cheet Bird."
Saynday, a classic trickster figure, escapes from the mountain ogre Sapoul by imitating the call of a bird that the ogre fears. Silver Horn effectively used watercolor to depict the ogre's shaggy coat and the bag in which he carries off his victims.
MS 4252. Courtesy of the National Anthropological Archives, Smithsonian Institution.

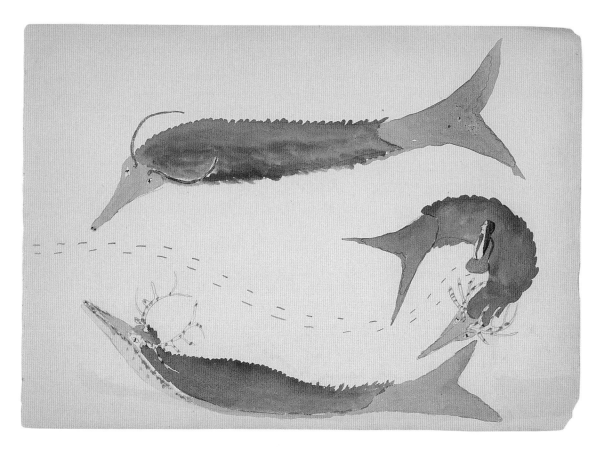

Plate 31. An illustration from "The Girl Who Married Big Mouth," showing her in the underwater home to which her new husband has taken her.
He and his parents are revealed there as underwater monsters with antlers on their heads and fish-like bodies covered with hair.
Gift of Mr. and Mrs. Charles Diker. Courtesy of the Museum of Indian Arts and Culture/Laboratory of Anthropology, Museum of New Mexico.

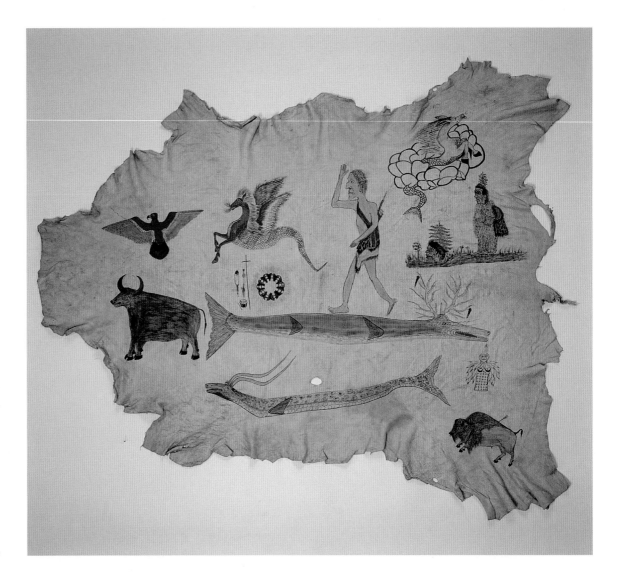

Plate 32. "The Kiowa Pantheon," as captioned by James Mooney.

On this hide, Silver Horn assembled figures from a number of stories set in mythic time, including versions of the whirlwind Red Horse, the trickster Saynday, the cannibal ogre Sapoul, the Thunderbird, and the water monster Zemaguani. He refused to include the Taime in this assemblage, but did show another sacred image, the Old Woman under the Cliff, which had been lost some years before.

#229,900. Courtesy of the Department of Anthropology, National Museum of Natural History, Smithsonian Institution.

Plate 33. Page from pictorial calendar covering summer 1832 through summer 1835.

During the first summer, the Medicine Lodge ceremony, indicated by the forked center pole, was held on Wolf Creek. The following year was the "Summer They Cut Off Their Heads," when a Kiowa village was massacred by the Osages, who beheaded the dead and carried off the sacred Taime, shown shrouded in feathers. The winter of 1833–34 was known throughout the Plains as the "Winter the Stars Fell," due to a brilliant meteor shower. The next summer shown is the "Cat-tail Rush Sun Dance," which Mooney placed in 1835. Silver Horn's calendar skips events for 1834 that were recorded on other Kiowa calendars.

MS 2531. Courtesy of the National Anthropological Archives, Smithsonian Institution.

Plate 34. Calendar page covering summer 1854 through winter 1854–55.
The picture indicates that the Medicine Lodge was held at Timber Mountain. Notable events that year were White Bear's taking up of the famous arrow lance to which his name glyph is connected and the gift of the Pipe Dance, shown by a decorated pipe stem, from another tribe. In the winter, beneath the symbol of a bare tree, the warrior Likes Enemies was killed by an Alaho (a Prairie tribe) shooting from cover. Paired cradleboards represent the birth of Silver Horn's twin brothers, White Buffalo and Oheltoint. Aisai's wife was also born near the same time.
MS 2531. Courtesy of the National Anthropological Archives, Smithsonian Institution.

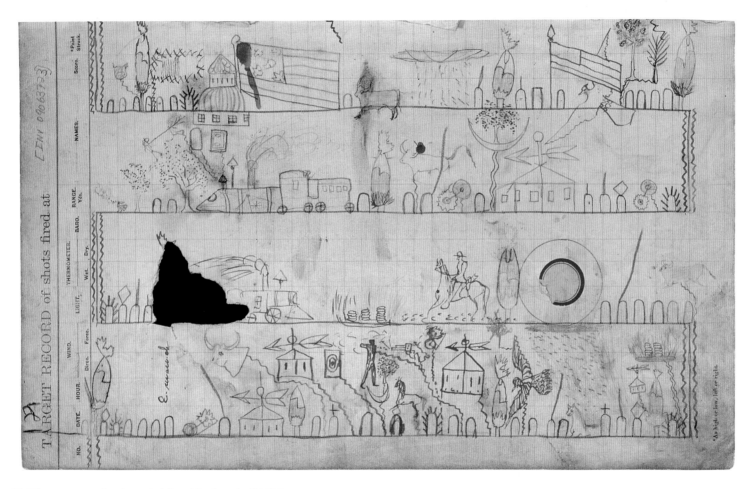

Plate 35. Diary page covering the period from March to April 1894.

During this time, a delegation of Kiowas, Comanches, and Apaches traveled to Washington, D.C., together with Lt. Hugh Scott to protest the Jerome Agreement, by which their lands would be opened to allotment. The U.S. Capitol appears on the top line. The train trip home is marked on the second and third lines, partially obscured by a hole torn in the paper. Stacks of coins surrounded by green shoots represent "grass money," payment received for leasing grazing land to cattle ranchers.

MS 4252. Courtesy of the National Anthropological Archives, Smithsonian Institution.

Plate 36. Miniature shield models painted on buckskin: *Upper left:* the Dragonfly Shield carried by Paakanti and Tenebatai. *Upper right:* the shield hereditary in Silver Horn's family, which originated with Padogai around 1830 and was carried by Tohausen, Agiati, and Haba. *Lower left:* shield representing a medicine spirit holding a pipe and wearing a cedar tree upon his head, carried by Tonkan and Yiagyaipanti. *Lower right:* the red shield originating with Akopti in 1862, which was dedicated to the Taime and incorporated into the Medicine Lodge ceremony. #229,848; 229,853; 229,861; 229,833. Courtesy of the Department of Anthropology, National Museum of Natural History, Smithsonian Institution.

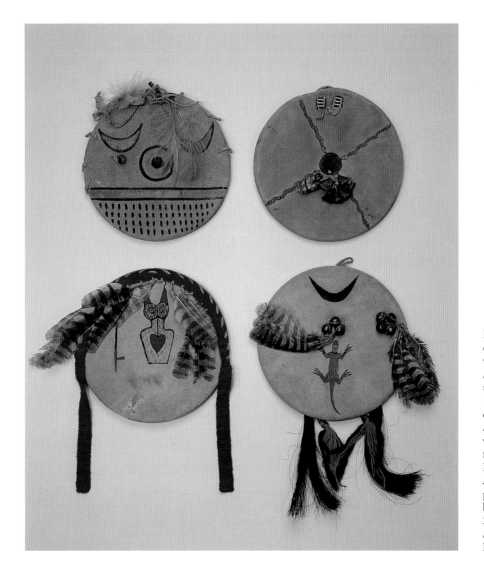

Plate 37. Miniature shield models painted on buckskin: *Upper left:* the Taime Shield, which originated ca. 1835 with Ansogiani, the Taime Keeper. *Upper right:* the Snake Shield, which was used ca. 1840–58 and has a rattlesnake rattle and deer dewclaws tied to the center. *Lower left:* the Owl Shield, which originated with Mamante, a powerful and much-feared medicine man. *Lower right:* the Lizard Shield, hereditary among the Apache allies of the Kiowas, who held a place in the camp circle as an affiliated band. #229,828; 229,863; 229,847; 229,881. Courtesy of the Department of Anthropology, National Museum of Natural History, Smithsonian Institution.

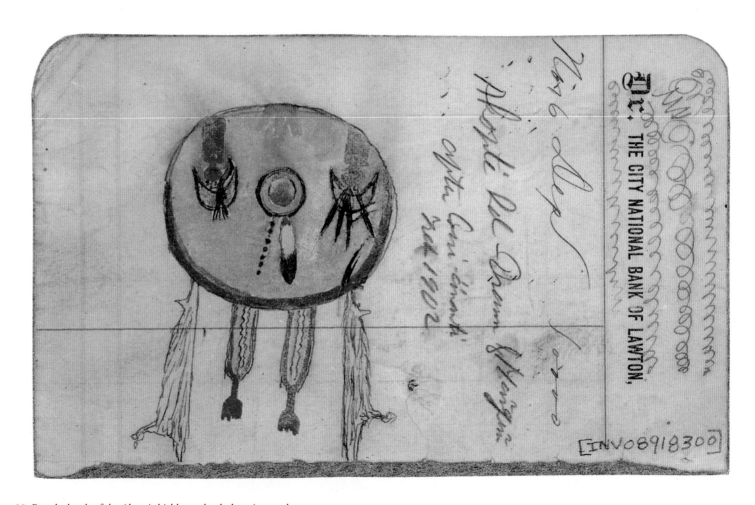

Plate 38. Rough sketch of the Akopti shield on a bank deposit record.
Inscribed "Drawn by Hangun" and dated February 1902, this is the earliest dated sample of Silver Horn's work for James Mooney.
MS 2538. Courtesy of the National Anthropological Archives, Smithsonian Institution.

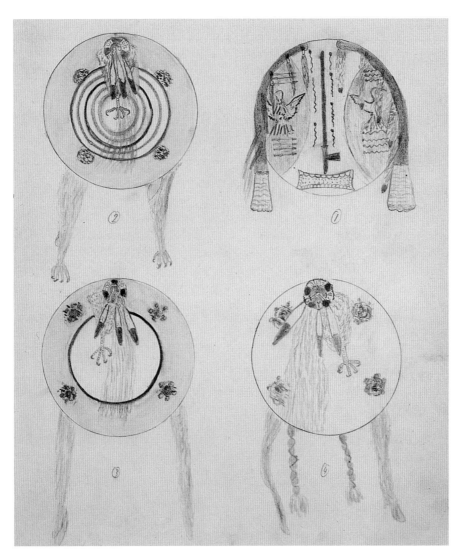

Plate 39. Illustration of four variants of the Bird Shield, with the inner cover shown in the upper right.
This is part of a book of drawings prepared by Silver Horn to provide color plates to accompany Mooney's publication on Kiowa heraldry, a project that was never completed. The book contains twenty-eight drawings showing eighty-two shield designs, grouped according to type.
MS 2531. Courtesy of the National Anthropological Archives, Smithsonian Institution.

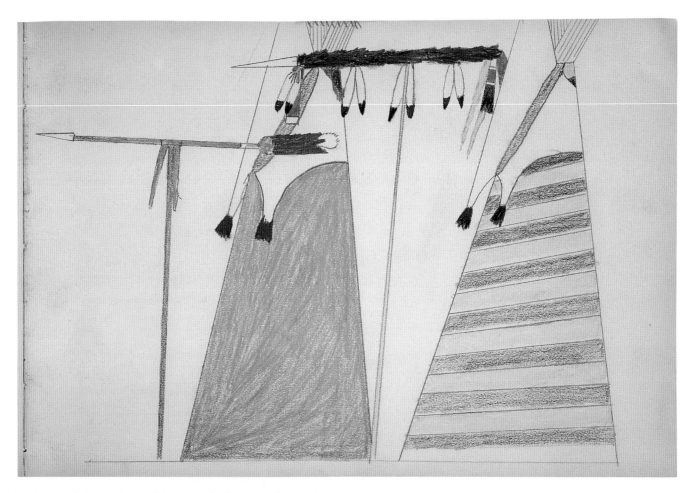

Plate 40. Painted tipis with the war lances of the owners displayed on poles outside.
On the left is the Red Tipi of White Bear, with his arrow-shaped lance or zebat. *On the right is the striped Tipi with Battle Pictures of Silver Horn's own family, with its accompanying lance with a feathered shaft.*
#1994.430. Courtesy of the Museum of Fine Arts, Boston. Gift of the Grandchildren of Lucretia McIlvain Shoemaker and the M. and M. Karolik Fund.

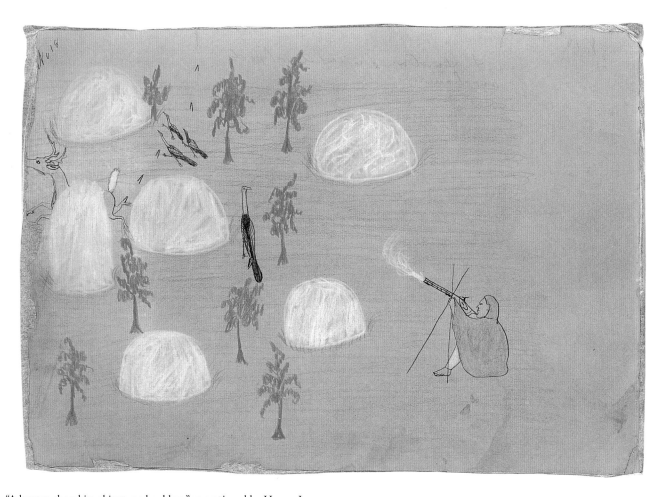

Plate 41. "A hunter: the white objects are boulders," as captioned by Horace Jones.
Silver Horn has placed the hunter in an unusually complex landscape with ground surface, rocks, and trees indicated. All contribute to the story, explaining how he failed to see a fine buck until it was flushed from cover when he fired at a flock of turkeys. The tinted surface of this page from a drawing book allowed Silver Horn to experiment with coloring in light objects rather than representing them by outline alone.
#1962.1. Courtesy of the Collection of the McNay Art Museum. Gift of Mrs. Terrell Bartlett.

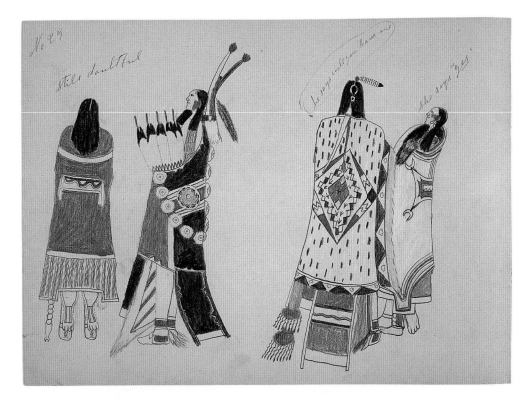

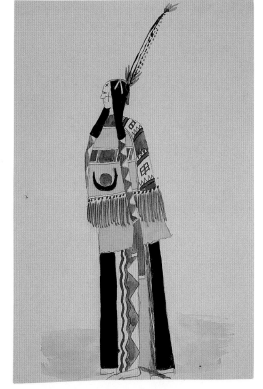

Plate 42. "Calling on the ladies—a courting scene," as captioned by Horace Jones.
Two elegantly dressed couples display the finest of Kiowa fashion. The woman on the right is wrapped in a buffalo robe painted with the border-and-hourglass design, while her suitor wears a Saltillo blanket from Mexico.
#1994.429. Courtesy of the Museum of Fine Arts, Boston. Gift of the Grandchildren of Lucretia McIlvain Shoemaker and the M. and M. Karolik Fund.

Plate 43. Full-length profile portrait of a man in a beaded buckskin cape and ribbon appliqué leggings.
While many of the drawings that Silver Horn produced for E. A. Burbank show innovative postures and facial treatment, others like this one follow established Plains conventions, with a focus on clothing rather than variations in form or features.
#29. Courtesy of the Newberry Library, E. E. Ayer Collection.

Chapter 5

Ceremonial Life, Old and New

The Kiowas are a religious people, and the spiritual world has always been a major source of artistic inspiration. Kiowa religion in the nineteenth century was based on the concept of dwdw or personal power. Power ultimately was derived from a single Creator, sometimes embodied as the Sun, but there were many spiritual intermediaries through which humans could obtain spiritual assistance.[1] The pursuit of power was largely an individual endeavor, but there were also shared religious ceremonies. Much of the religious art of the nineteenth century was based upon visions of the supernatural, but a number of artists also depicted the major tribal religious ceremony, the Medicine Lodge, using the narrative pictorial style developed for scenes of warfare.

The ceremonial life of the Kiowas was changing rapidly in the last decades of the nineteenth century. The Medicine Lodge, or Sun Dance, was discontinued during that time, while new ceremonies arose. The Peyote religion became established among the Kiowas, and Peyote meetings, as the ritual gatherings are called, were held regularly. During this time, a series of revitalistic movements arose, each with its own form of communal performance, the best known of which was the Ghost Dance. All of these spiritual expressions found a place in Silver Horn's art.

Silver Horn was a deeply religious man, and he produced many drawings of the spiritual life of the Kiowas. His illustrations provide a unique source of information about Kiowa ceremonialism, an intimate visual ethnography of a dynamic period in the religious history of the Kiowa people that was produced by an active and knowledgeable participant. His pictures of the Medicine Lodge ceremony are more detailed than those of other artists, and he created the only visual record known of a series of religious movements that emerged during the last decades of the nineteenth century. His art offers a wealth of information about ceremonial practices. His pictures illuminate the underlying belief system that united these new rituals, showing that they built upon existing concepts of the supernatural. Silver Horn did not, however, illustrate all aspects of spiritual life, and the omissions are themselves revealing. His reticence to show the more private, individualized aspects of Kiowa religion suggests that these aspects of religion were not considered appropriate for public representation.

The Medicine Lodge

The major religious ceremony of the Kiowas throughout much of the nineteenth century was the Kado or Medicine Lodge. Often referred to as the Sun Dance, it was held annually in early summer, when the entire tribe gathered together from dispersed camps into one great camp circle. Silver Horn drew many pictures of the Medicine Lodge over the course of his artistic career. His earliest works on paper dating from 1883 depict various aspects of the ceremony, as do his last hide paintings made around 1910.

The Medicine Lodge centered around an object of great religious veneration, the Taime, and the ceremony was led by the Taime Keeper. The Taime, described as a human effigy of stone and buckskin with a painted face and feather cloak, originally came from the Crow Indians of the Northern Plains. The Crows had given this medicine to a visiting Arapaho man, who in turn brought it to the Kiowas when he married into the tribe. The position of Taime Keeper has always been held by a descendant of that family. James Mooney estimated that the Taime came to the Kiowas around 1770. At this time, the Kiowas were moving south and east onto the open plains from their earlier residence in the Rocky Mountains near the headwaters of the Yellowstone River. During the course of this gradual move, the Kiowas must have been consolidating many of the cultural patterns known in the mid-nineteenth century, and the Taime became incorporated into the Medicine Lodge ceremony.

Similar ceremonies were held by other tribes throughout the Plains region, each with its own distinctive features and medicine objects. The Kiowa ceremony bore many features in common with the Sun Dance of other tribes; however, it differed in two principal features in addition to the central role of the Taime. One was that the element of self-torture such as piercing of the flesh, which was so prominent in other tribes, was entirely absent. Indeed, the shedding of any blood during the course of the ceremony was considered inauspicious. The other distinctive feature was that the dance within the Medicine Lodge was preceded by a mock hunt in which participants disguised as buffalo were herded into the lodge.

The last Kiowa Medicine Lodge ceremony was performed in 1887. The Commissioner of Indian Affairs believed that native religions were a hindrance to assimilating Indian people into the dominant American society and directed agency officials to make every effort to suppress their public performance. Under such pressure, the Kiowas' final attempt to hold the ceremony one last time in 1890 was halted by military intervention. Whether celebrating or deploring this action, published sources present this as a story of the imposition of government authority on native religious practice. In oral tradition, however, Kiowa people

assign themselves a more active role in shaping their lives. In the 1890s, Kiowas told Mooney that even before this final persecution the ceremony had been held only irregularly for several years due to the difficulty of finding a buffalo to make an effigy for the center pole (Mooney 1898:349–53). Some one hundred years later, amidst a furor over the possible reintroduction of the Sun Dance, several people told me that the Kiowas had decided that they must end the ceremony, because it no longer served their needs. As Roland Whitehorse described it, Kiowa people "put the ceremony away."

Many aspects of the ceremony are well described in the literature, and the primary events can be summarized from these written sources.[2] Silver Horn's illustrations enlarge upon this record, providing a significant amount of additional information about details of ritual and equipment as well as about the individual participants. Over the course of his life, he produced forty-two pictures of aspects of the Medicine Lodge, which are found in fifteen different sets of drawings.

Silver Horn's most systematic depiction of the preparations for the Medicine Lodge is a beautiful series of hide paintings commissioned by James Mooney (plates 18–21). Once the exact time and location of the Medicine Lodge encampment had been set by the Taime Keeper, the entire tribe assembled and placed itself under his direction. After ritual smoking, the Keeper brought out the Taime, which was exposed to public view only at this time, and rode around camp enjoining all to peaceful conduct. Scouts were then sent out to locate an appropriate tree to serve as the center pole of the lodge. The first hide in the series (plate 18) shows the smoking to the Taime and the scouts returning to report to the Keeper, who sits with his ceremonial equipment laid out before him. The camp next moved near the selected tree, and families and bands placed their tipis in a great circle opening to the east, creating the camp circle within which the Medicine Lodge would be constructed. A spirited sham battle was waged around the selected tree, in which some members of the warrior societies threw up a hasty breastwork and defended it, while others made a mock attack armed with lances and shields of leafy boughs (plate 19). The outcome was foreordained, for the defenders were always routed. A designated official then ceremoniously felled the tree (plate 20). In the last years of the ceremony, this office was held by a captive Mexican woman to ensure that no Kiowas would be subject to bad fortune resulting from any ritual errors (Spier 1921:440; Methvin 1996:64). After the Taime Keeper measured the tree, it was trimmed to size and brought to its designated location in the center of the camp circle. Both the center pole and other timber to construct the leafy lodge were dragged in by men and women riding double on horses amid much celebration (plate 21).

Before the center pole was raised and the circular lodge constructed around it, the buffalo effigy had

to be placed across the forked crotch at the top. The task of securing the hide for the effigy was entrusted to another official, who conducted a ritual hunt for the proper animal, a lone bull, which must be dispatched so as to die without bleeding from the mouth. The last man to carry out this function was Tohausen III or Guitala, a member of Silver Horn's family (Scott 1911:358; Greene 1996a:233). A strip of hide extending from nose to tail was cut from the back of the bull and brought back to camp. After ritual treatment in a sweat lodge, it was wrapped around a bundle of willow branches, tied with cloth offerings, and bound to the center pole of the ceremonial lodge.

This series of hide paintings of the preparations for the Medicine Lodge is one of Silver Horn's finest artistic achievements, but he also made many other drawings of the ceremony. One of the most precisely identified was done over twenty years earlier. It shows the Taime Keeper carrying the exposed Taime, followed by his wife and his assistant Mokeen (plate 23). The caption identifies this Keeper as Dohente ("No Moccasins"), who held office from 1873 to 1875 (Mooney 1898:337, 340). Another picture in the same book shows four women digging holes for the surrounding posts of the Medicine Lodge enclosure, a unique illustration of female participation in the ritual (fig. 5.1). A third picture shows the sweat lodge outside the Taime Keeper's tipi (fig. 5.2). The Taime in its case, wrapped in brightly colored cloths, is tied at the back of the lodge up near the smoke hole.

The Medicine Lodge enclosure was open to the sky, but the upper portions of the encircling wall were filled with a thick layer of leafy branches. The lodge was completed with the placement of a flat stone in the eastern doorway and the construction inside of a leafy screen near the wall opposite the doorway, behind which dancers could retire for rest. Eight shields dedicated to the Taime were hung on this screen, four yellow and four red, and the Taime was placed in front of the screen on a pole. Silver Horn produced several exterior representations of the lodge, one quite realistic, but often with the doorway opening exaggerated to reveal the participants within more clearly. In other instances, a leafy line around the edge of the picture is used to suggest the ritual enclosure, or the center pole alone defines the setting.

Once the lodge was complete, the ritual of "herding the buffalo" was enacted. Men and boys, with at least one woman participant as well, covered themselves in buffalo robes stretched over willow frames and settled down on the prairie near the camp circle in imitation of the animals. A ritual official armed with bow and arrow and carrying a burning brand roused the resting buffalo and drove them toward the Medicine Lodge enclosure, which they circled four times. Another official assisted to draw them into the lodge with the aid of a straight pipe of black stone. The buffalo were calmed and brought to rest inside,

after which their true identity was revealed. Silver Horn loved to depict the antics of the buffalo impersonators, a uniquely Kiowa aspect of the ritual (fig. 5.3). He shows the towering figures of the huge beasts, with shaggy hides, some with ornamented eyes and muzzles, supported on wooden frameworks held up by poles in the imposters' hands. Frequently, the older bison are accompanied by a frisky calf, with a hand emerging from the hide in back to hold the little tail at a jaunty angle.

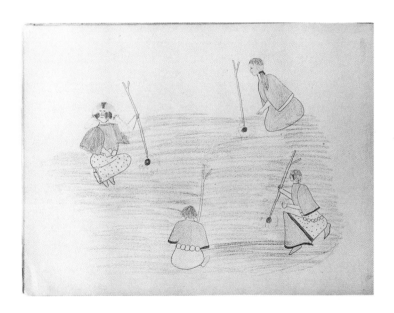

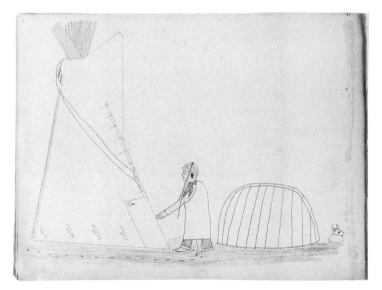

5.1. "Breaking foundation for Kiowa Medicine Lodge," as captioned by D. P. Brown.
Illustrations of women's roles in ritual life are rare.
#64.9. Courtesy of the Nelson-Atkins Museum of Art, Kansas City, Missouri. Gift of Mr. and Mrs. Dudley C. Brown.

5.2. "Lukah (Kiowa) going into Medicine Lodge to make 'medicine' for depredating party of Kiowa preparing to leave," as captioned by D. P. Brown.
The Taime Keeper's assistant Mokeen, also known as Looka, is consistently shown by Silver Horn as short with tightly curled hair.
#64.9. Courtesy of the Nelson-Atkins Museum of Art, Kansas City, Missouri. Gift of Mr. and Mrs. Dudley C. Brown.

Four days of ritual dancing before the Taime followed, led by the Taime Keeper with the assistance of four Taime priests, known as Demguko ("Yellow Breasts"), in reference to the yellow Taime shields each owned. The other dancers were men who had made a vow to the Taime that they would participate in the taxing ritual, in which they danced intermittently for four days without food or water, praying to the sun while blowing on eagle bone whistles. Each category of participant was distinguished by dress and body paint, and Silver Horn provided many detailed images of the Taime Keeper and the Demguko, although only one of a vowed dancer blowing on his eagle bone whistle. Some show these ritual leaders involved in the ceremony, while others are more static images, with figures posed to display their regalia. Perhaps the most dramatic image of a Taime priest shows a figure in profile, with arms upraised and gaze fixed upward

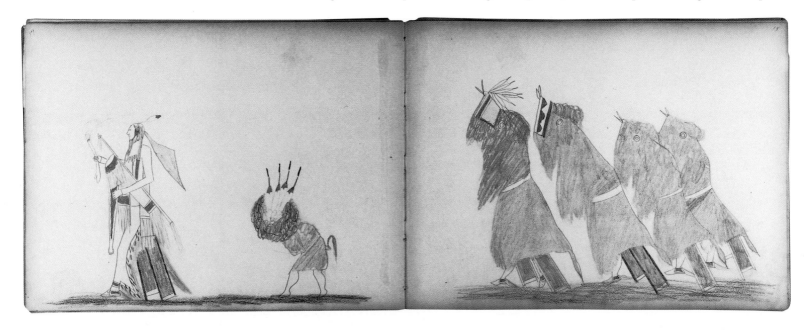

5.3. "Tine-ta and young men dressed to represent buffaloes," as captioned by D. P. Brown.
Buffalo impersonators were a distinctive feature of the Medicine Lodge ceremony of the Kiowas.
#64.9. Courtesy of the Nelson-Atkins Museum of Art, Kansas City, Missouri. Gift of Mr. and Mrs. Dudley C. Brown

toward the unseen sun in whose rays he is bathed (plate 24).[3] Behind him is an oversized representation of the Taime, in whose likeness his own face is painted.

The Medicine Lodge was a topic often revisited by Silver Horn, and changes in his mode of depiction are evident over time. His earlier pictures of the Medicine Lodge are scenes from life, showing ritual participants actively engaged in ceremonial functions. By the late 1890s, his representations of the ceremony are increasingly fragmented into a series of elements positioned for display. The Target Record book, which contains drawings produced between 1891 and 1897, includes images of both types. This raises the question as to whether Scott, who collected the book, was influential in effecting this change. By 1897, Scott was already drafting his paper on the Medicine Lodge (1911:368) and almost certainly commissioned Silver Horn to produce another display-type image of ritual equipment for use in that publication (fig. 5.4). It is not so clear that he influenced the pictures in the Target Book. Most of the leaves of that book must already have been filled with drawings when he first saw it, leaving little room for Silver Horn to have inserted the many Medicine Lodge images that are scattered among its pages. A few might have been made at Scott's request, as they either seem hastily sketched or are placed on pages with writing that the artists usually avoided, but the majority were more likely made without direct outside influence. Among these are images carefully displaying ritual figures and equipment without reference to action.

Many cultural changes were occurring during the period when Silver Horn was shifting his mode of depicting the ceremony. Silver Horn's change in style corresponded closely in time with the change in the ceremony's status, from an active practice in 1887 to defunct in 1890. He shifted from recording moments from a current ceremony to creating a didactic record of past ritual practices. Indeed, his visual fragmentation of the ceremony into a series of separate ritual elements echoed the fragmentation of established Kiowa religion by zealous Christian missionaries and agents.

Yet it was at this same time that Silver Horn produced his most organized, systematic representations of the Medicine Lodge, the hide painting series produced for James Mooney and an earlier muslin with four scenes of the same topic acquired by Hugh L. Scott, now at the Hearst Museum. The Scott muslin lacks specific documentation regarding its production or acquisition, but Scott may have played an active role in guiding its form. There is substantially more information regarding the hides that Silver Horn produced for Mooney. As early as 1894, Mooney had formulated a plan to document Kiowa culture fully. In addition to artifacts, sound recordings, and photographs, he planned "to illustrate their mythology and ceremonial by a full series of aboriginal drawings in colors on a sufficient and uniform scale by the best

artists in the tribe" (Mooney MS 4788). It was not, however, until 1902, with funds to produce an exhibit for the upcoming Louisiana Purchase Exposition, that he was able to pursue this aspect of the project. The artist he hired was Silver Horn, and the ceremony he selected was the Medicine Lodge. Working with paints and buckskins sent by an anthropological colleague in Chicago, Silver Horn produced this set of

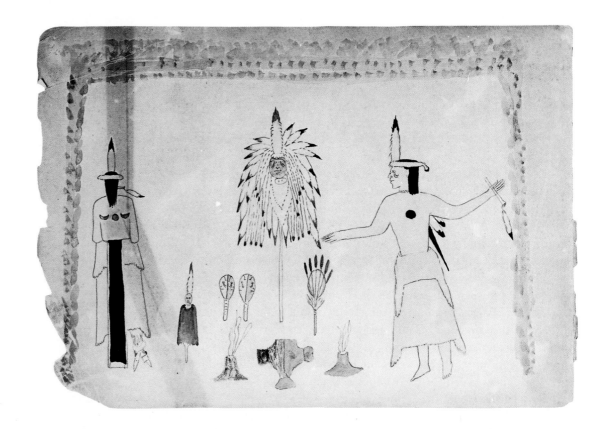

5.4. The Taime Keeper (right) and a Taime priest standing on either side of the feather-draped Taime.
The mottled green band surrounding them suggests the leafy structure of the ceremonial lodge. Scott (1911) published this image with each ritual item labeled in his work on the Medicine Lodge.
Gift of Mr. and Mrs. Charles Diker.
Courtesy of the Museum of Indian Arts and Culture/Laboratory of Anthropology, Museum of New Mexico.

paintings, described by Mooney as "unquestionably the finest specimens of the kind ever secured" (Mooney 1902d). There is no doubt that Mooney was instrumental in defining the form and content of this series, following the plan he had drawn up years before. Preliminary drawings for various figures found in Mooney's papers suggest that Silver Horn sketched the component parts and then worked with Mooney to determine how they should be combined into the larger synthetic whole. Mooney was critical in conceiving and facilitating the project, but he had never seen the Kiowa Medicine Lodge ceremony. Silver Horn must have known it well and had a deep understanding of the significance of each portion of the ritual.

Just as Scott cannot be credited with leading Silver Horn to view the Medicine Lodge in fragmented fashion, neither can Mooney be credited with changing Silver Horn's view to a consistently more integrated one. In addition to the four hide paintings that systematically lay out the preparations for the Medicine Lodge, Silver Horn produced two additional paintings showing both the Medicine Lodge and the emergent Peyote ceremony (fig. 5.5; plate 22). Elements and figures from the Medicine Lodge are presented in display fashion, much as they were in his earlier Target Record book.

While Silver Horn's drawings of the Medicine Lodge provide a wealth of ethnographic detail about ceremonial practices and ritual equipment of the late nineteenth century, they also provide new insight into conceptual aspects of the religion, such as veneration for the Taime. The Taime, which was never exposed to view except at the time of the Medicine Lodge ceremony, is shown in many drawings, often in great detail. Such open representation was not unique to Silver Horn, as images of the Taime appear in the work of other Kiowa artists as well. Yet James Mooney wrote regarding Silver Horn's hide paintings of the Medicine Lodge: "The great tribal palladium, the Taime, . . . is held too sacred for imitation, and the artist steadfastly refused to paint it" (Mooney MS 2538). This is a curious statement, as the Taime is clearly represented in another hide painting made in the same series (plate 22) and Silver Horn had shown it in several earlier works. Scott claimed that Mooney had difficulty in obtaining a model of the Taime, finally succeeding only with his assistance (Scott 1911:349). It is evident that there were contexts in which representation of this sacred image was considered appropriate and others that were more problematic. For Silver Horn, the guiding principle may have been that it should only be illustrated as a part of the ceremony in which it was exposed to view. If so, the same idea may have related to the model as well, and the ultimate agreement to make one may have resulted from the understanding that it was intended to be displayed within a model of the Medicine Lodge itself. While the Taime was an object of such veneration that depictions of it were subject to restrictions, such representations were clearly not the same as the object

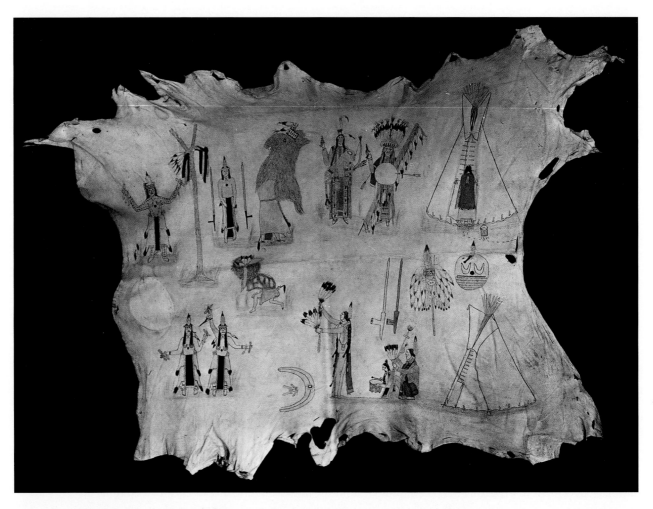

5.5. Hide painting combining elements of the Medicine Lodge ceremony (left) and the Peyote ritual (right).
The Taime and the shield dedicated to its service appear on the right, however, between images of the Peyote tipi.
#44,685. Courtesy of the Linden Museum, Stuttgart.

itself. The drawings could be viewed at any time, while the medicine itself, still maintained by the Kiowas, has not been exposed to view in over one hundred years since the last Medicine Lodge ceremony was performed.[4]

The Peyote Road

The Peyote ritual came to both the Kiowas and the Comanches around 1880 from Apache people, most likely the Lipans. The basic elements of the religion were probably already established, but these Southern Plains tribes quickly codified their own ritual details for the ceremony as well as adapting its doctrine to accord with their existing belief systems. The ceremony subsequently spread to many other tribes, where a wide variety of forms of the basic religion were developed. Many Peyote churches are now incorporated as branches of the Native American Church.

The ceremony as practiced by the Kiowas consists of an all-night ritual meeting held in a tipi erected for that purpose. Participants (usually all men) are seated around a crescent-shaped altar built of earth on which a line is drawn from end to end, representing the Peyote Road or the path to spiritual enlightenment. A large peyote button known as the Chief Peyote is placed in the center of the altar, and a ritual fire is built within the crescent. A leader known as a Road Man or Road Chief (referring to the Peyote Road) conducts an elaborate and highly formalized ritual in this setting. He is assisted by three or four other ritual specialists. In the course of the ceremony, which consists largely of praying and singing to the resonant accompaniment of a water drum, the participants consume a number of peyote buttons. Meetings conclude at dawn, when the Water Woman brings in a pail of water. Participants subsequently share a ritual meal.[5]

The peyote buttons, which are usually dried, are the tops of a small, spineless cactus (*Lophophora williamsii*). This plant, which grows along the Texas-Mexico border, contains alkaloids that affect the mental state and may produce visual and at times auditory hallucinations or visions. It is known to the Kiowas as *seni*, the same term used for other forms of cacti. During the late nineteenth century, white people in the area often referred to it by its Comanche name, *wokoway*. Others, including James Mooney, called it "mescal," a term properly used for a different plant.[6]

Evidently used originally by the Kiowas for war medicine, the plant was used for much the same purposes during the reservation era as it is today—to gain spiritual enlightenment and power and for healing. Peyotism became established among the Kiowas while the Medicine Lodge was still an active ceremony,

although at a time when it was in jeopardy because of the extermination of the buffalo. According to Mooney, the buffalo bull was the animal symbol of the Sun, while peyote was its vegetal representation. In Silver Horn's drawings, Peyotism is presented as an alternate route to access old sources of power. Ironically, the very forces of American expansion that caused the destruction of the buffalo made peyote more readily accessible to Plains people. Peyote does not grow in the Plains region, but the rapid expansion of the railroad network in the 1880s facilitated travel to the peyote gardens of south Texas and allowed shipment of large quantities of peyote to traders in the reservation area (Stewart 1987:61). Peyotism was well established by the time the Ghost Dance arose in 1890, and many individuals participated in both ceremonies. It outlived that religious movement, however, and continues as an active spiritual tradition among the Kiowas today.

Silver Horn's two earliest Peyote drawings were produced in 1883.[7] In one, the Water Woman is easily recognized: she sits outside the tipi with a pail of water and dishes containing the ritual breakfast. The other drawing shows a man standing outside a tipi, with a fan of feathers in each upraised arm (fig. 5.6). The drawing might not be recognized as related to Peyotism except for the caption provided by the collector, Dudley P. Brown, who identified it as representing the Comanche chief Quanah Parker, "making medicine before engaging in Wo-qua debauch [*sic*]." It was Quanah, a noted Peyote leader, whom Silver Horn first followed when he entered the religion, according to his son James (J. Silverhorn 1967b:5–6). The Peyote association of this drawing is substantiated by a nearly identical image on a later Silver Horn hide that shows a man in the same posture before a Peyote altar (fig. 5.5). These two limited scenes of the Peyote ritual indicate Silver Horn's early interest in the religion, but do not make it clear if he was yet a participant, as they show aspects of the religion open to view by anyone in a camp where a ceremony was being held.

The majority of Silver Horn's Peyote drawings date from 1891 and are found in three contemporaneous books of drawings now at the Field Museum, which contain fifty-two Peyote pictures. These drawings leave no doubt as to his deep participation in the religion by that time. They include views of the preparations for the ritual and of the ceremony itself as well as a series of representations of brilliantly colored Peyote visions. The majority of the drawings occur grouped together in two of the books, which also contain pictures of many other topics.

In one book, a series of fourteen sequential pictures drawn on the right-hand pages of the volume, back to front, provides an ordered presentation of various events of a Peyote ritual. The sequence begins

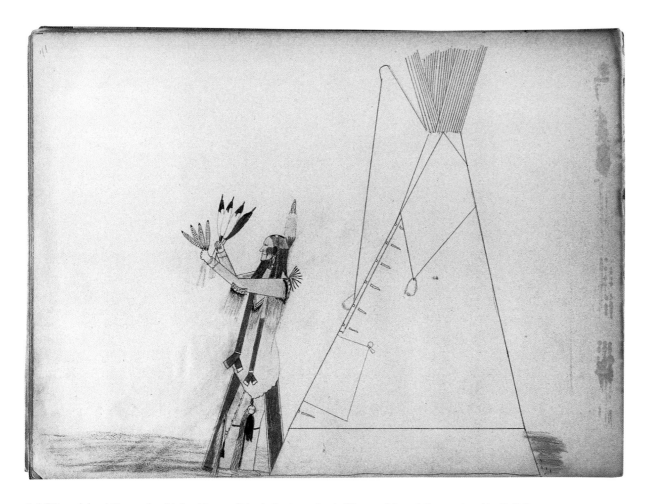

5.6. "Quanah head Comanche chief making medicine before engaging in Wo-qua debautch," as captioned by D. P. Brown.
Quanah Parker, the Peyote leader who introduced Silver Horn to the religion, wears buckskin clothing, which was preferred for ceremonial attire, and holds two loose feather fans. A bunch of flicker feathers, prized for doctoring, is attached to his shoulder.
#64.9. Courtesy of the Nelson-Atkins Museum of Art, Kansas City, Missouri. Gift of Mr. and Mrs. Dudley C. Brown.

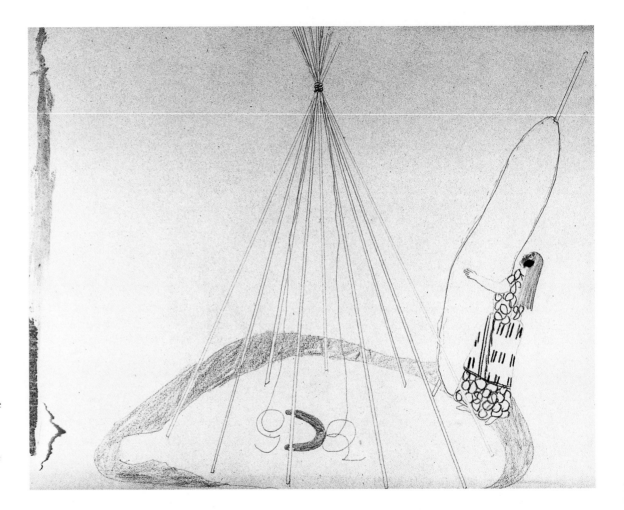

5.7. A woman lifting the cover of the Peyote tipi (wrapped around the lifting pole) into place against the standing lodge poles.
The crescent altar has already been built within the foundation circle.
#67,719 (neg. A113231). Courtesy of the Department of Anthropology, Field Museum of Natural History.

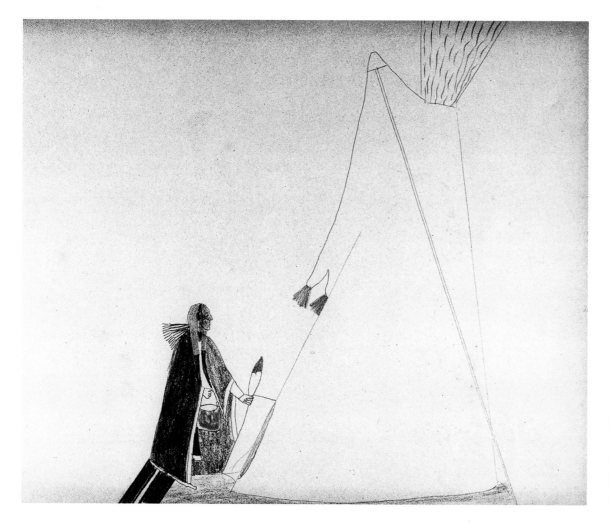

5.8. The Fire Chief returning, bringing water to the Peyote tipi at midnight. *He carries the feather that authorizes him to leave the meeting.* #67,719 (neg. A113229). Courtesy of the Department of Anthropology, Field Museum of Natural History.

with a man cutting out a circular area of sod where the tipi will be placed and continues with a woman setting up the tipi pole foundation and securing the canvas cover over it (fig. 5.7). Next is the midnight ritual of the Fire Chief going for water, carrying a single eagle feather to signify his authorization to leave the meeting (fig. 5.8). The Road Man is then shown outside the tipi holding the eagle bone whistle that he blows in each of the four directions. The dawn ritual of the Water Woman bringing a pail of water follows, and subsequently she is shown with dishes of food for the ritual morning meal. At the end of the ceremony in the tipi, the ritual equipment of all participants is laid out in the sun, and the members sit outside the tipi door (fig. 5.9). The sequence concludes with a view of the ground where the tipi formerly stood, with the altar still in place, now flanked with a crescent of ashes from the fire. Footprints leading away from the enclosure show that the participants have departed.

Interspersed among these images on the reverse of the pages are another half-dozen pictures reiterat-

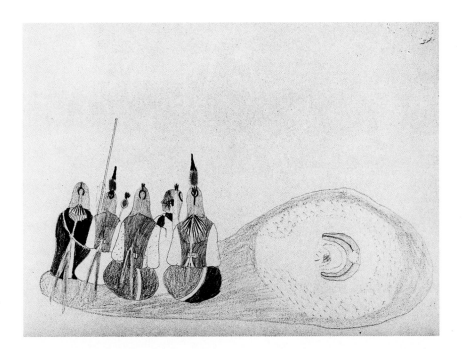

5.9. Peyote worshipers outside the tipi in the morning, singing and relaxing after their night of devotions. #67,719 (neg. A113228). Courtesy of the Department of Anthropology, Field Museum of Natural History.

ing various events of the ceremony. These also proceed in a loose time sequence from the back of the book to the front, but they are not synchronized with the first, more extensive set of images. The series begins with three ritual leaders about to enter the tipi. They can be identified by the paraphernalia they carry as the Road Man, the Drum Chief, and the Fire Chief. The following images are of the Road Man whistling at midnight, the Water Woman coming at dawn, and the bringing of the ritual breakfast. Next are two scenes of ritual equipment laid outside the tipi, once with a man and once with a woman in attendance. The final image is of two men outside the tipi, one with a rattle and one with a fan.

The two other books contain images that relate more to the ideological context of the Peyote religion than to its ritual form. Four drawings depict supplicants, both men and women, presenting themselves before a carefully drawn Chief Peyote, expanded in the artist's perspective to great size. A number of drawings show blessing rays streaming down from a celestial disk onto the Peyote altar or onto ritual participants. In most instances, the disk is green, like the green disk painted on the backs of tipi covers to represent the Sun, sometimes with yellow fringes to indicate its beneficent rays (plate 26). Other variants in the Silver Horn drawings include a yellow face and disks that are only partially colored green. In one picture, the green Sun disk is accompanied by the Moon, shown as a crescent rimming a disk, and a four-pointed star, representing the Morning Star, all of which transmit rays.

More than a dozen pictures represent Peyote visions. These brilliantly colored abstract images are placed within a circular outline; a small white tipi off to one side links them to the ceremonial enclosure. Such visionary images are a striking departure from Silver Horn's usual commitment to factual narrative illustration. Executed in red, green, and yellow, the images primarily contain a series of radially symmetrical forms from which rays extend in all directions, as though in a kaleidoscope. Some are suggestive of the rayed green Sun observed in more representational pictures. A crescent appears in one image, but without the median line that would identify it as the Peyote altar. Rainbowlike multicolored bands appear in several images (plate 27). A few pictures show the heads of unidentified animals, some perhaps cattle, one possibly a deer. The only other recognizable elements in any of the images are feathers, which appear in two pictures. While these drawings at first appear to be inconsistent with Silver Horn's guiding principle of literal representation, they are in fact probably very much in keeping with that concept. They accord closely with descriptions of the altered state of visual perception resulting from the ingestion of peyote, in which stimulation of the optical centers of the nervous system produces flared visions of brilliant colors and occasionally more organized hallucinations (LaBarre 1975:139–42). These drawings can be taken as literal representations of Peyote visions that Silver Horn experienced.

The representation of visions was not a new art form arising with the advent of Peyotism. The vision quest had great antiquity on the Plains, and images derived from visions were commonly painted on shields or tipi covers. The translation from visual experience to painted surface was not, however, an unmediated one. Through the course of long experience, cultural expectations of what spiritual beings one might encounter were well established, as was some shared knowledge of what they might look like. If a man were troubled as to how to interpret what he had seen, he could turn to an experienced priest for assistance. Further mediation occurred when a skilled shield maker or tipi painter was employed to paint the image of the vision. This individual as well worked within established conventions of iconography to translate what was described into new visual form. Visionary art was not intended to be a literal representation of what had been seen, but rather sought to encapsulate the essence of that encounter with the supernatural.

Peyotism brought a new form of vision seeking, positioned within a religion developing new concepts of spiritual contact and enlightenment. The old conventions to guide the interpretation of visionary experiences were not applicable in this context, and it would be some time before new standards were developed to take their place. Silver Horn's visionary drawings were produced during that time of transition and represent personal, unmediated representations of his visionary experiences.

After the production of these drawings in 1891, Silver Horn continued to include Peyote images in his repertoire, although never in so great a quantity. His most detailed treatment of the subject was on a hide painting (plate 22) that he produced for James Mooney as part of the Medicine Lodge series already described. In addition to depicting elements of that ceremony, he provided four detailed scenes of the Peyote ritual. One shows four ritual leaders preparing to enter the Peyote tipi, with the Road Man leading the procession (see fig. 2.5 for a detail). Faintly visible on the original hide, the word "By" is penciled in, with the tail of the final letter leading to the Road Man. Silver Horn eventually became a Peyote Road Man, according to his great-grandson Don Tofpi, and it is possible that this brief inscription, written by an unknown hand, was intended to identify this as a self-portrait of the artist.

Silver Horn's pictures of the Peyote ritual provide a wealth of ethnographic detail about the early years of the religion, greatly expanding upon the field observations made by James Mooney around the same time. The drawings provide strong support for Weston LaBarre's assertion that the Kiowa form of the ritual as he observed it in the mid-twentieth century was extremely conservative. Indeed, the basic elements of the ritual and many of the major items of material culture illustrated by Silver Horn are the same as those in use today.

Given this close correlation, the few areas of discrepancy between Silver Horn's pictures and described features of the religion are deserving of note and suggest topics for further study. The shape of the Peyote altar in Silver Horn's 1891 drawings is a tight curve, corresponding to what LaBarre called the "horseshoe" altar, typical in Comanche meetings. In his later drawings, the horns of the crescent are more widespread, as is characteristic of later Kiowa altars. This corresponds with what present-day Kiowas describe as a change in Kiowa practice over time. Silver Horn also changed the number of ritual leaders he depicted as officiating at a meeting, showing only three in an 1891 drawing, but four in his 1902 hide painting. The role of Cedar Chief was evidently added during that time and still remains somewhat optional (Stewart 1987:78; Wiedman and Greene 1988:41). He also shows a change in the number of dishes of food constituting the ritual breakfast, showing only three in his 1883 drawing but four in 1891 illustrations, an addition beyond the presently prescribed elements of corn, fruit, and meat. The ritual paraphernalia of rattle, staff, and fan are consistently present, but the fans he shows are all made of golden eagle feathers rather than the wide variety of plumage used in more recent times (Wiedman 1985). In a number of pictures, Silver Horn shows these ritual objects, together with the drum, whistle, and other equipment, displayed outside the tipi. Based on the placement of these drawings within a structured series illustrating the sequence of ritual events (unlike the Medicine Lodge "display" pictures), these images must be interpreted as an actual part of the Peyote meeting when the ritual instruments were arrayed outside after the ceremony in the tipi was concluded. This event is not recorded elsewhere as a part of the ritual, although it is routine for the ritual instruments to be passed around at the close of the ceremony (Stewart 1987:39).

An examination of the ways in which Silver Horn chose to illustrate this complex ceremony provides some insight into how he personally viewed the ritual and its doctrinal foundations. Although he produced many pictures relating to the ceremony, he seems to have been reticent to depict the more private aspects of ritual that took place within the tipi. The majority of pictures are of events that occurred outside its sheltering cover: bringing water, whistling to the directions, bringing the morning meal, and so forth. Interior views of the tipi are schematic floor plans, devoid of participants, but with the positions of Road Man and Drum Chief indicated in one by their ritual equipment. This "outsider" perspective has already been noted for the 1883 drawings, but is even more apparent in the much more extensive 1891 series. Out of over fifty Peyote pictures in these books, only a single image is of a participant inside the tipi. In that scene, a Road Man is seated behind the altar holding his rattle, staff, and fan. Silver Horn overcame this reluctance to depict scenes within the tipi in later years. First, one picture approached the topic

cautiously, showing the tipi with the cover rolled up part way, as it might be in warm weather, to reveal the participants seated inside (plate 25). Then, in the images produced on buckskin for Mooney (plate 22), Silver Horn offered a detailed and sensitive view of the worshipers seated around the altar. The leader sings to the accompaniment of his Drummer, while another man is preparing to consume a peyote button. Other worshipers hold their fans up to shield their light-sensitive eyes from the fire. This growing intimacy may correspond with Silver Horn's own growing authority within the religion.

The peyote button, epitomized in the form of the Chief Peyote, holds an important place in Silver Horn's conception of spiritual power sources. Silver Horn used the Peyote Chief itself as the primary symbol of the religion, either drawn in a realistic, albeit often oversized form or abstracted as a whorl of radiating lines around a center disk. He used this latter symbol occasionally in scenes of the ceremony to represent the Peyote itself, or as face paint upon a worshiper, and it appears in his calendar to indicate that a Peyote meeting was held. He shows both men and women petitioning the Peyote for aid (plate 26).

Peyote itself, however, is shown as an intermediary, receiving its power from the spiritual forces above, most often represented in the form of the Sun. Silver Horn's emphasis on the role of the Sun is not found in theological discussions of Peyotism recorded in the twentieth century. Instead, the Moon and the Morning Star, which appear in only one of Silver Horn's drawings, have come to be the more significant celestial phenomena of the religion.

Many of Silver Horn's Peyote pictures, particularly those representing visions, do not coincide with the imagery as it has been conceptualized in Peyote art for the past seventy years. His drawings of Peyote imagery are the earliest that are known and indeed predate the development of Kiowa Peyote painting by nearly four decades.[8] He was working at a time before the iconography of the religion was codified, and standard ways of representing unique visual experiences had not yet been developed. The multicolored sequence of colors characteristic of contemporary Peyote art and beadwork is suggested in some of his vision drawings, although the images are perhaps more closely related to the arching rainbow that appears in his pictures of other religious ceremonies. The crescent, a common symbolic element in later Peyote painting, appears as an isolated element in Silver Horn's work only once, in a vision drawing, and the spiraling smoke of the fire from which many later artists drew visionary inspiration is entirely lacking. The messenger birds, such as the long-necked water bird known as the Peyote Bird, had not yet been incorporated into the religion and are absent from Silver Horn's work.

The highly visual estheticism of Peyotism has made it an appealing subject for twentieth-century

Native American artists, many of whom, like the Kiowa Five, have been participants in the religion. Representations dating before the 1920s are, however, rare. Only the work of Carl Sweezey (Arapaho) and Ernest Spybuck (Shawnee) can be compared to that of Silver Horn in providing illustrative detail of the ceremony by a knowledgeable participant. Both of these artists were employed by anthropologists—Sweezey working as an artist for both James Mooney and George Dorsey (Bass 1966; Dorsey n.d.), while Spybuck was commissioned by Mark Harrington (Callander and Slivka 1984). As far as we know, each of them began producing Peyote pictures at the request of an academic patron rather than coming to the subject on his own initiative. Born twenty years earlier, Silver Horn preceded them by many years in his first approach to the topic. While there are changes in how he depicted the ceremony after he began work with Mooney, he had chosen the subject long before as a part of his general illustration of all aspects of Kiowa life.

Messianic Movements

Aside from the well-established ceremonies of the Medicine Lodge and the Peyote religion, a series of revitalistic movements of briefer duration arose on the reservation in the decade between 1880 and 1890, of which only the final one, the Ghost Dance, is well known. The world that the Kiowas had known seemed to be dying. The range of these nomadic people had been reduced to the narrow confines of the reservation. A vast network of independent Indian nations was now under the control of an alien white culture, which opposed and sought to disrupt many cultural practices. Diseases had decimated Indian communities in a series of epidemics. Perhaps most crushing, however, was the disappearance of the buffalo herds. The buffalo was both the primary means of sustaining life and a symbol of spiritual well-being. With its demise, the Kiowas were both impoverished and dispirited. The summer of 1879 is recorded in their calendar as Horse Eating Sun Dance, for hunting had been so poor that people were forced to eat their ponies to avoid starvation. No Sun Dance was held at all in 1880, probably because no bison could be procured for the center pole of the lodge.

In 1881, a medicine man announced that he had the power to bring back the buffalo. This man was Datekan ("Keeps His Name Always"). When he began to make medicine, he changed his name to Patepte ("Buffalo Coming Out"). It had been revealed to him that the buffalo were being held underground, as they had been in ancient times before the mythical figure Saynday released them into the world. With

spiritual aid, he sought to perform the same service through a ritual called the Buffalo Returning Ceremony, in the course of which the buffalo would be released from under a rock placed in a ceremonial tipi.[9]

Patepte's efforts are noted in several of the Kiowa calendars together with minimal sketches, but Silver Horn provided two beautifully detailed images of Patepte making medicine (fig. 5.10; plate 28). In each,

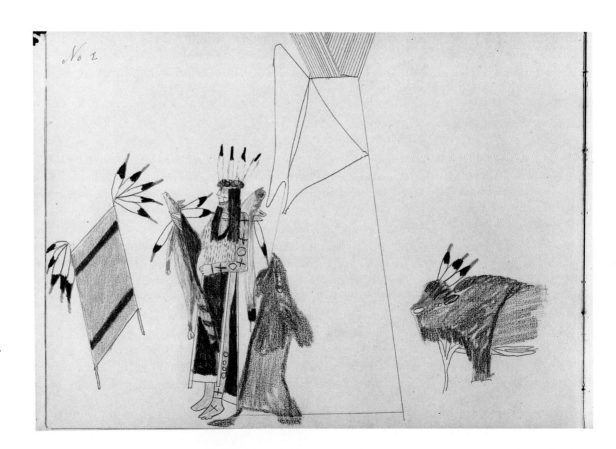

5.10. Patepte making medicine to bring back the buffalo.
A buffalo hide that he seeks to animate is placed on an armature of sticks, and another covers the door to his lodge.
#1994.429. Courtesy of the Museum of Fine Arts, Boston. Gift of the Grandchildren of Lucretia McIlvain Shoemaker and the M. and M. Karolik Fund.

he is shown emerging from his tipi in ritual costume. In addition to a breechcloth, he wears a mantle of blue and white, the garment referred to by Mooney as a "medicine shirt with blue beading." On his back is the complete skin of a wolf, and he holds a fox skin in one hand, the animals described by a participant in the ritual. In one picture, he holds a pipe, the traditional symbol of leadership. The ceremonial red blanket with eagle feathers that Patepte is shown wearing in a calendar entry for 1882 is here stretched between two posts outside the tipi. Silver Horn used the same image of the stretched blanket to represent this ritual in his own yearly calendar (Mooney MS 2531, 7). The depictions of Patepte's headdress and of the buffalo skin displayed on a pole are particularly revealing; they closely resemble ritual materials Silver Horn illustrated in association with the Medicine Lodge, a ceremony also concerned with maintaining the buffalo herds. The headdress with its upright eagle feather resembles the encircling band worn by the Taime Keeper's four assistants, while the buffalo skin is like those worn by the buffalo impersonators.

Another drawing in the Nelson-Atkins book of 1883 may also be associated with Patepte's revival attempts, for which he recruited seven men and seven women as disciples. It shows a group of men and women dancing in a circle, each with one arm upraised. They are dressed in ordinary clothing, and there is nothing to aid in identification of the scene except its association with other drawings in the book and information from the collector. It was captioned by Dudley Brown as "Kiowa Preparing a Messiah Dance."

Patepte's efforts to release the buffalo continued throughout the winter of 1882–83 without success, and he died the following winter (Kracht 1989:740). Silver Horn probably produced the first of his drawings while he was still actively carrying out the ceremony. In August 1883, Dudley P. Brown recorded as a caption for the drawing (plate 28), "Tau-ta-kah Kiowa making medicine in accordance with old custom," a spelling variant recognizable as synonymous with Mooney's Datekan. The other drawing (fig. 5.10) may have been produced a few years later. It was captioned at some length by Horace Jones:

> About 4 years ago the Buffalo having nearly all disappeared, a young medicine man undertook the rather difficult job of bringing the Buffalo back to this country as numerous as they were in old times. Great excitement prevailed among the Indians many of them having strong faith that this new prophet would succeed in his glorious undertaking and that hump ribs and marrow bones would again be as plenty as in the days of gone. This picture represents To-te-kone (the prophet) going through some of his mysterious ceremonies. It is needless to add that To-to-kone signally failed to accomplish this grand object much to the disgust of all the Indians. He now says that Great Spirit went back on him.

Some five years later, in the summer of 1888, another revitalistic medicine man rose to prominence prophesying the imminent destruction of all white people and their works and the return of the world as the Kiowas knew it. The buffalo would be restored. This prophet was known as Paingya ("In the Middle"), and he appears to have made a forceful impression upon Kiowa people. He called for them to abandon their scattered homes and farms, to withdraw their children from the agency schools, and to gather on Elk Creek to await in safety the cataclysm that would destroy the whites and prepare the world for regeneration. The majority of the population heeded his call, and a large camp was formed. The agent, Capt. Lee Hall, went to investigate the gathering, taking with him a small military escort, but being careful to maintain sufficient distance from the camp to avoid precipitating a panic. Through Kiowa intermediaries he learned that the destruction of the whites was to be supernatural in nature, and he was able to convince all involved that the best course was to wait and see what would happen. When the appointed date passed without incident, most people lost faith in Paingya's medicine.[10]

The ten close followers who constituted Paingya's disciples continued to follow him for another two or three years, however, forming a medicine society known as the Sons of the Sun. They established their own rituals and a distinctive costume consisting of red blankets and white buckskin leggings painted with blue arrows, points upward. As far as is known, Silver Horn did not produce any drawings of medicine making by Paingya and the Sons of the Sun, although he did place on his calendar for summer 1888 a picture of a legging adorned with a blue arrow and the indication of many tracks going toward a tipi camp along a creek (fig. 7.4). One other picture shows a man wearing leggings marked with arrows meeting with a white man in striped trousers, although the nature of their discourse is not clear. It is not surprising that Silver Horn did not depict this religious group in more detail, for they were strongly opposed to Peyotism, in which he was an active participant.

It was against this background of messianic movements that word of the Ghost Dance reached the Kiowas via the Cheyennes and Arapahos in 1890. The Ghost Dance message, predicting the destruction of the whites and the return of the buffalo together with the resurrection of the many Indians who had died, was quickly embraced by many Kiowa people; dances were widely held under the leadership of Patadal ("Poor Buffalo"), Asatitola ("The Messenger"), and other men who had been consecrated by the Arapaho apostle Sitting Bull and given a sacred feather to designate their priesthood. Seeking to learn more directly of the distant messiah with whom the dance originated, the Kiowa chief Apiatan ("Wooden Lance") traveled north to the Sioux, then west to Paiute country, where he met personally with Wovoka, whose

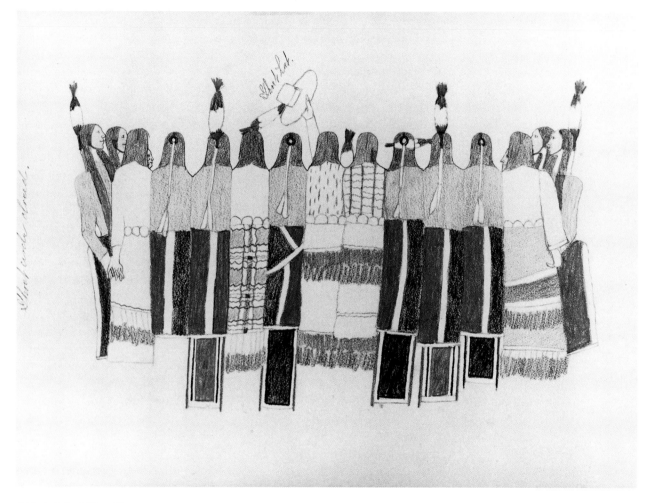

5.11. A circle of Ghost Dancers.
The men wear breechcloths, showing below blankets wrapped around their waists; the women are wrapped in bright shawls held by silver concho belts. The figures at each end of the line clasp hands.
Silberman Collection, #96.27.854. Courtesy of the National Cowboy Hall of Fame, Oklahoma City.

vision had inspired the dance and whom Plains Ghost Dancers believed to be an earthly messiah. Deeply disappointed in Wovoka and certain that he held no spiritual powers, Apiatan returned to the reservation in spring 1891 and denounced the dance as false. His report was widely accepted, and the Kiowas ceased Ghost Dancing. In his monograph on the Ghost Dance, Mooney wrote that the Kiowas had discontinued the dance, but immediately prior to publication in 1896 he amended the completed manuscript by inserting a note to indicate that he had recently learned that the dance was being revived.[11]

The revived dance was led by Patadal, Asatitola, and other former priests, and a number of dance centers were established throughout the reservation. Two forms of dance were practiced: small meetings held inside tipis on Sunday afternoons and much larger outdoor dances usually held on the Fourth of July and at New Year's, times when Kiowa people were allowed to assemble in large camps in recognition of these American holidays. Parker McKenzie, the Kiowa historian and linguist who was nearing one hundred years of age when I met him, clearly remembered dances held on his family's allotment where he was still living, near the banks of the Washita River. The message of the original Ghost Dance was reinterpreted in the revival. Rather than attempting to bring about the return of the dead, living participants were given the opportunity through trance to be temporarily reunited with their deceased loved ones in the spirit world. Ghost Dancing all but ended in 1916, when the movement was finally abandoned due to the harsh opposition of the agent to all forms of Indian dance.[12]

Silver Horn was almost certainly a participant in the Ghost Dance, perhaps from its earliest days. The leader who brought the dance to the Kiowas, Patadal, was a close relative, his mother's brother, and it would be natural for family members to accept his religious leadership. Silver Horn also was active in producing regalia for dancers, a role appropriate for a participant in the religion. His son Max remembered him telling how he had made the feathers that dancers wore in their hair as the most essential item of ritual costume, and an elderly Kiowa woman interviewed in the 1960s named Silver Horn as one who painted the buckskin dresses worn by women dancers (Brace 1967:2).

Only a few of Silver Horn's pictures are of the Ghost Dance. One picture in the 1891 books may represent the dance as it was first performed by the Kiowas. This image is of a circle of dancers in ordinary dress, but a few have upright feathers in their hair. There is a green tree in the center of the circle and a rainbow arching over the scene. Additional drawings of circle dancers appear in an undocumented book also probably dating to the early 1890s (fig. 5.11). Again, the dancers wear no distinctive costume with the exception of occasional upright feathers upon their heads, but Silver Horn has carefully drawn them holding hands, a feature of the Ghost Dance circle.

Silver Horn's most powerful and detailed drawing of the Ghost Dance is a painted hide showing an overview of a circle of dancers with surrounding spectators (plate 29). The scene is evidently of one of the large outdoor gatherings held on July 4 and at New Year's. It illustrates various features described in the published literature and the more extensive archival records such as the central pole, the circle of painted, feathered dancers, the dance leader in the center of the circle, his arm upraised, and the large tipi outside the circle to which individuals in trance might be carried. It also depicts many details that are not recorded or are obscure in other sources. For example, dancers are typically described as holding hands, but in this picture each participant appears instead to be holding a fan, bell, or other ritual object. The ritual costume also differs from other descriptions. Rather than men wearing buckskin shirts painted with the same motifs used in the Sun Dance, here only the women are shown in buckskin, and their dresses are painted with at least four different motifs, none quite like the paint of the Sun Dance. In his research on Kiowa religion, Benjamin Kracht (1989:818) learned a new detail about the dance, that the center pole was sometimes topped with a cross and accompanied by a cedar tree. This image confirms that detail, and the form of cross and tree can be seen. It is likely that this painting was produced soon before Silver Horn sold it to Dr. E. E. Rowell about 1910, during the period when the Ghost Dance was still actively performed. This drawing is a unique contemporary record of the ritual as it was performed in its last years among the Kiowas.

Spiritual Connections

Silver Horn's art is a rich source of ethnographic information about major Kiowa ceremonies, depicting many features that are not recorded elsewhere. His representations of religion are, however, selective rather than encompassing. The choices that he made are revealing of the underlying cultural principles that guided him (and no doubt other Kiowa artists) in determining what was appropriate for representation. Working within these broad precepts, Silver Horn's images still convey much about his personal view of the spiritual and suggest the connections and syncretisms he saw among the various religious expressions of the late nineteenth century.

Silver Horn's illustrations of ceremonies offer visual documentation that far exceeds the written records of these events and richly enhances the verbal knowledge still held within the Kiowa community.[13] The Medicine Lodge ceremony was beautifully and extensively illustrated in a number of works ranging in

scope from broad sequences of activities to minute details of costume and body paint. His images of the Peyote ceremony provide a well-dated record of the development of that ritual over time. The visionary and iconographic elements are particularly interesting, as they differ substantially from those that became codified in Peyote art in the twentieth century. He also illustrated poorly recorded messianic movements, including the Buffalo Returning Ceremony, which influenced later Kiowa response to the Ghost Dance. His visual documentation of the revived Ghost Dance is an evocative supplement to the verbal narratives surrounding that event.

The choices that Silver Horn made in depicting religious events are also revealing of cultural patterns. The ceremonies that he illustrated—the Medicine Lodge, the Ghost Dance, and outdoor aspects of the Peyote ritual—were public in character. He chose not to illustrate other, more private aspects of religion. While the personal vision quest was a major feature of Kiowa religious practice, it is a topic Silver Horn barely touched. Only two of his drawings are recognizable as individual spiritual encounters. In one, a man carrying the Padogai shield of Silver Horn's father and brother holds out a scalp to a horned figure that rises from a lake, perhaps Zemaguani, the horned serpent. The man, probably a relative of the artist, is evidently making an offering to this powerful spirit figure. Another major aspect of religion that is absent from Silver Horn's art is activity associated with the Tsaidetalyi or Ten Medicines. These sacred bundles, from which individuals might individually seek spiritual assistance, were protected by as many keepers dispersed throughout the tribe. Silver Horn succeeded his uncle as a keeper of one of the Ten Medicines in later life, although probably not until after his career as an artist had ended.

The aspects of religion that Silver Horn illustrated were not only ones of which he had knowledge, but also ones that he might claim some right to represent. He was a participant in all of the public ceremonies, but his depictions of more private devotions were based on his personal position. His Peyote visions, like other vision-inspired designs, would have been owned by him, following established custom. The drawing of his relative's encounter with Zemaguani is a depiction of a family honor, much like the war pictures previously discussed. And it is particularly revealing that Silver Horn's portrayals of the Peyote ceremony became increasingly intimate as he rose to become a Peyote leader.

Behind these cultural conventions, Silver Horn's personal view of spiritual power and of the ritual means to access it can be glimpsed. The Medicine Lodge, first depicted as an integrated ritual, became fragmented, then intermixed with representations of the Peyote religion, with the Taime itself eventually appearing between two Peyote tipis (fig. 5.5). In addition to intermixing the ritual objects of these two

ceremonies, he utilized the same iconographic devices for both to indicate the quest for spiritual power. In a set of drawings produced around 1891, both Medicine Lodge dancers and Peyote ritualists (plate 26) reach out imploringly to the same green disk, representative of the Sun. The rainbow is another iconographic device that he used as a representation of spiritual contact in different ceremonial contexts. It forms a protective arch over participants in both the Medicine Lodge and the Ghost Dance (fig. 10.5) as well as appearing in Peyote visions. Silver Horn's drawings reveal that he saw these changing ceremonies as alternate routes to access the same enduring sources of power.

Chapter 6

Visualizing the Oral Tradition

Max Silverhorn remembers his father as a storyteller. At night when the children were settled in bed, he would sit in the dark and tell them stories. He told them funny stories of Saynday, the trickster, and serious stories of the Twin Boys who brought blessings to the Kiowa people, and scary stories of Sapoul, the terrible ogre who ate people. These stories found their way into his art as well, and illustrations of more than forty-three different tales have survived. Those pictures left the Kiowa community long ago, but Max needed only a few minutes of studying the copies I showed him to recognize the story each represented—and then to retell it as he had learned it from his father. Silver Horn was forging new ground in producing visual representations of these ancient oral traditions. Drawings of myths and folktales were unprecedented and offered a new avenue for this gifted illustrator to explore the possibilities within narrative art.

During the nineteenth century, as today, the Kiowas had a rich oral literature through which knowledge was recorded, shared, and passed on to each new generation. Much of what we know about Kiowa oral literature of the nineteenth century is based on the work of Hugh L. Scott, most of which remains unpublished. He observed that the Kiowas differentiated between various classes of stories, recognizing some as history and others as "things that never truly happened" (Scott LOC, Box 76). Some years later, Elsie Clews Parsons (1929:xvii) found that the same distinction between "true stories" and "lie or joke" stories was still made. True stories included such events as the Kiowa migration to the Southern Plains, the separation of the tribe after an argument over the division of game, and the account of the girl who married the son of the Sun and became the mother of the Twin Boys. Prominent among joking stories were humorous tales about Saynday, that ambiguous trickster figure whom Kiowas describe as a liar and a cheat. Saynday stories are told for amusement and are considered moral tales rather than historical stories. Together these two kinds of literature have long constituted an important mechanism for the transmission of knowledge, both factual and philosophical, and for the maintenance of a shared sense of being Kiowa.

There were rules about when stories could be told and by whom. The recitation of coup, the formalized recounting of war deeds, was restricted to individuals who owned the rights to such stories. Historical

and mythical storytelling was more open in performance, but Saynday stories could be told only at night and only in the winter time, or Saynday might nip off the teller's nose. This practice is much relaxed in the present day, but there are still Kiowa people who adhere to it carefully, and in Silver Horn's time it must have been widely observed. Both men and women were storytellers, and anyone who knew a story could tell it.[1] As might be expected with such an open, vibrant oral tradition, a number of versions of stories have been recorded over the years, and many variants are told today. This variety is valued by Kiowa people, who speak with pride of "my family's way of telling it."

A Wealth of Tales

Most of Silver Horn's illustrations of Kiowa myths and tales appear in three sets of drawings from the 1890s: the ledger books acquired by Dudley Brown, now at the Field Museum of Natural History; the Target Record book produced while he was a scout at Fort Sill; and the group of drawings that he produced on commission for Hugh L. Scott. Two hide paintings from the early years of the twentieth century also include story elements. His repertoire was broad, but some stories were illustrated more than once.

One of the most important cycles of stories in Kiowa literature is that of the Twin Boys, culture heroes of mythological times, who performed many brave deeds to free the world of dangerous monsters.

A girl was out playing one day and saw a porcupine in the top of a tree. She wanted to catch it and began to climb the tree. Each time she drew near, however, the tree grew taller, carrying the porcupine further up, and she climbed after it. The tree grew until it pierced the sky, and the girl emerged into the upper world. There the porcupine revealed itself as Sun Boy (Paitalyi), the son of the Sun, a handsome young man whom she married. They had a son, and she forgot her life on the surface of the earth. Her husband warned her that when she was out gathering food she must never dig up a particular root if a buffalo had cropped the top of it. Ignoring the warning, she pried one up with her digging stick, creating a hole in the sky through which she could look down and see the world below. She was immediately filled with longing to return there, and, tying herself and her son to a long rope secured to the digging stick, she lowered them toward the ground. The rope was not long enough to reach, however, and she was stuck, hanging between sky and earth. Her husband was angry when he found her gone and, looking through the hole, saw her predicament. He threw a stone down the rope, which skipped over the boy and killed the woman. The rope broke, and both fell to the ground.

The boy was unhurt, but lonely and afraid. He found a nearby tipi, which he visited each day while the owner was away. The tipi belonged to Old Spider Woman, who saw the child's tracks and left food for it. Curious whether it was a boy or a girl, she also left out a girl's ball and a boy's small bow and arrow to see which it would prefer, and thus learned that it was a boy. She eventually adopted the child and raised him as her son. One day he was playing with a gaming wheel she had made for him and threw it high in the air. It struck him on the head as it came down, and he was split into two identical boys, known as the Twin Boys or the Split Boys.

The Twin Boys had many adventures. They encountered and overcame a cannibal after their gaming wheel lodged in the top poles of his tipi. They killed Zemaguani, the underwater monster also known as Big Mouth, who had horns like an elk, curly hair like a buffalo, and the tail of an alligator. Another of their foes was Iron Horn, the ferocious buffalo bull after which Silver Horn was named. Finally, they killed a huge serpent that they later discovered was the husband of Old Spider Woman. Eventually, one of the boys walked into a lake and disappeared. The other boy divided himself into ten parts and gave himself to the Kiowas as a source of medicine. The bundles derived from this source are known as Tsaidetalyi, or Boy Medicine, commonly referred to as the Ten Medicines.[2]

Silver Horn produced illustrations of several episodes of this story in the Field Museum books and again in the Scott drawings. In both he depicts the opening of the cycle, the story of "The Girl Who Married the Son of the Sun." The two groups of drawings are very different stylistically, one utilizing traditional flat forms and the other Western spatial illusionism, but the narrative is much the same. The girl is shown climbing up the tree, her course marked by footprints (fig. 6.1). The plane of the upper world is indicated in one drawing by a foreshortened rectangle floating above the figures on the earth, while in the other a wavy line crossing the page separates the planes of earth and sky. Subsequent drawings in each set show the woman letting herself and her child down on a rope through a hole she has cut in the sky and the boy safe next to her body after she has fallen to the ground dead. The subsequent history of the Twin Boys is illustrated only in the Field Museum drawings, which show the child's discovery by Old Spider Woman (fig. 6.2), his transformation into two boys, and two of their heroic adventures—the killing of the snake and their gaming wheel caught on the poles of the cannibal's lodge. There are no pictures of their transformation into the revered Ten Medicines, just as there are no pictures of the ceremonies associated with those bundles.

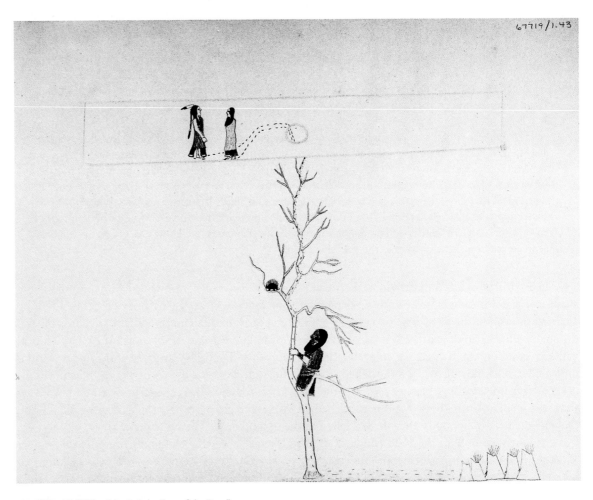

6.1. "The Girl Who Married the Son of the Sun."
The girl climbs up a tree in pursuit of a porcupine and emerges into the upper world to discover him transformed into a handsome young man.
#67,719 (neg. A113174). Courtesy of the Department of Anthropology, Field Museum of Natural History.

6.2. The boy who fell to earth.
The boy is adopted by Old Spider Woman, who lures him near with food and toys, shown by the tipi. She learns that he is a boy when he chooses to play with the small bow and arrows rather than the girl's ball.
#67,719 (neg. A113173). Courtesy of the Department of Anthropology, Field Museum of Natural History.

One of the most beautifully illustrated stories is that of the Buffalo Husband, or Muddy Feet, another widely told tale.

> A young woman was strangely attracted to a beautiful buffalo skull that lay by a stream near camp. One day while she was out getting water, she was approached by a handsome stranger who convinced her to elope with him. She did so, only to discover that he was actually a buffalo bull in disguise, who took her to live with his herd. The husband from whom she had been lured away prepared many arrows and set out to find his wife. She was glad to be rescued by him, but they were closely pursued by the angry bison. Four times her husband shot an arrow ahead of them, and each time they were transported the distance of the arrow flight, finally taking refuge in a tall tree. The bison herd attacked the tree with their horns and splintered the trunk. The couple leaped from tree to tree, while the man shot many of their attackers. The man was down to his last arrow when they were trapped in the fourth and final tree. The bull with whom the woman had eloped, attacking the tree with horns of shining metal, seemed impervious to arrows. The woman told her husband that his only point of vulnerability was the small cleft between his front hoofs. The husband aimed carefully and hit his mark, and they were saved.[3]

Silver Horn illustrated this story in a set of three drawings that masterfully capture many details. The first picture (fig. 6.3) compresses several elements into a single image. It shows the home camp where the husband is making arrows, the water bucket that the woman took to the stream, the gleaming bison skull found there, and the young man she meets. Tracks show them leaving the stream together, and his transformation is revealed as one set of human tracks changes into bison hoof prints and the woman is shown again, now wrapped in a painted bison robe. The second drawing (fig. 6.4) depicts her rescue by her husband. Three arrows in the ground mark the path of their flight, shown by two sets of human footprints followed by the tracks of the bison herd. The tracks lead to a group of four trees, in the crowns of which the fugitives can be seen. The trunks of three trees are splintered, and the fourth in which they hide is under attack by a great buffalo bull. The ground is littered with dead bison and spent arrows, while one arrow flies toward the cloven hoof of the attacker. The third drawing of the series illustrates a further episode of the tale, known to Silver Horn but not found in the recorded literature. In it, men attack a lone tipi, filling it with arrows. Nearby lie four slain figures, half-bison, half-human in form.

In these books, Silver Horn's earliest known pictures of folk stories, he seems to have been fascinated with exploring the concept of sequential illustration. While many stories are captured on a single page,

others are much expanded. Thirteen pictures are devoted to the longest story, the tale of a ferocious bear whose claws a young warrior desired for a necklace (fig. 6.5). The version that Silver Horn recorded differs somewhat from the one published by Parsons (1929:64–66) under the title "Buffalo Kills White Bear." Another lengthy series of eight pictures is devoted to the story of "The Miracle Boy" (fig. 6.6), also recorded

6.3. A woman enticed to elope with a handsome stranger, who then reveals himself as a buffalo bull.
His transformation is mirrored in his changing footprints.
#67,719 (neg. A113171). Courtesy of the Department of Anthropology, Field Museum of Natural History.

by Parsons (1929:59–62). In this story, a man wishes to get rid of his young brother. He takes him on a hunting expedition, where he kills a buffalo. He gives the young boy a stick and tells him to circle around the buffalo carcass and keep away the coyotes while he goes back to camp to get his skinning knife, thus abandoning him. Four years later, he is passing the same way and is amazed to find his brother still circling, now in a deep trench he has worn into the earth. Silver Horn here conveys the passage of time by a series of highly repetitive pictures of the boy, his stick at the ready, circling in a deepening rut while the bison carcass decays and eventually disappears.

Saynday enters Silver Horn's repertoire in the drawings that he produced while he was a scout at Fort Sill. Saynday is a classic trickster figure, possessed of miraculous powers but always trying to get what he wants through sly tricks. Selfish and greedy, he never follows the rules of proper social behavior, much less specific instructions laid down by supernatural helpers. Sometimes he gets away with it, but just as often the trick is on him. Stories of Saynday are always funny, and he is a favorite with children. Some tales are ribald and are told only after the children are asleep, while others are serious and account for the very origin of the Kiowa people. Saynday is described as a skinny fellow with muscles that bulge out on his legs in the wrong places, a big nose, and a great long phallus that he wears wrapped around his waist and tied like a sash to keep it out of the way. His remarkable appearance, known only from verbal descriptions, gave Silver Horn broad scope to craft a distinctive figure easily distinguished from drawings of mere mortals.

Working in the Target Record book that he shared with other artists (none of whom attempted Saynday), Silver Horn produced many pictures of the Kiowa trickster. The stories are all single- or two-page compositions, with sequential episodes on facing pages, each oriented toward the gutter or binding seam of the book. Compared to his earlier story illustrations, they mark a return to traditional narrative structure, with sequential events compressed into a single image and the course of action revealed through the extensive use of footprints and other visual signs. In "Why the Kiowas Have No Tails," Saynday is shown using his tail to fish through the ice of a pond (fig. 6.7). The marks on the ice tell the story of how Saynday ignored directions that he was to do this only three times. On the fourth try, his tail has been frozen in place and is being pulled off as he yanks himself free.[4]

"Saynday and the Cheet Bird" is an example of a two-page composition (fig. 6.8; plate 30), showing Saynday captured by the cannibal Sapoul. The first page is dominated by a fascinating portrait of the mountain ogre, who has been glimpsed only occasionally at nightfall, carrying off Saynday in a bag on his back. He is manlike but large and hairy, with a cedar tree growing out of the top of his head and another

from his chest. Footprints indicate a brief struggle where Saynday was captured, and a line of sound issues from his mouth. Saynday tricked Sapoul into admitting that he was afraid of the small "cheet bird," which he is now imitating. Terrified, Sapoul rushes through a thicket, and Saynday is able to grab onto a passing tree and pull himself free, still calling like a bird.[5]

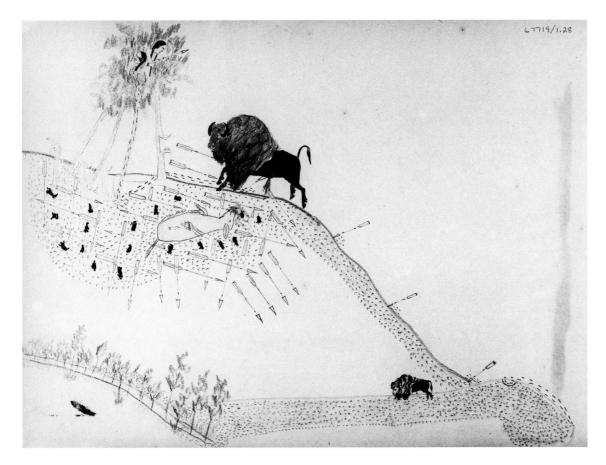

6.4. Arrows up the side of a hill marking the flight of the woman and her husband, who cling to the top of the only tree left standing.
A huge bull attacks the tree, while the husband aims his final arrow at the bull's one point of vulnerability.
#67,719 (neg. A113164). Courtesy of the Department of Anthropology, Field Museum of Natural History.

The use of footprints as a narrative device more than a representation of actual foot marks is demonstrated in the picture of "Sayday and the Flatulent Root" (fig. 6.9). Saynday had been warned against eating excessive amounts of a particular tuber, but ignored the warning, even sharing the food with his young son. The resulting intestinal gas was so powerful that they were blasted up off the ground as it was expelled.[6] Their flight into the air, weighted with tipi poles and rocks to try to hold them down, is faithfully traced in Silver Horn's drawing with lines of footprints. The illustration of the complex narrative of "Saynday, the Bear, and the Tight Tree" also relies upon carefully differentiated footprints to tell its tale

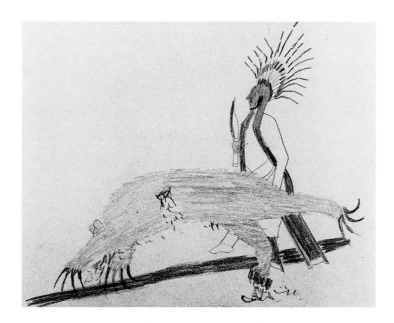

6.5. A warrior with a splendid headdress.
He has killed a ferocious bear and is cutting off its claws to make a necklace, which he wears in subsequent images in this long visual narrative.
#67,719 (neg. A113214). Courtesy of the Department of Anthropology, Field Museum of Natural History.

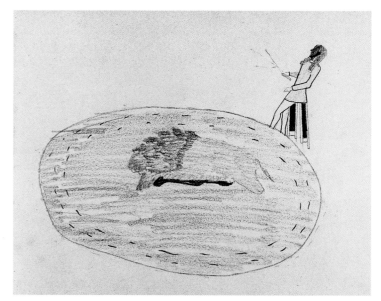

6.6. "The Miracle Boy" circling a bison carcass with a stick to protect it from scavengers, as instructed by his brother.
His endless circling has worn a deep path that conceals his feet.
#67,719 (neg. A113179). Courtesy of the Department of Anthropology, Field Museum of Natural History.

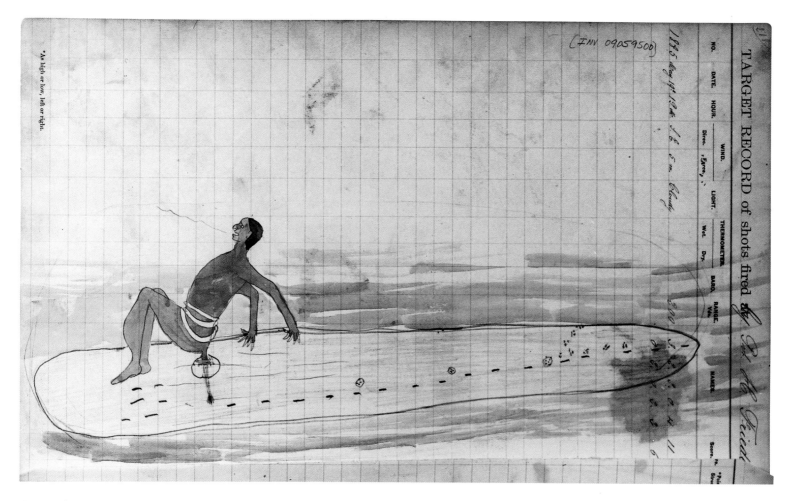

6.7. Saynday with his tail frozen in the ice of a pond.
Three circles beside a line of footprints mark his previous successful efforts to fish through the ice with his tail.
MS 4252. Courtesy of the National Anthropological Archives, Smithsonian Institution.

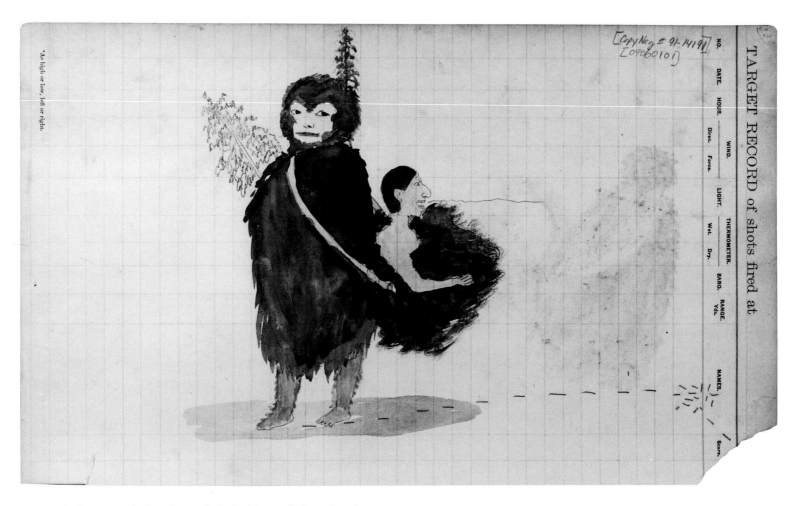

6.8. Saynday being carried off in a bag on the back of the cannibal ogre Sapoul.
Footprints indicate a brief struggle where Saynday was captured, and a line of sound issues from his mouth as he makes a bird call to frighten Sapoul.
MS 4252. Courtesy of the National Anthropological Archives, Smithsonian Institution.

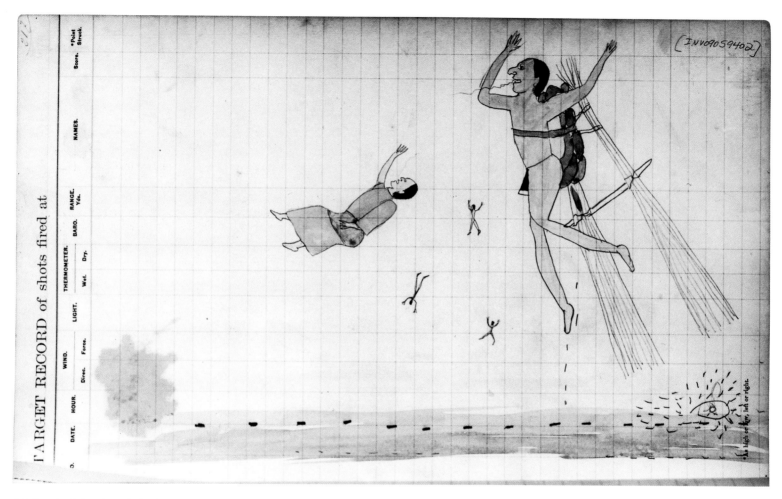

6.9. Saynday flying through the air.
Although weighted down with rocks and bundles of tipi poles, Saynday is blown into the air by the force of his flatulence after eating a root that he has been warned against.
MS 4252. Courtesy of the National Anthropological Archives, Smithsonian Institution.

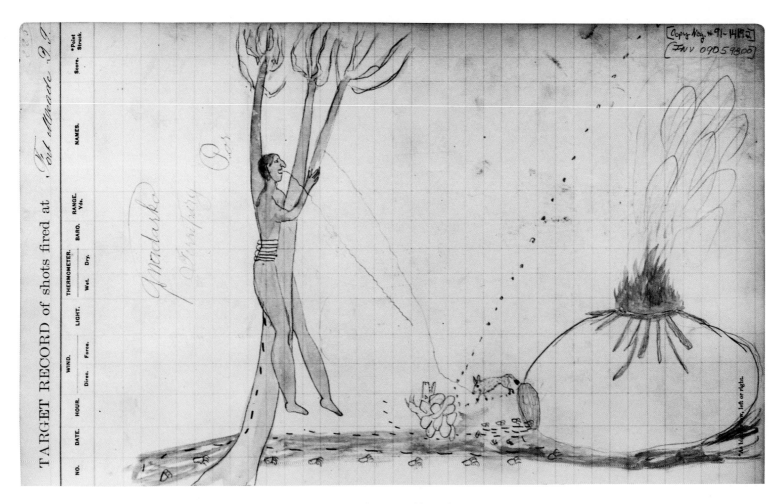

6.10. Saynday stuck tight in a tree, while a coyote eats the cooked bear that Saynday captured by trickery.
The tracks of each character in the story are differentiated—dashed lines for Saynday, clawed feet for the bear, and delicate spotted prints for the coyote.
MS 4252. Courtesy of the National Anthropological Archives, Smithsonian Institution.

(fig. 6.10). Saynday, represented by simple dashed prints, tricked a bear to go into an earthen oven, as the bear paws show. He pulled the bear meat out once it was cooked and amused himself while it cooled by playing in a tree, where he exercised his magical powers by commanding it to close and hold him tight and then to release him. A coyote came by, leaving a line of delicate paw prints, and asked to share the food. Saynday refused him, and the tree clamped down tight, holding Saynday while the coyote ate all the food.[7]

Silver Horn repeated many of the same Saynday stories in the drawings that he produced a few years later for Hugh Scott, but with some shifts in the way the narrative is presented. Several of the two-page compositions are combined into a single image, in which Saynday appears twice as if in a double exposure. The tale of "Saynday and the White Eagle" tells how an eagle gave Saynday a whistle that allowed him to dive from a high rock through the ice on the river below to catch otters, but the magic would work only three times. Saynday tried it once too often, with predictable results.[8] Silver Horn illustrated the whole story in a single image, showing Saynday perched on the rock with his whistle as well as lying bloody in the ice that failed to open on his final dive (fig. 6.11).

The Scott drawings include a number of images in which Silver Horn attempted to apply a Western mode of illustration to the traditional Kiowa stories. (See plate 12 for a Westernized illustration of the White Eagle story.) In these, Silver Horn labored to retain the narrative thread within competing elements of naturalistic landscape, portraiture, and complex postures. The footprints that he continued to rely upon to tell the story are one of the few visual links between these and his more traditional images (fig. 6.12).

The drawings made for Scott include many stories not previously illustrated by Silver Horn. Some are more serious stories of Saynday, in which he brought good things to the Kiowas. Chief among these was his release of the buffalo from where they were being held under the earth (fig. 6.13).[9] Others are unrelated to Saynday, such as the story of "The Girl Who Married the Son of the Sun" and of the split of the Kiowas into two tribes. One of Silver Horn's longest narrative series of pictures is included in this set of drawings, nine pictures telling the story of "The Girl Who Married Big Mouth." The pictures closely follow the story as recorded by Scott, showing her encounter with a handsome young man whom she agrees to marry, her discovery that he is the underwater monster Big Mouth, the underwater tipi to which he takes her, where he takes on the monstrous form of his parents (plate 31), and their eventual return to earth's surface.[10]

Beyond these three sets of pictures, Silver Horn drew on mythological themes in only two other works,

both hide paintings. Among his most striking works is a hide that he painted for James Mooney in 1904 (plate 32). Entitled "The Kiowa Pantheon," it consists of a series of mythical figures and religious objects rather than scenes from a story, including Saynday, Zemaguani, Sapoul, and Red Horse, a winged animal, half-horse, half-serpent, that rides in the clouds. Among these are juxtaposed an image of the

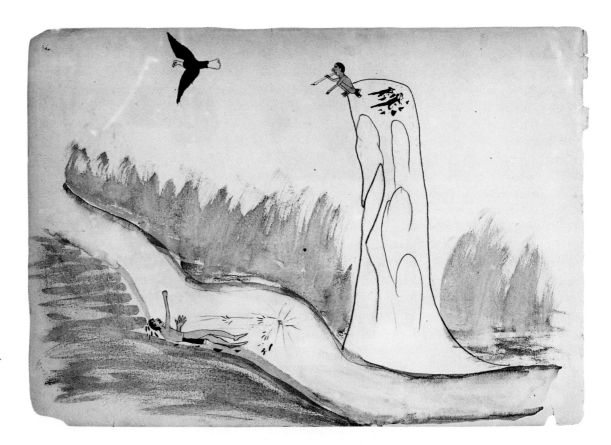

6.11. Picture combining events from the story of Saynday and the White (Bald) Eagle.
Saynday is shown perched on a high rock with his magical whistle, with the otters he has caught next to him. Below is another view of Saynday with a bloody head, with his hand prints next to the cracked surface of the ice on which he crashed.
Gift of Mr. and Mrs. Charles Diker.
Courtesy of the Museum of Indian Arts and Culture/Laboratory of Anthropology, Museum of New Mexico.

Gadombitsonhi (Old Woman under the Cliff), an object of religious veneration used during the Medicine Lodge ceremony, and a large peyote button, flanked by the ritual objects of the Peyote religion. Storytelling is abandoned in this painting, with mythical figures detached from their stories just as the sacred objects are separated from their ceremonies.

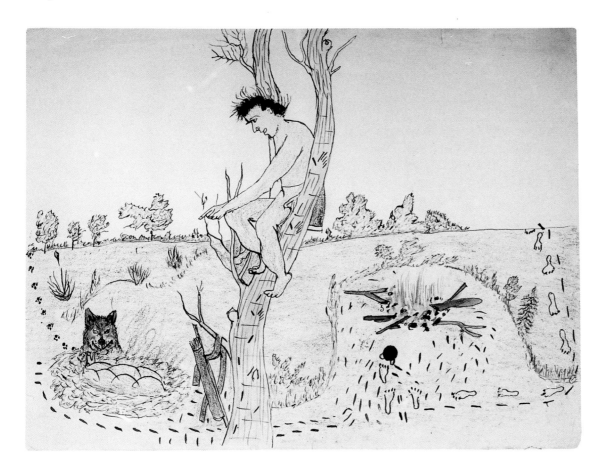

6.12. "Sayday and the Tight Tree," illustrated in the Westernized style with which Silver Horn briefly experimented.
The footprints provide the only visual continuity between this and the preceding illustration of the same story.
Gift of Mr. and Mrs. Charles Diker. Courtesy of the Museum of Indian Arts and Culture/Laboratory of Anthropology, Museum of New Mexico.

Silver Horn's last venture into the visual folktale is a curious, crowded hide now at Pomona College (fig. 6.14). It contains a number of scenes with extensive groundscape, but sometimes insufficient narrative detail to be certain what story each represents. One scene is a partial representation of the story of "The Girl Who Became a Bear." Some children were playing, with one pretending to be a bear and chasing the others.[11] In the course of play, however, the child was transformed into an actual bear. The other children fled in terror

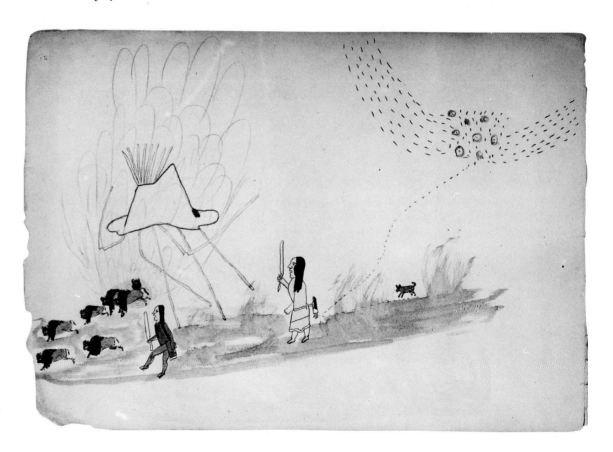

6.13. Saynday, disguised as a little dog, releasing the buffalo that were being held beneath the ground. Gift of Mr. and Mrs. Charles Diker. Courtesy of the Museum of Indian Arts and Culture/Laboratory of Anthropology, Museum of New Mexico.

and leapt on top of a tree stump to escape. The stump grew taller and taller, with its sides heavily scarred where the bear raked its claws into the bark, and carried them to safety in the sky, where they became stars. The Devil's Tower in Wyoming is what remains of the tree stump, while the stars are the Pleiades, known

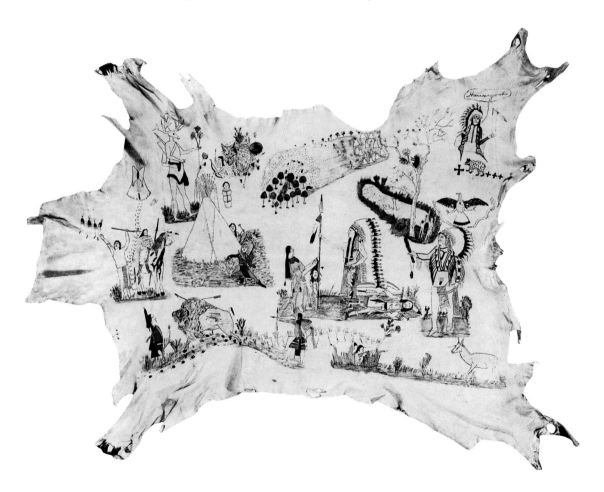

6.14. Hide painting illustrating several stories.
Saynday is drawn in the upper left with his head stuck in an elk skull. The story of "The Girl Who Became a Bear" appears in the upper center, where a bear emerges from a grove of trees.
#5106. Courtesy of Pomona College, Claremont, California. Gift of Martin Abernathy.

to the Kiowas as the Seven Sisters (Harrington 1939).[12] The drawing shows only a group of girls being pursued by a bear. The footprints alone establish the identity of this story, as they indicate that their pursuer came out from the woods three times in human form before being transformed into a bear.

Relationship of the Visual and Verbal Narratives

The illustration of mythological themes was a bold and imaginative innovation on Silver Horn's part, one with little precedent among either his own tribe or neighboring Plains people. Narrative art had always been focused on personal events. Pictures of war were illustrations of coup narratives. Illustrations of ceremonies expanded upon this foundation, but continued to celebrate men's activities and accomplishments. Drawings of myths and tales expanded upon it in another direction, extending illustration to include additional genres of oral literature. Like coup pictures, they were illustrations of what Silver Horn had heard rather than what he had seen. The narrative component remained primary and the linkage to the oral tradition strong. And they offered enormous scope for creativity in depicting creatures and characters not previously seen—Saynday, Sapoul, and Zemaguani.

Silver Horn began drawing pictures of myths for his own enjoyment, only later producing such illustrations for sale. The earliest drawings are in the Field Museum books and explore a wide range of topics. Stories of Saynday appear in the Target Record book produced soon after. The book was shared among several artists, who must have examined and commented upon each other's work, although Silver Horn alone drew pictures of myths. Only the drawings commissioned by Hugh Scott were influenced by the needs and expectations of an outside audience. When Scott acquired the Target Record book, he must have been delighted with the Saynday pictures, which so beautifully complemented his interests in the oral literature. Scott already had plans to publish a volume of Kiowa tales. Inspired by the drawings that he had seen, he commissioned Silver Horn to produce a new series of pictures on plain paper suitable for photomechanical reproduction. In the introduction to the unpublished manuscript that he eventually prepared, he described the production of the illustrations. "He was familiar with the tales from childhood, and drew the pictures for them off by himself somewhere in the mountains, without any direction or prompting other than a request from me, for example, to 'draw some Sinday pictures' " (Scott ca. 1920a:iv). This romantic image of native inspiration unsullied by white influence may have applied quite accurately to the production of the images in the Target Record book, but it cannot be accepted for the commissioned

pictures. In an earlier draft of the manuscript, Scott noted that his request for the pictures was "without other suggestion than that he might leave out those unfit to print" (Scott MS 2932). Scott well recognized that certain stories, such as "Saynday and the Flatulent Root," would be considered indelicate by the non-Indian audience who would read the book. Scott's censorship is also evident in the way Saynday is depicted. In the earlier set of drawings, he is shown with his penis coiled two or three times around his waist, while in the set made for publication this detail is omitted and he appears modestly clad in a breechcloth. It is also likely that Scott requested illustrations to go with the stories that he had previously recorded. All of the pictures in the commissioned set match stories recorded in his notes, although Silver Horn's earlier pictures include other stories.

While Silver Horn explored new visual territory, his work remained grounded within existing domains of both storytelling and narrative art. These stories, whether mythical, historical, or imaginary, were part of a communal heritage and could be told by anyone. By logical extension, the right to illustrate them was equally open. If, as Parsons suggested, there were restrictions surrounding stories of the Twin Boys, they did not extend to visual representations, for Silver Horn produced many images of them, long before he himself became a guardian of one of the bundles. Yet he stopped his illustrations short of their transformation into the Tsaidetalyi, just as he did not produce illustrations of ceremonial activities associated with this aspect of Kiowa religion.

Prohibitions about when Saynday stories could be told did not prevent Silver Horn from representing that strange character. While verbal performance is ephemeral, visual representations are enduring and inherently transcend the time of their production. We do not know when the early works were made, but Silver Horn produced the drawings that Scott commissioned in November, an acceptable season for talking about Saynday, and they could have been drawn at night. Once produced, however, they were available to be viewed at any time. Verbal and visual narratives were clearly perceived as separate. Attitudes toward them may perhaps be likened to current attitudes toward the tape-recording of Saynday stories. Some traditionalists will not tell Saynday stories except at appropriate times and seasons, yet have no objection to the stories being recorded for later play-back. The original performance is clearly separable from a representation of it.

Silver Horn also had to work from an established visual tradition. Kiowa art, grounded in pictures of warfare, was created to tell stories, but coup stories and their associated pictures were focused on a climactic moment. The new narratives that Silver Horn took up had a different structure. They consisted of a series

of events unfolding in linear fashion. He was presented with the challenge of how to represent in graphic form a sequenced and perhaps lengthy narrative, and he developed a repertoire of techniques for their presentation. First, he continued and expanded conventions that had been developed for coup narratives. As in the battle pictures, he relied heavily on footprints to show the course of events. To convey further information in complex scenes, he differentiated the tracks to conform to the specifics of the animal, so that we find buffalo tracks, wolf tracks, even rabbit tracks, in addition to the usual dashed lines of human prints and hooks for horse hooves. A charming addition is the use of hand prints to show where an individual has climbed a tree. Whereas the old ledger artists had fitted their narratives to a single or at most facing pages, Silver Horn produced a number of multipage story illustrations. While he was capable of economically telling much of a story with a single image, he experimented with illustrating some stories incrementally, allowing the sequence of events to unfold slowly over many pages. Another format that he used extensively in the Target Record book was illustrating a story on two facing pages. Like the two-page compositions of earlier ledger art, the pictures shared a common base at the gutter line, so that the book had to be rotated to move from one page to the next. Unlike the older structure, however, each was a complete picture of a part of the story, rather than two parts of a single image. Many of these two-page illustrations were combined into a single picture when he later reworked them for Scott. In these, he used a form of time compression in which the same figure appeared twice on a single page, representing two episodes or stages of the story—a virtual double exposure. Like the oral forms on which they were based, most of his story images are stripped to the essentials of character and action. Elements of landscape are included only if relevant to the narrative, and the rich details of clothing and coiffure so prominent in his works in other genres are absent here.

Silver Horn's approach to the illustration of myths changed over time. The lengthiest and most detailed illustrations appear in the Field Museum books, which represent his earliest experiments with the topic. Most of the sequences of pictures appear there, echoing the series of illustrations in the same books of the stages of the Peyote ceremony. These books were a place for experimentation with new ideas and modes of representation. The stories of Saynday make their appearance in the Target Record book, produced soon after but in a very different social context. This book was passed around among the Fort Sill scouts, and the joking stories of Saynday and his various antics must have been a source of general amusement. These were pictures made for fun. In the drawings for Scott, Silver Horn learned to adapt the traditional stories to suit the needs of an outside patron. Saynday was "cleaned up," and the stories were carefully selected to

cover the basic foundations of Kiowa world view. The Westernized drawings in this set, however, mark a distinct change in Silver Horn's approach to narrative illustration. In this set alone, he has included elements extraneous to the story. Not limiting himself to the story as told, he experimented with the introduction of nonessential elements of landscape and portraiture. The hide painting made for Mooney marks another departure from the concept of art as narrative. On it, characters are presented in isolation rather than within the context of the story. In Silver Horn's final representation of myth, the Pomona College hide, he returned to storytelling, but presented a series of episodes from different stories rather than illustrating any story in full. These final two works allude to the oral tradition rather than follow it. The visual and verbal traditions remained connected, but more loosely than before. In these late works, Silver Horn had moved to a pattern that artists of the twentieth century have continued, in which art looks to the oral literature for inspiration but does not try to replicate its storytelling function.

Only one other, unknown Kiowa artist explored this same territory in the nineteenth century. James Mooney acquired a group of twenty drawings of myths sometime after 1891, including pictures of the Twin Boys stories that he published in his *Calendar History,* as well as other tales (Mooney MS 2531, 2).[13] He did not record the name of the artist or why the pictures were made. The artist may have chosen the topic himself, or Mooney, who provided the drawing material, may have commissioned the pictures. Drawings of folktales from other Plains tribes are equally scarce before the twentieth century. The earliest ones with which I am familiar are the pictures by an unidentified Lakota artist that appear in the 1916 publication *Myths and Legends of the Sioux* (McLaughlin 1916). By the middle of the twentieth century, however, scenes from traditional stories were produced by many artists. Various tribal versions of the trickster were particularly popular, such as Albert Racine's images of the Blackfoot Napi and Richard West's pictures of the Cheyenne version, Vehoe. Among the Kiowas, artists have continued to envision Sayday based on their own family oral traditions, and versions by Roland Whitehorse, Bartell Littlechief, and Sharon Ahtone Harjo differ enormously (Marriott 1947; Boyd 1983).

Storytelling is a performance art, in which a personal interpretation of the story is imparted through elements of style, providing drama or humor through delivery as well as through the words of the narrative. This interpretive element is largely lost in the bare transcripts set down by Scott, Parsons, and Harrington. Silver Horn as a visual narrator, however, was able to transcend this recording difficulty, and his images are alive with drama and humor. How his children must have struggled to stay awake to hear just one more story!

Chapter 7

Marking Time: The Calendars

Plains pictorial art was a means of record keeping as well as storytelling, and Silver Horn produced masterful records that marked the passage of time. One record, an annual calendar, continued an established tradition of Kiowa graphic art. The other, a pictorial diary, was his own unique creation. There was a long custom of calendar keeping within his family, but Silver Horn transformed the mnemonic record with his lavish illustrations. The keeping of a diary was a new concept, and he worked without precedent to craft both its content and its form. In these two documents, he approached picture writing more closely than in any of his other work. Although many figures display his beautiful draftsmanship, in these pages he was not interested in overall composition but in clearly marking a series of events. In the process, he also left a remarkable record of how he conceptualized time.

The pictorial calendars of the Kiowas have been well known since James Mooney's *Calendar History of the Kiowa Indians* appeared in 1898. The calendars that he described consisted of a series of pictures representing events of each summer and winter over a number of years. The name of each season corresponded to the picture, thus creating a shared system of reference to past years. Events were placed in time by reference to the name of the season in which they occurred, such as the "Winter That Crow Neck Died" or the "Summer of the Double Sun Dance." Everyone would know approximately when that had taken place, or the pictorial calendar could be consulted to establish the date with certainty. The calendars thus served primarily as tools for establishing the sequence of events carried in the oral tradition, rather than as independent or complete historical records. The events chosen to name each season were not necessarily those of great moment but rather distinctive ones of common knowledge. As Mooney (1898:146) noted, an event would be chosen "for its value as a tally date rather than for its intrinsic importance." When men gathered for "peace smokes" to pass the pipe and recite stories of war or other historical occurrences, they brought out the calendar for reference in resolving controversies about the timing of events (Mooney 1898:144; Quoetone 1968b:1, 7).

Mooney based his calendar study upon the three annual counts and one monthly count that he learned about in the course of his early years among the Kiowas. The two most complete counts, those kept by

Tohausen (and later Agiati; fig. 1.14) and Settan, began with the winter of 1832–33, while the Anko count began in 1863–64. All of them were continued to the summer of 1892, when Mooney was carrying out his study. He got information directly from Settan and Anko about their calendars, while his knowledge of the Tohausen record was based on notes lent to him by Hugh L. Scott. Scott had purchased this calendar from its current keeper, Silver Horn's father, Agiati (nephew of the older Tohausen), who interpreted it for him up to the year 1867. He was too old and ill to complete the recording process, and Tahbone provided explanations for the remaining years (Scott 1894). Mooney (1898:144) believed that the Tohausen calendar was the oldest of the three and that the Settan version was directly derived from it. The two were nearly identical in form and content. Both were drawn with colored pencils on manila paper in the form of a heavy line spiraling inward in a clockwise direction toward the center of the sheet, with each season marker and picture appearing above the line. Winter pictures were associated with a black bar. Summer pictures included a representation of the Medicine Lodge, a drawing of the full lodge or of the forked center pole only. In years when the Medicine Lodge ceremony was not held, the summer picture was inserted alone between winter marks or was represented by a tree in leaf. In contrast, the Anko calendar placed the vertical black winter bars side by side across the center of the page with the winter pictures below. The forked Medicine Lodge poles were drawn between the tops of the bars, with the summer pictures above. Anko also varied somewhat from Tohausen and Settan in the pictures and year names that he chose to distinguish each season.

The single monthly calendar that Mooney learned of was also produced by Anko. It consisted of a series of upturned crescents, representing the "moons" or lunar months, placed side by side from left to right across facing pages of a small pocket notebook.[1] The line of moons curved down and around in the start of a spiral where it reached the right-hand margin of the page. This monthly calendar covered the period from August 1889 to July 1892. Some crescents were marked with pictures of events, at times in association with hash marks to indicate the day of the moon on which the event took place. Other moons were marked with symbols representing the Kiowa name for that month, such as "Ten Colds Moon" (September–October) or "Geese Going Moon" (November–December) (Mooney 1898:368).

Since the time of Mooney's publication, many other Kiowa calendars have come to light in public and private collections, and several are still retained by Kiowa families. Information on only a few of these has been published. For example, Alice Marriott (1947:292–305) published a text of the year names used in three calendars based on interviews she conducted in the 1930s, but she did not provide any illustrations or describe the form of these records. Another calendar drawn lineally on a long strip of muslin was

published in a series of articles by Hugh Corwin (1967, 1968, 1971a, 1971b, 1975). It was reportedly maintained by Ananti, the daughter (or possibly granddaughter) of Tohausen I, making it a unique example of pictorial art by a nineteenth-century Kiowa woman.

It seems surprising that so thorough a scholar as Mooney found only three or four calendars while so many have since been located. Mooney's study itself apparently contributed to an explosion in calendar keeping, however. His extensive interviews stimulated wide discussion about calendars, and his generous distribution of his book in the Kiowa community placed copies of the calendars in many hands. In 1911, Mooney wrote to a colleague that his work with the calendars had "given rise to several others in the tribe since its publication & discussion in my several years work among them, when it was under daily consultation" (Mooney 1911).

By the start of the twentieth century, there were several separate calendar traditions maintained in different Kiowa families. Many of the designations were the same, but there were also variations based on different experiences or on different judgments as to what was memorable. These differences among the calendar traditions became more marked for the years after 1892, the final year covered in Mooney's publication. As Jacob Ahtone, whose father kept a calendar, explained to me, many people relied on Mooney's book for knowledge of early events and accepted it as an authoritative source. For the years it did not cover, each family was free to chose events it deemed most appropriate.

The Annual Calendar

Silver Horn's family maintained the most prominent and oldest calendar tradition in the tribe. Tohausen had initiated calendar keeping among the Kiowas. His nephew Agiati succeeded him in the role of calendar keeper, and Agiati was followed by his son Silver Horn. Silver Horn continued keeping a calendar record as long as his vision permitted. His family remembers that when he was an old man he had one calendar recorded in a large book and another one on a long strip of cloth. Silver Horn's older brother Haba was also a calendar keeper, and it was probably from Haba that Silver Horn learned calendar work rather than from their father (J. Silverhorn 1967a:29). While Silver Horn evidently produced a number of calendars over the years, the only one whose location is known today is in the National Anthropological Archives at the Smithsonian Institution (Mooney MS 2531, 7).

In 1904, Silver Horn placed this beautiful pictorial calendar on the leaves of a blank book for James

Mooney (plates 33, 34). It was one that he made for Mooney rather than one that he had kept for some time, as the covers of the volume are identical to another blank book that Mooney took to the field with him that year. The calendar is slightly longer than Agiati's, covering the years from 1828 to 1904, although for the first four years only the summers are indicated. The pictures are in pen and ink with watercolor wash. The years proceed through the book from front to back, with each page reading left to right and both sides of each leaf filled. Winters are indicated by a sketch of a bare tree, while the designation for summer is the forked center pole of the Medicine Lodge with the oblong bundle of the buffalo effigy draped across it. A tree in leaf replaces the center pole for summers when the Medicine Lodge ceremony was not held. There is no consistent scale to the seasonal representations. A single season might take up an entire page, or six seasons might be fitted into the same space, depending on the scale and complexity of the accompanying pictorial images.

The pictures in the calendar are beautifully executed and highly detailed, strikingly different from the Agiati/Tohausen calendar (fig. 1.14) as well as the Settan and Anko calendars published in Mooney's *Calendar History* (fig. 7.1). Aside from the different devices for noting the seasons, the accompanying pictorial images are both more extensive and more detailed. Often season marks are surrounded with a whole suite of images representing different events. Many of the drawings are so detailed that, with only a general familiarity with the pictorial conventions that Silver Horn employed, they can almost be read without knowledge of the associated oral tradition. The Agiati drawings, in contrast, are quite simple and clearly served as a mnemonic aid in support of a primarily oral tradition. Once Agiati himself was no longer available to interpret them, Tahbone and the other men who assisted Scott with the calendar were only able to make informed guesses about the meaning of some of the pictures, even though they concerned relatively recent years and they had no doubt heard them explained in the past (Scott 1894).

Several types of events recur in Silver Horn's calendar, and he developed consistent conventions to represent them. Name glyphs, found nowhere else in Silver Horn's work, are used frequently, sometimes connected by a wavy line to a drawing of the person named, but often standing alone as a representation of that individual (fig. 7.2). Births are noted by an image of a cradleboard, often connected to a name glyph. Deaths are indicated by showing a bullet about to strike the person or by the picture of an owl connected to the person's name glyph. Owls are widely associated with concepts of death, and among the Kiowas they carried away the spirit of a person who died. Silver Horn's death bird is the great horned owl. In a few of his drawings, the tufted horns of the owl appear on the head of the person whose death is noted, merging

the deceased and the spirit carrier into one image. Many summers are named for the place where the Medicine Lodge camp was located, and Silver Horn represents these with clarity, producing a graphic of the place name rather than attempting a realistic picture of the landscape. For example, the Arkansas River, known to the Kiowas as Flint River, is denoted by a band of water with arrowheads drawn on it (fig. 7.3). Wolf Creek is drawn as a stream with a wolf next to it (plate 4), and Timber Hill is shown as a mound with many trees.

7.1. Entries from the calendars of Agiati, Settan, and Silver Horn for 1860, the Summer That Bird Appearing Died.

7.2. Calendar page covering winter 1868–69 through summer 1869.
Winter events include the birth of Wild Horse Colt's son, the arrest of Settainti (represented by his medicine lance), the release of Lone Wolf from prison, and the death of the Cheyenne leader Black Kettle. The summer shows the war bonnet that Big Bow captured from the Utes.
MS 2531. Courtesy of the National Anthropological Archives, Smithsonian Institution.

7.3. Calendar page covering summer 1883 through summer 1884.
The first summer's events include a visit by the Nez Perce (shown with prominent forelock) and the death of Heap of Bears (represented by an owl surrounded by many bear tracks). In the winter, the first grass money was received, payment for leasing land to cattle ranchers. The following summer, no Medicine Lodge was held, as indicated by a tree in leaf rather than the lodge center pole; Kiowa men hauled freight from the Arkansas River, which they called the Flint River (marked by arrow heads); and a woman was struck and killed by lightning, shown emanating from the wings of the thunderbird.
MS 2531. Courtesy of the National Anthropological Archives, Smithsonian Institution.

While Silver Horn included many images relating to warfare, none of these resemble coup pictures. Most are of a single figure rather than of combatants in action. When action is suggested, it is the recipient who is depicted, often with a bullet speeding toward him. Stories of coup, as the unique prerogatives of the warriors involved, were not appropriate for inclusion in the public record of the Kiowa calendar.

The Silver Horn calendar is accompanied by brief annotations written by James Mooney on the face of the drawings themselves. Mooney's handwriting, always difficult to decipher, is particularly so in these cramped notes, and he did not record information for all of the pictures (fig. 7.4).[2] The drawings can, however, be interpreted quite well by reference to other calendar sources. The most extensive text is that published by Mooney in the *Calendar History*, but the text that corresponds most closely to Silver Horn's images is the one for his brother Haba's calendar.

In 1909, five years after Mooney acquired the Silver Horn calendar, Mark Harrington purchased a calendar from Haba and, working through an interpreter, recorded Haba's explanation of the images on it. Harrington's notes are still preserved in the archives of the National Museum of the American Indian (Harrington 1909), although the original calendar can no longer be located. The text for the Haba record corresponds remarkably closely with the images on the Silver Horn calendar, demonstrating a strong link between the two. Of 139 seasonal entries appearing on both calendars, 134 record the same event or name. They correlate more closely with each other than either does with the calendar kept by their father, Agiati. Of the 111 seasonal entries the Agiati and Silver Horn calendars share, only 67 agree. The level of correspondence is about the same for the years for which Agiati provided explanations and for the years later interpreted by Tahbone. Haba was Silver Horn's teacher and mentor in many areas, and Silver Horn's son James believed that calendar making was one of the things that his father had learned from his older brother.

Silver Horn's calendar was not, however, identical to Haba's in content. Silver Horn often included more events for each year in his calendar than his brother did. He seems to have used Haba's calendar as a starting point, including all that it contained, but then adding further information. Mooney reported several instances where a summer or a winter was known by two different names. While Haba and other calendar keepers chose a single image from the alternatives, Silver Horn usually incorporated both into his pictorial record. He also added many other elements, such as births and deaths. Silver Horn's work is also strikingly different visually from that of other calendar keepers. His images go far beyond the basic year name mnemonic of the other calendars to represent a visual compilation of many things that occurred in

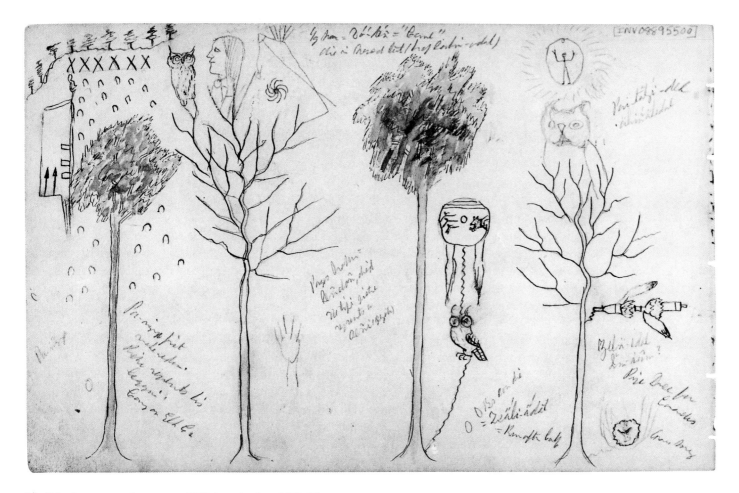

7.4. Calendar page covering summer 1888 through winter 1889–90.
No Medicine Lodge was held either year. The first summer, the followers of Paingya (represented by his medicine legging) assembled on Elk Creek. The next winter records the death of Sendon, a Peyote man, as indicated by the Peyote whorl on a tipi. The following summer, Stumbling Bear's son died, shown by a picture of the father's shield in connection with the owl. In the winter of 1889–90, Sun Boy died, the Comanches gave the Pipe Dance to the Kiowas, and grass money was paid again.
MS 2531. Courtesy of the National Anthropological Archives, Smithsonian Institution.

that season. While other calendars were a framework around which a rich oral narrative could be arranged, such as that which formed the foundation for Mooney's *Calendar History*, Silver Horn's calendar sought to illustrate that narrative as completely as possible.

The Pictorial Diary

Silver Horn was following an established cultural tradition in the production of his seasonal calendar, but another calendric record that he produced was unique. It is a daily calendar in the form of a pictorial diary (figs. 7.5 through 7.7; plate 35). Drawn on the ruled pages of a military Target Record book, it constitutes a detailed record of the passage of days and weeks illustrated with numerous tiny drawings of the events that distinguished them. Although Silver Horn began the calendar while he was serving in Troop L, Hugh Scott only learned of it while visiting Silver Horn a few years after he had left the army. It was the only daily calendar that Scott had ever seen, and he asked Silver Horn to make a copy of it for him. Instead, Silver Horn offered it as a gift in appreciation of the generous treatment he had received from Scott while serving with him. Feeling that it was too valuable an item to accept outright, Scott paid him $20. The early parts of the calendar record the years that Silver Horn served in Troop L under Scott's command, and the events were familiar and commonplace enough that Scott saw no need to write down an interpretation of them. He later described them as "just what happened to him as a soldier," leaving the document to speak for itself (Scott MS 4252). For the modern viewer, deciphering the once-routine events that the calendar depicts presents a significant challenge, but the results provide a graphic chart of how Silver Horn perceived time.

The calendar occupies thirty pages near the end of the bound volume. It begins near the back of the book, with subsequent entries moving toward the front. The entries on each page are drawn in a serpentine form, known as boustrophedon, so that the first line is read from left to right, the second from right to left, and so on, alternating direction with each line. A squiggly line connects the end of each line to the start of the next. The book, which was originally vertical in format, was turned sideways for production, so that each line of entries runs across the page between the original top and bottom. Entries are read from top to bottom, and facing pages are treated as a single unit. This format was evidently invented by Silver Horn after some experimentation, which appears on the first two pages of the calendar. In these, the book was turned upside down, and linear entries were made across the width of the two facing pages, beginning

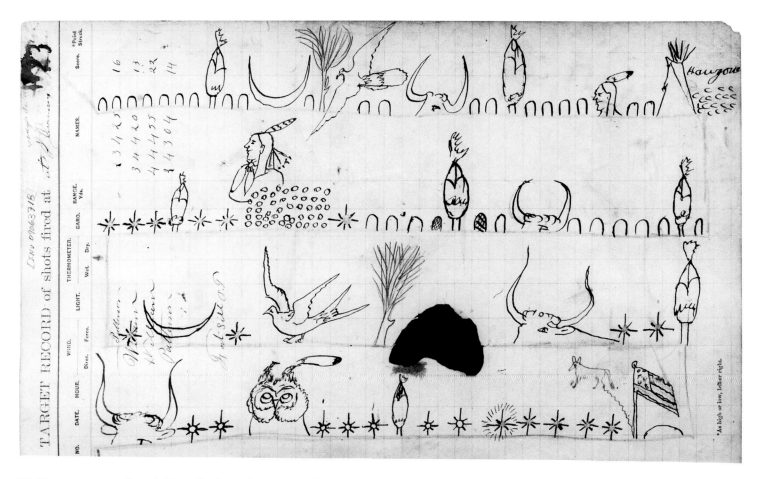

7.5. Diary page covering the period from October to December 1894.
Silver Horn consistently used feather markers for weeks, cattle markers for two-week ration issues, and bird markers for months, but he varied day markers somewhat. On this page, the change from the use of inverted Us to stars corresponds with his discharge from the army on November 23, 1894. He has pictured himself in civilian dress with many coins, representing funds withheld from his salary for payment at discharge.
MS 4252. Courtesy of the National Anthropological Archives, Smithsonian Institution.

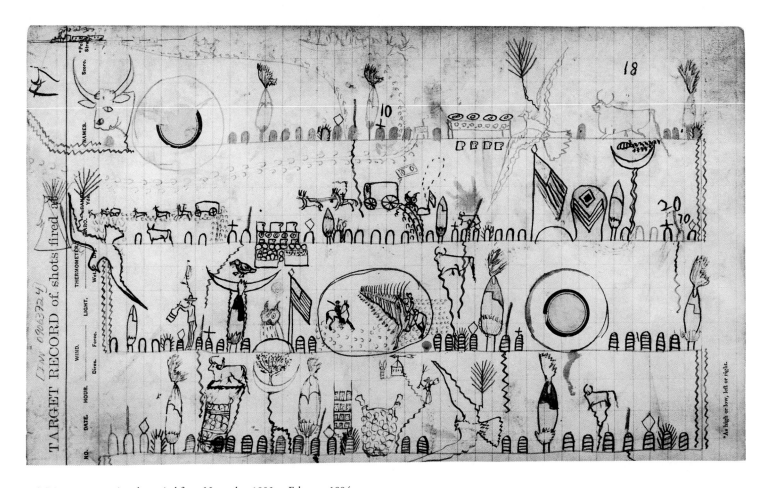

7.6. Diary page covering the period from November 1893 to February 1894.
Some pictures suggest the names of the lunar months. The crescent moon in the second line has a V of migrating geese with it, while the moon in the bottom line is flanked by a tree in leaf. Thanksgiving is shown on the top line by a table with plates and cups, and Christmas is similarly indicated on the second line. Many calendar entries note troop activities—providing escort to pay wagons, mounted dress review, and an infraction by the bugler.
MS 4252. Courtesy of the National Anthropological Archives, Smithsonian Institution.

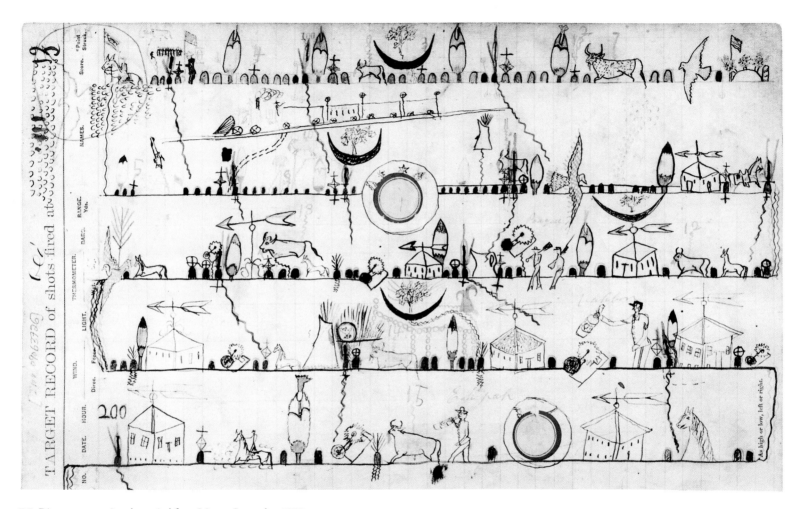

7.7. Diary page covering the period from May to September 1893.
The Fort Sill guard house with its weathervane appears several times, as does the great toothed saw of the post lumbermill. The Moon of Deer Horns Dropping Off is marked by curved horns next to a crescent and tree just to the right of the tipi in the fourth line.
MS 4252. Courtesy of the National Anthropological Archives, Smithsonian Institution.

at the bottom of the newly defined surface and working up. The four lines of entries all read from left to right, with the squiggly line connecting them leading diagonally from the end of each row across the width of the page up to the start of the new line. Once Silver Horn settled on the boustrophedon, top to bottom method, he recopied these entries into the new format, which he continued throughout the remainder of the calendar.

The calendar covers the period from January 1893 to June 1897. Like many diarists before and since, Silver Horn made copious pictorial entries in the early portion of the record, but was less enthusiastic about maintaining the diary in later years. Nevertheless, he faithfully marked at least the passage of days and weeks up to the time that he gave the ledger book to Scott.

The most prominent markers on the calendar are upright feathers, which are used to define the weeks. These are tail feathers of the golden eagle, adorned with downy fluff feathers at the base and the tip as though prepared for ceremonial use. They represent the feathers worn by Ghost Dancers. The Kiowa historian Parker McKenzie, who examined the diary with me, considered them a particularly appropriate weekly divider because the dance, known among the Kiowas as the One Feather Dance, was held on Sundays. Between each pair of feathers are seven daily marks plus a variety of pictures recording specific events. Silver Horn began each week with Monday and ended with Sunday. The marks used for days vary through the calendar. An inverted U form was used for the early part of the record, sometimes filled in with color or otherwise elaborated (figs. 7.6, 7.7). About a third of the way into the record, corresponding to the date Silver Horn left the army, the day marks change to an eight-armed "star" composed of four intersecting lines. The star varies at times, when the two diagonal lines are drawn as squiggles or are omitted altogether.

Certain pictures appear regularly. A drawing of a longhorn steer appears every two weeks, placed two days before the week's end. This represents ration day, commonly referred to as the "beef issue," which took place on alternate Fridays. Flour, sugar, coffee, and other items of food that had become staples of the reservation diet were issued together with beef "on the hoof," rangy longhorns that the recipients killed and butchered themselves.

Another entry appearing regularly is an upturned crescent, representing the "moon" or lunar month of traditional Kiowa reckoning. An additional image is sometimes placed above the crescent, alluding to the name of the month. The names for each moon, as recorded by Mooney (1898:368–69), do not lend themselves to unambiguous representation. Four separate month names refer to the migrations of geese,

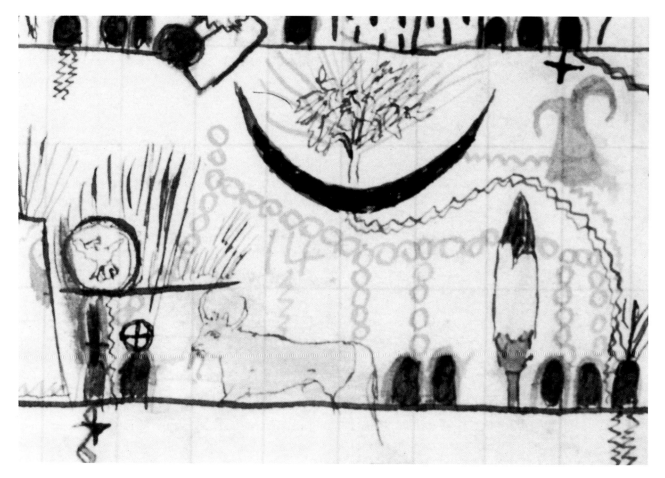

7.8. Detail of diary page shown in full in figure 7.7, showing the stacked coins of the "grass money" payment. MS 4252. Courtesy of the National Anthropological Archives, Smithsonian Institution.

three to the progression of leaf growth, and two to deer shedding their antlers. Both a summer and winter month share the name "Aganti," translated as "I Am Coming," and another of the twelve lunar months is known as "Ten Colds." Silver Horn represented twenty-nine moons on his calendar, covering a period of twenty-seven months. Nine of these have no symbol other than the crescent, while thirteen of the remaining twenty show a tree in leaf. Only four have associated images of birds, while a shed antler joins the leafy tree image to indicate the "Moon of Deer Horns Dropping" (fig. 7.8). Ten stroke marks above one crescent suggest the name "Ten Colds," and the month known as "I Am Coming" is represented once by feathers hanging from the crescent. The feather device was also used by Anko to indicate this moon on his monthly calendar, as the initial syllable of the month name is the same as the word for feather (Mooney 1898:373).

The crescents do not appear in Silver Horn's diary at fixed intervals, ranging anywhere from twenty-four to thirty-five days apart (except for one nine-week period where the moon indicator was totally omitted). In general, Silver Horn arranged them so that there were twelve moons each year, corresponding to the cycle described by Mooney. He was clearly not relying on direct lunar observation, which would have been regular in cycle and resulted in thirteen moons to the solar year. This is not surprising, as Mooney indicates a fair amount of flexibility in the Kiowa system, which at least in the 1890s was based on convention rather than astronomical calculation. In May 1895, after months of drawing simple crescents in the diary without further embellishment, Silver Horn ceased noting the moons altogether.

Another figure appearing regularly on the calendar is the image of a bird, usually with wings outstretched, flying from right to left (fig. 7.9). A count of the days between birds establishes that they represent the start of each month as defined by the Western calendar. Over the course of the nearly five years that the calendar covers, Silver Horn was quite consistent in his placement of the month markers, observing variation in the number of days each month, including one leap year. His choice of marker suggests his connection to the Western monthly calendar system. Army personnel were at that time paid monthly in cash with coins embossed with an eagle. As Towana Spivey, director of the Fort Sill Museum, pointed out, "when the eagle flies" is still military slang for payday. In the late years of the calendar, when Silver Horn marked few particular events, the monthly flying bird was continued consistently, together with the weekly feather marker and the biweekly beef issue.[3]

January 1893, the start of the diary, was nearly a year and a half into Silver Horn's enlistment, and many of the early pictorial images relate to his military life. A small square building, with its hipped roof

surmounted by a weathervane, appears often. When I visited Fort Sill and asked Towana Spivey if he could identify the building, he suggested I look out the window. The drawing is a good likeness of the guard house, which still sports the same vane, although now the building houses museum exhibits rather than

7.9. Detail of diary page, showing the flying bird that Silver Horn used as a standard month marker. MS 4252. Courtesy of the National Anthropological Archives, Smithsonian Institution.

prisoners. The guard house was a point where troops were often called to muster, but I have not been able to figure out why it was drawn on certain days. Pictures of a large circular saw appear frequently, indicating days when the troops worked at the post lumber mill. There are many representations of target practice, at which Silver Horn excelled, according to his sons. Several images depict scouts who were court-martialed and punished for breaches of military discipline. A bottle in the hand often indicates the cause of the infraction, although a few shootings are also shown. Scott noted that he had fewer discipline problems in Troop L than with comparable white units that he had commanded, and the infrequency of their occurrence together with their consistent notation in army muster rolls made such events useful markers in helping me to correlate Silver Horn's calendar with Western calendar dates. Someone, perhaps one of the Carlisle-educated scouts, wrote the names of a few individuals next to some of the pictures. Thus Tabbahorty's conviction for drunkenness on April 22, 1893, which was labeled on the calendar as well as noted with a date in the muster rolls, served as a firm reference point that aided in deciphering the dating of the calendar.

As in his annual calendar, Silver Horn recorded both births and deaths in his pictorial diary. Some of the deaths are of fellow scouts, while others are of individuals who do not appear on the muster rolls of the troop. Also as in the annual calendar, the great horned owl is used to represent death. Other deaths, however, show a casket draped with the American flag or a low mound topped with a cross or a flag. The death of Yellow Buffalo, an Arapaho scout who died on February 10, 1893, appears on both the initial trial pages and the redrawn pages where Silver Horn transferred information into the new boustrophedon format. The first version shows the flag-draped casket, while an owl appears in the second version instead. Births are indicated with a tiny cradleboard, much as they appear in the annual calendar.

Silver Horn's diary or daily calendar is a remarkable and unique document evidently created on his own initiative to serve his own interests. Some precedent for such a type of personal record may be seen in the Anko monthly calendar. While the Anko calendar is organized by months, it includes notations to indicate the day of the month on which various events occurred, thus providing a finer-grained record of time. The calendar that is conceptually closest to Silver Horn's diary is the record that was kept by another Kiowa man, Gaukein ("Ten"). Two very similar versions of the Gaukein calendar have been preserved, one at the Panhandle-Plains Museum and the other at the Fort Sill Museum. Both calendars are drawn on long narrow strips of cotton cloth and consist of a continuous line with short vertical marks to indicate the days, with a taller crossed bar dividing them into groupings of seven (fig. 7.10). Small pictures are added occa-

sionally along the line, but there are few of them, often weeks apart. It is not known when the calendars were produced (the museums purchased theirs in the 1960s), and they have not as yet been correlated with the Western calendar system, although many clearly represent events of the reservation years. Like the Tohausen and Settan annual calendars, the Gaukein record must have been largely a sequencing or counting mechanism used in conjunction with other sources of knowledge. Silver Horn's diary, in contrast, while it no doubt served these functions, also provided a much richer illustration of daily life, including both more frequent and more detailed pictures. Until the Gaukein calendar is more fully deciphered, it is difficult to compare its content with that of Silver Horn's diary, but one striking difference is readily apparent. Silver Horn, a religious traditionalist, used the Ghost Dance feather as his weekly marker, while Gaukein, a Christian convert who was a leader of the Cedar Creek Mission, used the Christian cross.

Silver Horn's diary dramatically illustrates the extent to which he and other Kiowa people were already enmeshed in Western modes of conceptualizing time. New units had been added to the former referents of days, moons, seasons, and years. Days were grouped into weeks, which were divided by Sunday, known as "medicine day." Unlike the Western calendar, however, Silver Horn made Sunday the last rather than the first day of each week. Another additional unit of time was the two-week period of the beef issue, which gained its own Kiowa term, "pago konakan," translated as one end or series of nights (Mooney 1898:365). Mooney noted that special terms had developed for Western holidays that Kiowa people were encouraged to observe. Christmas was "Pia kiada" (Feast Day) and the Fourth of July was known as "Tsankia kiada" (Racing Day). These are appropriately noted in Silver Horn's diary with a picture of a table laden with food on December 25 and a rider whipping his speeding horse on July 4.

In describing Kiowa terms for units of time, Mooney (1898:365) presented months and moons as synonymous. Silver Horn's diary, however, demonstrates that he saw them as distinct. The diary begins with the two cycles running independently, one of crescent moons and the other of flying birds. The former is somewhat variable in length, depending perhaps on the rate of progression of natural seasonal phenomena. The latter is correlated with the Western calendar, providing for months of twenty-eight, thirty, or thirty-one days, following traditions deriving from the Roman era. Over the course of the calendar, these two cycles eventually came into correspondence, and for a few months Silver Horn placed the marks for the two side by side. Soon he abandoned the moon marking, retaining only the monthly eagle. Mammon had displaced Luna!

Silver Horn's diary is clear testimony of the extent to which concepts of time and money (or other

7.10. Detail of a calendar or diary kept by Gaukein on which crosses are used to divide the days into weeks.
Occasional pictures appear in the upper margin.
Gaukein, n.d. Courtesy of the Fort Sill Museum, Fort Sill, Oklahoma.

material resources) had become connected for the reservation Kiowas. The rhythm of the year had once been governed by the seasons, with their variability from year to year, the movements of the bison, and the summer gathering for the Medicine Lodge ceremony, timed to correspond with the best pasturage and omitted altogether in drought years. Now life was locked into a routine of great predictability, with the biweekly beef issue as a central organizing principle. Twice a year "grass money" was dispersed, payment for leasing a part of the reservation to cattle ranchers to graze their herds (fig. 7.8). Silver Horn carefully recorded these payments in both his daily and annual calendars with pictures of coins surrounded by grass. He was one of the few Kiowas fortunate enough to find cash employment, and army payday, "when the eagle flies," became another way to mark the passage of time. When he enlisted, Silver Horn, together with other recruits, arranged to have a portion of his monthly pay withheld to be paid in a lump sum at the time of discharge. His diary marks that date with an image of himself in civilian dress above many rows of circles representing coins. Silver Horn's recognition of the important connection between time and money in Western culture continued in his later work for James Mooney. Mooney paid him periodically for his illustrations based on the number of days he worked, and Silver Horn's calendric notations appear along the edges of some drawings where he kept record of the time for which he was due payment (fig. 7.11).

More traditional concepts of time are not, however, completely absent from his diary. As noted, the moons appear through the first twenty-seven months of the record. And after the first few pages, the monthly eagles are accompanied by the image of a tree, its foliage varying to indicate the passage of the seasons. Throughout the calendar, a variety of symbols are appended to the day marks. In one lengthy section, a simple cross appears on the top of each tenth day mark. Ten was the basic unit of the Kiowa counting system, and this must indicate where someone was interested in counting the passage of time by a meaningful traditional unit rather than by the confusing welter of weeks and issues and months that had been imposed as a part of reservation life.

Silver Horn's annual calendar was much more firmly rooted in an established tradition than was his daily record and consequently offered less room for innovation. The weight of history provided a stabilizing effect on the content of the calendar, although Silver Horn found plenty of scope for creativity in his methods of illustration. He included pictures of all the events he knew to be associated with each season rather than only those for which it was named. The extensive use of name glyphs, seldom seen elsewhere in his artwork, facilitates the identification of drawings and brings it closer to picture writing than any of his other works. Some additions to content, however, mark the calendar as a product of its times. Notations

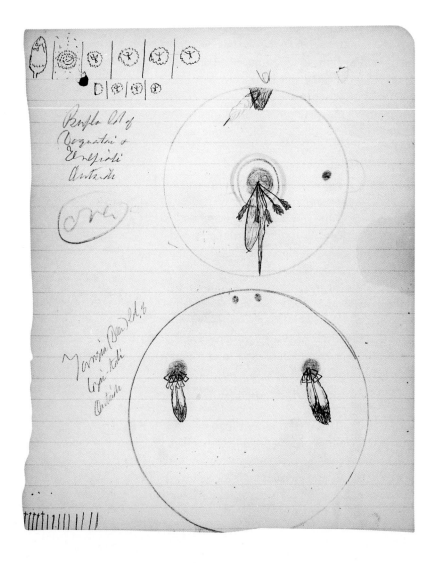

7.11. Calendric marginalia made by Silver Horn to track payments due for the days he worked for James Mooney. MS 2538. Courtesy of the National Anthropological Archives, Smithsonian Institution.

of the deaths of prominent people appear in all of the Kiowa calendars. Silver Horn included the births of many individuals as well, far exceeding his brother Haba in this respect, who recorded only the births of his own children. Elderly Kiowa people interviewed in the 1960s felt that one reason for the proliferation of calendars in the reservation years was the sudden need for people to establish their age for various agency requirements (Quoetone 1968b:3). Agency and other government officials were not comfortable relying on oral testimony, but were prepared to accept the "written" evidence of the pictorial calendars. As recently as the 1930s, a calendar made by Silver Horn was lost when it was borrowed by a man trying to establish his eligibility for social security benefits (Quoetone 1968a:4). Silver Horn's inclusion of such information in his 1904 calendar indicates a similar need for birth records at that time.

The two calendars, the daily and the annual, with only a decade separating their production, differ in background and in the reasons for their creation. The daily diary was a unique innovation, created by Silver Horn for his personal use and maintained over a period of years. The annual calendar was a continuation of an established tradition, produced in a short period under commission as a copy of one that he kept. Both records are distinctly Kiowa products, but each in its own way is revealing of the pervasive influence of white constructs of time on reservation people. Both records were tools that Kiowa people used to operate in that environment.

Chapter 8

Visions on Shields and Tipis: Kiowa Heraldry

One of the most highly valued possessions in Kiowa society was the supernatural aid, or "medicine," received in a visionary encounter with the spirit world. As a token of such an encounter, a man might obtain a design to be painted upon his shield or tipi cover. Painted tipis brought blessings to those who lived encircled by the design on the sloping walls, while images on shields provided a means to invoke spiritual protection in war. The colors and abstract elements of designs were symbolically associated with aspects of the power source; additional pictorial images or attached materials, such as feathers or claws, made more direct reference to the spirit world. Some men painted their own designs, while others employed a talented artist to do so under their supervision. Although the use of shields in warfare had ended by the time Silver Horn reached adulthood, he undoubtedly painted more shield designs than any Kiowa artist of previous generations. Working in conjunction with the Smithsonian anthropologist James Mooney, he created a comprehensive and enduring record of a centuries-old heritage of Kiowa visionary art (fig. 8.1; plates 36 and 37).

About one-fifth of Kiowa tipis were painted with visionary designs and represented the elite residences of the tribe. While prestigious, they also carried obligations that could become onerous over time. Some came with spiritual prohibitions against certain kinds of foods. All came with social expectations of keeping up appearances. Buffalo hide tipis lasted only a year or two in regular use. They become weather-stained or rotten around the bottom where they were staked to the ground. Poor people might get by with cutting off the bottom and making do for another year with a smaller tipi, but a prestigious painted cover demanded regular renewal. Although the cover was subject to decay, the design itself was enduring and could readily be reproduced on a new cover as long as the individual owned the right to it. A design might lapse for a time and not be painted on a cover, but the owner still held the rights to the design and could renew it whenever he or she chose. Families sought to maintain control of designs as objects of status and to pass them on only to others related by birth or marriage. A design might be owned by a series of people over the course of its history. Some people held designs for so long a time that they were named for them, such as Red Tipi Man. Other designs were transferred more frequently, passing through a series of relatives.

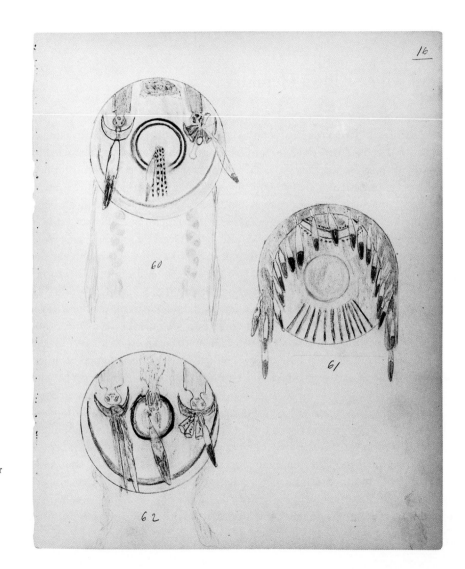

8.1. Illustration of two versions of the outer cover and one version of the inner cover of the red shield of Akopti ("Timber Mountain").
Other medicine items associated with this shield are shown in plate 1.
MS 2531. Courtesy of the National Anthropological Archives, Smithsonian Institution.

Shield designs were a powerful source of protection in warfare. A shield typically consisted of several parts. The base of the shield was a rawhide disk sixteen to twenty inches in diameter, made of hide from the hump of a buffalo bull and processed with heat and moisture to shrink and further thicken it. The thick, dense base provided physical protection against arrows or even bullets from early firearms, and a man who did not have access to a medicine shield might carry an unpainted one. Most of the protective power, however, came from spiritual sources as represented by the painted designs. Some Plains people painted the rawhide shield base itself, but the Kiowas placed their designs on the buckskin covers. Usually there were two covers, an outer one that was visible at any time and an inner one that was exposed only when the shield was in use. A series of attachments or trimmings was often placed on the shield, such as bells, tinklers, feathers, dewclaws, or other parts of animals, each item having reference to some aspect of the spiritual powers to be evoked.

Shield designs, like tipi designs, were transferable, but they were also replicable. The original vision often gave authority for the power to be divided so that multiple copies of a shield could be made and used simultaneously, most often four. All of the individuals who received one of these had the right to pass the power and the shield design on to a new owner when they were ready to relinquish their ownership of it. In other instances, such as the Bird Shields, later revelations gave the owners new authority to divide the power yet again and distribute additional shields (Mooney MS 1878). While any man might seek to obtain power directly from a supernatural source, not all were successful in their quests. Most of the shields in use derived from the vision encounters of relatively few individuals, replicated and dispersed through the community through transfer to brothers, sons, and nephews. As with tipis, the design and the power were enduring, and a lost or damaged shield could be replaced.

The shield complex ended abruptly for the Kiowas in 1874 with the termination of warfare on the Southern Plains. Many shields were confiscated as armaments at the Kiowa surrender and burned. Others were disposed of by their owners—abandoned to the elements, buried with family members, given away, or sold. By the 1890s, very few shields remained in Kiowa hands. Painted tipis also fell into disuse after confinement to the reservation, although some designs were painted on canvas covers for a few years after buffalo hides were no longer available. The Medicine Lodge camp circle had been the prime opportunity to display painted tipis, each of which held a designated position. With the disruption of the religious gathering that had served as a central organizing force in Kiowa social life, there must have seemed little point in continuing to renew tipis as they wore out. Designs were still owned, but there were few

occasions worthy of their display. The last painted tipi in regular use among the Kiowas was the Tipi with Battle Pictures, and it too lapsed into disuse with the death of its owner, Silver Horn's father, around 1893.[1]

James Mooney's Heraldry Project

James Mooney learned of the importance of shield and tipi designs early in his association with the Kiowas and began making notes on what he soon came to call his "heraldry project." He found discussions of these designs to be a vehicle for access to many aspects of Kiowa knowledge—social organization, history, religion, symbolism, mythology, medicine, the laws of descent and heredity, and name systems. Indeed his notes on a single tipi design might touch on all of these areas (Mooney MS 2531, 1, MS 4733; Mooney 1902d). Much as he had used the calendar system as a framework for organizing Kiowa history, he felt that the heraldic system could be a key to understanding social organization. His vision of the potential of heraldry studies is most clearly stated in the label copy he wrote for an 1897 exhibition (Mooney, Old labels file, Box 10):

> Two of the mechanisms for perpetuating law were especially prominent; one was a system of arranging the family habitations (skin tents or tipis) in a definite form known as the camping circle; the other was a system of heraldry . . .
>
> The central feature of the camping circle is a "medicine lodge" or "sun temple"; about this the tipis of the suntribes [sic] are erected in fixed and invariable order, by which family and tribal precedence and all other individual and collective rights and duties are expressed . . . The arrangement of the various features of the circle is memorized by the tribesmen, and serves as a scheme for establishing reciprocal rights and duties among the various individuals of the tribe, not only in the circle, but on other occasions, i.e., the circle itself is a kind of technic statute of such simplicity as easily to be remembered.
>
> The heraldic system comprises a series of symbolic shields representing mystical orders. These shields are sacred, they are regarded as possessing supernatural potency, and but a single individual is regarded as qualified to make and exhibit the tutelar symbol. These shields are erected on symbolically decorated tripods in connection with the tipis, and many of the tipis are themselves decorated with hieroglyphic markings.
>
> The various symbols combine with the arrangement of the camping circle to form a material code of law, easily memorized through constant association, and easily handed down from generation to generation by recollection of distinct forms and figures as well as by oral tradition.

In this text, Mooney presented the tipis as the primary model of Kiowa social organization. Later, however, he came to focus more on the shields as the organizing principle in Kiowa society. While he used the term "heraldry" for both shields and tipis, it was particularly with regard to shield designs that the term expressed the parallel he saw between the Kiowa system and the European system of family coats of arms. "We have here a prevailing custom which was rapidly crystallizing into a tribal law under which the shield would have become the hereditary crest and family coat of arms and badge of common ancestry" (Mooney MS 1878). Through extensive study of the distribution of various shield types, he was able to establish that they usually circulated among family members, often over two or three generations. He postulated that the Kiowa shield system had originated around the time that they acquired the horse and became engaged in mounted warfare, which he estimated to have been around the close of the sixteenth century. It had developed over the course of two and one-half centuries until the Kiowas were overwhelmed by white society. Had the system continued undisturbed for another century, he felt that the parallel to the European system would have been complete. Shield designs would have become tightly identified with specific families, serving much as family crests.

Mooney studied Kiowa heraldry off and on for over a decade, but never brought his studies to conclusion and publication. He had clearly established that the clan system, once proclaimed as the universal organizing principle of all Native American societies, did not exist among the Kiowas, but he struggled to arrive at an alternate explanation of social organization. The heraldic system, based as it was on rules of descent and linked to the recognized band system, seemed promising. Yet he was never able to mesh the heraldic tipis with the heraldic shields to create an overall explanatory model of Kiowa social structure.

While Mooney never published his heraldry studies, he assembled a substantial body of notes and a phenomenal visual record. Shields and tipis are visual media, and Mooney recognized the necessity of expanding his methods of study to incorporate new techniques for their recording. He sought out the few old shields that still survived and purchased those that he could. He made notes on shields that were in the hands of other collectors and photographed the last few Kiowa shield owners, showing each with his shield, headdress, and other items of war medicine. Most of the shields, however, had long since been lost. At the time when he went to work with the Kiowas, only a single painted tipi remained in use in the tribe, and the designs on it were so faded as to be nearly indistinguishable.

To record these shield and tipi designs, Mooney had to orchestrate their re-creation based on the memories of Kiowa people. He struck upon two methods of doing so. One was to employ native artists to make

drawings of the designs (plate 38), a technique already employed by other BAE scientists to record information about cultural activities no longer practiced (Ewers 1983). The other method was the construction of models of the shields and tipis. Mooney was committed to interpreting anthropological research to the public and recognized that models would make a striking exhibit. He prepared a formal outline of his concept for such display, which centered on the systematic presentation of a single culture in fine detail (Mooney MS 4788). In addition to broad coverage of all aspects of the material culture through single, representative specimens, selected topics should be covered in depth. For the Kiowas, that topic would be the heraldic system as represented in the shields and tipis. Part of Mooney's plan was that the models should be made by members of the culture that they represented in order to enhance their interest for the public as well as to increase their scientific value. This was a departure from established museum practice, which relied upon museum preparators for the construction of models. Such artisans worked under the supervision of a curator, creating visual representations of things they had never themselves seen in accordance with verbal instructions. Mooney's conception of model construction was quite different.

In 1891, Mooney had his first tipi model constructed as part of his collecting efforts for the World Columbian Exposition to be held in Chicago in 1893. The Bureau of American Ethnology had a special appropriation to acquire collections for an exhibition there, and Mooney was able to assemble and purchase an important collection of Kiowa material. Many of the items represented things currently in use by the Kiowas, but Parker McKenzie told me that his mother-in-law and other craftspeople were commissioned to produce older-style items that were no longer in use. Among the items included in the exhibit was a model of Big Bow's tipi.

Many other models followed. In 1892, Mooney returned to the Smithsonian with forty-six shield models for the collection of the U.S. National Museum. These consisted of painted buckskin covers stretched over thin rawhide disks seven and one-half inches in diameter. The visionary designs were painted on their surfaces, as were representations of the various trimmings and medicine objects associated with the shield, such as feathers, dewclaws, or horsehair appendages. Mooney's notes reveal almost nothing about how these models were obtained and who made them, but his next venture into model-making is much better documented. In 1894 and 1895, he turned his attention to tipis, this time including both the Kiowas and the associated Plains Apaches in his study. His notes record the identity of the makers of most of the models as well as something about his methods of work. Writing from his base camp with Gaapiatan's family near Mount Scott in the Wichita Mountains, Mooney reported that the tipi work

involved "travel over every part of the reservation in order to negotiate with each person or family represented, as, owing to the 'medicin,' no man wil [sic] make, or talk at length about, another's tipi" (Mooney MS 4733). Information recorded about the makers supports this claim. A great number of individuals are represented, and each was usually a member of the family of the most recent owner. In spite of working with so many different people, not only to record information about the tipi designs but also to secure their services as painters, by the end of 1895, Mooney had been able to assemble models of forty out of the fifty designs that he believed had once existed (Mooney MS 4733). It must have been with great pride that he personally oversaw the installation of twenty-three of the tipi models and a few of the shield models at the Tennessee Centennial Exposition in Nashville in 1897. The Trans-Mississippi and International Exposition held in Omaha in 1898 was considerably less satisfactory as an opportunity for public education, but again he was able to display his wonderful models, albeit only briefly.[2]

In 1901, Mooney's heraldry studies entered a new era, in which Silver Horn played a major role. Some years previously, Mooney had met George Dorsey, a rising young anthropologist who became the curator of anthropology at the Field Columbian Museum. Together they developed a joint project between the Field Museum and the Bureau of American Ethnology to collaborate in building their collections of Southern Plains material. The BAE would fund Mooney for an extended period of fieldwork in Oklahoma Territory, and the Field Museum would provide financial and logistical support. The Field Museum would receive a "first class" collection of exhibit material from the Southern Cheyennes, and Mooney would be able to study Cheyenne heraldry as well as extend his Kiowa work.

In December 1901, Mooney proceeded to the field, this time accompanied by his young wife, Ione, with greater financial support than ever before. He set up his headquarters in an unused government house at Mount Scott and immediately began construction of a partially roofed canvas shelter, known as the "corral," in which model-making on a substantial scale could proceed. Now able to pay Kiowa people for their knowledge, he could invite them to visit him at his headquarters to be interviewed rather than chase about the reservation. He was also able to employ a regular artist, and he wrote to the bureau with great satisfaction that he had the best artist in the tribe under regular employment (Mooney 1902b).

Silver Horn's calendar entry for the winter of 1901–2 records the start of his work on the project. Mooney had long had the idea of seeking out the finest artist of the tribe, and Silver Horn had been brought to his attention as early as 1893 when Mooney made a note to himself for future reference, "Best Kiowa painter = Hangut now a soldier" (Mooney MS 1887). For years, however, he had not had funds to

hire both an artist and an interpreter and had to rely upon individuals such as Paul Setkopte and Belo Cozad who could perform dual services. The earliest drawings marked with Silver Horn's name and date found in Mooney's vast and often disorganized notes are inscribed February 1902 (plate 38).

In addition to having Silver Horn produce drawings on paper of shield designs and their associated medicine as dictated by former owners, Mooney initiated work on a new series of shield models. Evidently dissatisfied with the original series with their two-dimensional representations of attachments and often indifferent painting, he established a new standard and started over on the whole series. Uniform blanks consisting of a buckskin cover and a rawhide backing were built upon a flanged foundation of galvanized iron six and one-half inches in diameter, eliminating earlier problems with warping of the foundation. Details such as feathers, bells, and dewclaws were now applied in miniature. The materials were almost all supplied by George Dorsey, and their correspondence reveals that Mooney kept him hopping on the rounds of the Chicago dealers in hides and millinery supplies. Some ingenuity was required to find items of suitable scale. Hog "toe nails," for example, were finally settled upon as the best material to represent bison dewclaws in miniature, although with the definite drawback that they became "rather fragrant" if the shipment from Chicago was long in coming. The most striking difference between this series of models and the previous one, however, is in the quality of the painting. Designs are drawn in fine detail, with geometric forms smoothly and boldly colored and representational images depicted with considerable naturalism (fig. 8.2; plates 36 and 37). Unlike his practice for the earlier tipi work, Mooney did not record the maker of each shield model, but noted in a letter that his artist (Silver Horn) "executed every model & painting of the collection excepting 4" (Mooney 1904c). The only model of this series known to have been made by another artist is the full-sized model of the Padogai shield, which was made by Padalti, Silver Horn's half-brother (Mooney MS 1897).

Silver Horn continued regular employment with Mooney through 1904. In addition to work on the shield models, he painted a few additional tipi models to round out the earlier series. Old tags written by Mooney establish that at least two, one Kiowa and one Apache, were produced by "Hangun" under the dictation of former owners or family members (fig. 8.3). Silver Horn's work extended beyond the heraldry project; during this time, he also produced the hide paintings of the Medicine Lodge ceremony, drew the pictorial calendar described in the previous chapter, and possibly applied his craft skills in producing models of other types of objects. Mooney employed Silver Horn because of his skills as an artist, but he also found him a source of information on many cultural topics, crediting him as the source in various notes

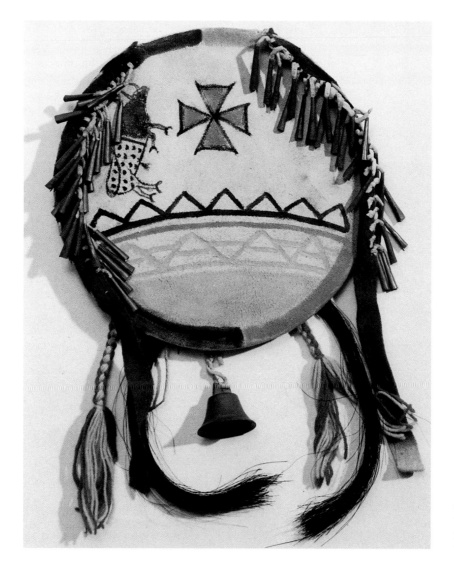

8.2. Model of the inner cover of the Cow Shield belonging to White Horse.
The model was copied directly from the original shield, which White Horse sold to James Mooney in 1892.
#229,839. Courtesy of the Department of Anthropology, National Museum of Natural History, Smithsonian Institution.

on shields and tipis (Mooney MS 2531). Often these notes are from joint interviews with Silver Horn and his older brother Haba or occasionally his younger brother Kogaitadal (James Waldo).

Silver Horn's work was prominently featured in a major exhibition at the Louisiana Purchase Exposition held in St. Louis in the summer of 1904 (fig. 8.4). The exhibit, entitled "Heraldry of the Kiowa Indians," included ninety shield models, five tipi models, and six paintings on buckskin, in addition to two original shields and a number of photographs of shield owners. The exhibition label, prepared by Mooney, concludes with the information: "All the models of shields and tipis as well as the paintings are the work

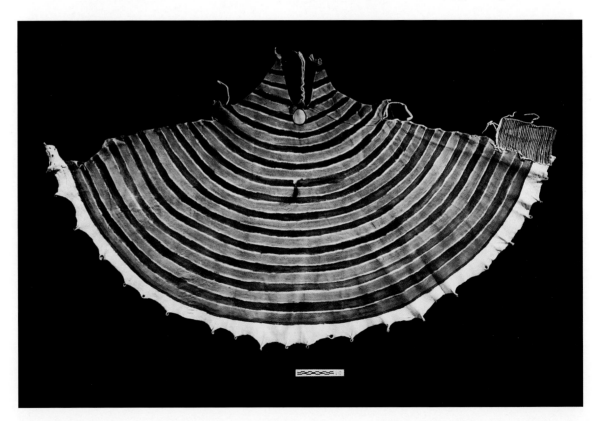

8.3. Model of the Black Stripe Tipi, which originated with Beaver Cap.
This is one of the few tipi models made by Silver Horn.
#245,018. Courtesy of the Department of Anthropology, National Museum of Natural History, Smithsonian Institution.

of a full-blood Kiowa Indian who speaks no English" (Mooney, Old label file, Box 10).[3] This minimal credit given the artist seems woefully inadequate by today's standards, but it is more than a non-Indian preparator would have received. The label was intended to attest to the authenticity of the product rather than to credit the artist for his creative work. Mooney reserved such individual recognition for the owners of the shield designs. The labels included their names with each shield, and several shield-owners were further identified with photographic portraits. The system of credits was thus in accordance with Kiowa rather than Western practice, with each shield or tipi design considered the product of its owner rather than of the painter who had reproduced it on buckskin.

Once the model work was under control, Mooney applied himself to organizing his notes on Kiowa heraldry, and Silver Horn was his close collaborator in this endeavor. By 1904, Mooney reported to the BAE, "I keep my artist constantly with me" (Mooney 1904b). Mooney systematically placed shield names in blank field books, and Silver Horn prepared finely detailed illustrations of each in the appropriate place (plate 39; Mooney MS 2531, 1, 12). Had Mooney's heraldry studies ever been published, Silver Horn's illustrations would have constituted a major feature of the book.

The models and drawings constitute a striking record of the corpus of Kiowa shield designs. They capture key elements of the iconography as well as the range of nuanced variations within each type, based on subsequent revelations to individual owners. A comparison with the few surviving original shields indicates that the proportions in the miniatures are not always true to their full-sized antecedents, but the basic elements are faithfully recorded, although the painting is finer and figures often more naturalistic. The Buffalo Shields, the most ancient of Kiowa designs, are here in a wide variety of forms, all united by the blue or green "eye" of the buffalo at the center. The Bird Shields are equally varied, but all show four dark spots smudged at the four directions on the outer cover. The Bear Shield, received from a member of the Crow tribe, and the Mescalero Shield, captured from an enemy of that tribe, were carefully recorded by Silver Horn, together with the Black Shield that Setdayaite was carrying when he was killed by the Utes and the Taime captured. Surely no other artist ever was privileged to paint the designs of so many noted Kiowa warriors.

When Mooney had entered into collaboration with the Field Museum, he had agreed to provide a collection of Cheyenne material. From the start, it was his intention to supplement a collection of original artifacts with a series of heraldic miniatures similar to those that he was preparing for the Kiowas. It is not clear to what extent Silver Horn was involved in this Cheyenne work. The earliest Cheyenne shield

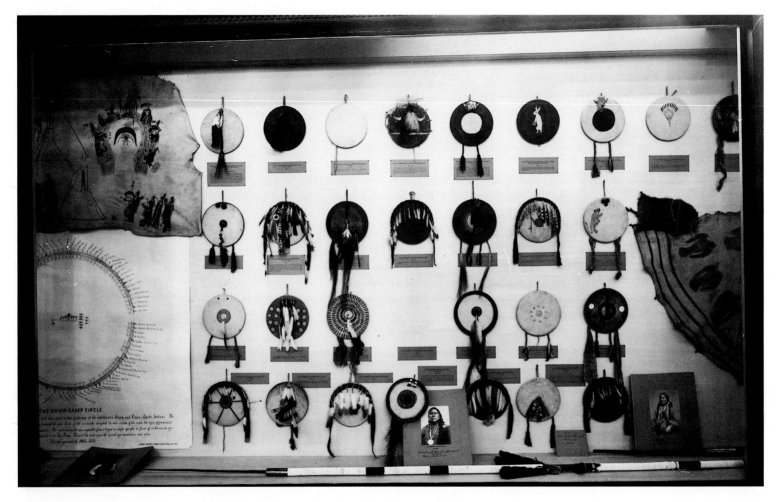

8.4. The Bureau of American Ethnology exhibit at the Louisiana Purchase Exposition in St. Louis.
This exhibit prominently featured Silver Horn's shield models and hide paintings, as well as a few tipi models made by other Kiowa people.
Photographer unknown, 1904. MS 2531. Courtesy of the National Anthropological Archives, Smithsonian Institution.

models were painted in 1902 by the Cheyenne Howling Wolf, while he was visiting Mooney's camp at Mount Scott (Mooney 1902a). The next year, Mooney began traveling through Cheyenne country north of the old Kiowa Reservation to gain community support for a project there, and in October he established a headquarters at Cantonment in a house provided by Rudolph Petter, a Mennonite missionary (Mooney 1903b). Blanks for both shield and tipi models continued to be prepared at the Mount Scott base and were then brought north to the Cheyenne headquarters for painting. As in his previous Kiowa work, Mooney interviewed large numbers of owners of shield and tipi designs and had drawings produced to their dictation (Mooney MS 2531, MS 2538). None of these drawings of Cheyenne materials now in the National Anthropological Archives are by Silver Horn. Mooney was easily able to locate and employ a number of skilled Cheyenne artists as early as 1902. Among the names inscribed on drawings, those of Hubbel Big Horse and Charles Murphy (Nakoimens or "Bear Wings") are particularly prominent, as is that of Carl Sweezey, an Arapaho.

Nevertheless, in the fall of 1903, Mooney took Silver Horn with him to the Cheyenne reservation to assist in work on the model series (Mooney 1903d). The nature of his work there is not well recorded, and additional research is needed to define the scope of his activities.[4] If Mooney continued true to his established methods, he would have relied primarily on Cheyenne artists for the painting of designs, with Silver Horn providing technical assistance. It is difficult to make stylistic attributions for the models that have purely geometric designs, but those that have representational images do not appear to be Silver Horn's work, with two exceptions. The model of High Back Wolf's shield, which was copied from the original in the collection of the Field Museum rather than produced from verbal report, is documented to have been painted by Silver Horn (Mooney MS 2531, 13), and the model of the pictorial tipi of Pocked Nose is stylistically similar to Silver Horn's work. Yet in March, Mooney wrote to the registrar of the Field Museum that he had brought a full-sized tipi cover and tipi liners to Mount Scott "to be painted by my Kiowa artist" (Mooney 1904b). The tipi, one that Mooney had hired a group of Cheyenne women to construct of native-tanned cowhides, was to be painted with the Bushy Head design of buffalo horns and tracks. The design, although finely painted, is too simple to allow for certain stylistic attribution. One of the two pictorial hide tipi liners that Mooney sent to the Field Museum, however, was clearly done by Silver Horn and corresponds closely to the figural style he employed on other hide paintings that he produced around the same time (fig. 8.5; cf. fig. 3.15). Mooney was pressed for time to make good on his commitment to the Field Museum, and the technique of painting on hide was difficult to master. It appears that he used

the services of his Kiowa artist as a shortcut, having him copy onto the hide scenes that had already been drawn on paper by Cheyenne artists, which have been retained in his papers (Mooney MS 2538). While the basic form and content of the images were carefully copied, Silver Horn's drawing style is quite different from that of the original Cheyenne artists. It seems that one of the best known and most beautiful of all "Cheyenne" hide paintings was produced by Silver Horn![5]

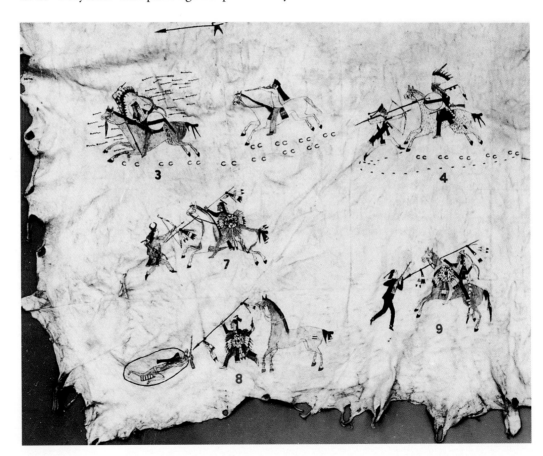

8.5. Detail of hide tipi liner with scenes of noted Cheyenne battles, commissioned by James Mooney.
Silver Horn produced these images from preliminary drawings made by Cheyenne artists, and the liner was previously assumed also to be by a Cheyenne artist.
#96,796. Courtesy of the Department of Anthropology, Field Museum of Natural History.

Mooney did not completely separate himself from his Kiowa work and devote himself to the Cheyenne project until February 1906, when he closed the Mount Scott headquarters and took up regular residence at Cantonment (Mooney 1906a). By this time, he had another pictorial tipi liner in progress, one for which Cheyenne artists deserve full credit (FMNH Cat. #96,808). In April of that year, he shipped to the Field Museum the fruits of his Cheyenne heraldry project, fifty model shields and eighteen tipi models, to join the full-sized painted cowhide tipi and liner that he had sent in 1904.

Although he worked for Mooney on a regular basis for only three years and irregularly for a few more, the experience made a significant impression on Silver Horn. His son Max remembered him speaking of it often. The project itself was one that Kiowa people found very rewarding, and Mooney was remembered both as a good employer and as a staunch supporter of Kiowa religious freedom, particularly the Peyote religion (Moses 1984). Although Silver Horn had been selling his drawings for many years, regular employment as an artist was a new experience, and it must have been both stimulating and satisfying. It gave him the opportunity to focus on his work as never before and to experiment with new materials and develop new techniques for pen and ink drawings on buckskin.

Heraldry at Home

Mooney's project was highly successful because it built directly upon patterns of artistic production already established within the community. There was precedent in Kiowa society for Silver Horn's role as a recorder of heraldic designs, and he himself had explored this territory prior to his employment with the Smithsonian project.

Shield and tipi designs were regularly depicted in Kiowa narrative art and served to identify the individuals shown. The representation of a shield alone, presented as an independent design rather than as an identifier for its owner, was almost unknown in Kiowa art. There was no reason in Kiowa society to produce such images in isolation rather than as part of a wider narrative. Pictures of painted tipis, however, appear occasionally in Kiowa art as the primary focus of a drawing. A fairly standardized mode of depiction was followed during the 1870s and 1880s, which included the tipi in full view with sufficient detail of the design presented to facilitate recognition, together with important regalia of the owner displayed on a pole outside or above the tipi. In some images, a shield on its tripod is included or the owner of the tipi himself is shown (plate 40).[6]

The skilled artist held an esteemed role in producing visionary art, and the owners of shield and tipi designs regularly employed artists to paint such images under their direction. In Mooney's original tipi model project, he had traveled widely to have individuals who held the rights to designs paint them for him. In his later shield work, he chose instead to have the owners of designs (or their heirs) visit him and direct his staff artist, Silver Horn, in their recording. Their knowledge was important, but their authorization to use the designs was essential. In producing these designs, Silver Horn was following an established artistic role. When a person wanted something painted, whether a Ghost Dance dress or a tipi cover, the most able artist was sought out and paid for his services. The heraldry project proceeded along exactly the same lines, with elderly shield and tipi owners directing Silver Horn in replicating their designs on paper, preparatory to later production of the models.

The models themselves, however, were intended for an unprecedented use—display at an exposition. At the turn of the century, there was of course no Kiowa tradition regarding museum exhibition, but the general concept of display was not a new one. "Dance shields," traditional designs painted upon nontraditional materials such as canvas or buckskin without any rawhide foundation, are known from the early years of the twentieth century and were probably already in use by the time of Mooney's work among the Kiowas.[7] No longer called upon for spiritual protection in war, the shield designs were still valued as symbols of honor and were displayed at dances and other secular occasions. The Kiowas were recontextualizing the heraldic designs from tokens of spiritual support to emblems of family prestige. Community concerns surrounding model production must have focused more on ownership and authorization than they did on religion.

Silver Horn's most detailed tipi pictures and those that most closely foreshadow the illustration work that he later did for Mooney are those that he produced for E. A. Burbank (fig. 8.6). Within a set of drawings that consists primarily of single-figure portraits of individuals and drawings of animals are six carefully delineated illustrations of Kiowa painted tipis, including the Tipi with Battle Pictures, which is shown in two views. The drawings were produced two or three years after Mooney's initial tipi model project. Silver Horn was not involved in Mooney's work at that time, but it undoubtedly generated substantial discussion within the Kiowa community about these no longer used designs.

Silver Horn was also making models of his family's heraldic devices before he went to work for Mooney. A beautiful miniature of the Tipi with Battle Pictures painted with scenes in Silver Horn's unmistakable style was acquired by Hugh Scott before he left Fort Sill in 1897. Tied to the tipi is a tiny model of the

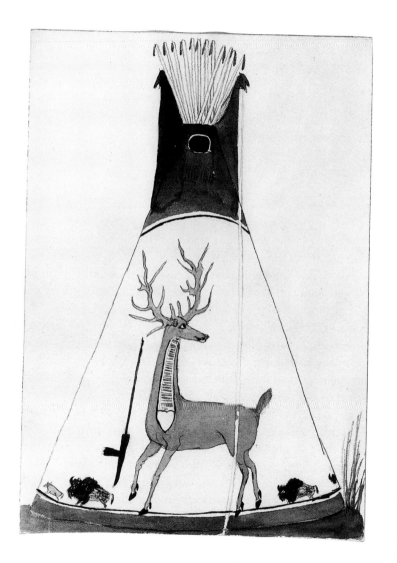

8.6. Back view of the Buffalo Tipi, which belonged to Never Got Shot.
Like the model made for Mooney, it shows an elk with heartline and one buffalo calf among the adult animals, but it differs in the way these animals are posed.
#106. Courtesy of the Newberry Library, E. E. Ayer Collection.

Padogai shield, once carried by his father and brother. Also in Scott's collection is a full-scale model of the same shield, perhaps also made by Silver Horn. (Both are described in the appendix.)

Silver Horn continued artistic production for another decade after his association with the heraldry project, but his later works, admittedly few in number, do not show any increase in the use of shield and tipi designs. No additional models by him are known. Silver Horn respected old patterns of ownership of heraldic designs, and few owners saw any place for the exercise of their prerogatives during the early years of the twentieth century.[8]

A Final Tipi

Silver Horn's involvement with heraldry, however, did not end with his work for James Mooney. His last and perhaps most magnificent tipi painting project was not a model but a full-sized version of the Tipi with Battle Pictures. Sometime around 1916, Silver Horn's brother Charley Buffalo (Oheltoint) sponsored a renewal of the Tipi with Battle Pictures. The design for this tipi had been held by members of their family since 1845, although it had not been used since the death of their father, Agiati, in the early 1890s. One side was painted with broad yellow and black stripes representing war expeditions. The other side was painted with battle scenes showing actual combat experiences of various Kiowa warriors. The scenes selected for inclusion might change with each renewal, based on the decision of the owner in consultation with other respected men. No warrior's deed, however, would be included without his permission, although the request was an honor and not likely to be refused. Charley Buffalo continued this tradition with his renewal. He sought to replicate not the identical form of the tipi as last used but rather the practice of inviting various warriors to give their deeds for representation on the cover. The renewal was a major event, including several days of feasting, reciting of coup, and painting. Many people gathered to hear the old warriors tell of their deeds, and stories of the event are still remembered by the descendants of those who participated. Painting of the war deeds as dictated by their owners was carried out by a group of artists, including Silver Horn, his brothers White Buffalo and James Waldo, and several other men (LaBarre et al. 1935:519). One side of the cover was again boldly striped, while the other was arrayed with a field of flying warriors, with each scene of combat carefully detailed although only a few inches high. That tipi cover no longer exists, but memory of it lives on (Greene 1993; Greene and Drescher 1994).[9]

The renewed tipi gave the family an opportunity to display its rank and prerogatives as well as

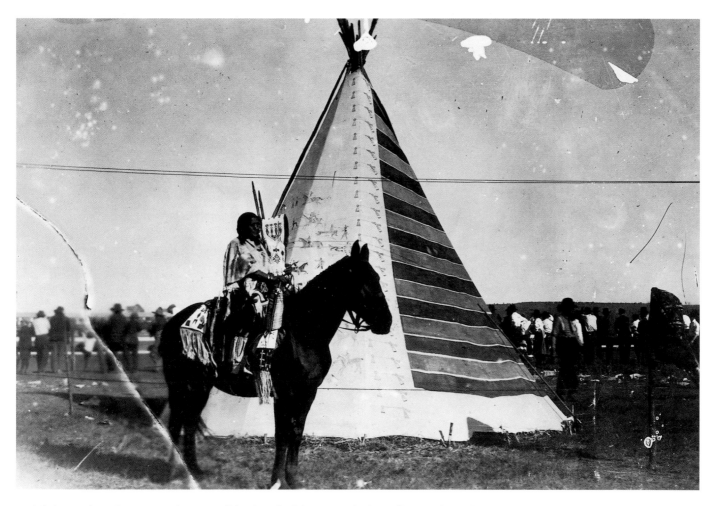

8.7. The Tipi with Battle Pictures with Mary Buffalo, the wife of the owner, Charley Buffalo, posed outside.
Several photographs were taken of the tipi on this occasion, but this image, although damaged, most clearly shows the battle scenes on the cover.
Photographer unknown, ca. 1916. Phillips Collection #715. Courtesy of the Western History Collections, University of Oklahoma.

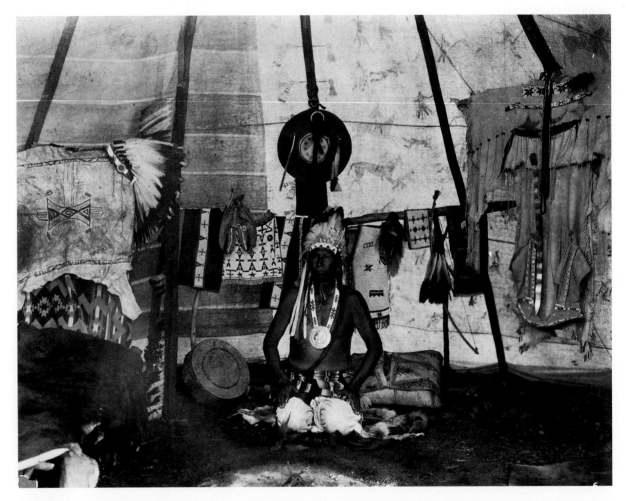

8.8. Interior view of the Tipi with Battle Pictures, as it appeared in the silent film *Daughter of the Dawn*.
In addition to the battle scenes on the cover, the photograph shows a version of the Padogai shield hanging in the center of the picture and a painted Ghost Dance dress on the right.
Photographer unknown, ca. 1916. Miller Collection, #4. Courtesy of the Museum of the Great Plains, Lawton, Oklahoma.

serving as an assertion of ethnic identity during a particularly oppressive period of forced assimilation by the Kiowa agency. It was displayed at various Indian gatherings, but photographs of it come from two more public settings. Several photographs of it at an Indian Fair show Charley Buffalo's wife, Mary, posing beside it on horseback (fig. 8.7). The best pictures of the tipi cover, however, date from its use in a 1917 silent film, *Daughter of the Dawn,* which featured an Indian cast and wide community participation in set production. The original film has evidently been lost, but a complete set of promotional still photographs has survived. The tipi cover is shown in some detail in one picture, in which the Indian heroine Ester LaBarr (no relation to Weston LaBarre) emerges from the tipi door to meet her beau, played by White Parker, a son of Quanah Parker. In another, her father, played by Hunting Horse, sits inside the tipi amid a display of tribal regalia, including a copy of the Padogai shield (fig. 8.8). The sun shining through the cloth cover reveals what are perhaps Silver Horn's last works of graphic art painted on the exterior.

Chapter 9

Scenes from Life

Silver Horn's grand themes were the subjects most valued by his society: the achievements and accouterments of war, the great religious ceremonies, the ancient stories enshrined in the mythic literature, and the calendar system that ordered the events of the secular world. But he also presented the traditional topics that so many ledger artists turned to during the reservation era—courtship, hunting, men and their adornments. These alternate areas of male achievement were a natural extension of an art developed to record male accomplishments. In Silver Horn's hands, these themes were expanded to become broader illustrations of Kiowa life.

Men and Women

Men were the producers of Plains graphic art as well as the primary audience for which it was intended, whether Indian or white. Women and their activities were seldom depicted, except as they intersected with men's interests. Women appear primarily in pictures of courting behavior, showing the rendezvous of a man and a woman. Courting scenes occur occasionally in early ledger art and were a mainstay of reservation production. The appearance of images of romance within the established warrior art tradition did not, however, necessarily signal men's increased interest in interpersonal relationships. Instead these pictures fit well into established concepts of art as a record of male victories, expanded to include sexual conquests—certainly more readily available than military achievements during the reservation years.[1] Courting scenes are always reserved, with the amorous nature of interaction implied through various conventions rather than explicitly shown. In some pictures, a man enfolds a woman within the blanket that he wears, a Plains courting custom less common among the Kiowas than among more northern tribes. In some pictures, the woman carries a pail for water or an axe for gathering wood. From the male perspective, both of these elements are suggestive of courting, for such tasks took women away from the supervised atmosphere of camp and provided men with opportunities to press their attentions upon them privately. Many pictures of men and women together, however, provide no such indicators, and the nature of their interaction must be interpreted through a wider knowledge of the art and culture.

Silver Horn produced many drawings showing encounters between men and women, as well as a few with multiple couples (plate 42). Some are classic courting scenes, with the identity of the couple hidden by their shared blanket (fig. 9.1), or a man similarly concealed waiting for a woman to emerge from a tipi door. More often, however, Silver Horn presented the figures in fancy dress, illustrating every element of clothing and horse gear with the loving attention of the craftsman. Bold figures proudly display elk tooth dresses, German silver concho belts, beaded and fringed leggings, engraved hair plates, and ribbonwork appliquéd saddle blankets (fig. 3.7). Horace Jones's caption to one such scene, identifying the figures as "Dude" and "Dude-ess," captures the essence of the dandified display that characterizes many of the pictures of couples. Some couples stand facing each other, but in many others one figure is on foot walking away while the other follows on horseback. The only evidence that these pictures are concerned with courtship is the absence of other activity. For the Kiowas, a man and a woman being alone together for no particular reason was sufficiently suggestive in itself.

Marriage was a major organizing factor in Kiowa society, not only linking a man and a woman, but also forming a bond between their two extended groups of kin. Ideally marriages were carefully arranged following the acceptance of a request and accompanying gifts from the man's family to the woman's kin. Such formalized marriages arranged by kin groups were often circumvented, however, and the couple suited themselves by simply eloping. After marriage, a woman was subject to her husband's authority. Fidelity was expected, but illicit liaisons were a subject of frequent gossip. If a husband were abusive, his wife could abandon him if she had male relatives to whom she could turn for support. Elopement with another man was an alternate, although riskier, way out of a bad marriage. If a marriage broke up, both parties usually found new partners, for Kiowa social as well as economic life was based on male-female partnership.

Courting, marriage, and elopement are often thought of as activities of the young, but this was not necessarily so. Men of wealth frequently had several wives and might continue to acquire new spouses throughout their lives. Marriages often dissolved through death or divorce, and many people married several times in their lives. "Wife stealing" also appears to have occurred with some frequency in the nineteenth century. It was a means for a man to assert his status and for a woman to escape an unhappy union. The elopement of a married woman with another man was a deep affront to the dignity of the discarded husband, who might pursue the eloping couple and attack either or both of them.[2]

The diverse nature of the social interactions conveniently glossed as "courting" in ledger art is revealed by the detailed captions accompanying Silver Horn's drawings in the Nelson-Atkins book. These

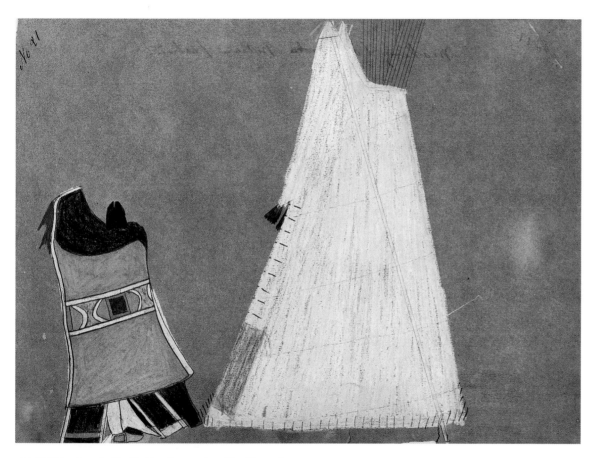

9.1. "Making Love Indian Fashion," as captioned by Horace Jones.
The courting couple stands next to a tipi, with the seams joining the canvas strips carefully drawn.
#1962.1. Courtesy of the Collection of the McNay Art Museum. Gift of Mrs. Terrell Bartlett.

drawings include more context and action and less attention to personal adornment than in Silver Horn's later pictures of men and women, and the captions reveal more complex stories. Several are of elopements with "maidens," but many others are scenes of wife stealing, either elopements or secret rendezvous (fig. 9.2). One graphically depicts the couple overtaken by the irate husband. The woman lies with her head bashed in, while her would-be lover flees for his life (fig. 9.3). The names of the participants in such

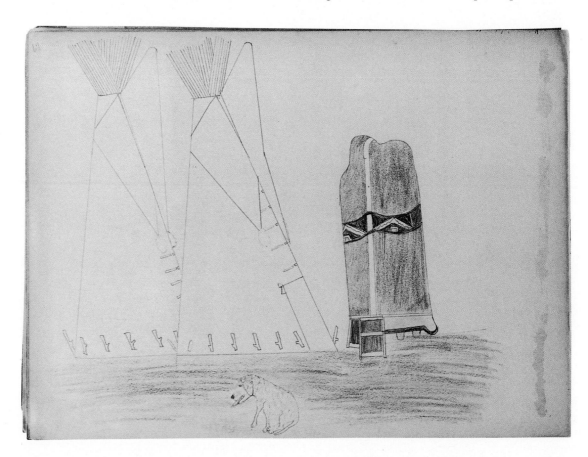

9.2. "Haun-pa Kiowa making love to Bo-in-cha's wife at the latter's camp at night," as captioned by D. P. Brown. *The sharp, ruler-drawn lines of the tipis contrast with the delicate sketching of the dog in the foreground, which has been given a bone to keep it quiet.*
#64.9. Courtesy of the Nelson-Atkins Museum of Art, Kansas City, Missouri. Gift of Mr. and Mrs. Dudley C. Brown.

scandals are fully recorded in Brown's captions, but perhaps it is as well that his atrocious attempts to spell Kiowa names make it almost impossible to guess who they might be. These are pictures drawn from camp gossip as much as from manly boasting.

Some of the scenes of men and women may well represent married couples rather than romantic encounters prior to marriage. The general significance of the picture would not, however, necessarily be different. Each proclaims a man's success in securing a woman, whether she be eligible maiden, virtuous spouse, or someone else's wife. Although the full nature of each story can never be known, Silver Horn's pictures do provide insight into Kiowa concepts of courtship. Securing a woman was a measure of male success and as such was worthy of pictorial recording. The sometimes startling juxtaposition of pictures of courting with bloody pictures of counting coup on successive pages of a drawing book would not have seemed strange to a Kiowa viewer of the time.

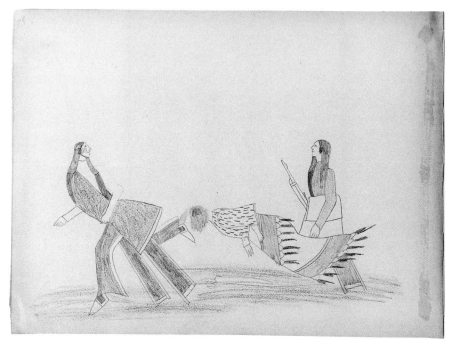

9.3. "Chane-doodle (Kiowa) overtaken after eloping with the wife of Tau-dome—Tau-dome killed his wife and takes all of Chane-doodle's clothing and ponies," as captioned by D. P. Brown.
The potentially violent results associated with wife stealing, shown here, belie the seeming tranquility of the "courting" scene in fig. 9.2.
#64.9. Courtesy of the Nelson-Atkins Museum of Art, Kansas City, Missouri. Gift of Mr. and Mrs. Dudley C. Brown.

Silver Horn's pictures record conquests but offer little insight into the nature of Kiowa marriage and domestic relations between the sexes. These were not subjects he (or other artists) considered suitable for the pictorial record. Only one of his drawings illustrates what might be a scene of domestic life. It shows a man with a heavy stick upraised, while a woman, with lines of speech pouring from her mouth, dodges to keep a tipi between the two of them (fig. 9.4). If this represented Silver Horn's idea of marriage, it is small wonder that he did not take a wife until he was over forty.

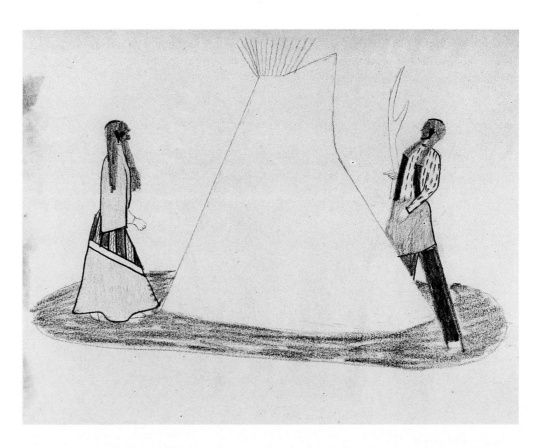

9.4. A woman, with speech pouring from her mouth, placing herself on the opposite side of a tipi from a man with a heavy stick. #67,719 (neg. A113181). Courtesy of the Department of Anthropology, Field Museum of Natural History.

Hunting

Hunting was another arena for male achievement that was often depicted in reservation-era art. In earlier days, hunting, together with the trade in horses, constituted the mainstay of the Kiowa economy. Buffalo were particularly important for meat as well as the heavy hides used for tipi covers and for robes, while deer and antelope provided finer skins for clothing. The availability of game of various types was a primary factor influencing where the Kiowas placed their camps and how often they moved them. Such mobility ended with confinement to the reservation, and the final extermination of the bison by professional hunters soon followed. The buffalo had disappeared from Kiowa country by 1879. People became dependent for food upon the rations issued every two weeks by the government agency, while canvas, muslin, and calico came to take the place of hides for tents and clothing. Only small game remained within the bounds of the reservation. Accounts of Troop L's activities at Fort Sill in the 1890s, such as those of Hugh Scott (1928) and Wilbur Nye (1943, 1962), tell of Kiowa soldiers often accompanying officers on hunting trips into the Wichita Mountains, and no doubt Indian people on the reservation similarly relied upon wild game to supplement their rations.

Like other artists of the time, Silver Horn produced a number of images of hunting; although this was not one of his favorite topics, his drawings provide an abundance of detail about Kiowa hunting practices, far beyond the scant information in the literature. He depicts a considerable range of game being pursued, from bison to ducks, and illustrates a variety of hunting techniques. Surprisingly, bison hunting, the mainstay of Plains artists as well as Plains hunters, does not dominate his work, nor are all hunts successful.

Buffalo and deer hunts appear in Silver Horn's pictures with about equal frequency. His pictures demonstrate that very different techniques were involved in their pursuit and quite different risks encountered. The deer hunters that he shows all employ firearms and often are positioned to shoot from cover, with the barrels of their weapons steadied on crossed sticks. In some pictures, deer hunters conceal themselves beneath wolf or coyote skin caps. One picture (fig. 9.5) provides a fascinating detailed view of a hunter stalking antelope, disguised beneath a complete pronghorn skin.

Buffalo hunting is presented as a very different proposition, with hunters shown on horseback armed with bows and arrows. Rather than depicting successful pursuit, however, the majority of Silver Horn's images of buffalo hunting show the hunter in grave danger as he is charged by a wounded animal. In some pictures, his horse is gored by the enraged animal, while in others he has already lost his mount and is about to be attacked (fig. 9.6).

Many of Silver Horn's drawings of hunting have a rich narrative quality, suggesting that they are illustrations of actual events rather than more generalized representations of a type of activity. Like pictures of warfare and of myths, these hunting scenes were probably based on stories that he had heard told. In three separate drawings, he depicted an incident in which a young man was surprised by an enemy while he was up a tree after bird eggs, with his gun left lying below. In others, he pictured men shooting bears—surely memorable events, as bears were spiritually dangerous animals with strong medicine and Kiowa people did not ordinarily hunt them. Other pictures are of remarkable events. One scene on a hide painting (fig. 6.14) shows a man shooting a deer and the bullet ricocheting off its skull to return and strike the hunter, surely a curious tale (Alexander 1938: plate 25).

9.5. A hunter camouflaged beneath an entire pronghorn skin with horns attached.
He has managed to kill two animals without alarming the others, one of which turns a curious gaze upon him.
#1994.430. Courtesy of the Museum of Fine Arts, Boston. Gift of the Grandchildren of Lucretia McIlvain Shoemaker and the M. and M. Karolik Fund.

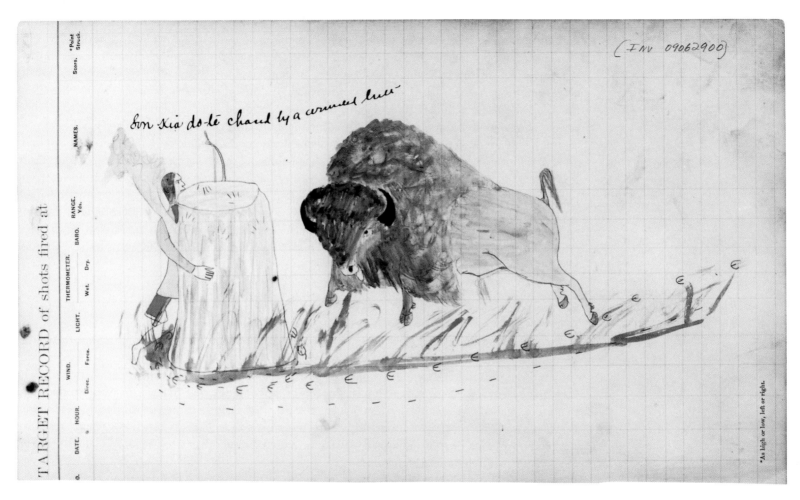

9.6. "Son-kia-do-te" (Sankadote) charged by a buffalo.
The prints of hooves, feet, and even hands reveal a lively chase around the tree stump.
MS 4252. Courtesy of the National Anthropological Archives, Smithsonian Institution.

Although Silver Horn was a keen shot, his pictures of hunting more often show the humorous rather than the triumphant aspects. One scene (fig. 9.6) graphically tells the story of a lively pursuit, in which a dismounted hunter dodges to keep a tree stump between himself and an angry buffalo. The accompanying inscription identifies the unfortunate hunter as "Son-kia-do-te." Sankadota no doubt survived the event, and his harrowing experience was transformed into the humorous story at his expense here illustrated by Silver Horn. Turkeys were a game item that continued to be available during the reservation period, and he produced several scenes of hunting these ungainly birds. In one (plate 41), a hunter concentrating his attention on a flock of turkeys flushes a much more desirable buck deer, which he has overlooked, from cover. It flashes across a corner of the picture and makes its escape before he can fire again. It is easy to imagine the delight with which these unfortunate hunters' comrades told such stories. Some pictures may be of Silver Horn's own stories, for his family says that he was a great teller of tales. Hugh Scott kept hunting dogs while he was at Fort Sill, and two drawings in the Target Record book (fig. 9.7) of dogs pursuing deer probably show his animals. The long-tailed, droop-eared hound following and periodically losing the looping track of a buck while his master trots along after him seems to have afforded Silver Horn a fair amount of amusement.

Portraits

Plains pictorial art was devoted to representations of people, but it was quite different from modern Western portraiture. The art was rooted in scenes of warfare, which portrayed the accomplishments of specific individuals. Even the crudest drawings sought to depict people in ways that identified them personally. The identifying elements, however, were not the aspects of face or figure that characterize Western traditions of portraiture. Rather, the emphasis was on distinctive personal accouterments, such as shields, headdresses, hair plates, or horse paint. Portraiture as an effort to capture a facial likeness, much less a character study, was unknown. A man was distinguished by what he achieved rather than what he looked like, and the art focused on recording those achievements.

As the repertoire of subjects in drawings expanded, pictures appeared of single male figures who were not engaged in any particular activity. The faces of these figures, often described as "parading dandies," were treated with minimal detail, each like every other produced by that artist, while items of personal dress that denoted wealth and prestige were carefully represented. In the earliest Southern Plains images, these

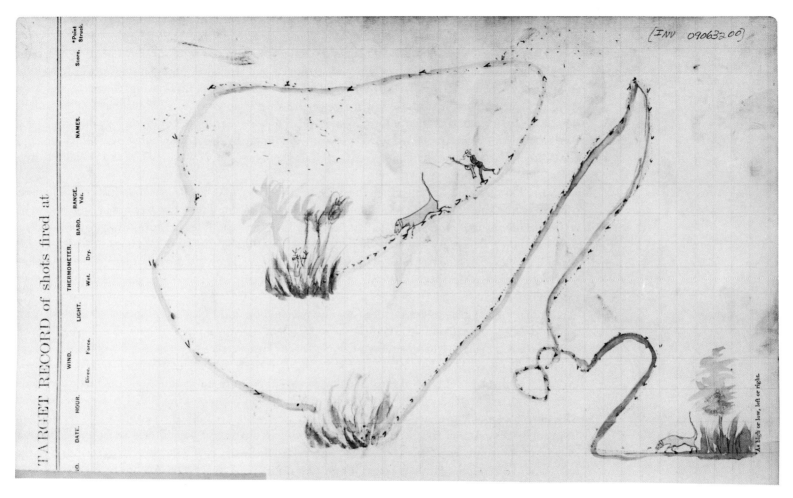

Along the left margin of the image (part of the printed form):

TARGET RECORD of shots fired at

NO. | DATE. | HOUR. | WIND. Direc. Force. | LIGHT. | THERMOMETER. Wet. Dry. | BARO. | RANGE, Yds. | NAMES. | Score. | *Point Struck.

[INV 09063200]

As high or low, left or right.

9.7. A looping trail of green highlighting the tracks of a deer, leading to a brushy grove in the center of the page.
A separate line of smaller tracks shows the course of the hunting dog that is tracking it. The dog occasionally loses the scent, but ultimately leads its master to where the deer is hidden.
MS 4252. Courtesy of the National Anthropological Archives, Smithsonian Institution.

were expensive trade goods (Greene 1997), while later, more finely detailed drawings lavished attention on flashy items of dress—calico print shirts, dangling silver earrings, and beaded leggings.

Most of Silver Horn's drawings of people show the same lack of regard for differentiation in face or physique. He drew facial profiles carefully and sensitively and struggled throughout his career to capture frontal views. There is little variation among the faces within any set of his drawings, however, and what there is relates more to the care invested in each picture than to an effort at individual representation. His human figures also consistently conform to an idealized tall, slender form. For example, a drawing of Big Bow (Zepkoeete) shows that noted warrior, identified not only by the caption but also by his painted tipi and peace medal, as a typically slim figure (fig. 9.8), although photographs show him as a massive, barrel-chested man.

Silver Horn carefully distinguished the physical appearance of only one person in his work. That was Mokeen, a Mexican captive who was adopted into the family of the Taime Keepers and in time rose to be an important religious functionary (LaBarre et al. 1935:280, 636). In Silver Horn's drawings, Mokeen is shown as shorter than other figures, with tightly curled short black hair (fig. 5.2). The same features identify him in one of the hide paintings of the Medicine Lodge ceremony produced for James Mooney (plate 18), where a captive Mexican woman who had a role in the ceremony is also distinguished from the Kiowa women by her wavy hair.

Yet in one set of drawings made for E. A. Burbank and now at the Newberry Library, Silver Horn went further than any other Plains artist of his time to represent individual physical variability. Burbank's own portrait studies, many produced at Fort Sill while Silver Horn watched, were based on a different concept of how to represent the individual. He encouraged Silver Horn to emulate him, and these drawings are the result. In them, Silver Horn experimented with various postures and produced figures that were seated or kneeling as well as standing on uneven ground or leaning upon a support (fig. 9.9). He also experimented with different facial angles, adding the three-quarter view to his established repertoire of profile and full front and back views. And he introduced some variation in physique. One full-face, waist-length portrait shows a man with the broad face and barrel-chest characteristic of many Southern Plains men. It is in the treatment of faces, however, that there is the greatest evidence of an attempt to achieve a distinctive likeness, with more carefully constructed variation in the facial lines of figures shown in profile and more detail in the representation of features. Creases and shading are used to define the angles of the face (fig.

9.10). The drawings clearly reveal the efforts of an artist struggling to understand a new technique, and Silver Horn was probably not successful in creating any recognizable likenesses. Yet the pictures demonstrate a conscious experiment with a different way of treating the established subject of individual representation.

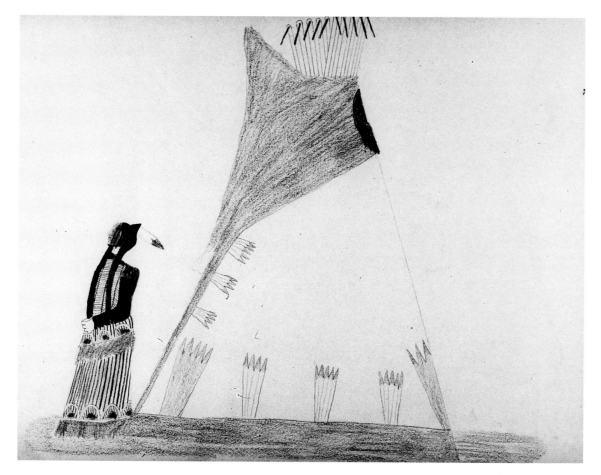

9.8. The Tail Picture Tipi, which passed through several owners, but was most closely associated with its last owner, Big Bow.
The tipi was named for the eagle tail feathers painted on it.
#67,719 (neg. A113249). Courtesy of the Department of Anthropology, Field Museum of Natural History.

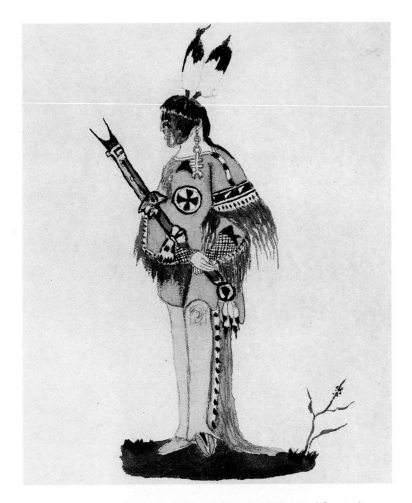

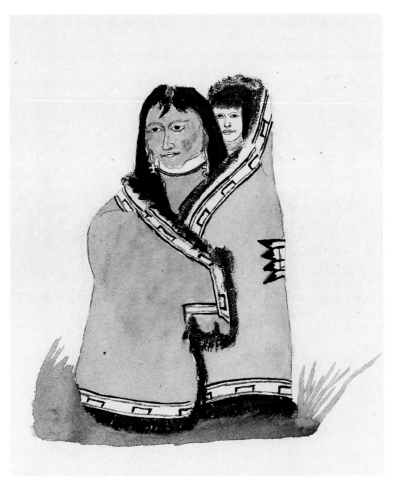

9.9. Standing figure in three-quarter view, holding a highly decorated flute in the crook of his arm.
One foot rests on a rock, pulling his buckskin legging tight over the knee.
#94. Courtesy of the Newberry Library, E. E. Ayer Collection.

9.10. A woman and child.
Their forms are concealed beneath a painted buffalo robe, focusing attention on their carefully detailed faces.
#121. Courtesy of the Newberry Library, E. E. Ayer Collection.

The same group of drawings includes several pictures of animals—bison, antelope, and deer. While these are the same types of animals that appear in Silver Horn's hunting scenes, here they are not part of an action narrative but are drawn grazing or at rest (fig. 9.11). Like the drawings of people, these are pure figure studies rather than narrative illustrations, and Silver Horn explored the forms and textures of the animals in an effort to capture on paper their grace and power.

Although Silver Horn retained in his later work a few features of the naturalistic style that he developed in his portrait studies, it was not a mode of representation that he continued to pursue. Clothing, accouterments, events, and no doubt accompanying oral testimony continued to be the basis for the identification of the people he depicted.

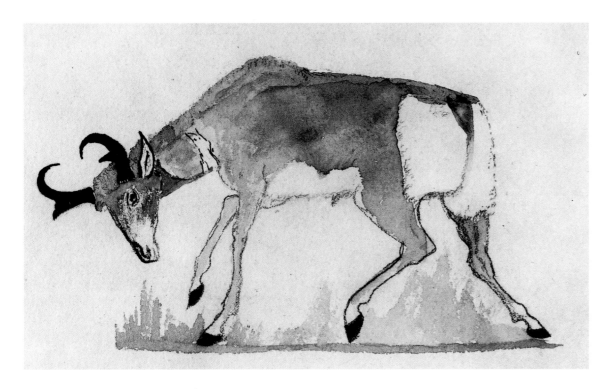

9.11. A delicately sketched antelope stooping to graze, but casting a wary glance toward his flank. #85. Courtesy of the Newberry Library, E. E. Ayer Collection.

Like other artists of the era, Silver Horn produced some pictures of wider aspects of reservation life—dances, social gatherings, and visits from other tribes. A remarkable series of ten pictures in one of the books now at the Field Museum illustrates a wide variety of recreational games. He shows men engaged in contests of marksmanship and speed (fig. 9.12), competing in archery, arrow throwing, and riflery as well as races on foot and horseback. Surprisingly, he also illustrates women's competitions, ranging from vigorous ballgames (fig. 9.13) to gambling around the painted rawhide "board" of the awl game. Many of these pictures were created to illustrate a type of activity rather than any specific event. The drawings constitute a visual record comparable in organization to the descriptive ethnographies of the day, something like a Kiowa pictorial version of Stewart Culin's *Games of the North American Indians* (1907). Rather than illustrating particular events or stories, Silver Horn instead was drawing upon general cultural knowledge. Like his portraits, they are a departure from traditional narrative illustration and an exploration of a new type of visual storytelling.

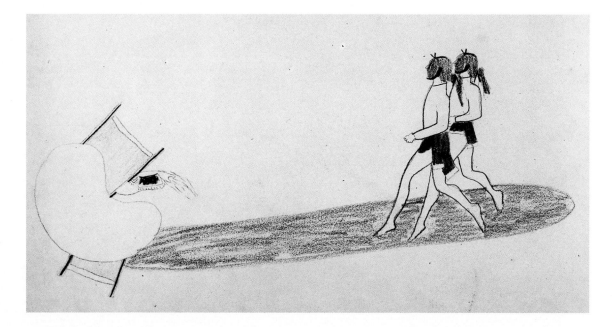

9.12. Two men competing in a foot race toward a moccasin marking the finish line. *Their hair and breechcloths are tied up out of the way.*
#67,719 (A113187). Courtesy of the Department of Anthropology, Field Museum of Natural History.

Silver Horn's scenes from daily life are rich in detail, providing specific information about many aspects of Kiowa life that are not well recorded elsewhere. His pictures of hunting, of dances, and of the relations between men and women go much further than those of other artists in depicting detail and variety in these activities. In spite of their variety, however, his art remains a limited source of information for other aspects of society. He stretched the warrior art tradition in certain directions, while choosing to ignore others. His work contrasts sharply, for example, with that of the Fort Marion artists, who also expanded upon

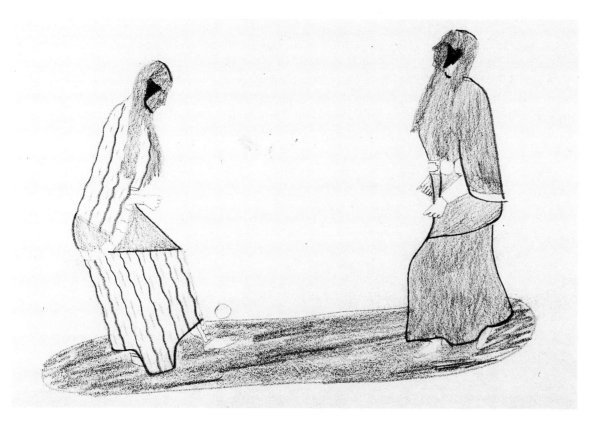

9.13. Two women playing a game of football, in which the ball is carried and passed using only the feet. #67,719 (neg. A113186). Courtesy of the Department of Anthropology, Field Museum of Natural History.

established subject matter, but in different directions. Their work often includes depictions of setting, with complex village scenes or even landscapes (cf. Harris 1989:29, 77), consistently absent from Silver Horn's drawings. Scenes of domestic activity are often included (cf. Dunn 1969), and buffalo hunts end with animals butchered and meat roasting on the fire (Harris 1989:45, 47). Although Silver Horn's career developed after these artists, including his brother Oheltoint, returned to the reservation, his work cannot be considered a continuation of their artistic tradition.

Silver Horn's unique depictions of many aspects of Kiowa life presaged the wider illustration of traditional aspects of culture that twentieth-century artists presented in their works. Tribal festivities with accompanying dances and games entered the repertoire, but for Silver Horn were always focused within the boundaries of the Kiowa community. Only in his calendars is the wider world of white society that had engulfed the Kiowa world acknowledged.

Silver Horn, however, did not conceive of his art as a systematic visual record of Kiowa culture. Even in his scenes from life, he stayed close to the basic cornerstones of narrative art—boasting, storytelling, and prestigious display of male accomplishments. His illustrations continued to be based heavily upon verbal narratives, although he was lighthearted enough to include gossip and teasing as well as stories of proud achievements.

Chapter 10

Innovator and Traditionalist

Silver Horn was a conservative man who lived during a period of great change. Not a casual producer of occasional drawings, he was deeply committed to art, and his surviving works span four decades of creativity. He was a visual innovator, firmly rooted in an established tradition of pictorial art but ready to explore new media, methods, and content. Conceptually, however, he was a traditionalist. He remained true to the fundamental principles underlying the art forms in which he worked, although he expanded upon them in response to new circumstances (fig. 10.1).

Silver Horn has often been described as a bridge between Plains art of the nineteenth and the twentieth centuries, for his career spanned the critical interval between the warrior art tradition of one century and the easel art tradition of the next.[1] The visual continuities over this long period are clearly evident. One can trace the outlined figures of men and horses, filled with flat blocks of color and devoid of background, from the earliest hide paintings through ledger art to Silver Horn's elegant drawing books of the reservation era, through traditional-style paintings of the mid-twentieth century to the ledger revival style late in the century. Stephen Mopope and James Auchiah, two artists of the Kiowa Five, whose success stimulated a broader revival of Plains painting in the 1930s and who were themselves much emulated, acknowledged Silver Horn as their first childhood teacher (Jacobson ca. 1954; Ewers n.d.).

Continuity in the cultural principles underlying Plains art over this period has received little scrutiny, however. In considering Silver Horn's place in the ongoing development of Plains art, I have sought to establish what concepts shaped his art and to consider how he built upon the heritage of the previous Plains graphic tradition. My interest has been as much in exploring the concept of art within Kiowa society as in considering what Silver Horn's pictures looked like. Such influences on subsequent artists have not yet been fully examined, although a variety of anecdotes suggest that their art is quite different conceptually from that of Silver Horn.

The Plains narrative art tradition arose to record pictures of war, specifically individual coups or deeds of honor (fig. 10.2). It was inherently male centered, intensely personal, and essentially celebratory in nature. Silver Horn's career came just after the period of warfare ended, but he thoroughly embraced that heritage. During the reservation period, artists expanded their repertoire from coup counting to additional

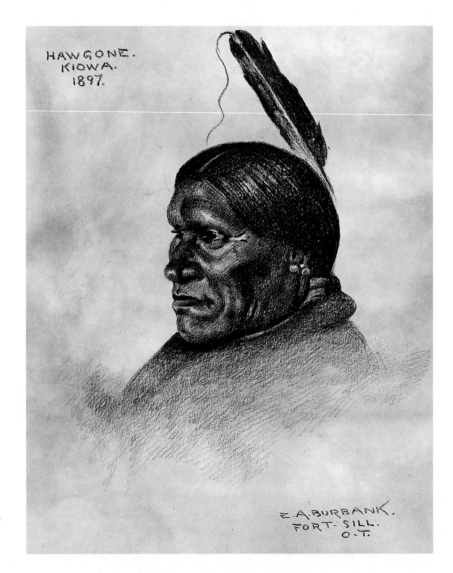

10.1. Portrait of Silver Horn by the Chicago artist E. A. Burbank, who introduced Silver Horn to Western concepts of portraiture. Courtesy of the Gilcrease Museum, Tulsa, Oklahoma.

forms of male conquest, such as hunting and courting, as well as ceremonial activities that brought personal status. Silver Horn included these same types of scenes, but often with a shift in focus. He still presented male concerns, but moved beyond the celebration of the individual to place attention on other aspects of the scene as well—the complex methods and uncertain outcomes of the hunt, the beautiful costume of courting couples, the details of ritual practice. Even in the classic arena of warfare, he introduced changes. He produced some pictures of historic conflicts in which the identities of individual warriors

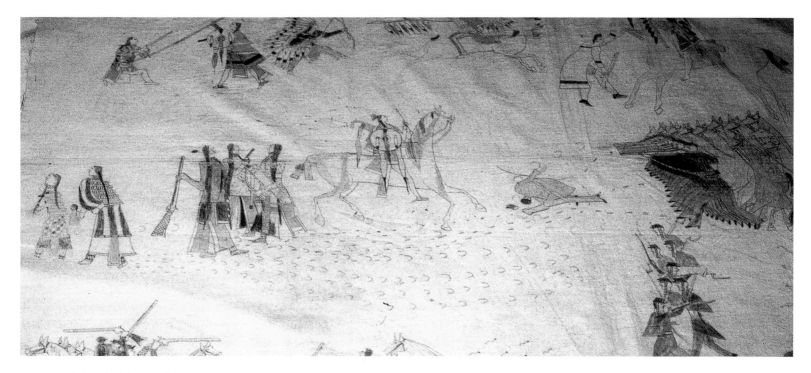

10.2. Detail of muslin (shown in full in plate 7).
A warrior carrying the Padogai shield hereditary in Silver Horn's family draws the fire of advancing troops while other members of his party, including two women and a small child, escape the attack. Taking such a risk to protect others was a highly respected coup.
#68.20.1. Courtesy of the Museum, Oklahoma Historical Society.

were of less importance than the broader record of tribal history. In these, he moved the art from an exclusively personal record to a representation of a communal heritage, from a narrow biographical view to a wider look at the past. For artists of the twentieth century, warfare was only one among many themes drawn from the past. Their pictures represented types of activities rather than personal events and brought to fuller development the transition that Silver Horn had begun to explore, shifting the focus of art from the personal to a tribal, or even intertribal, representation.

The Plains art tradition never stood as an independent entity, but was integrally linked to the oral tradition that it illustrated. The painted buffalo robe supported the verbal recitation of coup; the ledger page, the boast of women won. Silver Horn's work was embedded in this narrative tradition, and most of the stories that he illustrated were based on verbal accounts, whether myths, personal coup counts, more generalized historical narratives, or camp gossip. Even his pictures of ceremonies were never generic illustrations of cultural practices, but visual stories of specific events and particular people. While Silver Horn distanced himself from the basic Plains concept of conquest as the primary theme of art, he remained committed to art as an illustration of narrative and oral tradition. In contrast, modern artists did not usually produce narrative works. Their early pictures, as epitomized in the portfolio *Kiowa Indian Art,* concentrated upon the depiction of individuals rather than events (fig. 10.3). Oral traditions were a source of inspiration from which figures or events might be drawn, but their paintings referenced such stories rather than attempted to illustrate them in full, as Silver Horn had.

For Silver Horn, this strong affinity for the narrative determined what was included in a picture. Tiny details important to the story were represented, while all that was extraneous was omitted. At the encouragement of Burbank, he briefly experimented with the inclusion of full landscapes, but quickly reverted to his original concepts. Like earlier artists on hides and ledgers, Silver Horn placed a rock or a tree in a picture only if it had a place in the original oral tradition. Following this concept of literal exactness, he exercised little "artistic license." Even when illustrating his own narratives, his representations were true to their sources. His son Max convinced me that his pictures must be read quite literally. Everything that was put in meant something. His father did not include elements for purely decorative purposes, nor, usually, as abstract symbolic elements. To Max, the thunderbirds in the calendar were not symbolic of a thunderstorm, but were included only if such birds were actually seen flying before a storm. Younger artists in the twentieth century did not see their work as dependent upon the oral tradition. The separation freed them to make independent choices based on new, purely visual criteria. In *The Ten Grandmothers* (1945), Alice

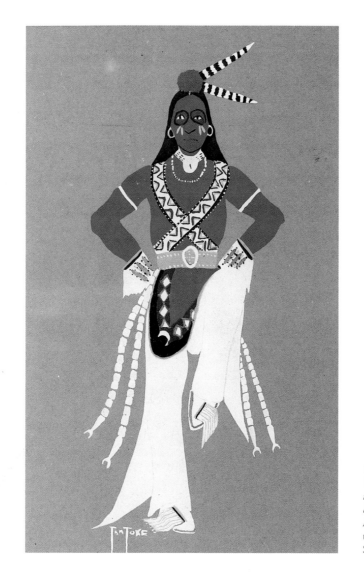

10.3. *Medicine Dance* by Monroe Tsatoke. *This painting was reproduced as plate 27 in the portfolio* Kiowa Indian Art, *published by Oscar Jacobson in 1929.* Acee Blue Eagle Collection. Courtesy of the National Anthropological Archives, Smithsonian Institution.

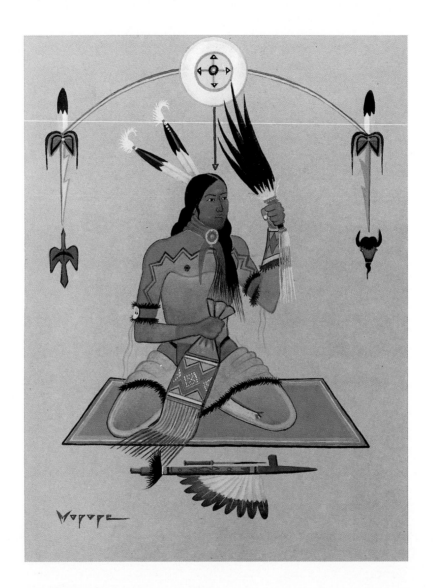

10.4. *Medicine Man* by Stephen Mopope,
Silver Horn's grandnephew.
*The decorative motifs framing the central
figure are united by an overarching rainbow.*
Acee Blue Eagle Collection. Courtesy of
the National Anthropological Archives,
Smithsonian Institution.

Marriott's insightful account of Kiowa history, she described the conflict an artist experienced while working on a mural in the Anadarko post office in the 1930s. A university-trained artist, he sought to create a balanced visual composition according to principles he had learned in school. The elderly Kiowa spectators in his audience, however, were only concerned with factual accuracy in the picture. They complained that he was putting things in the wrong places, for they could not conceive of the camp he was drawing as existing only as an artistic composition. Although not named by Marriott, the artist of the murals that still adorn the post office walls was Stephen Mopope, Silver Horn's grandnephew (fig. 10.4).

Throughout my study of Silver Horn, Kiowa people repeatedly expressed two general principles pervading Kiowa culture, important not only to art, but to all aspects of social action. The first is the primacy of family in determining an individual's place in society. The second is a highly developed sense of personal rights, which legitimize individual actions in many spheres of life. The two concepts are closely linked, as many rights are based on family position. Silver Horn clearly respected these principles throughout his artistic career, whether representing the designs of shields or the war deeds of past days. In his pictures of religion perhaps more than in other areas, he based his right to represent scenes upon the authority of personal participation rather than on family position. As a Peyote man as well as a Ghost Dancer, he had the right to produce images of such ceremonies (fig. 10.5). His representations of the Peyote ceremony became more intimate over time, correlating with his rise to leadership within the religion and an increased sense of having the right to depict its more private aspects.

An awareness of such rights of representation may have influenced twentieth-century artists more than any other aspect of the older art system. Indeed, I wonder if the move toward paintings of generic rather than specific events may be, at least in part, due to a breakdown in mechanisms for obtaining the right to represent specific scenes, coupled with a sensitivity to surviving ideas of ownership of such intangibles. Certainly all of the early artists who painted Peyote pictures were themselves active members of the religion. Even today, social disapprobation remains a force with which artists must reckon. For example, some Kiowa people expressed disapproval of old recordings of Kiowa ceremonial singing now distributed by the Library of Congress. The basis of their complaint was not that the music should be restricted, but that the singers were wrong. They belonged to Christian denominations that denounced the ceremonies, and they had themselves renounced participation. In other words, they were viewed as no longer having the right to produce a representation of such music. The way in which such attitudes have affected visual artists and their choices of subjects deserves systematic study.

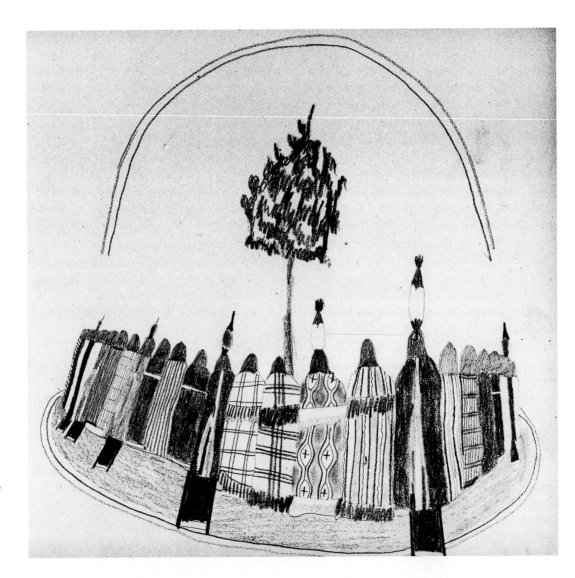

10.5. A circle of Ghost Dancers (a few
with feathers in their hair).
*A rainbow, used by Silver Horn to indicate
spiritual power, arches over the dancers, as it
does in his drawings of the Medicine Lodge
ceremony.*
#67,719 (neg. A113233). Courtesy of the
Department of Anthropology, Field
Museum of Natural History.

Kiowa art developed to serve an audience within the community, and it was shaped by their needs, knowledge, and expectations. Occasionally outsiders purchased items that caught their fancy, but it was not until well into the reservation period that items were made specifically for a nonnative audience.[2] Silver Horn produced a number of books for sale, regularly selling them through intermediaries who provided written captions to explicate the drawings to an outside audience. Such commodification of art had some influence on his work, but it was only one of many factors. His commissioned work for Mooney and Scott differed more radically. It was consciously didactic in nature, laying out cultural practices for examination and consumption rather than enacting them on paper. He became a role model for professional artists of subsequent generations. As a respected religious leader from a distinguished family, he legitimized the commercialization of art and the production of works for sale outside of the Kiowa community. Economic as well as social circumstances have dictated that twentieth-century artists must look to a nonnative audience as their primary market, taking into account their knowledge and expectations. Consumers of Indian art have largely sought pictures that referenced the past, laying out traditional culture for examination in traditional styles. The market, mediated by juried exhibitions, has replaced community opinion in determining the range of acceptability.

Whether displayed on a buffalo robe or a tipi liner, art was a very public product in Kiowa society through much of the nineteenth century. The introduction of the book, which could be shared with a selected audience or kept private, provided artists with a new opportunity for self-expression. In books made for himself rather than for sale, Silver Horn took full advantage of this freedom from community oversight to explore new ideas. He demonstrated that the creative process could be separated from its previous roles in support of the social and cultural system or its new role in the market place. Art could be an object of contemplation as well as of social action.

Silver Horn was born when visual representations played a significant role in the maintenance of many aspects of the Plains social system. By the end of his life, this was no longer so. After languishing briefly during the first two decades of the twentieth century, Kiowa art experienced a dramatic resurgence in the 1920s and led the way for a broad revival of Plains graphic art among many tribes. The role of art, however, had changed forever. Artistic production was no longer integral to wider Kiowa society, although it has remained a source of personal and tribal pride.

Kiowa people today have limited familiarity with the pictorial art of the nineteenth century, unless they have carried out research in museums and archives as some artists have. This lack of knowledge is not

surprising. Few Kiowa drawings from before the reservation period have survived, and most of the art produced during the late years of the century left the community soon after production (fig. 10.6). The drawings that remained within Kiowa families were subject to the vicissitudes of life in rural Oklahoma, where house fires and severe storms have claimed many cherished possessions. The last book of drawings that the Silverhorn family had was lost when James's house burned in the 1970s.

But the fundamental principles that guided Silver Horn's work remain alive in Kiowa society, although they are now separated from art production. My understanding of his art was constantly guided by Kiowa perceptions and insights. While Kiowa art has changed dramatically since Silver Horn's time, many aspects of culture have remained more constant. People who knew Silver Horn, or have come to know him through family stories, are confident that he shared their same basic values. They believe that his drawings must have been produced in accordance with the proper Kiowa way of doing things, guided by enduring underlying principles and values. Their basic knowledge of the "Kiowa way" formed the lens through which I learned to look at his art.

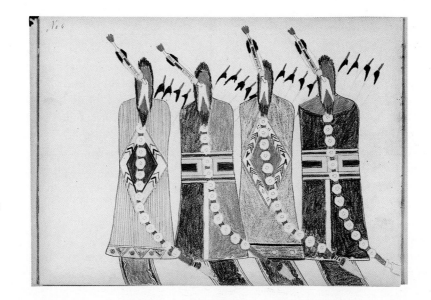

10.6. "Young Kiowa braves in full dress," as captioned by Horace Jones.
This is a rear view of a line of Kiowa men, with the lines of their German silver hair plates and appliquéd breechcloths swaying in unison.
#1994.429. Courtesy of the Museum of Fine Arts, Boston. Gift of the Grandchildren of Lucretia McIlvain Shoemaker and the M. and M. Karolik Fund.

Appendix

The following listing includes all of the Silver Horn works that I have been able to locate for study. I have examined all of them personally, with the exception of the hide paintings at Pomona College and the Linden Museum. The entry for "Documentation" is a compilation of information from museum records as well as other sources, while "Comments" offers a brief description of each piece together with my assessment of the documentation.

Field Museum of Natural History
Chicago, Illinois

Cat. No.: 67,839, gourd rattle

Images: two scenes

Size: approx. 15" long without fringe

Media: Incised and painted gourd, beaded wooden handle

Documentation: Collected by James Mooney for the Field Museum, recorded as Accession #825 in 1902. The tribe but not the maker is recorded.

Comments: This is a Peyote rattle with a scene of a Peyote altar on one side and of a Peyote leader on the other. The probable attribution of this piece to Silver Horn was brought to my attention by Daniel Swan.

Illustrated here: fig. 2.11

Cat. No.: 67,719, four books of drawings

Images: 256 images

Size: Books 1 and 2, 13¾" wide × 9¾" high
 Books 3 and 4, 14¾" wide × 10¾" high

Media: Pencil, colored pencil, and ink on the leaves of four bound drawing books

Documentation: Collected by Dudley P. Brown, probably directly from the artist, and sold to the museum in 1899 as part of a larger collection, Accession #654. Inscribed inside back cover of vol. 3: "How.e.Gon—Kiowa, Troop L. 7th U.S. Cavalry. Fort Sill Indian Ty. September 20th, 91. Thomas Clancy [Clancy was Hugh Scott's orderly]." In correspondence between Brown and George Dorsey, curator of the museum, Brown explains that he knows the artist, whom he identifies as "Haun-quoh," personally, as he lives only six miles from his ranch.

Comments: Three of the books, now numbered 2 through 4, are similar stylistically, while the drawings in volume 1 are smaller and more delicate. The exact dating of the works may never be known, but it is likely that they were produced over a span of time shortly prior to Silver Horn's enlistment in Troop L in 1891, perhaps continuing briefly after enlistment. The inclusion of one drawing of the Ghost Dance as practiced in its early form suggests a date of 1890–91. The drawings cover a wide range of topics, including illustrations of myths, religion, warfare, hunting, and courtship. Dudley Brown was also the collector of the book of drawings at the Nelson-Atkins Museum, dated 1883.

Published illustrations:
 Fenner (1974:33, 34)
 Wiedman (1985:40)
 Wiedman and Greene (1988:33–39)
 Maurer (1992:134, 167)
 Szabo (1994:34, 205)
 Time-Life Books (1995:122–25)

Illustrated here: figs. 1.12, 3.8, 3.9, 4.10, 5.7 to 5.9, 6.1, 6.2 to 6.6, 9.4, 9.8, 9.12, 9.13, 10.5; plates 11, 26, 27

Cat. No.: 96,796, painting on hide tipi liner

Images: 11 scenes on one liner

Size: 141" wide × 83" high

Media: Ink and paint on finely tanned cowhide

Documentation: This liner was made for the Field Museum for display in the Bushy Head tipi. It was received by the museum in 1904 as a part of Accession #958, referenced as the James Mooney Expedition. It was cataloged as Cheyenne, and Mooney provided detailed information about the Cheyenne battle exploits depicted on its surface. It was assumed to have been produced by Cheyenne artists working for Mooney. Gordon Yellowman, however, recently brought to my attention correspondence from Mooney to the Field Museum registrar D.C. Davis, reporting that the tipi liner was "to be painted by my Kiowa artist." Stylistic comparison confirms that this plan was carried out. (The same conclusion regarding authorship was reached independently by Fr. Peter Powell [in press].)

Comments: Preliminary drawings on paper for all of the scenes on the tipi liner were produced by Cheyenne artists and have been preserved among Mooney's papers (NAA MS 2538). The other Cheyenne tipi liner that is part of this accession (96,808, which was not actually received until 1906) appears to be by one of the Cheyenne artists who made the preliminary drawings.

Published illustrations:
Powell (1976:40, detail 41)

Illustrated here: fig. 8.5 (detail)

Cat. No.: 96,928, painted shield model

Images: 1

Size: 6½" diameter

Media: Ink and paint on buckskin over a metal and rawhide foundation

Documentation: This is a part of Accession #958. James Mooney's notes (NAA MS 2531, vol. 13) indicate that this model of the shield belonging to the Cheyenne warrior High Back Wolf was made by Silver Horn as a copy of the original in the Field Museum collection (cat. no. 15,334).

Comments: This model is a simplified version of the design on the original shield, which James Mooney also collected. Silver Horn made the model before Mooney shipped the original shield to Chicago. It is of the same

form and materials as the Kiowa shield models in the Smithsonian collection (NMNH 229,801–91, 229,893, 229,903, 229,913–20).

Haffenreffer Museum of Anthropology, Brown University
Bristol, Rhode Island

Cat. No.: 77-187, hide painting

Images: 10 scenes on one hide

Size: 54½" wide × 43" high

Media: Ink and paint on buckskin

Documentation: Commissioned from the artist by George P. Rowell between 1905 and 1910. Rowell's brother James was married to Maude, a Kiowa woman who was half-sister to Silver Horn's wife, Hattie. His other brother, Everett, collected the other Silver Horn hide at the Haffenreffer.

Comments: This hide is similar to one in the Medicine Lodge series (NMNH 229,897) and to the Linden Museum hide (44,685) in combining scenes from both the Medicine Lodge and the Peyote ritual. It also includes scenes of hunting, battle, and two painted lodges, the Tipi with Tail Pictures and the Porcupine Tipi.

Published illustrations:
Hail (1980:215, detail 216)

Cat. No.: 77-188, hide painting

Images: 1

Size: 43" wide × 31" high

Media: Ink and paint on buckskin

Documentation: Purchased by E. Everett Rowell directly from the artist around 1910, for $20. Rowell's brother James was married to Maude, a Kiowa woman who was half-sister to Silver Horn's wife, Hattie.

Comments: This painting is unusual for Silver Horn's late hide paintings, as it consists of a single integrated scene rather than a series of vignettes. It is one of Silver Horn's finest works and demonstrates the quality he was still capable of at this late period in his career.

Published illustrations:
Hail (1980:217)
Krech (1994:detail 90)

Illustrated here: plate 29

Hearst Museum of Anthropology, University of California Berkeley, California

Cat. No.: 2-4816, painting on rawhide

Images: 1

Size: 32" wide × 21" high

Media: Pencil and paint on rawhide

Documentation: This was received as a part of Accession #14, the Hugh L. Scott collection. The collection came to the museum in 1901 and contained materials collected by Scott before he left the West in 1897, including material acquired during his years (1889–97) at Fort Sill. Funds for purchase of the collection came from museum patron Phoebe Apperson Hearst. Dr. Phillip Mills Jones, a medical doctor and a personal agent for Mrs. Hearst, secured the collection from Mrs. Hugh Scott while her husband was posted in Cuba after the Spanish American War. The original museum accession list gives tribal designations for most items

but little additional information. In correspondence with the museum, Scott offered to visit and provide further details about many items, but that visit never occurred. Alfred Kroeber, the museum's curator, was able to clarify some ambiguities in the accession listing through correspondence with James Mooney.

This painting appears as #107 on the typed accession list as "Drawing—half-gone—Kiowa Indian." "Half-gone" was later corrected by hand to read "by Hah-gone," and Mooney (1903a) wrote "for Hah-gone write Han-gun = Iron Man. He is my regular artist."

Comments: The painting is on a rectangular piece of poorly prepared rawhide with a large scar across the center. It has been cut off irregularly along the left side, resulting in the loss of a portion of the image. The right side has a painted scalloped border. The body of the piece consists of scattered scenes of war. The original fine pencil drawing is largely obscured by thick, opaque watercolor.

Published illustrations:
Miles (1963:189)
Caldararo (1991:189)

Cat. No.: 2-4867D, model shield cover

Images: 1

Size: 18" diameter

Media: Buckskin, paint, feathers, dewclaws, horsehair wrapped in wool cloth

Documentation: This was received as a part of Accession #14, the Hugh Scott collection, a history of which is given above. The accession file lists three separate pieces, one shield (#52) and two shield covers (#85 and 86), all identified as Comanche. Three buckskin covers are now tied over the rawhide shield, all cataloged as Comanche under the same catalog number with letter suffixes for each piece.

Kroeber corresponded with James Mooney about the outermost cover in this group (catalog number D). After receiving a photograph of it, Mooney was able to identify the design as the Padogai shield once carried by the Kiowa chief Tohausen. He was puzzled by this because he believed that no copies of it remained in existence and was not aware that Scott had owned such a shield.

Comments: While the other pieces cataloged as 2-4867 may well be Comanche, this outer cover does not belong with them. It is a Kiowa design, as Mooney recognized. It is not, however, as he assumed, an old cover used in war, but a more recent model very similar in materials and techniques to other models being made for Mooney in the same period. No doubt he would have realized this had he ever seen the original. The authorship of the model cannot be established, but it is quite likely that it, like the tipi model with its smaller shield (2-4912), was made by Silver Horn.

Published illustrations:
Storm (1972:98) (Note: The shield was photographed upside down, with the horsehair bundle hanging below the shield rather than across its center as it should.)

Cat. No.: 2-4912, tipi model

Images: 4 scenes

Size: Tipi cover: 46" wide × 21" high
Shield model: 4½" diameter

Media: Cover—ink and paint on buckskin, with wooden poles, pegs, and stakes; Shield—paint, feathers, horsehair, wool cloth on buckskin over rawhide

Documentation: This was received as a part of Accession #14, the Hugh Scott collection, a summary of which is given above. It appears on the accession list as #97, "Tepee, complete." No tribal designation was given, and it was originally cataloged as Teton Dakota. This was subsequently changed to a Southern Plains attribution—Comanche or Kiowa.

Comments: This model is a beautiful rendition of the famed Kiowa Tipi with Battle Pictures (see Greene 1993; Greene and Drescher 1994), much finer than Oheltoint's version published in Mooney (1898: pl. 79). This piece can without doubt be attributed to Silver Horn on stylistic grounds. It is notable that while his brother Oheltoint produced pictures of war with whites, Silver Horn instead chose scenes in which native enemies predominate, including a Kiowa warrior surrounded by Osage enemies at the top, as reported in oral histories of the tipi.

The cover is similar to the tipi models that James Mooney was commissioning during the period when Hugh Scott was at Fort Sill. Although Silver Horn did not work for Mooney until 1902, this cover was probably inspired by those earlier models. This piece is smaller than the Mooney models, which range from 54" to 63" wide, and the poles and pegs are less finished and uniform in appearance. Tied to the tipi cover is a painted model of the Padogai shield hereditary in Silver Horn's family. It is not possible to attribute the simple design to a specific artist's hand, but it is likely that Silver Horn produced it as a companion to the tipi cover.

Cat. No.: 2-4922, painting on rawhide

Images: 1

Size: 16¾" wide × 10" high

Media: Pencil and paint on rawhide

Documentation: This was received as a part of Accession #14, the Hugh Scott collection, a history of which is given above. It appears on the accession listing as #1, "Kiowa painting on rawhide, buffalo hunt." It was subsequently attributed to Silver Horn in the museum's catalog, with the erroneous information added that it was made for General Scott to illustrate the Saynday stories.

Comments: This piece is worked on a rectangular piece of poorly prepared rawhide with a burned area in the upper right corner. It is framed with a painted rectangular border. The scene is of a hunter pursuing a bison and calf. An alligator-like creature, possibly Zemaguani, appears above them. The picture has no connection with the Saynday stories. The original fine pencil drawing is largely obscured by thick, opaque watercolor.

Published illustrations:
Caldararo (1991:189)

Cat. No.: 2-7547, muslin painting

Images: 4 scenes

Size: 58½" wide × 35½" high

Media: Pencil and paint on muslin

Documentation: The catalog record indicates that this piece was collected by Phillip M. Jones, with funds donated to the museum by Phoebe Hearst. The accession number is not known. It was identified as Kiowa and attributed to Silver Horn by museum staff in 1969. As the museum contains very little Southern Plains material, it seems likely that this piece was originally a part of Accession #14, the Hugh Scott collection, also acquired by Jones with funds from Hearst, from which it accidentally became separated.

Comments: The muslin, now badly water-stained, appears to have been painted by a single artist. It contains four separate scenes from the Medicine Lodge ceremony: the mock battle for the center pole, the Taime Keeper measuring the pole, the buffalo impersonators circling the lodge, and the dancers inside the lodge with the Taime exposed. All except the third scene have correlates in the Medicine Lodge hide paintings produced for James Mooney in 1902–4. The impersonators appear in several other drawings, including the Target Record book (NAA 4252) that Hugh Scott acquired from Silver Horn in 1897.

Linden Museum
Stuttgart, Germany

Cat. No.: 44685, hide painting

Images: 4 scenes

Size: 47" wide × 29½" high

Media: Ink and paint on buckskin

Documentation: This painting was acquired in 1906 by Carl Graf von Linden, the museum's founder. It was purchased for him in June of that year for $30 by Rudolf Cronau, who saw it for sale at the Indian Exhibits Company in New York. The invoice from the company lists it as a Crow painting. That misidentification was continued in the museum's records until 1998, when curator Dr. Sonja Schierle recognized it as probably by Silver Horn and was subsequently able to locate documentation of its purchase, which she graciously provided to me.

Comments: The excellent documentation accompanying this piece establishes that Silver Horn must have produced it on a freelance basis while he was still working occasionally for James Mooney. It is quite similar to another hide in the Medicine Lodge series (NMNH 229,897).

Published illustrations:
Schulze-Thulin (1973:22)

Illustrated here: fig. 5.5

McNay Art Museum
San Antonio, Texas

Cat. No.: 1962.1, book of drawings

Images: 32

Size: 14" wide × 9¾" high

Media: Pencil and colored pencil in a disbound drawing book

Documentation: Frontispiece inscribed: "Fort Sill, I.T. July 13, 1887. These pictures were painted by a Kiowa Indian whose name is Ho-goon or Silver Horns; he has never been to school and has seen but little of the white man's civilization, consequently the pictures are a fair index of a wild Indian's idea of art. The battle scenes are intended to represent events that have actually occurred 15 or 20 years ago; the Kiowas at that time being at war not only with the whites but also with other tribes of Indians. The other pictures merely represent scenes that happen in their ordinary, every day life. Horace P. Jones, U.S. Interpreter." Individual captions on the faces and backs of most pages are written in the same hand, presumed to be that of Jones, the interpreter at Fort Sill from its founding until his death in 1901. Inside front cover inscribed: "Presented by General John L. Bullis to Mrs. Irmid William Cassin—1887." He was not promoted to the rank of general until 1905, indicating that the inscription was added sometime after the presentation. Bullis was never stationed in Kiowa country, but served in Texas and may have visited there.

The book was loaned by Mrs. Cassin to the Smithsonian Bureau of American Ethnology for study in 1933, at which time it was photographed and was viewed by Gen. Hugh Scott, who was visiting the bureau. A letter from Matthew Stirling, chief of the BAE, to Mrs. Cassin records Scott's comments on the book and notes the return of the book. The letter is reproduced in Williams (1990:49). The book was received by the museum in 1962 as a gift from Mrs. Terrell Bartlett of San Antonio, Texas.

Comments: The inscription is nearly identical to that in another book collected by Bullis that was loaned to John C. Ewers for study in the 1950s. Its present location is unknown.

Published illustrations:
Haines (1963:71)
Fairbanks (1975:82)
Silberman (1978:72)
Boyd (1981:15, 1983:127)
Williams (1990:32, 33, 34, 35)
Berlo (1996:166–67)

Illustrated here: figs. 3.7, 9.1; plate 41

Museum of Fine Arts
Boston, Massachusetts

Cat. No.: 1994.429, book of drawings

Images: 34

Size: 14" wide × 10" high

Media: Pencil and colored pencil in a bound drawing book

Documentation: Collected by Capt. Alfred Collins Markley, an army officer who rose to become a brigadier general. Three obituaries for General Markley are pasted inside the front cover of the book, which is inscribed

"Property of Mrs. Lewis F. Shoemaker, Devon, Pa." It descended in Markley's family to Mrs. Lewis T. Shoemaker, who donated three books of Indian drawings to the Museum of Fine Arts in 1994, with only the information that they were collected by Markley in the West. This book and the next entry (1994.430) were recognized by the curator, Linda Foss-Nichols, as produced by Silver Horn. The third book, which is Cheyenne, is inscribed "Capt. Markley—24 Inf USA."

Comments: Markley, who was promoted to captain in 1879, served with the Twenty-fourth Infantry at Fort Sill, arriving in February 1881 and remaining until 1887 or 1888; it was undoubtedly during this time that he acquired the Kiowa drawings. Horace P. Jones, the interpreter who provided the captions, was at Fort Sill from its founding until his death in 1901. His comments on the number of years that had passed since two well-known events, the Ute capture of the Taime and the Buffalo Calling Ceremony, date the book to approximately 1885. This book and its companion piece (1994.430) are notable for the confidence of the drawing and the particularly intense use of color. It depicts a wide range of subjects, including warfare, ceremonies, and hunting.

Illustrated here: figs. 4.7, 5.10, 10.6; plates 10, 16, 42

Cat. No.: 1994.430, book of drawings

Images: 33

Size: 14¾" wide × 10⅛" high

Media: Pencil and colored pencil in a bound drawing book

Documentation: These drawings were received together with #1994.429 and share the same collecting history.

Comments: These works are quite similar in content and style to those in #1994.429 and must have been produced around the same time. They lack the captioning by Horace Jones, but several pages are roughly inscribed "Wite Hrse." The writing corresponds in general with the same name written in a book of drawings by the Fort Marion prisoners, now in the Pratt Papers at the Beinecke Library, Yale University. That inscription is believed to have been made by the Kiowa warrior White Horse.

Illustrated here: figs. 4.8, 4.9, 9.6; plates 15, 40

Museum of the Great Plains
Lawton, Oklahoma

Cat. No.: 79.29.7, painted hide

Images: 13 scenes

Size: 51" wide

Media: Ink and pencil on buckskin

Documentation: Purchased from the artist by A. D. Lawrence, owner of the Red Store near Fort Sill, between 1911 and 1922. It passed to Lawrence's son, Arthur Lawrence of Lawton, Oklahoma, who donated it to the museum (then the Comanche County Historical Society) in 1956. Inscribed in the lower right corner "Hungu."

Comments: The hide was probably produced early in the 1910s, around the time that Silver Horn painted other hides for sale before his eyesight failed completely. The drawing is roughly executed by comparison with other works. It consists of scenes of warfare, including a circle picture in the center of the hide. The Tail Picture tipi is shown, although without any obvious connection to other scenes. The inscription is markedly different from his signature as it appears on other works (see fig. 3.17). Some figures in one corner may be by a different artist.

Museum of Indian Arts and Culture
Santa Fe, New Mexico

Cat. No.: 55141-55171, book of drawings plus loose sheets

Images: 53

Size: 40 drawings 13¼" wide × 9¼" high
 13 drawings 11¾" wide × 8¾" high

Media: 40 drawings in pencil and watercolor on the leaves of a disbound drawing book
 13 drawings in ink and crayon on loose sheets of paper

Documentation: Cover inscribed by Hugh Scott: "Drawn and painted by Hawgone (Iron Horns) a full Kiowa Indian un . . . tiution near Fort Sill O.T. November 1897. These are illustrations of the Kiowa fables." One page of drawings inscribed "Hawgone." The production of the drawings is described by Scott in three unpublished manuscripts, one at the Library of Congress (Scott Collection), one at the National Anthropological Archives (MS 2932), and one acquired with the drawings, which is an edited version of the LOC material prepared by Gillette Griswold, once director of the Fort Sill Museum. The drawings were commissioned by Hugh Scott in 1897 prior to leaving Fort Sill and were evidently still in his possession as late as the 1920s, after which they were placed on deposit at the Fort Sill Museum by his family. The drawings were later withdrawn by his grandson Hugh Scott II and auctioned by W. E. Channing's Fine American Indian Art, Santa Fe, as lot #193, in August 1989. They were purchased by Mr. and Mrs. Charles Diker and were loaned to the Smithsonian for inclusion in the exhibition *Sayday Was Coming Along . . .* They were subsequently donated to the Museum of Indian Arts and Culture in 1997.

Comments: There are two distinct sets of drawings in this collection. The larger one, formerly in a bound volume, consists of forty pages produced in a traditional two-dimensional style with limited background. The other thirteen drawings, evidently made on loose sheets, are more naturalistic, with an effort to place three-dimensional figures within a full landscape. With the exception of one picture of the Medicine Lodge ceremony, all of the images illustrate oral traditions. They are most closely related to the Target Record Book (NAA 4252), with its Sayday pictures, and the Newberry Library drawings, which were influenced by E. A. Burbank.

Published illustrations:
 Scott (1911: pl. 20)
 Boyd (1981:45, 1983:4–5, 44–45, 92–93, 127, 185)
 Greene and Reuss (1993:5, 9, 11, 13, 17, 19, 23, 25, 30, 31)

Illustrated here: figs. 3.13, 5.4, 6.11 to 6.13; plates 12, 31

National Anthropological Archives, Smithsonian Institution
Washington, D.C.

Cat. No.: MS 1874, drawing

Images: 1

Size: 11" wide × 9½" high

Media: Pencil and colored pencil on a loose sheet of paper

Documentation: The manuscript forms part of the papers of James Mooney. The drawing is attributed to Silver Horn.

Comments: The drawing was probably produced during the period 1902–4. It appears to have originally been a part of MS 2538 and to have accidentally become associated with this manuscript containing drawings by another unidentified artist.

Illustrated here: plate 1

Cat. No.: MS 2531, vol. 1, drawings in a bound volume

Images: 9 drawings

Size: 10" wide × 15" high

Media: Pencil and colored pencil in a bound volume

Documentation: The manuscript forms part of the papers of James Mooney. The drawings are attributed to Silver Horn.

Comments: The drawings are interspersed among Mooney's notes on Kiowa shields.

Cat. No.: MS 2531, vol. 7, pictorial calendar in a bound volume

Images: 51

Size: 9½" wide × 6" high

Media: Ink, watercolor, pencil, and crayon in a bound volume

Documentation: The manuscript forms part of the papers of James Mooney. Inscription in James Mooney's hand on cover: "No. 23. Kiowa colls. 1904. Nov. 14 James Mooney." The book is identical to that used by Mooney for his own notes that year. The inscription "Hawgone" appears on the margin of one page. This and various notes on the pages referring to "Hangun" support the attribution of the drawings to Silver Horn.

Comments: The faces of the drawings are heavily annotated by James Mooney, providing identification for the events depicted.

Published illustrations:
Merrill et al. (1997:208–12)

Illustrated here: figs. 2.4, 2.9, 4.1, 7.2 to 7.4; plates 4, 33, 34

Cat. No.: MS 2531, vol. 12, book of drawings

Images: 28

Size: 7¾" wide × 9½" high

Media: Pencil, colored pencil, and crayon on the leaves of a bound volume

Documentation: The manuscript forms part of the papers of James Mooney. The drawings are attributed to Silver Horn.

Comments: This volume contains a systematic set of drawings showing eighty-two Kiowa shield designs, arranged three or four to a page. Carefully prepared, with annotations limited to the backs of pages, these drawings were intended to serve as plates in Mooney's planned publication on Kiowa heraldry.

Published illustrations:
Merrill et al. (1997:213–15)

Illustrated here: fig. 8.1; plate 39

Cat. No.: MS 2538, drawings

Images: 109

Size: Various

Media: Pencil, colored pencil, ink, crayon, and watercolor on loose sheets of paper

Documentation: The manuscript forms part of the papers of James Mooney. Many drawings are inscribed by Mooney with the name of the artist ("Hangun" or simply "H") and the date. Other drawings are attributed to Silver Horn on the basis of style.

Comments: This manuscript contains work by a number of Kiowa, Cheyenne, Arapaho, and Apache artists. Some of the Silver Horn drawings are carefully prepared, but others are roughly sketched. Most are heavily annotated by Mooney on the face of the drawings.

Published illustrations:
Merrill et al. (1997:217, 219, 221)

Illustrated here: figs. 1.1, 1.10, 3.14, 7.11; plate 38

Cat. No.: MS 4252, book of drawings—Target Record book

Images: 79

Size: 8¼" wide × 13½" high

Media: Pencil, colored pencil, ink, and watercolor on the pages of a bound record book

Documentation: Acquired by Hugh Scott in 1897 directly from the artist, whom he paid $20 for the book. He described its acquisition in NAA MS 2932 and told Matthew Stirling of the Bureau of American Ethnology about it and its authorship during a 1933 visit to the bureau. It was purchased by the BAE in 1936 for $50 from Scott's widow. Scott (1911:355) published illustrations redrawn from the book, crediting them to "Hawgone." The name "Hawgone" is inscribed in several places in the book, as are other names, including Auchiah, another member of Troop L.

Comments: The book contains target practice records made in 1884 at Fort Meade, Dakota Territory, where Hugh Scott was posted from 1883 to 1886 prior to his transfer to Fort Sill. Presumably he brought the book with him for future use, but instead it passed into the hands of his scouts. The book contains work by at least two other artists in addition to Silver Horn. The majority of the drawings were probably produced during the years 1891 to 1894, while Silver Horn was enlisted in Troop L. Silver Horn's work in the book consists primarily of images of the Medicine Lodge and illustrations of Saynday stories. His thirty-page pictorial diary covering the period from January 1893 to June 1897 is found at one end of the book.

Published illustrations:
Scott (1911:363, pls. 18, 19, 21–25) (all redrawn)
Greene and Reuss (1993:3, 30)
Merrill et al. (1997:222–25, 227–29)

Illustrated here: figs. 2.10, 3.10, 3.11, 6.7–6.10, 7.5–7.9, 9.5, 9.7; plates 24, 30, 35

National Cowboy and Western Heritage Museum
Oklahoma City, Oklahoma

Cat. No.: 96.27, book of drawings

Images: 75 drawings

Size: 15" wide × 11" high

Media: Pencil and crayon on the leaves of a disbound drawing book

Documentation: Typed label pasted on exterior cover: "Book showing Costumes of Different Tribes Drawn by
an Indian Artist, Mrs. D.B. Black (1890–95)." Pencil inscription on interior of cover: "75 original drawings
showing costumes of Kiowas and Comanches drawn by an Indian artist, Mrs. D.B. Black (1890–95). Chas.
A. Philhower, Westfield, N.J." Individual inscriptions on many pages, some partially obscured by mats,
identify the individuals shown as Comanches and occasionally as Kiowas. Received by the museum as a part
of the Arthur and Shifra Silberman Collection shortly after the death of Arthur Silberman in 1995. The
drawings were acquired by the Silbermans from a private collector in New Orleans. Attribution of these
works to Silver Horn is longstanding. They were displayed with that identification at the New Orleans
Museum of Art and later at the National Cowboy Hall of Fame in the exhibition *Beyond the Prison Gates,*
where the date range of 1890–95 was accepted.

Comments: All available surfaces of the book are filled, but many pages appear to have been produced hastily.
The drawing is skillful but without the careful attention to detail in hands and clothing that distinguishes
much of Silver Horn's other work. Pictures of the Ghost Dance and of a Peyote ritual, which appear to have
been among the first pages of the book, are exceptions to this pattern. They contain highly detailed and sen-
sitive images of these rituals.

Illustrated here: figure 5.11; plate 25

National Museum of the American Indian, Smithsonian Institution Washington, D.C.

Cat. No.: 2/1670, hide painting

Images: 7 scenes

Size: 39½" wide

Media: Ink, pencil, and watercolor on buckskin

Documentation: Purchased for the Museum of the American Indian by Mark R. Harrington for $14 in May 1909, probably directly from the artist. Cataloged as "Painting of adventures, Kiowa, by Hangua."

Comments: This hide is stylistically similar to the other acquired by Harrington a few months later and was probably made for sale a short time before it was purchased. As with most of the Kiowa material he acquired for the museum, Harrington recorded the sale price and the name of the seller but no additional information. The hide contains five scenes of battle against Indian enemies and two scenes of courtship.

Cat. No.: 2/8329, hide painting

Images: 4 scenes

Size: 40" wide

Media: Ink, pencil, and watercolor on buckskin

Documentation: Purchased for the Museum of the American Indian by Mark R. Harrington for $7.50 in November 1909, probably directly from the artist. Cataloged as "Painting of adventures by Hangua, Kiowa."

Comments: The banded composition of this hide is unique in Silver Horn's work, with the extended groundline used as a major compositional feature. At least two scenes must be illustrations of stories, although accompanying texts have not been identified.

Published illustrations:
 Brody (1971:26)

Illustrated here: fig. 3.16

National Museum of Natural History, Smithsonian Institution
Washington, D.C.

Cat. No.: 229,894, hide painting—Medicine Lodge Series

Images: 1

Size: 50" wide

Media: Ink and paint on buckskin

Documentation: This series of hide paintings (229,894–97; 229,900–901) illustrating the preparations for the Medicine Lodge ceremony was received by the museum in 1904 as a part of Accession #42,431. That accession contained material assembled by James Mooney for display at the Louisiana Purchase Exposition held in St. Louis in that year. The original interpretive label prepared for that exhibit reads:

> The Sun Dance—Smoking to the Medicine. This painting on buckskin represents one of the preliminary ceremonies of the great annual Sun Dance, last enacted by the Kiowa in 1887. At the upper left corner is the cottonwood tree that has been chosen to be cut down to form the center pole of the medicine lodge. The framework of crossed poles below shows where it is to be planted. On the right upper corner is a group of priests, with the ceremonial fans, black fans, black pipe, and medicine bags. In the center sits the chief priest of the ceremony, the keeper of the Taime, or sacred image, wearing upon his brow a fillet of jack-rabbit skin. Behind him sits the woman whose office it is to cut down the tree at each annual Sun Dance. Among the Kiowa, this must be done by a captive woman, who, at this period was a Mexican, as indicated by the wavy hair and light skin. The mounted warrior, with scalp erect upon a staff, is returning to announce that he has "counted coup" upon the sacred tree, as upon the body of an enemy, to claim it for the tribe. The lower part of the picture represents the "smoking," or incensing to the sacred Taime, before taking it from its parfleche case and undoing the wrappings. This also must be done by a captive, in order that no harm befall the tribe from neglect of any of the accompanying tabus. The captive, another Mexican, still living, sits at the farther end, wearing a military coat. Behind and in front are the chiefs of the officiating warrior societies. [typographical errors corrected]

Comments: This series of paintings was cataloged without the name of the artist. Silver Horn's authorship of the series was established by John C. Ewers based on interviews with Kiowa people in the 1940s and confirmed by the extensive documentation of their production preserved in James Mooney's papers.

Published illustrations:
Alexander (1938: pls. 21–23)
Ewers (1939: pl. 14)
Maurer (1992:163)

Illustrated here: plate 18

Cat. No.: 229,895, hide painting—Medicine Lodge Series

Images: 1

Size: 56" wide

Media: Ink and paint on buckskin

Documentation: The original label prepared by James Mooney reads:

The Sun Dance—The Sham Battle. This represents the warriors of the various military societies fighting for possession of the tree intended for the center pole of the medicine lodge. The tree, with the women who are to bring it in, are defended by other warriors behind the breastwork. Besides their weapons, the warriors carry shields and "coup sticks" or clubs made of interwoven leafy willow rods, and both warriors and horses are decked in their finest ceremonial equipment of paint and ornamentation, each one according to his society or office. The warrior on the extreme left carries a ceremonial coup stick with fox-skin pendant. This was one of the most picturesque spectacles of the old Indian life, hundreds of warriors frequently taking part in the spirited mimic contest. [typographical errors corrected]

Comments: See 229,894.

Published illustrations:
 Boyd (1981:45)
 Maurer (1992: illus. p. 164)

Illustrated here: fig. 3.15 detail; plate 19

Cat. No. 229,896: Hide painting—Medicine Lodge Series

Images: 1

Size: 56" wide

Media: Ink and paint on buckskin

Documentation: Original exhibit label prepared by James Mooney reads:

> The Sun Dance—Building the Medicine Lodge. This represents the building of the medicine lodge
> and the decoration of the center pole, and the bringing in of the uprights and leafy cottonwood
> branches by the women, escorted by warriors beating hand drums, while all sing chants in unison.
> In the foreground are two warriors riding with their sweethearts mounted behind them. On the com-
> pletion of the medicine lodge a long procession of warriors and young women, mounted thus in
> pairs, rode slowly around the entire camp circle singing chants until after sundown.

Comments: See 229,894.

Published illustrations:
 Alexander (1938: pl. 21)
 Boyd (1981:120)
 Maurer (1992:165)
 Merrill et al. (1997:92)

Illustrated here: plate 21

Cat. No.: 229,897, hide painting—Medicine Lodge Series

Images: 1

Size: 56" wide

Media: Ink and paint on buckskin

Documentation: Original exhibit label prepared by James Mooney:

> The Sun Dance and The Peyote Ceremony. The figures on the left with the mounted warrior in the center have reference to the Sun Dance. Those of the center and right refer to the Peyote rite. In the first group we have the decorated center pole of the medicine lodge, the pipes, fan and rattles of the dance, the Taime box closed, and the same box open, with the sacred image partly exposed, two Sun Dancers (with their Sun Dance paint, head-band of jack rabbit skin, yellow down feather, head pendant, eagle bone whistle, and bunch of wild sage in hand or between lips as in the dance, wristlets and anklets of leafy willow, other bunches of wild sage at their belts, and one with a scalp hanging from his wrist), a Buffalo Dancer masked with a buffalo robe, one imaginary warrior figure with a red shield, and, at the top, a member of a warrior society in full Sun Dance equipment.
>
> In the Peyote group we have, at the bottom, the ceremonial tipi with four principal worshipers just entering with drum, rattle, feather fan, and staff. On the other side are two more, together with pouch, staff, drum, rattle, fan, eagle-bone whistle, and several other belongings of the rite, including the large sacred Peyote.
>
> Above we see the tipi again, with a woman in elk-tooth dress waiting outside for the signal to hand in the sacred food. In the upper right hand corner is the circle of worshipers inside the tipi, the two with drum and rattle at the west end, with the fire, the mound, and the sacred Peyote in the center.

Comments: See 229,894.

Published illustrations:
 Alexander (1938: pl. 23)
 Boyd (1981:115)
 Maurer (1992:165)

Illustrated here: fig. 2.5 detail; plate 22

Cat. No.: 229,900, hide painting

Images: 11 scenes

Size: 52" wide

Media: Ink and paint on buckskin

Documentation: Original exhibit label prepared by James Mooney:

> The Kiowa Pantheon. The gods and mythic creations of the Kiowa. The figure at the left upper corner is the Thunder, conceived as a great bird which causes the lightning by the snapping of its beak, thunder by the flapping of its wings, and rain by shaking the drops of moisture from its feathers. The second and fourth figures above are different conceptions of the Whirlwind, conceived as a winged horse with body of clouds. Between is Sindi, a lanky, naked trickster and wonder worker, equivalent to the Manabozho of the Algonquian tribes, always hungry and always going about in search of unwary prey. Behind him are two Sapodal, great hairy cannibals, carrying skin bags for their human prey, wearing a cedar tree upon their heads. They are sometimes represented as mere disembodied heads, living and moving about. The two fish figures are differing conceptions of the Zemaguani, or great horned fish, supposed to frequent deep-water caverns, where it has sometimes been seen for brief moments. According to some accounts it sometimes seizes and kills an unlucky swimmer and wears his scalp upon its horns. Above the Zemaguani is the sacred Peyote (or Mescal) plant, with the drum, staff, rattle, and eagle feather fan used in the Peyote ceremony. To the left is the Kiowa conception of the mastodon, known to them from the fossil bones frequently found in clay banks, and imagined to be those of a deep-river monster, under the name of Tsoi-Gadal, the Water Buffalo. The actual buffalo is figured in the lower right-hand corner, and above it is the Gadombitsonhi—Old Woman under the Cliff—a sacred wonder-working image formerly belonging to the "Big Shield" band, but mysteriously lost some seventy years ago. The great tribal palladium, the Taime is held too sacred for imitation, and the artist steadfastly refused to paint it.

Comments: See 229,894. Although not a part of the Medicine Lodge series, this hide was painted at the same time and included in the same exhibition.

Published illustrations:
Boyd (1981:3)

Illustrated here: plate 32

Cat. No.: 229,901, hide painting—Medicine Lodge Series

Images: 1

Size: 52½" wide

Media: Ink and paint on buckskin

Documentation: Original exhibit label prepared by James Mooney:

> The Sun Dance—The Camp Circle—Measuring the Pole. At the lower right hand corner we have the ceremonial group about to cut down the tree destined for the centerpole of the medicine lodge. To the left we have the priest measuring the trunk for the height. In the upper right hand corner we see the slain buffalo from which a string of hide has been cut along the forehead and back to be wrapped around the main transverse pendant of the center pole. The green spot near by is the buffalo wallow. The tipi circle represents the hereditary decorated tipis of the prominent families of the tribe as formerly set up in proper position in the great Sun Dance Circle, the priests' tipi, the sweat house, and the center pole of the medicine lodge being already set up within the circle.

Comments: See 229,894.

Published illustrations:
Alexander (1938: pl. 22)
Boyd (1981:121 detail)
Maurer (1992:164)

Illustrated here: plate 20

Cat. No.: 229,801–91, 229,893, 229,903, 229,913–20, shield models

Images: 101

Size: 6½" diameter

Media: Paint and ink on buckskin with feathers, cloth, and other materials added

Documentation: These models were received in 1904 as a part of Accession #42,431. The models were commissioned and prepared under the direction of James Mooney for display at the Louisiana Purchase Exposition. Silver Horn is identified as the artist of the models in Mooney's correspondence and elsewhere in his notes, although he often refers only to "my artist" and seldom provides his name.

Comments: Mooney's original tags and notes provide the names of most shield designs and identify the owners of the designs. This was the second series of models commissioned by Mooney. An earlier series, slightly larger in diameter, was prepared by unknown artists for the 1893 World Columbian Exposition.

Published illustrations:
 Merrill et al. (1997:97, 100, 101, 149)

Illustrated here: fig. 8.2; plates 36, 37

Cat. No.: 233,092, hide painting

Images: 3 scenes

Size: 54" wide

Media: Ink and paint on buckskin

Documentation: This hide is a part of Accession #42,431, described above. It was cataloged by reference to a tag on the hide written by James Mooney: "Kiowa buckskin painting by Hanqun [sic] detailing war exploits of his brother Haba, from dictation of Haba. James Mooney 1904."

Comments: A rough sketch of the hide and a detailed interpretation of the events depicted appear in Mooney's papers (NAA MS 2531, vol. 2), dated September 28–30, 1904. It shows the war exploits of Silver Horn's brother Haba, their father, Agiati, and the warrior Big Bow.

Illustrated here: plate 14

Cat. No.: 245,018, 245,026, tipi models

Images: 2

Size: 54" wide

Media: Paint on buckskin

Documentation: These models are part of Accession #42,431, described above. Mooney's notes for these tipi designs identify Silver Horn as the maker of the models. Catalog #245,018 is a Kiowa design known as the Black Stripe Tipi; 245,026 is a Plains Apache (Kiowa Apache) design called the Bashae Tipi, from the name of its owner.

Comments: Most of the tipi models commissioned by James Mooney were made before he employed Silver Horn, and he recorded the names of the various artists. These two models were made at a later date to fill gaps in the series.

Published illustrations:
Ewers (1978:40)

Illustrated here: fig. 8.3

Cat. No.: 385,902, rawhide painting

Images: 3 scenes

Size: 39" wide

Media: Pencil and paint on rawhide

Documentation: Collected by James D. Glennan, an army officer and physician who rose to the rank of brigadier general. From 1892 to 1897, he was posted at Fort Sill, where he assembled a collection of Southern Plains material. The collection was donated to the museum by his heirs in 1947 and recorded as Accession #177,672. Glennan kept a catalog of his collection, recording the tribe and in some instances the name of the individual from whom items were acquired. Not all items in the catalog were received by the museum. This rawhide cannot be firmly matched to an entry, although Glennan recorded two paintings on "buckskin" by Silver Horn. This piece has been assigned to Silver Horn by attribution.

Comments: This piece is similar to the two rawhide paintings in the Hearst Museum both in general technique and in the use of a framing border. As in those paintings, the original delicate drawing is largely obscured by the thick, opaque paint.

Illustrated here: fig. 3.12

Nelson-Atkins Museum of Art
Kansas City, Missouri

Cat. No.: 64.9, book of drawings

Images: 75 drawings

Size: 15¾" wide × 11" high

Media: Pencil and colored pencil in a bound drawing book

Documentation: Collected from the artist by Dudley P. Brown, who recorded detailed captioning information on stationery dated "Anadarko, I.T., August 1883." Donated to the museum in 1965 by his son, Dudley C. Brown. Dudley P. Brown also collected the four books at the Field Museum of Natural History.

Comments: A finely drawn book with some unique subject matter, made the more remarkable by the detail of

the accompanying captions. This is Silver Horn's earliest known work on paper and shows a finely developed drawing technique. The 1883 dating of the work has at times been questioned because of the belief that the final picture in the book, captioned by Brown as a "Messiah dance," represents the Ghost Dance, which did not reach the Kiowas until 1891. As discussed in chapter 5, however, the Ghost Dance was only one of a series of messianic movements in which Kiowa people participated, including the Buffalo Calling ceremony, which is clearly pictured earlier in the book.

Published illustrations:
 Coe (1977:184)

Illustrated here: figs. 3.6, 4.5, 4.6, 5.1–5.3, 5.6, 9.2, 9.3; plates 8, 9, 17, 23, 28

Newberry Library
Chicago, Illinois

Cat. No.: Ayer Collection, set of drawings

Images: 123 drawings

Size: #1–#31: 31 drawings 5" wide × 7¾" high
 #32–#84: 53 drawings 5½" wide × 8¾" high
 #85–#123: 39 drawings 6⅞" wide × 9¾" high

Media: Pencil and watercolor on loose sheets of paper

Documentation: Part of the E.E. Ayer Collection, assumed to have been collected by Ayer's nephew E.A. Burbank, an artist who met Silver Horn in 1897 and made a sketch of him. In a brief article published in 1900 and again in a more lengthy series of reminiscences (Burbank 1900; Burbank and Joyce 1944), Burbank described his association with Silver Horn and the circumstances under which he acquired at least a portion of the drawings, which were sent to him in return for the gift of a set of watercolor paints. Drawings 1–31 inscribed on the back: "Drawn by Hawgone (Kiowa Indian) Ft. Sill OT May 1897." Drawing 101 inscribed on the face, "Portrait of himself by Hawgone—Authority Gen. Scott," and on the verso, "Hawgone now blind (Aug. 7, 1921)."

Comments: The majority of the drawings are full-length portraits of individual men, with additional images of painted tipis and a few animals. Two sets of drawings follow the Kiowa tradition of focusing attention on costume rather than facial features and representing figures as flat, two-dimensional forms. The third set of drawings shows great attention to delineating facial planes and features as well as using shading and line to give three-dimensionality to figures.

Published illustrations:
 Burbank (1900:91)
 Maurer (1977:197)

Illustrated here: figs. 8.6, 9.9–9.11; plates 13, 43

Oklahoma Historical Society
Oklahoma City, Oklahoma

Cat. No.: 4396, muslin painting

Images: 1

Size: 92" wide × 69½" high

Media: Pencil and paint on muslin

Documentation: Received by the museum without documentation from Neal Evans in 1936. It was first recorded as a loan then subsequently converted into a donation. The history of its collecting is recorded in the papers of James Mooney, who made notes of an interview with Evans in 1904, at which time he examined the muslin (NAA MS 2497). Evans collected it from the Kiowas, while he was a post trader at Fort Sill from 1876 to 1880, after which he moved to Fort Reno. Captions on the muslin were written by Evans based on information given to him by Kiowas at the time of acquisition: "Osage and Kiowa Fight," "Ft. Zarah," and "6th Infty."

Comments: This is Silver Horn's earliest known work and is assigned to him by attribution. It is probably by this single artist, but there are some inconsistencies in the drawing that could indicate either multiple hands at

work or a young artist not yet fixed in his habits. It can be firmly linked to the notes made by Mooney, who recorded the number of mounted figures and tipis illustrated. The Cheyenne men who viewed the piece with Mooney thought that it represented a battle in which Cheyennes as well as Kiowas (together with their Osage allies) were involved in a fight with enemies they identified as "Alahos," meaning eastern Indians. Mooney thought they must be referring to a battle that occurred in 1854, as recorded in his *Calendar History* (Mooney 1898:300). If so, the muslin records different aspects of the event than appear in his book.

Published illustrations:
Szabo (1993:15) (correct caption on 13)

Illustrated here: figs. 3.2, 3.3; plate 6

Cat. No.: 68.20.1, muslin painting

Images: 22 scenes, including 6 by Silver Horn

Size: 120" wide × 72" high

Media: Pencil and paint on muslin

Documentation: Received by Ellsworth Ely Van Horne, who was working at a trader's store near the Kiowa Agency, as a departure gift when he left Indian Territory between 1886 and 1888. His departure came soon after his marriage to Charlotte Louisa Clark, an Anadarko schoolteacher. Their wedding was held in the chapel at Fort Sill and was attended by Capt. Lee Hall, agent to the Kiowas from 1885 to 1887 (and collector of the Witte Museum muslin). The muslin passed to his son, Arthur Clark Van Horne. It was donated to the museum by Arthur's widow, Harriet Van Horne, in 1968, who provided this record of its history.

Comments: This muslin includes the work of several artists, one of whom has been identified as Silver Horn by attribution.

Published illustrations:
Silberman (1978:72)

Illustrated here: figs. 3.4, 4.2, 10.2; plate 7

Philbrook Museum of Art
Tulsa, Oklahoma

Cat. No.: 82.6, muslin painting

Images: 17 scenes, including 10 by Silver Horn and 2 others to which he contributed

Size: 75" wide × 86" high

Media: Pencil, colored pencil, ink, and paint on muslin

Documentation: Received by the museum in the 1980s without any documentation from the Muskogee Public Library, which had received it from Mrs. Viola Addington in 1934. Attributed to Silver Horn by the curator Ed Wade and other museum staff.

Comments: This is a classic exploit muslin with war vignettes by at least three artists, one of whom is Silver Horn. It is unusual in that many of the figures are identified by inscriptions, with Sun Boy most prominent. The writing has been attributed to Hugh Scott, but it does not appear to me to resemble his hand.

Published illustrations:
Young (1986:49, detail 61)
Wade (1991:200)

Illustrated here: fig. 4.4

Pomona College Museum
Claremont, California

Cat. No.: 5106, hide painting

Images: 12 scenes

Size: 55" wide

Media: Ink and paint on buckskin

Documentation: Given to the college in 1938 by Martin Abernathy, a Protestant missionary, who identified it as Kiowa and provided limited and somewhat erroneous information about the content of the images. "Haun-goo-ah" is inscribed in the upper right corner.

Comments: The hide painting was researched by Hartley Burr Alexander, who corresponded with John P. Harrington, the Smithsonian linguist, regarding the proper translation into English of the artist's name as written on the hide. Alexander recognized that the work was by the same artist who produced the Medicine Lodge hide painting series at the Smithsonian. The painting is undated, but is probably among the last that the artist produced in the 1910s. It reiterates many themes explored in earlier works, but with much more detailed landscape setting and naturalism in poses.

Published illustrations:
Alexander (1938: pl. 24, details in pl. 25, a–i)
Tillett (1976:31 detail)
Koeninger and Mack (1979:49)

Illustrated here: fig. 6.14

Southwest Museum
Los Angeles, California

Cat. No.: 653-G-1, muslin painting

Images: 1

Size: 65" wide × 41½" high

Media: Pencil and paint on muslin

Documentation: Recorded by the museum as collected by J.E. Mifflin, Jr., while visiting his cousin Mrs. Hugh Scott at Fort Sill between 1880 and 1890. (The Scotts were actually there from 1889 to 1897.) It passed from him to his cousin Mrs. Richard Henry Alexander and then to her daughter, Mrs. Elizabeth C. Anderson, who donated it to the Southwest Museum in 1935 and provided its history. The muslin is inscribed: "Custer's fight on the Washita with Black Kettle & Cheyennes painted by Ho-gon—Silver Horn—a Kiowa Indian. J.E. Mifflin I."

Comments: While the donor had the dates of the Scotts' residence at Fort Sill slightly wrong, the rest of the information is reasonable, and the muslin probably dates from that period. While Silver Horn must have drawn many of the figures on this muslin, the work of at least one other hand can be discerned.

Witte Museum
San Antonio, Texas

Cat. No.: 40-151, muslin painting

Images: 12 scenes, including 3 by Silver Horn

Size: not recorded

Media: Pencil and colored pencil on muslin

Documentation: Collected in Indian Territory by Capt. Lee Hall, a former Texas Ranger, who was the agent for the Kiowa, Comanche, and Apache Reservation from August 1885 to October 1887. Received by the museum in 1941 from Hall's daughter-in-law, Mrs. Dorothy H. Hall. Potential attribution to Silver Horn was suggested to the museum by Arthur Silberman in the 1970s or 1980s.

Comments: This is a classic exploit muslin with war vignettes by at least three artists, one of whom is Silver Horn. His work in this piece is stylistically closer to the bold drawings in the McNay Museum and the Museum of Fine Arts than to the delicate work in the Nelson-Atkins book.

Illustrated here: figs. 3.5, 4.3

Notes

Chapter 1. From the Plains Pictorial Tradition

1. The importance of recognizing individual artists was acknowledged in two recent major exhibitions of Plains drawing (Maurer 1992; Berlo 1996) that highlighted named artists. The construction of full biographies for these individuals was beyond the scope of these projects, however. Great contributions remain to be made in this area as connections are established between the drawings and descendants of the artists or other members of the community. One such ongoing project is Arthur Amiotte's research on the work of his great-grandfather, the Lakota artist Standing Bear. Petersen's *Plains Indian Art from Fort Marion* (1971) was greatly enriched by her pioneering efforts to seek out descendants of these artists. The Fort Marion artists are undoubtedly the best-known Plains artists of the nineteenth century, with a full-length book devoted to the work of the Cheyenne Howling Wolf (Szabo 1994). Yet the total oeuvre of each of these artists is relatively small, and the topics covered often narrow by comparison with Silver Horn.

2. The recognition of distinct genres of rock art is an important contribution made by James Keyser (1977), who termed them "biographic" and "ceremonial." I believe that these two forms are closely related to if not congruent with the categories I am here calling "narrative" and "visionary" art. My usage generally follows Feest (1992:50–55). All authors choose terms suited to the nature of their analysis, and I have chosen terms most evocative of my understanding of the meaning of the art forms to their nineteenth-century producers.

3. For example, an undocumented book of drawings in the Texas Memorial Museum has been variously attributed to the Kiowas and to the Arapahos (Maurer 1992:204, 273, 283; Berlo 1996:76–79).

4. Work inscribed as having been produced by an eleventh artist, Tanedooah, has been located in a Vermont collection since Petersen's groundbreaking work.

5. One of the artists commissioned by James Mooney was Silver Horn's brother Oheltoint, who painted a miniature tipi cover, still preserved at the Smithsonian. A photograph of another artist, Zotom, posed as though painting a tipi model, has been widely published, leading to the mistaken idea that he produced many works. In fact, like Oheltoint, he seems to have painted only a single tipi model.

Chapter 2. It Comes from Family

1. Like many other Plains tribes, the Kiowas had a series of warrior societies, which were collectively known as Yapahe. Their names and translations are recorded in somewhat varying form in Mooney (1898:230),

Lowie (1916), LaBarre et al. (1935:526–59), and Meadows (1991). Boys belonged to the Polanyi ("Rabbits"), while young men usually first joined the Adltoyui ("Young Mountain Sheep" or "Shepherds"). Mature warriors might belong to the Tsentanma ("Horse Headdresses" or "Horse Caps"), the Tonkongya ("Black Legs" or "Black Feet"), or the Taimpego ("Berries" or "Skunk Berries"). A select few of the most prestigious warriors belonged to the Koitsenko ("Real Dogs," "Principal Dogs," or "Horses").

2. At some point in his life, he was given the name Talipaide ("Boy Hero"). He never used the name and later gave it to his son George (J. Silverhorn 1967a:7).

3. A model of this shield cover is in the Hugh Scott collection at the Hearst Museum of Anthropology, cat. no. 2-4867d (see the appendix).

4. Members of the Tonkongya, the Kiowa Black Leggings Warrior Society, currently wear red capes as part of their official dress, commemorating the capture of such a cape from a Mexican soldier by a nineteenth-century member of the society (Bantista [1983]:6). The Tohausen cape could have a similar history as a war trophy.

5. Due to an editorial error, the lance is erroneously captioned in that article as a sash, as suggested in Szabo (1993:19). The depiction of the lance point, however, makes its identity clear.

6. See Greene 1996a for a more extended discussion of material culture items in Silver Horn's family.

7. There is some confusion in the records over Silver Horn's society membership. He told James Mooney that he was invited to join the Tsentanma but declined, for he was then actively involved in a recently introduced society, the Ohomah (Mooney MS 2531, 6:165). In 1935, however, he reported that at age nineteen he did join the Tsentanma, the warrior society to which several of his brothers belonged (LaBarre et al. 1935:41, 526). Membership in societies was probably less clearly defined during this era, when their functions were primarily social and active participation was less obligatory.

8. James appears in agency records under the name Billie. Such discrepancies are fairly common because agency clerks were always willing to assign names themselves without consultation if the parents were slow to register a child properly.

9. No comprehensive overview of Kiowa reservation and postreservation life has been written, but poignant glimpses can be found in *The Way to Rainy Mountain* (Momaday 1969) and *The Ten Grandmothers* (Marriott 1945). For coverage of this period on the adjacent Cheyenne and Arapaho reservation, where people experienced many of the same problems, see Berthrong's *The Cheyenne and Arapaho Ordeal* (1976).

10. Many years later, while discussing the pictorial diary, Hugh Scott told Matthew Stirling that Silver Horn had joined him on a trip to Washington, D.C., in 1894 as part of a delegation seeking to present their objections directly to the president. The participation of the official tribal delegates Apiatan (Kiowa), Naboni (Comanche), and Apache Jim (Plains Apache) is well documented, but I have been unable to find any confirmation that Silver Horn accompanied them.

11.　Silver Horn evidently had the economic resources to support his moral position. Hugh Scott reported that when he visited him in 1920, he had $18,000 on deposit in a bank from royalties paid for oil struck on his allotment (Scott MS 2932, 2).

12.　I would like to thank Daniel Swan for bringing this rattle to my attention.

Chapter 3. Paper to Buckskin: Illustrating Kiowa Culture

1.　The authorship of the primary set of works ascribed to Oheltoint, a book of fifty-five drawings in the Pratt Papers at the Beinecke Library, Yale University, is now in serious question. These works as well as others believed to be by Oheltoint were examined as part of a workshop that I organized at the 1999 meeting of the Native American Art Studies Association. An assembled panel of art historians (Janet Berlo, Bill Holm, Imre Nagy, and Joyce Szabo) concluded that there were many problems in defining Oheltoint's work and that more examples were needed to reach firm conclusions.

2.　Plains artists often built up pictures in a series of layers, drawing first the horse, then the rider, then adding his clothing or weaponry. The outlines of each layer were clearly apparent in the finished picture unless they were heavily colored over, resulting in what is sometimes called a "transparent" style, where, for example, the belly and back of a horse are seen as lines passing through the body of the rider. Silver Horn worked in the same way, beginning with the horse rather than the rider, but he planned his images very carefully, leaving gaps where he intended to insert another element. A close examination shows that he began by drawing the fore- and hindquarters of the horse, leaving a space for the rider between, then finishing up the lines of belly and back once the rider was completed.

3.　The book was loaned to John C. Ewers in the 1970s for study, and my analysis is based on his notes.

4.　See chapter 5 for an extended discussion of this ceremony.

5.　See Greene (1992a) for discussion of page usage; also see Szabo (1989) for discussion of a linear narrative by Howling Wolf of events associated with the Medicine Lodge Treaty of 1867.

6.　While Cheyenne people under the leadership of Black Kettle took the brunt of that attack, a number of Kiowas who were camped adjacent to them were also involved (Mooney 1898:187).

7.　Scott's planned book was never published, although a small booklet using a few of his stories and pictures was produced to accompany an exhibition of the drawings (Greene and Reuss 1993). Drafts of various portions of Scott's manuscript can be found among his papers in the Smithsonian (Scott MS 2932), the Library of Congress (Scott Collection), and accompanying the drawings (MIAC).

8.　The precision with which Silver Horn worked is now slightly obscured by the accidental transfer of some paints and ink to other areas across fold lines.

Chapter 4. The Art of Coup Counting

1. I have found a few works with limited documentation that suggest that some other artists were working in obscurity during the first two decades of the twentieth century, crafting their own unique responses to changing times. Much more research is needed before we can comment on their identity or artistic intent.

2. Mooney (1898:271) noted for a later period that it was typical that one part of the tribe might be raiding in Mexico while another band was trading on the Upper Missouri.

3. Wade (1991:200) suggested that the handwriting resembles that of Hugh Scott, but I do not observe any points of similarity.

4. The most comprehensive effort to date to make such linkages for a set of Cheyenne drawings is found in a detailed study of the Dog Soldiers Ledger at the Colorado Historical Society (Afton, Halaas, and Masich 1997). In spite of the good documentation accompanying the drawings and extensive research with military records as well as Cheyenne source material, the authors met with very limited success in tying pictures to specific events.

5. The Kiowas were involved in this fight, one band being camped downriver from Black Kettle. See chapter 3, note 6. Both the Padogai shield and the painted designs on the tipis, including the striped Tipi with Battle Pictures, indicate that it is indeed a Kiowa camp under siege here, although the exact event cannot be verified.

6. This story is still told in the White Horse family. Florene Whitehorse Taylor explained to me that the point of the story was not White Horse's strength and ferocity, but that he was childless and wanted to capture a child to raise as his own son. There are differences among the three drawings of this event. The drawing by Koba, who was incarcerated with White Horse at Fort Marion, is remarkably similar to Silver Horn's work, reproduced here as plate 15, with the shield and headdress drawn in much the same way. In the other drawing by Silver Horn (fig. 4.7), the warrior is dressed quite differently. Possibly another warrior carried out a similar bold capture, and Horace Jones wrongly assumed that the picture was of White Horse.

7. It is perhaps not coincidental that the only comparable images I have encountered in Plains graphic art are among Red Horse's drawings of the Custer battle. In that series, the Sioux artist has filled many oversized pages with the dismembered bodies of the defeated Seventh Cavalry (NAA MS 2367).

8. It is notable that Silver Horn never illustrated one aspect of war—the capture of horses. While this is to be expected in art limited to the bounds of the coup system, which did not recognize horse capture as a deed of honor, it is remarkable that this important activity was never added when the range of subject matter expanded. Evidently Silver Horn considered it beneath comment, a crass economic pursuit.

Chapter 5. Ceremonial Life, Old and New

1. An extensive discussion of Kiowa concepts of power can be found in Kracht (1989:77–96) and in LaBarre et al. (1935:938–48).

2. Thomas Battey, a Quaker teacher working among the Kiowas in the mid-1870s, observed and described the ceremony to the extent that his limited knowledge of Kiowa language and culture allowed (Battey 1968). More informed descriptions based on interviews with participants are provided in Methvin (1996) and particularly in Scott (1911), as well as Mooney (1898). Extensive unpublished information about details of the ceremony and its religious leaders is available in LaBarre et al. (1935), much of which has been incorporated in Kracht (1989).

3. Scott (1911: pl. xviii) described these as cloth offerings, an identification that I believe must be in error.

4. There have been various attempts among the Kiowas to revive the Medicine Lodge ceremony, most recently in 1997, but without the support of the Taime Keeper they have not been successful.

5. Major sources on the history and beliefs of the Peyote religion are LaBarre (1975), Slotkin (1975), and Stewart (1987). Important unpublished information on the early beliefs of Peyotism can be found in Mooney MS 1887 and MS 1930. Swan (1999) is an excellent source on the incorporation of art and material culture into the religion. My understanding of Silver Horn's Peyote pictures has benefited greatly from discussion with Daniel Swan, who also showed copies of these drawings to a number of Kiowa Peyotists and solicited comments on them during his own studies.

6. In later correspondence with Alfred Kroeber, Mooney himself pointed out that "mescal" was a misnomer (Mooney 1903a).

7. I formerly (Wiedman and Greene 1988) identified his 1891 drawings as having that distinction, before the 1883 pictures came to my attention.

8. While no other graphic artists of the late nineteenth century produced Peyote pictures, many decorated gourd rattles with Peyote-related designs incised on the surface and painted in bright colors. Some designs are representational (see fig. 2.11 and Mooney 1892), while others are abstract (see Swan 1999:47). Daniel Swan pointed out to me the resemblance between some of these images on rattles and Silver Horn's visionary drawings. The resemblance suggests that there were some shared conventions emerging for representing the Peyote experience, although only Silver Horn placed them on paper.

9. The Buffalo Returning Ceremony received brief notice from Mooney (1896:163, 1898:349–50). More extensive information is available in an unpublished manuscript by Alice Marriott (n.d.).

10. Paingya's efforts to restore the buffalo are noted in Mooney (1896:163–64, 1898:356–57). A limited

and biased account of the Elk Creek gathering from the perspective of Capt. Lee Hall is included in Raymond (1940:240). The later course of Paingya's followers is described in LaBarre et al. (1935:829–33, 884–86).

11. The origin and initial acceptance of the Ghost Dance is well covered in Mooney (1896).

12. Kracht (1992) is the only published source on the later years of the Kiowa Ghost Dance. He draws heavily on unpublished material in LaBarre et al. (1935) and various government sources, as cited in Kracht (1989).

13. Kiowa people who were preparing ritual costumes to be used during the 1997 efforts to revive the Sun Dance contacted me to obtain copies of these images as an important source of information.

Chapter 6. Visualizing the Oral Tradition

1. Among some North American tribes, the role of storyteller was a formalized one, and only certain individuals were authorized to tell specific stories (Radin 1956). The only suggestion of such restriction among the Kiowas is the comment by Parsons (1929:xvii) that some people were reluctant to talk about the Twin Boys, saying that the story belonged to the Ten Medicine Keepers. Stories of them were widely recorded by Scott, Mooney, Marriott, Boyd, and Momaday, however, none of whom noted such a restriction. It would be of interest to learn more about the social position of the people from whom they heard the stories.

2. The version presented here is based primarily on Scott (ca. 1897, 1:125, ca. 1920a:1–11). For additional versions, see Boyd (1983:2–12), LaBarre et al. (1935:798–800, 1257–62, 1272–73), Momaday (1969:22–34), and Parsons (1929:1–8).

3. The version presented here is based primarily on Parsons (1929:76–78). For additional versions, see Boyd (1983:70–73), LaBarre et al. (1935:1114–19, 1266–67), and Momaday (1969:54).

4. See Boyd (1983:188–89) and Scott (ca. 1920a:39–40) for versions of this story.

5. See Scott (ca. 1897, 2:123, 133, 150, ca. 1920a:74–75) and LaBarre et al. (1935:378–79) for versions of this story.

6. See Boyd (1983:192–93) and Scott (ca. 1897, 1:133) for versions of this story.

7. See Scott (ca. 1897, 2:41, ca. 1920a:88–90) and Marriott (1947:57–62) for versions of this story.

8. See Boyd (1983:191–92) and Scott (ca. 1897, 1:161, 2:134, ca. 1920a:92–93) for versions of this story.

9. See Boyd (1983:66), Marriott (1947:18–26), Parsons (1929:21), and Scott (ca. 1897, 3:18, ca. 1920a:29–32) for versions of this story.

10. See Scott (ca. 1897, 3:13, ca. 1920a:23–25) for versions of this story.

11. In some recorded versions, the child is a girl, in others a boy. See Boyd (1983:88), Momaday (1969:8), Parsons (1929:9), and Scott (ca. 1897, 1:173, ca. 1920a:35–38).

12. James Silverhorn's seven daughters are known jokingly as the Seven Sisters.

13. Two Sayday pictures from this series were published the year before Mooney's report came out (Humfreville 1897:331, 333), where they were identified merely as "made by a Kiowa."

Chapter 7. Marking Time: The Calendars

1. Anko's monthly and annual calendars were drawn on separate pages of this notebook. For publication, Mooney had an illustrator combine both records from this notebook and redraw them on a photograph of a buffalo hide. The resulting image, which appears in his *Calendar History* as plate 80, gives a very different impression than the small, worn book that has been preserved in NAA MS 2538. The published construct has been reified by subsequent Kiowa artists such as Bobby Hill and Charlie Rowell, who have painted calendars on hide in emulation of it.

2. Several authors, including Jantzer-White (1996), have noted that modern Western viewers, socialized to privilege text over pictures, often place undue reliance upon inscriptions in interpreting Plains Indian drawings. In this instance, Mooney's handwriting is so bad that the pictures must be used as a primary source for explicating the text.

3. Several modern Kiowa people who examined copies of the calendar thought that the birds might be thunderbirds and that they would therefore indicate a thunderstorm that day. Their regularity of placement rules out that interpretation, but supports the idea that they represent the coins, although they are not clear replicas of any coins of the time. Nineteenth-century Kiowa people evidently found little resemblance between the symbolic image of the American eagle, as it appeared on coins and other government issues, and the bald eagle with which they were familiar. Instead, they believed that these items carried representations of the more powerful thunderbird.

Chapter 8. Visions on Shields and Tipis: Kiowa Heraldry

1. A full description of the Tipi with Battle Pictures is given in Greene (1993). Various tipi and shield designs have been revived by families in the twentieth century for display at tribal gatherings as well as at public expositions.

2. See Moses (1984:108–21) for a discussion of these expositions and Mooney's involvement. Many of the tipi models are illustrated in Ewers (1978).

3. Photographs of the exhibit (Mooney MS 2531) demonstrate that a few of the tipi models were actually ones previously produced by other artists.

4. Fagin (1988) has suggested that all of the Field Museum tipi models were painted by Silver Horn. The Mooney correspondence that she cites in support of this, however, relates to his Kiowa project, not to the Cheyenne work as she assumed, and many can be matched stylistically to the works on paper by Cheyenne artists.

5. Gordon Yellowman, cultural affairs officer for the Southern Cheyennes, found the correspondence on this and encouraged me to look into the origin of this piece. In subsequent discussions with Father Peter Powell, I discovered that he had independently reached the same conclusion that the painting must be by Silver Horn.

6. For published images of this type, see McCoy (1987, 1996) and Szabo (1993), although I do not agree with the latter author's attribution of these drawings to Silver Horn. Unpublished Kiowa tipi drawings following this form are also found in NAA MS 4656 and MS 392,725.

7. For examples of such Kiowa shields, see the collections of the National Museum of the American Indian (cat. #2/4644; 2/2475; 2/2476; 12/3230). The Fort Sill Museum also has a canvas copy of the Padogai shield hereditary in Silver Horn's family.

8. In recent years, there has been a resurgence of Kiowa interest in their heraldic traditions, and Silver Horn's drawings and Mooney's notes are recognized as precious repositories of information. Reasserting claims to such designs is, however, a complex process of negotiation among a host of descendants, for many design owners died virtually "intestate." Kiowa Agency heirship records devote much attention to the disposition of cows and plows, but make no mention of more highly valued intangibles such as shield and tipi designs.

9. It is ironic that the Tipi with Battle Pictures is chiefly remembered not from this full-sized version but rather from the model made for James Mooney by Charley Buffalo, which was published by Mooney (1898). Charley was able to fit only seven scenes of battle on that miniature cover. Modern Kiowa tipi painters reproducing the tipi in full size have used the published model as a source of information. In these new versions, the tiny figures that crowded the scale model have assumed heroic proportions. For examples by Dixon Palmer, see illustrations in Libhart and Ellison (1973:23) and Maurer (1992:228).

Chapter 9. Scenes from Life

1. The symbolic connections among warfare, courting, and hunting were at the core of my dissertation on Cheyenne art (Greene 1985) and are presented in brief summary in Greene (1996b). For a general discussion of depictions of Plains courting customs, see Powers (1980).

2. It is not possible now to determine how common elopement and wife stealing actually were, for scandalous liaisons may have been better remembered than staid marriages. Irregular marriages were, however, suffi-

ciently common to have generated institutionalized methods for coping with the social disruption they caused. For example, an elopement without gifts to a bride's family was considered "stealing" (Mooney 1898:294), and her female relatives had the right to raid the property of the groom's family and to carry off unopposed whatever they felt was appropriate compensation (LaBarre et al. 1935:256). Similarly, in cases of wife stealing, violence might be averted through swift intervention by family members who arranged for the incident to be settled by a gift of horses to restore the dignity of the offended husband (LaBarre et al. 1935:279, 321, 334, 401; Richardson 1940:70–75).

Chapter 10. Innovator and Traditionalist

 1. For Silver Horn's influence on modern Plains artists, see Ellison (1972:12), Silberman (1978:15–16), Rushing (1996:56), and Donnelley (2000: 88–93).

 2. At the very outset of the reservation period, the artists imprisoned at Fort Marion found a large outside audience for their drawings, and they produced hundreds of pictures for sale. This was one of many factors that set their experience apart from that of the artists who remained at home, as I have suggested elsewhere (Greene 1992a). A number of fine studies have made the Fort Marion work well known, but they have focused primarily on the artists' response to their exposure to Western visual forms. No study has yet examined the complex social factors that confronted them and how they reconciled previous concepts of the role of art with the new opportunities and limitations presented by incarceration far from home.

Bibliography

Published Materials

Afton, Jean, David Fridtjof Halaas, and Andrew E. Masich
 1997 *Cheyenne Dog Soldiers: A Ledgerbook History of Coups and Combat.* Denver: Colorado Historical
 Society.
Alexander, Hartley Burr
 1938 *Sioux Indian Painting.* Nice, France: C. Szwedzicki.
Anadarko Daily News
 1940a Silver Horn, Indian Soldier Dies. 12/15/1940.
 1940b Silver Horn Is Buried Today. 12/16/1940.
Archuleta, Margaret, and Rennard Strickland
 1991 *Shared Visions: Native American Painters and Sculptors in the Twentieth Century.* New York: New
 Press.
Bantista, Rudy
 [1983] *Twenty-fifth Anniversary, Kiowa Black Leggings Warrior Society.* Privately published.
Bass, Althea
 1954 James Mooney in Oklahoma. *Chronicles of Oklahoma* 32: 246–62.
 1956 Carl Sweezey, Arapaho Artist. *Chronicles of Oklahoma* 34: 429–31.
 1966 *The Arapaho Way: A Memoir of an Indian Boyhood.* New York: Clarkson N. Potter, Inc.
Battey, Thomas
 1968 *The Life and Adventures of a Quaker among the Indians.* Norman: University of Oklahoma Press.
 [Orig. pub. Boston: Lee & Shepard, 1875.]
Berlo, Janet C., ed.
 1996 *Plains Indian Drawings 1865–1935: Pages from a Visual History.* New York: Harry N. Abrams.
Berthrong, Donald J.
 1976 *The Cheyenne and Arapaho Ordeal: Reservation and Agency Life in the Indian Territory, 1875–1907.*
 Norman: University of Oklahoma Press.
Blish, Helen H.
 1967 *A Pictographic History of the Oglala Sioux.* Lincoln: University of Nebraska Press.

Boyd, Maurice
 1981 *Kiowa Voices, Vol. 1: Ceremonial Dance, Ritual, and Song.* Fort Worth: Texas Christian University Press.
 1983 *Kiowa Voices, Vol. 2: Myths, Legends, and Folktales.* Fort Worth: Texas Christian University Press.

Brody, J. J.
 1971 *Indian Painters and White Patrons.* Albuquerque: University of New Mexico Press.

Burbank, Edward A.
 1900 Studies of Art in American Life, III—In Indian Tepees. *Brush and Pencil* 7(2): 75–91.

Burbank, E. A., and Ernest Joyce
 1944 *Burbank among the Indians.* Caldwell, Idaho: Caxton Printers, Ltd.

Caldararo, Niccolo
 1991 Mounting Two Plains Hide Paintings. *Curator* 34(3): 187–98.

Callander, Lee A., and Ruth Slivka
 1984 *Shawnee Home Life: The Paintings of Earnest Spybuck.* New York: Museum of the American Indian.

Coe, Ralph T.
 1977 *Sacred Circles: Two Thousand Years of North American Indian Art.* Kansas City: Nelson Gallery of Art–Atkins Museum of Fine Arts.

Conner, Stuart W., and Betty Lu Conner
 1971 *Rock Art of the Montana High Plains.* Santa Barbara: Art Galleries, University of California.

Corwin, Hugh D., ed.
 1967 The A-nan-thy Odle-paugh Calendar. *Prairie Lore* (October): 66–83.
 1968 The Ananthy Odle-paugh Calendar. *Prairie Lore* (April): 226–28.
 1971a The A-nanthy Odle-paugh Kiowa Calendar. *Prairie Lore* (January): 130–53.
 1971b A-Nanthy Odle-paugh Kiowa Calendar. *Prairie Lore* (October): 107–25.
 1975 The A-Nanthy Odle-paugh Kiowa Calendar. *Prairie Lore* (January): 154–63.

Culin, Stewart
 1907 *Games of the North American Indians.* Bureau of American Ethnology. 24th Annual Report for 1902–3. [Reprint, New York: Dover, 1974.]

Donnelley, Robert G.
 2000 *Transforming Images: The Art of Silver Horn and His Successors.* Chicago: The David and Alfred Smart Museum of Art, University of Chicago.

Dunn, Dorothy, ed.
 1969 *1877: Plains Indian Sketch Books of Zo-Tom and Howling Wolf.* Flagstaff, Ariz.: Northland Press.

Ellison, Rosemary
1972 *Contemporary Southern Plains Indian Painting.* Anadarko, Okla.: Indian Arts and Crafts Board.
1976 *Contemporary Southern Plains Indian Metalwork.* Anadarko, Okla.: Indian Arts and Crafts Board.
Ewers, John C.
1939 *Plains Indian Painting: A Description of an Aboriginal American Art.* Palo Alto, Calif.: Stanford
 University Press.
1977 The Making and Use of Maps by Plains Indian Warriors. *By Valor and Arms* 3(1): 36–43.
1978 *Murals in the Round: Painted Tipis of the Kiowa and Kiowa-Apache Indians.* Washington, D.C.:
 Smithsonian Institution Press.
1983 Plains Indian Artists and Anthropologists: A Fruitful Collaboration. *American Indian Art Magazine*
 9(1): 36–49.
Fagin, Nancy
1988 The James Mooney Collection of Cheyenne Tipi Models at Field Museum of Natural History.
 Plains Anthropologist 33-120: 261–78.
Fairbanks, Jonathan L.
1975 *Frontier America: The Far West.* Boston: Museum of Fine Arts.
Fane, Diana, Ira Jacknis, and Lise M. Breen
1991 *Objects of Myth and Memory: American Indian Art at the Brooklyn Museum.* Brooklyn, N.Y.:
 Brooklyn Museum.
Feest, Christian F.
1992 *Native Arts of North America.* London: Thames and Hudson.
Fenner, Earl C.
1974 Tsaidetali. *Indian America* 8(7):33–48.
Foster, Morris W.
1992 Introduction. In *Rank and Warfare among the Plains Indians,* by Bernard Mishkin, v–xv. Lincoln:
 University of Nebraska Press.
Fredlund, Glen, Linea Sundstrom, and Rebecca Armstrong
1996 Crazy Mule's Maps of the Upper Missouri, 1877–1880. *Plains Anthropologist* 41-155: 5–27.
Galvin, John, ed.
1970 *Through the Country of the Comanche Indians in the Year 1845: The Journal of a U.S. Army
 Expedition Led by Lt. James W. Abert.* San Francisco: John Howell.
Greene, Candace S.
1992a Artists in Blue: the Indian Scouts of Fort Reno and Fort Supply. *American Indian Art Magazine*
 18(2): 50–57.

1992b Five Paintings of the Medicine Lodge Ceremony. In *Visions of the People,* ed. Evan Maurer, pp. 162–65. Minneapolis: Minneapolis Institute of Arts.

1993 The Tepee with Battle Pictures. *Natural History Magazine* 102(10): 68–76.

1996a Exploring the Three "Little Bluffs" of the Kiowa. *Plains Anthropologist* 41-157: 221–42.

1996b Structure and Meaning in Cheyenne Ledger Art. In *Plains Indian Drawings 1865–1935: Pages from a Visual History,* ed. Janet Catherine Berlo, pp. 26–33. New York: Harry N. Abrams, Inc.

1997 Southern Plains Graphic Art before the Reservation. *American Indian Art Magazine* 22(3): 44–53.

1998 Courting and Counting Coup: Cheyenne Ledger Art at Gilcrease. *Gilcrease Journal* 6(1): 4–19.

Greene, Candace S., and Thomas Drescher

1994 The Tipi with Battle Pictures: The Kiowa Tradition of Intangible Property Rights. *Trademark Reporter* 84(4): 418–33.

Greene, Candace S., and Frederick Reuss

1993 *Saynday Was Coming Along . . .* Washington, D.C.: Smithsonian Institution Traveling Exhibition Service.

Hail, Barbara A.

1980 *Hau, Kola! The Plains Indian Collections of the Haffenreffer Museum of Anthropology.* Providence, R.I.: Brown University.

Haines, Francis

1963 *Appaloosa: The Spotted Horse in Art and History.* Austin: University of Texas Press.

Harrington, John P.

1939 Kiowa Memories of the Northland. In *So Live the Works of Man,* ed. D. Brand and F. Harvey, pp. 162–76. Albuquerque: University of New Mexico Press.

1946 Three Kiowa Texts. *International Journal of American Linguistics* 12: 237–42.

Harris, Moira F.

1989 *Between Two Cultures: Kiowa Art from Fort Marion.* St. Paul, Minn.: Pogo Press, Inc.

Horse Capture, George P., Anne Vitart, Michel Waldberg, and W. Richard West, Jr.

1993 *Robes of Splendor: Native North American Painted Buffalo Hides.* New York: New Press.

Hough, Walter

1892 *Catalogue of the Ethnological Exhibit from the United States National Museum.* Washington, D.C.: Columbian Historical Exposition, Madrid.

Humfreville, J. Lee

1897 *Twenty Years among Our Savage Indians.* Hartford, Conn.: Heartland Publishing Co.

Jacobson, Oscar

1929 *Kiowa Indian Art: Watercolor Paintings by the Indians of Oklahoma.* Nice, France: C. Szwedzicki.

Jantzer-White, Marilee
 1996 Narrative and Landscape in the Drawings of Etahdleuh Doanmoe. In *Plains Indian Drawings 1865–1935: Pages from a Visual History,* ed. Janet Catherine Berlo, pp. 50–55. New York: Harry N. Abrams, Inc.

Keim, De B. Randolph
 1885 *Sheridan's Troopers on the Borders: A Winter Campaign on the Plains.* Philadelphia: Claxton, Remsen, and Haffelfinger. [Reprint, Glorieta, N.Mex.: Rio Grande Press, 1977.]

Keyser, James D.
 1977 Writing-on-Stone: Rock Art on the Northwestern Plains. *Canadian Journal of Archaeology* 1: 15–80.

Koeninger, Kay, and Joanne M. Mack
 1979 *Native American Art from the Permanent Collection.* Claremont, Calif.: Galleries of the Claremont Colleges, Pomona College, Scripps College.

Kracht, Benjamin R.
 1992 The Kiowa Ghost Dance, 1894–1916: An Unheralded Revitalization Movement. *Ethnohistory* 39(4): 452–77.

Krech, Shepard, III, ed.
 1994 *A Passionate Hobby: Rudolf Frederick Haffenreffer and the King Philip Museum.* Bristol, R.I.: Haffenreffer Museum of Anthropology, Brown University.

LaBarre, Weston
 1975 *The Peyote Cult.* New York: Schocken Books. [Orig. pub. 1938.]

Levy, Jerrold C.
 1961 Ecology of the Southern Plains. In *Proceedings of the 1961 Meeting of the American Ethnological Society,* ed. Viola Garfield, pp. 18–25. Seattle: University of Washington Press.

Libhart, Miles, and Rosemary Ellison
 1973 *Painted Tipis by Contemporary Plains Indian Artists.* Anadarko, Okla.: Indian Arts and Crafts Board.

Lockwood, Frank C.
 1929 *The Life of Edward E. Ayer.* Chicago: A. C. McClurg & Co.

Lowie, Robert
 1916 Societies of the Kiowa. *Anthropological Papers of the American Museum of Natural History,* vol. 11, part 11, pp. 837–51.

Mallery, Garrick

1886 *Pictographs of the North American Indians: A Preliminary Report.* Bureau of American Ethnology. 4th Annual Report for 1882–83.

1893 *Picture Writing of the American Indians.* Bureau of American Ethnology, 10th Annual Report for 1888–89, pp. 3–807. [Reprint, New York: Dover Books, 1972.]

Marriott, Alice

1945 *The Ten Grandmothers: Epic of the Kiowas.* Norman: University of Oklahoma Press.

1947 *Winter Telling Stories.* New York: Thomas Y. Crowell.

1968 *American Indian Mythology.* New York: Thomas Y. Crowell.

Marriott, Alice, and Carol K. Rachlin

1975 *Plains Indian Mythology.* New York: Thomas Y. Crowell.

Maurer, Evan M.

1977 *The Native American Heritage: A Survey of North American Art.* Chicago: Art Institute of Chicago.

1992 *Visions of the People: A Pictorial History of Plains Indian Life.* Minneapolis: Minneapolis Institute of Arts.

Mayhall, Mildred P.

1962 *The Kiowas.* Norman: University of Oklahoma Press.

McCoy, Ronald

1987 *Kiowa Memories: Images from Indian Territory, 1880.* Santa Fe, N.Mex.: Morning Star Gallery.

1995 Miniature Shields: James Mooney's Fieldwork among the Kiowa and Kiowa-Apache. *American Indian Art Magazine* 20(3): 65–71.

1996 Searching for Clues in Kiowa Ledger Drawings: Combining James Mooney's Fieldwork and the Barber Collection of the Cincinnati Art Museum. *American Indian Art Magazine* 21(3): 54–61.

McLaughlin, Marie L.

1916 *Myths and Legends of the Sioux.* Bismarck, N.Dak.: Bismarck Tribune Co.

Merrill, William L., Marian K. Hansson, Candace S. Greene, and Frederick Reuss

1997 *Guide to the Kiowa Collections at the Smithsonian Institution.* Contributions to Anthropology Series. Washington, D.C.: Smithsonian Institution Press.

Methvin, J. J.

1996 *Andele, or the Mexican-Kiowa Captive.* Albuquerque: University of New Mexico Press. [Orig. pub. Louisville, Ky.: Pentecostal Herald Press, 1899.]

Miles, Charles

1963 *Indian and Eskimo Artifacts of North America.* New York: Bonanza Books.

Mishkin, Bernard
 1992 *Rank and Warfare among the Plains Indians.* Lincoln: University of Nebraska Press. [Orig. pub. as AES Monograph #3, Seattle: University of Washington Press, 1940.]

Momaday, N. Scott
 1969 *The Way to Rainy Mountain.* Albuquerque: University of New Mexico Press.

Mooney, James
 1892 A Kiowa Mescal Rattle. *American Anthropologist* 5: 64–65.
 1896 *The Ghost-Dance Religion and the Sioux Outbreak of 1890.* Bureau of American Ethnology. 14th Annual Report for 1892–93, pt. 2.
 1898 *Calendar History of the Kiowa Indians.* Bureau of American Ethnology. 17th Annual Report for 1895–96, pt. 2.
 1901 Indian Shield Heraldry. *Southern Workman* 30(9): 500–504.

Moses, L. G.
 1984 *The Indian Man: A Biography of James Mooney.* Urbana: University of Illinois Press.

Nye, Wilbur S.
 1938 Excitement on the Sweetwater. *Chronicles of Oklahoma* 16: 241–49.
 1943 *Carbine and Lance: The Story of Old Fort Sill.* Norman: University of Oklahoma Press.
 1962 *Bad Medicine and Good: Tales of the Kiowa.* Norman: University of Oklahoma Press.
 1968 *Plains Indian Raiders: The Final Phases of Warfare from the Arkansas to the Red River.* Norman: University of Oklahoma Press.

Parsons, Elsie Clews
 1929 *Kiowa Tales.* Memoirs of the American Folk-Lore Society, vol. 22.

Petersen, Karen D.
 1971 *Plains Indian Art from Fort Marion.* Norman: University of Oklahoma Press.

Powell, Peter J.
 1976 They Drew from Power. In *Montana: Past and Present,* pp. 1–54. Los Angeles: William Andrews Clark Memorial Library.
 in press *In Sun's Likeness and Power: Cheyenne Accounts of Shield and Tipi Heraldry as Narrated to James Mooney, Ethnologist, 1902–1906.* Washington, D.C.: Smithsonian Institution Press.

Powers, William K.
 1980 The Art of Courtship among the Oglala. *American Indian Art Magazine* 5(2): 40–47.

Price, Byron
 1977 The Utopian Experiment: The U.S. Army and the Indian: 1890–1897. *By Valor and Arms* 3(1): 15–35.

Radin, Paul
 1956 *The Trickster: A Study in American Indian Mythology.* New York: Dell Publishing Co.

Raymond, Dora N.
 1940 *Captain Lee Hall of Texas.* Norman: University of Oklahoma Press.

Richardson, Jane
 1940 *Law and Status among the Kiowa Indians.* Monographs of the American Ethnological Society, 1. New York: J. J. Augustin Publisher.

Roessel, Robert A., Jr.
 1983 Navajo History, 1850–1923. In *Handbook of North American Indians,* vol. 10, pp. 506–23. Washington, D.C.: Smithsonian Institution.

Rushing, W. Jackson
 1996 The Legacy of Ledger Book Drawings in Twentieth-Century Native American Art. In *Plains Indian Drawings 1865–1935: Pages from a Visual History,* ed. Janet Catherine Berlo, pp. 56–62. New York: Harry N. Abrams, Inc.

Schneider, Mary Jane
 1982 Connections: Family Ties in Kiowa Art. In *Pathways to Plains Prehistory: Anthropological Perspectives of Plains Natives and Their Pasts,* ed. D. Wyckoff and J. Hofman, pp. 7–18. Duncan, Okla.: Cross Timbers Press.

Schulze-Thulin, Axel von
 1973 *Indianische Malerei in Nordamerika, 1830–1970: Prärie und Plains, Südwesten, neue Indianer.* Stuttgart: Linden Museum.

Scott, Hugh L.
 1898 The Sign Language of the Plains Indian. In *The International Folk-Lore Congress of the World's Columbian Exposition,* vol. 1, pp. 206–20. Chicago: Charles H. Sergel Co.
 1911 Notes on the Kado, or Sun Dance of the Kiowa. *American Anthropologist* n.s. 13(3): 345–79.
 1928 *Some Memories of a Soldier.* New York: Century Co.

Silberman, Arthur
 1978 *One Hundred Years of Native American Painting.* Oklahoma City: Oklahoma Museum of Art.

Slotkin, J. S.
 1975 *The Peyote Religion: A Study in Indian-White Relations.* New York: Octagon Books.

Smith, Marian
 1938 The War Complex of the Plains Indians. *Proceedings of the American Philosophical Society* 78: 425–64.

Spier, Leslie
1921 Notes on the Kiowa Sun Dance. *Anthropological Papers of the American Museum of Natural History,* vol. 16, part 6, pp. 437–50.
Stewart, Omer C.
1987 *Peyote Religion: A History.* Norman: University of Oklahoma Press.
Storm, Hyemeyohsts
1972 *Seven Arrows.* New York: Harper & Row Publishers.
Swan, Daniel C.
1999 *Peyote Religious Art: Symbols of Faith and Belief.* Jackson: University Press of Mississippi.
Szabo, Joyce M.
1989 Medicine Lodge Treaty Remembered. *American Indian Art Magazine* 14(4): 52–59, 87.
1993 Shields and Lodges, Warriors and Chiefs: Kiowa Drawings as Historical Records. *Ethnohistory* 41(1): 3–24.
1994 *Howling Wolf and the History of Ledger Art.* Albuquerque: University of New Mexico Press.
Thoburn, J. B.
1924 Horace P. Jones, Scout and Interpreter. *Chronicles of Oklahoma* 2(4): 383–85.
Thurman, Melburn D.
1982 Plains Indian Winter Counts and the New Ethnohistory. *Plains Anthropologist* 27-96: 173–75.
Tillett, Leslie
1976 *Wind on the Buffalo Grass: The Indians' Own Account of the Battle at the Little Big Horn River, and the Death of Their Life on the Plains.* New York: Thomas Y. Crowell.
Time-Life Books
1995 *Tribes of the Southern Plains.* Alexandria, Va.: Time-Life Books.
Turpin, Solveig A.
1989 The End of the Trail: An 1870s Plains Combat Autobiography in Southwest Texas. *Plains Anthropologist* 34-124, pt. 1: 105–10.
Wade, Edwin L.
1991 Native American Paintings and Sculpture. In *The Philbrook Museum of Art: A Handbook to the Collections,* pp. 198–201. Tulsa, Okla.: Philbrook Museum of Art.
Wiedman, Dennis
1985 Staff, Fan, Rattle, and Drum: Spiritual and Artistic Expressions of Oklahoma Peyotists. *American Indian Art Magazine* 10(3): 38–45.

Wiedman, Dennis, and Candace Greene
 1988 Early Kiowa Peyote Ritual and Symbol: The 1891 Drawing Books of Silverhorn (Haungooah). *American Indian Art Magazine* 13(4): 32–41.
Williams, Jean, ed.
 1990 *American Indian Artists: The Avery Collection and the McNay Permanent Collection.* San Antonio, Tex.: Marion Koogler McNay Art Museum.
Wissler, Clark, ed.
 1921 *Sun Dance of the Plains Indians.* Anthropological Papers of the American Museum of Natural History, vol. 16.
Young, Gloria
 1986 Aesthetic Archives: The Visual Language of Plains Ledger Art. In *The Arts of the North American Indian: Native Traditions in Evolution,* ed. Edwin L. Wade, pp. 45–62. New York: Hudson Hills Press.

Unpublished Materials

Anadarko Indian Agency
 n.d. Probate Records, Silver Horn. Kiowa Agency Files.
Auchiah, James
 1972 Personal communication to John C. Ewers. Notes in possession of C. Greene.
Big Bow, Harding
 1997 Personal communication to Daniel Swan. Notes in possession of C. Greene.
Brace, Lou Ella
 1967 Doris Duke Oral History Project, Tape 173-2. University of Oklahoma Western History Collection.
Bureau of American Ethnology (BAE)
 1902 Letterbooks, Accounts, Vouchers July–August 1902. National Anthropological Archives, Smithsonian Institution.
Colby, William M.
 1977 Routes to Rainy Mountain: A Biography of James Mooney. Ph.D. dissertation, University of Wisconsin, Madison.
Domjanovich, Steve[n]
 1982 Letter to J. C. Ewers, 10/28/82. C. Greene files.

Dorsey, George
1901 Letter to J. Mooney, 5/21/1901. Field Museum of Natural History, Archives, Dorsey-Mooney
 Correspondence (hereafter FMNH D-M).
n.d. Papers of George Dorsey, 1903–6, A-1. Field Museum of Natural History, Department of
 Anthropology Archives.
Evans, Neal
n.d. Autobiographical sketch. Claude Hensley Collection. Western History Collection, University of
 Oklahoma.
Ewers, John C.
n.d. Unpublished notes on Silver Horn in the possession of C. Greene.
Greene, Candace S.
1985 Women, Bison, and Coup: A Structural Analysis of Cheyenne Pictographic Art. Ph.D. disserta-
 tion, University of Oklahoma.
Harrington, John P.
1936 Letter to H. B. Alexander, 8/4/36. Papers of John P. Harrington. Microfilm roll 12, frame 743,
 National Anthropological Archives, Smithsonian Institution.
Harrington, Mark R.
1909 Box 151, Papers of Mark R. Harrington. Archives, National Museum of the American Indian,
 Smithsonian Institution.
Jacobson, Oscar B.
ca. 1954 [Unpublished manuscript regarding Oklahoma artists.] Papers of Oscar Brousse Jacobson, Western
 History Collections, University of Oklahoma Library.
Kracht, Benjamin R.
1989 Kiowa Religion: An Ethnohistorical Analysis of Ritual Symbolism, 1832–1987. Ph.D. dissertation,
 Southern Methodist University.
Kroeber, Alfred L.
1903 Letter to J. Mooney, 1903. Papers of Alfred L. Kroeber, Correspondence Outgoing. Bancroft
 Library, University of California, Berkeley.
LaBarre, Weston, et al.
1935 Typescript of Students' Notes. [Combined notes of Wm. Bascom, Donald Collier, W. LaBarre,
 Bernard Mishkin, and Jane Richardson of the 1935 Laboratory of Anthropology Field School, led
 by A. Lesser.] Papers of Weston LaBarre, National Anthropological Archives, Smithsonian
 Institution.

Marriott, Alice
 n.d. A Study of the Buffalo Origin Myth and the Buffalo-Returning Ceremony of the Kiowa Indians. Papers of Alice Marriott, Western History Collection, University of Oklahoma Library.
Meadows, William C.
 1991 Tonkonga: An Ethnohistory of the Kiowa Black Legs Military Society. Master's thesis, Department of Anthropology, University of Oklahoma.
Mooney, James
 1901 Letter to G. Dorsey, 12/30/1901. FMNH D-M.
 1902a Letter to G. Dorsey, 1/20/1902. FMNH D-M.
 1902b Letter to G. Dorsey, 2/9/1902. FMNH D-M.
 1902c Letter to W. J. McGee, 4/1/1902. Bureau of American Ethnology, Letters Received, James Mooney 1888–1906 (hereafter BAE LR). National Anthropological Archives, Smithsonian Institution.
 1902d Letter to W. J. McGee, 6/25/1902. BAE LR. National Anthropological Archives, Smithsonian Institution.
 1902e Letter to [W. J. McGee], 12/16/1902. BAE LR, National Anthropological Archives, Smithsonian Institution.
 1903a Letter to Alfred Kroeber, 2/10/1903. Papers of Alfred L. Kroeber, Correspondence Incoming. Bancroft Library, University of California, Berkeley.
 1903b Letter to G. Dorsey, 10/31/1903. FMNH D-M.
 1903c Letter to M. R. Harrington, 11/3/1903. OC #115, Archives, National Museum of the American Indian, Smithsonian Institution.
 1903d Letter to W. H. Holmes, 11/3/1903. BAE LR. National Anthropological Archives, Smithsonian Institution.
 1904a Letter to W. H. Holmes, 1/23/1904. BAE LR. National Anthropological Archives, Smithsonian Institution.
 1904b Letter to D. C. Davies, 3/18/1904. FMNH D-M.
 1904c Letter to W. H. Holmes, 4/15/1904. BAE LR. National Anthropological Archives, Smithsonian Institution.
 1904d Letter to W. H. Holmes, 4/25/1904. BAE LR. National Anthropological Archives, Smithsonian Institution.
 1906a Letter to G. Dorsey, 2/6/1906. FMNH D-M.
 1906b Letter to G. Dorsey, 3/16/1906. FMNH D-M.

1911 Letter to M. R. Harrington, 11/3/1911. OC #115, National Museum of the American Indian, Smithsonian Institution.

MS 1874 [Drawings of shields and war gear, n.d.] National Anthropological Archives, Smithsonian Institution.

MS 1878 [Notes regarding Kiowa bird shields, n.d.] National Anthropological Archives, Smithsonian Institution.

MS 1887 [Notes regarding shields, Peyotism, and Kiowa culture, ca. 1912–19.] National Anthropological Archives, Smithsonian Institution.

MS 1897 [Notes and correspondence, ca. 1902–11.] National Anthropological Archives, Smithsonian Institution.

MS 1930 National Anthropological Archives, Smithsonian Institution.

MS 2497 [Unprocessed notes regarding research in the Southeast, Southwest, and Plains, ca. 1894–1906.] National Anthropological Archives, Smithsonian Institution.

MS 2531 National Anthropological Archives, Smithsonian Institution.

MS 2538 National Anthropological Archives, Smithsonian Institution.

MS 4733 [Reports of research activities, 1896–98.] National Anthropological Archives, Smithsonian Institution.

MS 4734 [Reports of research activities, 1892–96.] National Anthropological Archives, Smithsonian Institution.

MS 4788 "Outline Plan for Ethnologic Museum Collection" [1894]. National Anthropological Archives, Smithsonian Institution.

Old labels file, Box 10, Records of the Department of Anthropology. National Anthropological Archives, Smithsonian Institution.

National Archives (NA)

RG 94, Muster Rolls, 7th Regiment, U.S. Cavalry, January 1885–December 1897.

National Archives, Southwest Regional Center (NA SRC)

RG 75, Allottee File #94.

RG 75, Land Transaction Files.

RG 75, Schedule of Allotments.

Quoetone, Guy

1967 Doris Duke Oral History Project, Tape 26. University of Oklahoma Western History Collection.

1968a Doris Duke Oral History Project, Tape 245b. University of Oklahoma Western History Collection.

1968b Doris Duke Oral History Project, Tape 246. University of Oklahoma Western History Collection.

Scott, Hugh L.

1894 Calendar file. Papers of Hugh L. Scott, Archives, Fort Sill Museum.

ca. 1897 [Notes on Indian culture, sign language, and stories.] Ledgers of Hugh L. Scott, Archives, Fort Sill Museum.

ca. 1920a Tales of the South Plains. Edited with a foreword by Gillett Griswold [ca. 1970]. Unpublished MS in the possession of C. Greene.

ca. 1920b Tales of the South Plains: Origins, the Warpath, Customs, and Adventure. Edited and with an introduction by Gillett Griswold [ca. 1970]. Unpublished MS in the possession of C. Greene.

MS 2932 National Anthropological Archives, Smithsonian Institution.

MS 4252 [Accompanying notes.] National Anthropological Archives, Smithsonian Institution.

Papers of Hugh L. Scott, ca. 1874–1934. Manuscript Division, Library of Congress.

Silverhorn, James

1967a Doris Duke Oral History Project, Tape 18. University of Oklahoma Western History Collection.

1967b Doris Duke Oral History Project, Tape 19. University of Oklahoma Western History Collection.

1967c Doris Duke Oral History Project, Tape 145. University of Oklahoma Western History Collection.

1967d Doris Duke Oral History Project, Tape 146. University of Oklahoma Western History Collection.

Southern Plains Indian Museum [SPIM]

n.d. Silverhorn, Vertical File. Southern Plains Indian Museum (Anadarko) Archives.

Index

Page numbers for illustrations are printed in *italics*. Plate numbers for the colored plates, which follow page 108, are indicated by boldface type preceded by the abbreviation pl.